P9-CCX-960

ART OF THE WESTERN WORLD

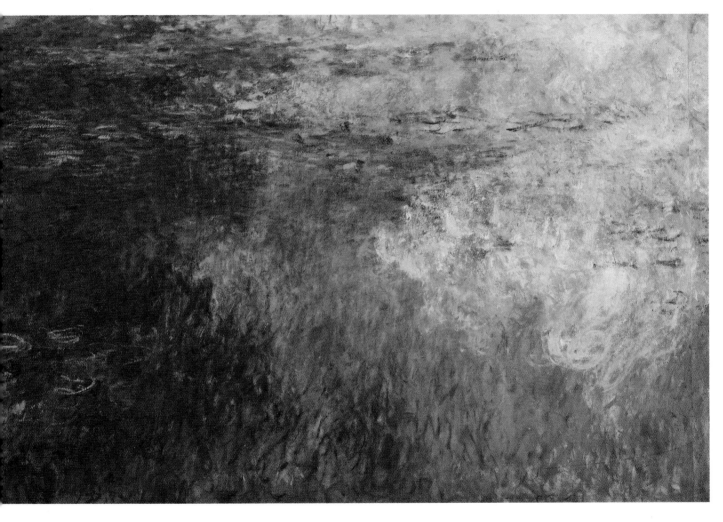

From Ancient Greece to Post-Modernism

S U M M I T B O O K S
NEW YORK LONDON TORONTO SYDNEY TOKYO

**FOR HERMAN B WELLS
WITH ADMIRATION**

SUMMIT BOOKS

Simon & Schuster Building
Rockefeller Center
1230 Avenue of the Americas
New York, New York 10020

Introduction Copyright © 1989 by Michael Wood
Text Copyright © 1989 by Educational Broadcasting Cor-
poration, Bruce Cole and Adelheid Gealt
All rights reserved
including the right of reproduction
in whole or in part in any form.

SUMMIT BOOKS and colophon are trademarks
of Simon & Schuster Inc.

Designed by Levavi & Levavi, Inc.
Manufactured in the United States of America

10 9 8 7 6 5 4 3 2

Library of Congress Cataloging in Publication Data
Cole, Bruce
 Art of the western world: from ancient Greece to post-
modernism/by Bruce Cole and Adelheid Gealt: with an
introduction by Michael Wood.
 p. cm.
 Bibliography: p.
 Includes index.
 1. Art—History. I. Gealt, Adelheid M. II. Title.
N5300.C715 1989 89-4311
709––dc19 CIP
ISBN 0-671-67007-7

CONTENTS

ACKNOWLEDGMENTS

It is a pleasure to acknowledge several people without whom this book would not have been finished. In Bloomington, Linda Baden was editor, advisor, valued source of good sense, friend, and an island of calm when things got hectic. Juliet Graver and Megan Soske helped us put the book together with a cheerfulness, skill, and dedication that could not have been bettered. Much valued encouragement and help were furnished by an exemplary dean, Morton Lowengrub of the College of Arts and Sciences at Indiana University. We also wish to thank Michael Cavanagh, Kevin Montague, Lois Baker, Jennifer Williams, and Carey Hendron.

In New York, Dominick Anfuso, Senior Editor at Summit Books, helped us wrestle a recalcitrant manuscript into shape. At WNET we were fortunate to be able to work with Tim Gunn, David Kessler, and David Wolff. We also wish to thank Laurie Winfrey and Fay Torrysap.

The Art of the Western World television series was produced for the Public Broadcasting System by WNET/New York in association with TV/South Great Britain, ORF-Austria, and Television Espana, S.A. Major funding for the series was provided by the Annenberg/CPB Project, with major corporate funding provided by the Movado Watch Corporation. Special thanks to Executive Producer Perry Miller Adato and Coordinating Producer Gail Jansen.

Our acknowledgments would be incomplete without heartfelt thanks to Doreen, Stephanie, Ryan, Carol, Barry, and the rest of our families who put up with it all with a patience that was more than angelic.

B.C. & A.G.

PREFACE

The art of the West is one of humankind's most glorious achievements. From the dawn of civilization to the present day, our art has been ever present and essential. It has served as a physical and spiritual bridge between mortals and gods, has helped men and women understand the workings of the human soul, and in times of anguish and sorrow has offered solace and helped reconcile us to life. As in all cultures and at all times, art is not a luxury but a necessity without which we would be vastly impoverished.

For its particularly human orientation, the art of the West has an important place in the history of civilization. For much of its nearly two-thousand-year history, Western art has centered on the human form; alternately idealized, brutalized, or simply transcribed, it has served as a mirror of human thought and emotion. Moreover, in its long, unceasing, and brilliant attempt to define, interpret, and alter reality, Western art is exceptional and distinct from the other great arts.

Despite its fundamental importance for all our lives, art has too often become the purview of specialists who have obfuscated it with obtuse theory and scholarly apparatus. Moreover, a naive and mis-guided cultural relativism which spurns qualitative judgments has recently obscured and downgraded the brilliance of Western art.

Like the PBS series "Art of the Western World," to which we hope this book will serve as an agreeable companion, we unashamedly celebrate the art of the West from its glorious beginnings in ancient Greece to our own time. We have tried to tell this story clearly, with little of the cumbersome apparatus or terminology of art history. The artists and works we discuss are among the most seminal, moving, interesting, or just simply beautiful we know, and we hope that our readers will fall under their magic and transcendent spell.

Our art is part of us; in it flows the spiritual and intellectual lifeblood which still nourishes and sustains our ancient civilization. It is also a living, redemptive force in an age that has witnessed the madness and destruction which is also, unfortunately, our Western heritage. Art can embody and transcend both its creators and its times to reveal enduring truths about the human condition; the more we understand art, the more we understand ourselves and the complexities of our world.

BRUCE COLE AND ADELHEID GEALT
May 1989

INTRODUCTION

A book on the story of Western art seems at first to need no explanation. Most of us think that we know what Western art is, in comparison with the art of Africa or India. Its images are unmistakable; it is a tradition that stretches from the Elgin marbles to Michelangelo to the Impressionists. We absorb them unthinkingly,

MICHAEL WOOD IN CLAUDE MONET'S GARDEN AT GIVERNY, FRANCE.

and they have helped to shape the way we see. Even with modern abstract painters, such as Jackson Pollock, there is still little doubt that they are specifically *Western* artists, addressing themselves to specifically Western concerns. To assert these notions, however, invites a number of fundamental questions. We are a collecting, museum and gallery-based culture with canons of taste that determine not only the monetary value we place on works of art but also our view of the past. Our visual tradition is largely a received idea.

But is there such a thing as Western tradition? If so, what is it? What are its main characteristics? To what extent is it derived from the Greeks and the Romans? Is it Christian? Does it include the Celtic and Germanic strain from northern Europe? And how does modern art connect with that past? We may assume that the art of the past is a kind of cultural symbolism, a shorthand that helps us understand earlier times—but what do the works of modern artists—of van Gogh or Pollock—signify? With the advances of TV, film, video, and the electronic media, does traditional art still have meaning? Does art even exist in the way it did in the past? These are questions that are broached in this book, for in art, perhaps, lies one clue to how the West has conceived of itself.

No doubt there will be art as long as there are people to create. From the caveman to Jasper Johns, many have painted or sculpted simply because they felt compelled to. But this book is not so much about what led artists to create, but what Western society has desired of its art, whether through the influence of emperors, kings and popes, churchmen and nobles, the bourgeoisie or modern tycoons, as well as the modern gallery goer who buys reproductions for the wall at home. This survey attempts to show art not as isolated cultural objects, deprived of their original context in museums or galleries, but in relation to the society that produced it. Such a task is, of course, fraught with difficulties, for to reconstruction we bring all our preconceptions. Each generation interprets the past, including art, according to its own needs. There is no truly objective history, only our interpretation. Thus not only is art itself an expression of culture, but so are art history, taste, and prices—how we select and define reveals our own priorities, our own ways of seeing.

This book primarily considers those works of art that we, and earlier generations, have designated as "masterpieces," works that, in addition to being products of their time, seem to stand outside the conditions of history and have universality. This quality operates not only across time but also across cultures—one thinks of the poetic image of the dancing Shiva of the eleventh-century Chola bronzes from India—and operates even in abstract art—for example, in the aboriginal rock art of Australia or the tenth-century Mimbres pottery from Arizona or a Persian carpet. That these images still have the power to move us in the era of mass reproduction, television and video, and the rapid internationalizing of culture perhaps points us toward the fundamental mystery of great art. Through the distinctive forms of the Greek or the Indian, we touch the broad traditions of humanity as a whole, which express in artistic form the sum of past experiences that have molded the human psyche over so many millennia.

A survey of Western art could begin in different places—the caves of Lascaux or Altamira, Stonehenge, Mycenae, or even ancient Egypt—and the choice of the beginning reveals the point of view of the survey. This book begins with classical Greece, an interpretation that has been standard since the late eighteenth century, when European theorists proclaimed Greek art as artistic perfection. Since then, Western democracies have often traced their political ideals back to the ancient Greeks. At the same time they have tended to idealize Greek art and society and to exaggerate the influence of Greece on modern Western society, at the expense of other traditions, such as the Celtic and Germanic. But in the story of art presented here, there is good reason to stress the crucial importance of Greek art, and to begin with it.

Taking the long view, a continuous tradition connects us with the Greeks; the visual language they invented is ingrained in our daily lives. Certain themes found in Greek art run through the story told in this book: what one might call the West's obsession with realism, including a pursuit of three-dimensional illusionism; the idealization of the human form; and the concept of the individual as paramount, as opposed to the community or to nature, and in contrast to the non-individualistic art of the East.

THE "CLASSICAL MOMENT": REALISM, ARCHETYPAL MYTHS AND THE TRAGIC VISION

The "classical moment" in Greece—that is, the fifth century B.C.—occurred in the lifetimes of those who had seen the transition from tyranny to democracy in Athens just before 500 B.C., and it lasted only a few generations. The poet and dramatist Aeschylus, for example, was old enough to remember the pre-Periclean tyranny; he had fought at Marathon and Salamis, and produced a play with the young Pericles. Pericles lived to see the Parthenon completed, along with many of the other great building projects of classical Greece.

The speed of progress in the arts at that time, as in other fields, was astonishing. The fundamental anthropocentrism of Greek art, one of its characteristics since its origins, had been fully realized, perfected, and idealized: during the fifth century B.C. man indeed became the "measure of all things." It has often been said that the abrupt change from the Archaic style of sixth-century B.C. Greek sculpture to the classical style about 480 B.C.—the date of the defeat of the invading Persians at Salamis—is the single most rapid change in Western art. Many historians usually attribute this change in part to the repulse of the Persian empire and the emergence of the fledgling Athenian democracy into an optimistic and expansive golden age. In this atmosphere, it is argued, the Greek idea of freedom—the assertion of man's autonomy and free will, and his ability to master his environment through his intellect—transmitted itself into the visual arts and even "liberated" the depiction of the human form. Thus a new style evolved from the Archaic sources, which could convey a reality at whose center was the autonomous human being. Such an interpretation can be sustained not only in the visual arts but also in literature, poetry, and drama. The poetry and plays of Aeschylus, Sophocles, and Pindar; the sculptures at Olympia and the Parthenon; the statues of Polyclitus; and apparently the lost paintings of Polygnotus, who invented a new style of painting during those years, are all concerned with questions of free will and fate, barbarism and civilization, the rational and the irrational. Aeschylus' drama, the *Oresteia*, has its thematic parallel in the metopes and pediments of the Parthenon: faith in the use of reason

coupled with a belief in the ability of art to portray a reality that was being defined anew by politics, science and philosophy.

As with all great art, the lasting effect is the result not only of technical skill and formal beauty, but as importantly, of spiritual content, which is a second key component of Greek art. Its religious and mythic dimension, and the archetypal power of the Greek myths themselves, created themes that have continued to be a rich source of meaning. This power can be seen in the sculptures of the Parthenon, which in many ways epitomize the Greek achievement. Since they are now in a fragmentary state, the modern viewer must imagine these figures and their effect on their contemporaries, whose preconceptions differed radically from those of modern times. If we try to imagine what an Athenian of ancient Greece saw above the entrance of Athena's temple, then we can see those Olympian gods, with their beautiful bodies, richly clothed and finely coiffured, their heads adorned with splendid diadems, their mythical personalities symbolized in their poses and attributes—figures from a living religion whose cults went back to the Bronze Age. These gods and goddesses had an emotional force that purely allegorical figures could never have. They were endowed with rich and complex associations—like Aeschylus' Athena or Euripides' Dionysus or the countless cults of deities scattered throughout Greece. So despite the contemporaneity of the Parthenon sculptures, the Athenian artists had not lost touch with their religious roots. The Acropolis was still the ancient cult sanctuary of Athena, the place of the owl, the snake, the sacred spring and the cave. On this prehistoric citadel the most sacred object was a doll-like olive-wood statue dressed with a new robe at the end of each Great Panatheneia, a ritual that continued at least as late as the third century A.D.

But the Parthenon statues could also stand for political power and even perhaps imperial ambition. The realistic, yet idealized, human form represented an ideal of harmonious human existence. The English traveler George Wheeler, who was lucky enough to see them still intact in 1679, called them "for Matter and Art, the most beautiful piece of Antiquity remaining in the World."

The classical Greek style and its mythic and religious content were two of the great legacies of Athens to the rest of the world. But Greek humanism also bequeathed a third crucial element to Western tradition—its tragic vision of life. The portrayal of the inevitability of human suffering is unusual in the public art of other cultures. But in Western art, pagan and Christian, the concept that suffering brings wisdom is one of the great themes, and it is derived from the Greeks. Presumably this is what infused the "tragic gravity" of the works of Apelles (the greatest Greek painter, according to ancient opinion), and as well as those by Polygnotus, who was the leading painter of the artistic revolution of the mid-fifth century B.C. Polygnotus' most famous picture, the Sack of Troy, dealt with the aftermath of war, the psychology of victors and vanquished, "parents lying on the bodies of their children . . . lamenting the fate of their loved ones," as Aeschylus put it in verse, perhaps recalling Polygnotus' masterpiece.

Not only is man empowered by his intellect, but he is endowed with the gift of emotion. Both qualities set him apart from all other of nature's species, for which reason the Greeks so exalted mankind. For all the rational qualities we attribute to their civilization, the Greeks attempted to find, in their art, harmony in the conflict of the rational and irrational. During the "classical moment" of the fifth century B.C. the main themes of Western art to come were defined: reason and freedom; human autonomy; the idealization of the individual human body; realism; pantheistic humanism; and the tragic vision of life.

HELLENISTIC ART, THE ROMANS, AND THE END OF THE CLASSICAL STYLE

The future of classical art was determined by the cultural dominance of Athens over the Greek world despite her political defeat in the Peloponnesian War at the end of the fifth century. In the fourth century an astonishing era of expansion took Greek art as far as India, where Greek realism transformed the abstract art of Buddhism (and gave us the Buddha in a toga that we still have today). The fourth century was the time of the great realist sculptors Praxiteles and Lysippus and the painters Zeuxis and Apelles, the time of the most famous images of clas-

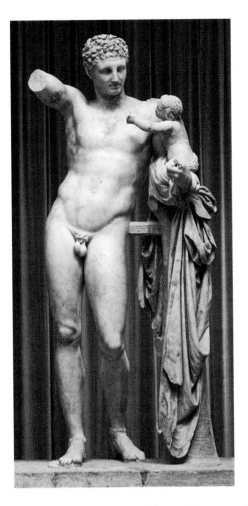

PRAXITELES, HERMES, C. 300–320 B.C. *This statue of Hermes, attributed to the brilliant sculptor Praxiteles, embodies the fully realized humanistic vision of classical Greece.*

sical art, such as the Aphrodite of Cnidus and Lysippus' portrait of Alexander the Great. After Alexander's conquest of Asia, Greek cities were founded as far as Samarkand and the Punjab in India, and Greek art and culture were fostered throughout this immense area. This post-classical art is known as Hellenistic and its art has many similarities to our own: it was internationalist, cosmopolitan, and individualist; fascinated by violence and passion in its public art; and quoted self-consciously from great art of the past. Death and violence, portrayed in realistic and moving terms, formed the theme of large groups of statues erected by the Pergamene rulers in their own city and in Athens, statues copied again and again in antiquity, which also fascinated Renaissance artists when

classical sculpture was rediscovered in the fifteenth and sixteenth centuries A.D.

Unlike the art of fifth-century Greece or of ancient Egypt, Hellenistic art did not belong to a single country or people. This was a world like ours, too, in that for the first time we find private patrons, collectors, dealers, art historians, as well as a sense of style—even reproductions of old masters! A scintillating, self-aware art that took realism—mimetic art—as far as it could go, it nonetheless did not stray from the essential aesthetic premises of the fifth century: man still remained the center of focus and formal expression.

After Greece fell to the Romans in the second century B.C., official art satisfied itself for the next two hundred years with following what had been laid down by the great artists of the fifth and fourth centuries B.C. Except in architecture and civil engineering, the Romans did not produce a visual "revolution," such as we find in the later history of Western art. While Pliny tells a curious tale of the two great painters Apelles and Protogenes competing to paint a single line on a large, empty panel—the result, he claims, "esteemed more than any masterpiece" because it "looked like a blank space"—this departure into abstraction was clearly viewed as nothing more than an amusing anecdote, such was the continuing weight of the "classical moment."

Roman figurative art was thus derivative of the Greek. The paintings found in Rome, Pompeii, and elsewhere were primarily versions of the famous stories visualized by Polygnotus and the other great Greek artists. The statues that filled Hadrian's villa at Tivoli and the homes of thousands of lesser Roman collectors were copies of the famous Greek masterpieces by Polyclitus and Praxiteles. But whereas Greek artists had kept company with poets, philosophers, and politicians, Roman artists were strictly technical workers: "Even if you were to become a Phidias," says Lucian in *The Dream*, "you'd still be looked on as a mechanic, a man who lives by his hands." Such an attitude was hardly surprising in a society where a reproduction of a master was valued above an original, contemporary work. This was the art of a conservative ruling class that disliked innovation and preferred traditional themes.

Revolution did finally occur in Rome, though, and

in art as well. What can be called the second great revolution in Western art took place toward the end of the Roman Empire, and, as in so many phases of Western art, it is connected with changes in society at large. Often called the Age of Anxiety, the late antique world underwent a spiritual crisis in the third and fourth centuries when the philosophical premises sustaining antiquity since before the age of Pericles began to disintegrate. At this time, too, the traditional anthropocentrism of the visual arts began to be questioned and reevaluated. Even in the reign of Augustus, scholars have detected signs of a reversal of taste, toward earlier, more "primitive" and anti-naturalistic—even abstract—modes of art. Collectors expressed admiration for the mysterious hieratic shapes of the Egyptian tradition. The Roman author Quintilian tells of connoisseurs who preferred the austere art of the "primitive" Greeks to the perfection of masterpieces in later times—almost in the fashion of modern collectors who have turned to the art of Africa, Polynesia, or pre-Columbian America. Roman artists even created archaic "fakes" that were much prized, and skilled sculptors, such as the Greek authors of the Laocoön (first century A.D.), could cleverly put an archaic statue of Athena in the hands of a "realistic" Odysseus in the villa cave at Sperlonga. With the increasing standardization and trivialization of subject matter in Roman art, and the psychological challenge of new religious cults, which were both anti-anthropocentric and anti-naturalistic, we can see how the way was prepared for the breakdown of the classical mimetic tradition, almost through lack of conviction.

By the fourth century A.D., the breakdown—or rejection—of classical standards was complete, as evident in such official art as the famous group of the Tetrarchs now in Venice. In this primitive, blocklike, work stripped down to the essential fact of the unity of this Roman military junta, only the vestiges of a humanistic aesthetic remain. A brutal simplicity in art was appropriate for a time of real threats, both physical and psychological. The artists who worked in this anti-naturalistic manner were not, as one scholar has declared, "third-century forerunners of a Picasso or a Klee who on their own discovered the aesthetic potential of primitive art forms." Rather, they were commissioned by their military patrons to communicate a new reality in a new visual language that common men all over the empire could read.

This internal reorientation of art was complete in the fourth century, when Christianity became the "official" religion of the empire, though the Christian view of reality was broadly shared by many of the transcendental cults and philosophies that had arisen during the troubled second and third centuries. At the heart of the Christian message was the conviction that ultimate reality was not accessible to the rational intelligence of man, but only through faith. This premise had consequences for the figurative arts that were as far-reaching as those that had grown out of the opposite conviction in the fifth century B.C. in Athens, when Sophocles had written that "there are many wonders on this earth, but the greatest is Man." For making visible what cannot be known the resources of mimetic art were useless. Once Christianity became the religion of the empire and artists were required to find a way of expressing the unknowable—the Christian mystery—a return to a visual language of symbols was inevitable. When artists committed themselves to this path in the service of Christian emperors, churchmen, and wealthy patrons, the classical art of Phidias and Praxiteles was dead.

A new, transcendent view of the universe and a new language of symbols would dominate Western art for the next thousand years, just as Greek rational humanism with its realistic art had shaped the previous millennium. Only during the Renaissance would the two traditions be fused.

THE MEDIEVAL ERA

In the fifth century, the Roman world split irrevocably into Eastern and Western components. The Eastern half continued almost intact as the Byzantine empire, while the Western provinces were overrun by Germanic-speaking barbarians. Rome itself was sacked in 410. In the absence of a centralized, imperial government, the Catholic Church filled the power vacuum, establishing Christianity as the adhesive that would bind the lands previously included in the Western Roman Empire.

During the early Middle Ages, elements came together from which the modern Western world emerged—namely, Germanic languages and soci-

ety, Greco-Roman culture and law, and Judeo-Christian religion and ethics. In art, too, these are the sources that define the medieval and modern Western traditions.

The classical style, then, was not the only one to shape the roots of Western art. The so-called barbarians of the North—Celts and Germanic peoples—had their own distinctive way of visualizing. Before their exposure to Roman and Christian art, they had not been concerned with the representation of human beings in their art. Nor did they look at nature in an analytical way. Rather, they copied interior models and visualized abstract concepts with a taste for fantastic elaboration of interlace and ornament. Celtic and Germanic art had no ambition to copy the shapes of the real world, and this attitude appears to be the source for a deeply seated nonrepresentational strain in Northern European art, one that has persisted even to this day. The abstraction of the *Book of Kells,* the "flaming line, tender curves and tense geometry" of Anglo-Saxon art have been found by some scholars to have echoes in the modern era in works by John Flaxman and William Blake, while the visionary painting of the early medieval era in the North has been compared to the sixteenth-century works of Altdorfer, Cranach, and Grünewald, as well as to the twentieth-century German expressionist paintings of Wassily Kandinsky, Franz Marc, Max Beckmann, and Otto Dix. The abstract, linear art of the Gothic North was set in opposition to that of the classical standards of the Mediterranean world, an attitude that has dominated Western art up to the nineteenth century. In fact, the Northern tradition is both equal and opposite to the Latin.

The non-classical style is immediately evident in the gold treasures from Sutton Hoo (c. 625), with their astonishing technical brilliance, which mimic the effects of ancient metalwork tradition. The abstract, interlace ornament was adapted for Christian purposes in Western Europe. In the British Isles in the seventh and eighth centuries, a series of masterpieces of book illumination and sculpture—including the Books of Durrow, Lindisfarne, and Kells, and the sculpture of Bewcastle and Ruthwell—shows a fusion of the Northern abstract style with a figural style descended from the Roman empire, creating a powerful Christian art.

The origins of a distinctively Western style, where

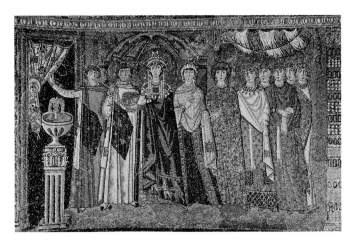

JUSTINIAN AND HIS COURT, SANT' APOLLINARE NUOVO, RAVENNA, ITALY, C. 500. *The glittering symbolic language of Byzantine art incorporated Persian and Oriental elements foreign to the Greco-Roman tradition.*

these classical and non-classical elements were first effectively integrated, are found in art created during the *renovatio* of the Frankish king Charlemagne in the late eighth century. Charlemagne's empire extended from Spain to the Rhine and to Italy, where he was crowned as a latterday Roman emperor in 800 A.D., crystallizing the Western barbarians' desire to be regarded as the heirs of Rome. Gathering the best scholars and artists, Charlemagne sponsored an art and an ideology for his renewed Christian empire. The artists in his service drew on and fused Italian, Byzantine, Celtic, and Anglo-Saxon models. Later generations would call him *Europae Pater,* father of Europe—perhaps the most important single patron in the story of Western art.

The art of the early Middle Ages was primarily that of the great Germanic dynasties that succeeded Rome in the West. Having adopted Christianity, they saw themselves in some ways as heirs of Rome, and their art expresses the indivisibility of earthly and heavenly power. The important centers of artistic production were the royal abbeys—Saint-Denis, Reims, Tours, Fulda, Winchester, and Canterbury. These were hard times, constantly beset by violence, famine, and war. But in the tenth century, Western Europe became more stable, after prolonged invasions by Vikings, Saracens, and Hungarians, and we see the beginnings of a slow rise in material wealth and standard of living.

The tenth century also saw a revival of monasti-

cism in England, France, Germany, and Spain, while the growth of the cult of saints under the sponsorship of kings such as Athelstan (924–39) in England led to the improvement or establishment of numerous pilgrimage churches all over Western Europe in order to meet the needs of religious pilgrims. Monasticism and the cult of the saints were, in fact, two forces that formed the art of the eleventh and twelfth centuries, known since the nineteenth century as Romanesque.

In Romanesque art, the classical and non-classical roots of Western art were reconciled in a new and original way. It is the first specifically Western artistic style—not the self-conscious revival of classical art of the Carolingian revival, nor the "barbaric" style that had been drafted into Christian service by Celtic and Germanic artists in England, France, Germany, and Ireland. Monumental art—both sculpture and architecture—was revived for the first time since antiquity. And though the orientation of Romanesque art was still rigidly fixed on the hereafter of heaven, with humanity holding a low place in the celestial hierarchy, artists nonetheless began to include themselves in their art by signing them. Though distorted and dramatically and expressively rendered, as in Gislebertus's extraordinary cycle of sculpture at St.-Lazare in Autun, man begins to retake center stage in the art of the Romanesque period.

The great cycles of sculpture at Autun, Vézelay, and Moissac also show how completely the antique idea of monumental sculpture had been revived. By the mid-twelfth century, in fact, old theories of art had been transformed: nature itself could be surpassed by art. The Gothic style signals the return to an expressive naturalism in art in a way that parallels the achievements of the ancients. With the finest examples found on the portals of the great cathedrals, Gothic sculpture once again included images that reflected "the mirror of the physical world the higher truths of the spiritual."

The Gothic cathedrals represent the peak of the hierarchical social order that had superseded the late antique world. Originating in northern France about 1140, Gothic art spread all over Europe and in a century transformed the look of virtually every major city. There had been nothing like it since the great construction programs of the Roman Empire: not merely in the quantity of stone shifted, the size of the cathedrals, the spaces enclosed, but also in the sheer technical quality of the architecture, carpentry, sculpture, painting, and glasswork.

These vast building projects were made possible by the huge surpluses available to rich bishoprics and abbeys, such as Chartres, Saint-Denis, and Canterbury. But in the thirteenth century, a change of mood can be detected, as the old bonds of the feudal order began to loosen under social and economic strains. As the feudal hierarchy began to break down, the supreme authority of the church was increasingly challenged by the independent secular leaders of the burgeoning nation states. The fourteenth century saw revolts of the peasantry in many parts of the West, and the crisis atmosphere of the period was accentuated by economic decline, devastating famines, and a catastrophic series of plagues, beginning with the Black Death of 1347–50, which continued endemically for the rest of the century (and for some four centuries thereafter).

As the authority of the church disintegrated in the late Middle Ages, a new awareness of mankind and earthly existence can be discerned in the visual arts. Not surprisingly, in the wealthy Italian city-states, where the remnants of classical antiquity literally lay about, a new art developed in response to this new view of the world. Furthering the kernel of optimism for humanity that can be found in such High Gothic art as the sculpture programs of Chartres and Reims, the Italian artists of the fourteenth and fifteenth centuries began to look to the classical tradition. They successfully reintegrated both the style and ethos of ancient humanism with the Christian philosophy that had now become a firm part of the Western tradition.

THE RENAISSANCE: THE RETURN OF NATURALISM

The Italian Renaissance represents a true *renovatio* of the classical tradition. During the thirteenth and fourteenth centuries, artists such as Cimabue, Giotto, and Giovanni Pisano were still conditioned by Gothic and Byzantine modes, although their works also display a new humanism that exalts man's empathy, suffering, and emotion. Humanity was depicted with great dignity. Antique art was, in

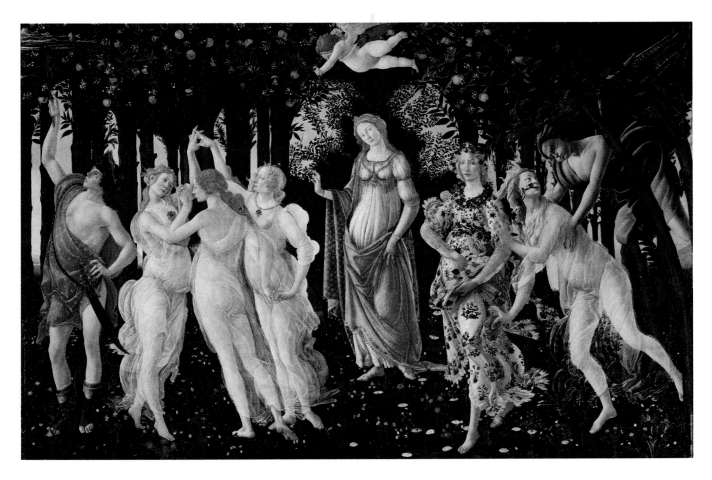

SANDRO BOTTICELLI, PRIMAVERA, C. 1482. *Sandro Botticelli, the favorite painter of the Medicis, was perhaps the Italian Renaissance's most imaginative re-inventor of classical myth.*

fact, often used as models for the depiction of Christian heroes, and thus it is not surprising that classical mythology was eventually used for its incomparable rich store of archetypes and images that parallel many of the Christian types. By the sixteenth century, Raphael could paint the pagan god Apollo on the walls of the papal apartments in Rome. The rediscovery of classical texts, and even of ancient works of art themselves, added to this impetus. Once more the ideal human form was placed at the center of art, and the quest for realism —the illusion of the third dimension—became a central question for Western artists. In the hands of such artists as Raphael and Michelangelo, "modern" painting and sculpture emulated the ancients.

No artistic career more dramatically illuminates the new attitudes than that of Michelangelo. Painter, architect, and sculptor, he alone among his contemporaries was felt by the Florentine art historian Vasari to have rivaled—even to have surpassed— the ancients. But Michaelangelo did more, for he went beyond the mimetic tradition of the ancients and questioned the basis on which it rested. In that sense he remains for us the quintessential Western artist, and his works constitute a unique commentary on the relationship between the classical and the non-classical strains in Western civilization.

The exquisite "realistic" *Pietà* in Saint Peter's, Rome, shows how the young (twenty-three-year-old) Michelangelo mastered the formal style of Donatello with qualities of balance and perfection. Shortly afterward, in 1506, the artist was present at the rediscovery in Rome of the *Laocoön Group,* which the Roman writer Pliny had deemed "preferable to all other works of art." The influence of the Laocoön as well as other Hellenistic works can be traced throughout Michelangelo's art, and his battle to supersede the classical mimetic tradition continued to his last working day. Thus it is not surprising

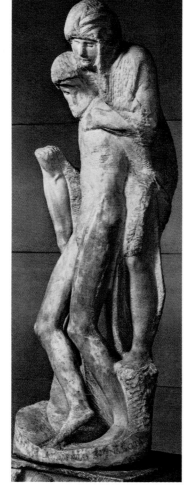

MICHELANGELO BUONARROTI, RONDANINI PIETÀ, 1555–64.
The contrast between the Pietá completed by Michelangelo when he was twenty-four years old (p. 141) and this Pietá reworked in the last days of his life when he was eighty-eight illustrates the struggle that is at the heart of the Western tradition of representation: how to portray spiritual essence directly in stone.

lo's long career that poignantly stands for all. Six days before his death the artist was found in his studio by a pupil, working on what is today known as the *Rondanini Pietà*. Though his sight was failing, friends marveled at his continuing strength in old age (he was now eighty-nine). Begun early in his mature career, the sculpture was first conceived in his "classical" style. But now the old man set about it with a hammer and punch, hacking away Christ's head and upper body and creating Him anew out of the Virgin's body. A severed arm, and the legs, smoothly polished and realistically worked, remain from the earlier work. What he left is a strange hybrid of mimetic, abstract, and expressive forms that simultaneously reaches back into the Gothic and forward into our own time—and still speaks the visual language of its own day. The last working day of his life Michelangelo was still struggling with how to portray the unknowable, to show spiritual essence directly in stone. Here we come, finally, face to face with what art can or cannot do. The inevitability of failure is perhaps what led Michelangelo near the end to write in a sonnet to Vasari: "Now I know I was a fool to make art into an idol or a king."

If Florence and Rome saw the peak of naturalistic sculpture, it was in Venice that the most thoroughgoing assimilation of the classical tradition took place. Though artists such as Titian observed and copied antique monuments, inscriptions, and statues like the Laocoön, Venetian artists more intuitively understood the spirit of Hellenism, perhaps as a result of the peculiarities of Venetian geography and history, poised between the eastern and western Mediterranean, between the Latin and the Hellenic. In the sixteenth century Venice still held an empire in parts of Greece and the Aegean, including Crete (where El Greco grew up and was trained). Venice had a large Greek community and was the center of Greek scholarship and book production in Europe from the fifteenth to the eighteenth centuries. Here if anywhere the sensibility of Greek humanism could be expected to have survived in Christian culture, and so it did. This insight helps us understand the flowering of Venetian art as created by the Bellinis, Giorgione, Titian, Tintoretto, and others.

Throughout a long career of sixty-five years, Titian moved with particular ease between pagan, human-

that Michelangelo was particularly impressed by another sculpture in the Vatican collection, the moving but shattered Belvedere torso. As he grew older, his sculptural work increasingly explored the boundary between what can or cannot be expressed by the mimetic. He took up the challenge by exploiting the contrast between the finished and the unfinished or fragmentary: for by portraying an image only partly freed from the stone, it was possible to make concrete a spirituality that transcends matter itself, a spiritual reality that the illusionism somehow obscured or resisted. So the material out of which the spirit was to be rendered had to be used to negate itself. In taking on this challenge, Michelangelo effectively bridged the chasm between classical mimetic art and medieval spiritualism to create works that are the quintessential synthesis of the two opposing traditions of Western art.

We can indeed point to one work in Michelange-

ist, and Christian themes, as witnessed in the spectacular mythological cycle inspired by Ovid for Alfonso d'Este's "humanist dreamland" in his palace at Ferrara. These Bacchanalian pictures were all executed, as Vasari says, with "particular fineness and incredible diligence." In the last decade and a half of his career, Titian's technique developed into a highly personal and expressive style. From this period comes a tremendous series of mythological themes. Among these is the *Death of Actaeon,* which Titian seems to have kept in his studio and reworked in the last years of his life. This is a somber masterpiece of classical horror (the subject of a lost tragedy by Aeschylus and a painting by Polygnotus). Punished for seeing Diana in her bath, the hunter Actaeon is transformed into a stag and killed by his own hounds. In the painting Actaeon is still all too human—only his head has been turned into that of an animal—while his dogs tear his body like hellhounds, and the pitiless divinity is poised to shoot her bow. In late works such as this one, Titian assimilated the tragic vision of the ancients: "Call no man happy until he dies," as Sophocles said. Here Titian put aside the formal canons of Renaissance art, but retained the essence of the classical spirit; his final works are visions and evocations of Christian *and* pagan mysteries that are expressed with equal intensity and imaginative expression.

In the seventeenth century, we enter the world of art galleries, dealers, collectors, and patrons. No one has ever attempted to estimate the amount of art created during this time to satisfy the market, and most of it was undoubtedly not great art—as poor as the mass-produced art of the Romans. At the highest level, the assumptions laid down by the Italian artists of the Renaissance (and the Baroque period, which followed) determined the standards of art across Europe. But in the northwest of Europe, especially in the Protestant, individualist Netherlands and England, a new secular bourgeois art was developing. Here the commercial cities of Antwerp, Amsterdam, and London were taking over the economic leadership of Europe, shifting the center of gravity away from the Mediterranean for the first time in the history of the West. Powerful oligarchies brought about the first industrialization and created empires across the seas to find new markets for their products. So too the center of gravity of art,

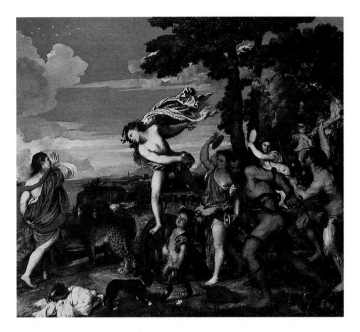

TITIAN, BACCHUS AND ARIADNE, 1522–23. *In Titian's late paintings a highly personal, tragic vision of classical myth speaks alongside a deep-seated Christian passion.*

and art markets, shifted from Italy to northern Europe.

It was in France that the great humanistic phase of Western art, which began in the Renaissance, came to an end, and with it the connection with the classical past. The achievements of the Renaissance, like those of the fifth century B.C., were so far-reaching and impressive that they were essentially accepted as the way art should be made from the fifteenth century up till the late nineteenth century. A final classical revival took place in the late eighteenth century when artists and thinkers sought a more austere non-religious art, an art for a new secular social order, which, it was hoped, was based on unaltering principles derived from classical philosophy and art—a rational humanism for an Age of Reason. Classical art and architecture were revived and reinterpreted as the "true style." Theorists such as Winckelmann and Goethe hailed the "noble simplicity" of this style, especially for its portrayal of the human form, and called it Liberty. This overidealized conception appeared before and during the heady days of the French Revolution, and art and politics were perhaps never combined so closely as in the Neoclassical works of David. But the ideals of the Age of Reason that underlay the

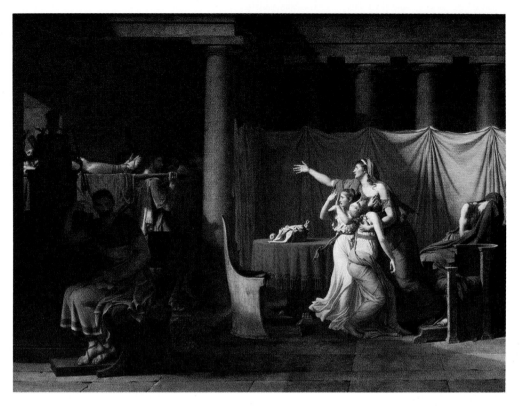

JACQUES-LOUIS DAVID, VICTORS BRINGING BRUTUS THE BODY OF HIS SON, 1788–89. *David re-created the classical tradition in dazzling displays of technical virtuosity; his* Victors Bringing Brutus the Body of His Son *conveys some of the monumentalism of Greek sculpture.*

revolution were submerged in violence and unreason, and gave way to the Napoleonic empire and to war which engulfed the whole of Europe. The Neoclassical experiment was very influential in architecture but was rapidly dropped by the avant-garde in art. The age of Napoleon ushered in a new conception of man, known in Europe as Romanticism, and we are still feeling the consequences of this radical shift. The move into abstraction in the later nineteenth century and the twentieth, with its rejection of the world of fact, its inwardness, its emphasis on the pure experience of the artist, appears, in historic hindsight, like the last phase of Romanticism. So European art of the nineteenth century brings our story full circle, to another reevaluation of realism in Western art.

ART IN THE MODERN WORLD

The central material facts of Western history over the last one hundred fifty years have been industrialization, the population explosion, and the creation of a mass proletariat and liberal democracy. In terms of culture, the breakdown of the old value system, the decline of religion, and the emergence of a scientific view of the world distinguish this period from all others, and these factors have irrevocably changed the function of art. The roots of this world view can be sought in the West's long tradition of individualism; in the rise of Protestantism and capitalism in northwestern Europe in the Renaissance; in the separation of secular, rational, scientific philosophy from the spiritual life, which gains in pace from the Renaissance onward. These themes all converge in Romanticism. The values of this new age were not piety or virtue, as in the ancient world; not loyalty or constancy, the old Roman virtues; not religious faith or even scientific truth, but the capacity for experience. As the poet Baudelaire put it: "The key to Romanticism is not science or even truth but *feeling.*" Imagination and the self-determining will became paramount.

The subjective experience of the world now became all-important, as the concept grew of the artist as an individual, with an independently creative will, freed from the traditional system of patron and his status as a technician. But other realities and ideas were also altering established Western beliefs about man and his place in the world and cosmos. On the positive side, the powerful machines of the industrial age surpassed manpower, making diffi-

cult tasks easy, and reducing production time and communications so drastically that the pace of life literally seemed to quicken. Scientific discoveries—in chemistry, physics, and biology—made the universe more comprehensible and fostered an interest in the material facts of the world. But these wondrous changes were accompanied by equally strong negative forces: industrialization dehumanized the labor force; gave rise to unprecedented poverty, in the newly created class of urban poor; and rendered deadly new weapons that would eventually dehumanize even the manner in which war was conducted. The growth of cities, hailed by those who wholeheartedly and optimistically embraced the new modern era, was lamented by others, who feared that urbanization would further alienate man from nature. Not surprisingly, such conflicting notions about modern life brought about changes in ways of seeing that are as profound as those in Greek antiquity, the early Middle Ages, and the Renaissance.

Rejecting the established, now-irrelevant genres of the Academic tradition, artists like Courbet and Manet painted what they saw around them—the

CLAUDE MONET, WATER LILIES. *With Monet's late works Western art moves into abstraction and abandons the pursuit of the illusion of the third dimension for a more subjective exploration of color, light, and painted surface.*

real, modern world. Manet endlessly rethought the nature of painting and its constituent elements—the framed canvas, color, light, and texture, and took radical steps to create a modern style. The Impressionists similarly took their cues from quotidian life in the city and country, and, reflecting the scientific, material bent of the period, translated ideas about perception, optics, color, and light onto shimmering canvases. The formal theories and painterly language of the Impressionists were developed and endowed with a passionate expressiveness in the works of Gauguin and van Gogh, and by the German Expressionists, who desperately sought a now all but irreversible reconciliation of man with nature and, as important, with his spiritual self.

The real break with the past, however, occurred in the twentieth century, as the Cubists and their followers captured the simultaneity and speed, as well as the fragmentation, of modern existence. By the 1920s, abstraction in the arts had become the paramount mode, with man all but banished from the picture plane. While a strong current of realism has survived, art has celebrated the creative process, subjective expression, the workings of the subconscious, materials and media, man over nature (and the opposite), man over machine (and the opposite), even the experience of two world wars, and the new commercial age—largely in non-objective visual terms. Only in the 1980s, as many of the

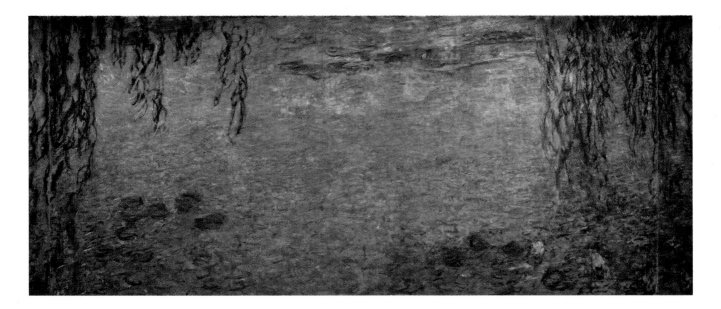

ARSHILE GORKY, UNTITLED, 1944. *The move to abstraction in the twentieth century may be just as revealing about the psyche of our era as the same move was during the Late Roman "Age of Anxiety."*

discoveries and experiments in visualizing have exhausted their potential, has man begun to reappear in art, though in a way that differs from the humanistic tradition that we have traced from antiquity.

Modern art is now international in the way Hellenistic art was—bought by Japanese chain stores and seen in African hotels. Indeed, many of the most modern artists used foreign forms—van Gogh and Gauguin from Japanese prints; Picasso and Braque from African and Polynesian sculpture. These movements have coincided with dramatic new developments that have forever changed our ways of seeing and our idea of what art is; photography, film and video, and scientific discoveries have altered our understanding of matter and the nature of reality itself. Now, curiously, with the most sophisticated methods of mass reproduction by computer graphics and animation, we have reached the point where more art is being made than ever before; more people see art than ever before, and yet the art being created in the traditional media of painting and sculpture is generally deemed to be disposable, unoriginal. But art is made by its time, and in our time film and video are undoubtedly the

mass art forms, the arts in which it is assumed the great issues of human life are presented. In that sense film is the true successor of the Greek mimetic revolution, and the West is still in the grip of that obsession with the illusion of reality in art, still "slave to the image," as Freud said.

So whither the future for Western art? There are more working artists and more consumers of art than ever before. As a business, art is booming. But it is plain now, with the spread of an electronic global culture, that we face the prospect of the erosion of all differences, the prospect of great conformity and simplification. What we now call the West began as Western Europe, and its art as a synthesis of Christian, classical and Germanic themes. Forever experimenting and self-conscious, continually adopting other traditions and other ways of seeing, the West became the home of modernism, the most important change in our ways of seeing since the Renaissance. Now, with modernism, the West has become a state of mind, rather than a geographical region, and is perceived as such by other cultures —Islam, Africa, India and the rest—who have felt its often destructive impact. Today critics are fiercely divided over the legacy of modernism, as to whether it has proved a force for liberation or a sign of terminal cultural decay (the much-prophesied "Decline of the West"). But viewed in the light of earlier revolutions in Western ways of seeing, we can think of it as a natural part of the continuing story of Western artists' quest for self-expression. Individualist, humanistic, problematic, the best of Western art is like those other great Western art forms, music and tragic drama, in that it is a record of the triumphs and failures of a culture striving to express spirtuality through art. Its roots lie in ancient Greece, where the themes of reason, freedom and human autonomy first arose, and where the tragic vision of life attained its earliest expression. In its highest achievements it bears witness to the never-ending struggle for free societies; it offers us the profoundest explorations of the human condition; it even attempts to go beyond the facts of the material world and give form to the formless, to the unknowable. As such, the sum of Western art is one of the chief keys to the Western past—and to its present.

MICHAEL WOOD
May 1989

ART OF THE WESTERN WORLD

From Ancient Greece to Post-Modernism

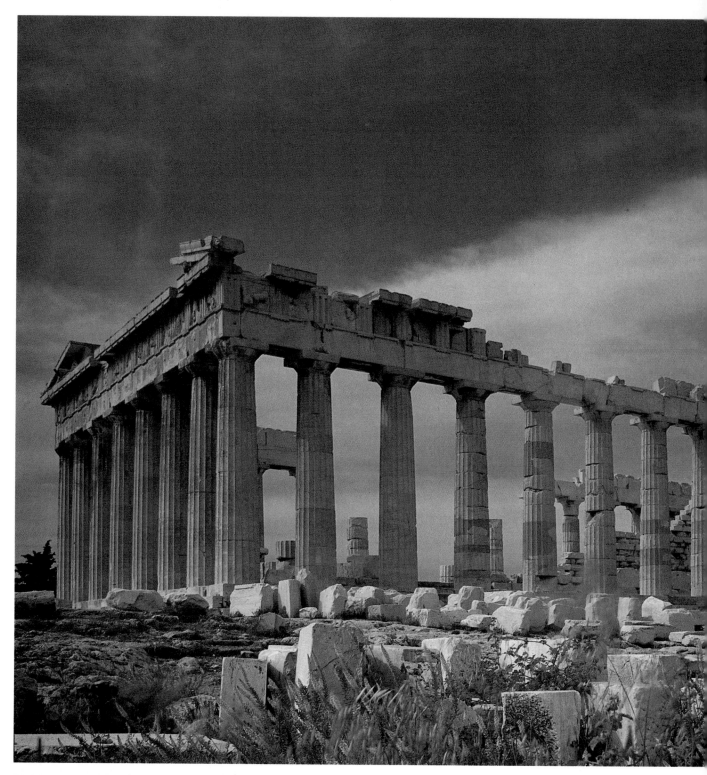

PARTHENON, c. 447–432 B.C. *Athena, to whom the Parthenon was dedicated, is the daughter of Zeus and one of the major figures in the Greek pantheon. The goddess of wisdom, she was protectress of learning, the arts, and household crafts and was the patroness of Athens.*

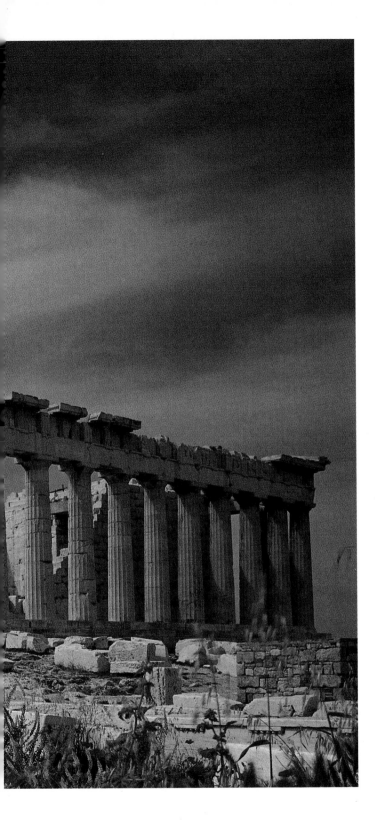

[1]

THE ART OF GREECE

In 1972 two great bronze warriors [pp. 4–5] were pulled from the sea off the Italian town of Riace. When they were first displayed in Florence, the large crowds who came to see them were filled with wonder and admiration. Although the life-size figures were created over two and a half millennia ago, these unexpected gifts from the ancient past spoke in a language still understood: the warriors possessed a godlike strength, yet they were also human. They come from the very dawn of the history of Western art. They are Greeks fashioned by Greeks, paradigms of the civilization that produced them.

The civilization of the ancient Greeks, whose city-states dominated the islands and coast of the Aegean Sea, is the fountainhead of Western culture. Before the Romans annexed Greece and sacked Athens in 86 B.C., the Greeks had established the disciplines of history, philosophy, astronomy, mathematics, poetry, drama, music, and aesthetics. The images of human perfection the Greeks left behind in clay, metal, stone, and paint have remained touchstones for all subsequent Western art.

The ancestors of the Greeks lived in the valleys of a limestone mountain range rising from the Aegean Sea. In addition to farming and hunting, they fished, sailed, and explored; and, inevitably, they warred. Cultures rose and fell in relatively rapid succession (in contrast to the stable empire existing in Egypt), until the people now described as the ancient Greeks emerged about 1000 B.C. These were

a people who blended history and myth, who delighted in the discovery of scientific principles but who rejected dogma. Discourse, study, investigation, cogitation, and debate were important in their lives, as were wars, athletics, games, and contests. They were trained to use both their bodies and their minds. Winners of their athletic competitions were commemorated not only in sculptures like the Riace warriors, but in poetry as well. Indeed, great Greek poets like Pindar are now known largely through their odes to victorious competitors in the Olympic games. Pride, courage, strength, resourcefulness, honesty, and virtue made up the Greek ideal of manhood and were given expression in Greek art and philosophy.

During the five centuries before the Riace warriors were created, Greece had developed a seminal civilization. By 776 B.C. the Greeks had founded the Olympic games, which, revived in the nineteenth century, continue today as the world's most celebrated athletic competition. By the middle of the eighth century, they had set down in writing the *Iliad* and the *Odyssey,* the repositories of their myths and their history. Homer's epic poems were a fundamental inspiration for Greek art. During the eighth century Greek city-states (poleis) gained sufficient wealth to support thriving pottery industries. Athens manufactured huge funerary vases with stylized geometric decoration; other city-states, such as Corinth, produced their own indigenous styles, and the foundations were laid that transformed pottery making into a fine art. In this period the Greeks also began to experiment with monumental sculpture. The rigid, static *kouroi* (figures of nude young males) that marked graves or stood near temples were early experiments with the human figure during the course of Greek civilization.

Aristocratic patrons supported this early phase of Greek art. But by the end of the sixth century Athens had introduced democracy, spawning a dynamic balance of power among individual citizens. That democratic spirit and a temporary cessation of rivalry among the Greek city-states saved Greece from the Persian invasions of 490 B.C. and again in 479 B.C. Led by Pericles (c. 495–429 B.C.), Athens emerged as the dominant power among the city-states and entered its fabled golden age.

Pericles built Athens into the cultural and intellectual center of Greece. His lifetime inaugurated

BRONZE WARRIORS, C. 450 B.C.
These two figures, possibly the Homeric heroes Agamemnon and Menelaos, were the product of nearly 500 years of experimentation with the human form in Greece.

the classical phase of Greek art, which lasted until the Macedonians became the rulers of Greece about 338 B.C. The classical ideal had both aesthetic and political implications. As democracy balanced the needs of the individual with those of the group, classical art balanced interest in individual, natural, specific features with generalities, ideas, and norms, straining neither in one direction nor the other.

From 480 to 323 B.C., Greece achieved a high point of civilization. Socrates, Plato, and Aristotle

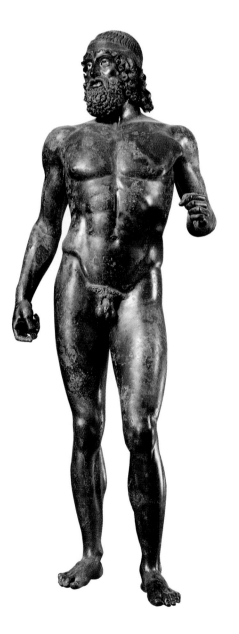

laid the cornerstones of Western philosophy. Herodotus chronicled the Persian wars and helped establish the discipline of history. Aeschylus and Sophocles refined Greek tragedy. All cultivated an outlook on life that was humanistic, antiauthoritarian, questioning, and undogmatic. They searched for ideals while recognizing human limitations and the importance of the individual.

The warriors from Riace reflect many of the same principles. Produced after roughly five hundred years of experimentation with the human form in Greece, they demonstrate the perfection achieved during the fifth century B.C., when reality and ideality reached a state of equilibrium. Perfectly proportioned according to an aesthetic standard, these warriors exhibit the ideal male body, with each part a measured and harmonious component of the whole, evoking the Greek reliance on measurement in the context of art. As Plato said, "If there are arts, there is a standard of measure, and if there is a standard of measure, there are arts; but if either is wanting, there is neither."

Here, then, is yet another basic aspect of Greek art: the Greeks thought about what they created in aesthetic terms; they had serious debates about what constituted art. Though many earlier civilizations produced objects that are now considered art, most previous cultures had not discussed them aesthetically (or there are no records). Objects were produced to have a specific function. A sculpture might represent a deity, mark a tomb, or serve as a votive offering. Pottery, though it might be embellished, was meant to hold oil or wine.

Undeniably, Greek art had similar functions. In fact, the Riace warriors may have been part of a larger group of figures, commissioned by the Athenians and dedicated to the sanctuary at Delphi to commemorate their victory at Marathon. But such functional roles did not prevent the Athenians from imbuing their creations with aesthetic ideals. Such purely aesthetic notions demonstrate a highly sophisticated culture, a culture that created and collected objects as art and that used art for self-expression and social understanding. Greeks asked themselves fundamental questions about their origins, about their destiny, about morality and government; and they used art in their quest. The search for beauty motivated their creativity, as did the traditional reasons for making art objects. Greek

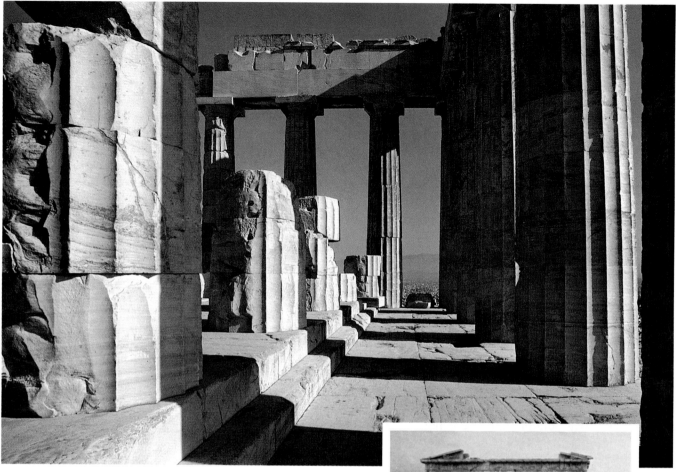

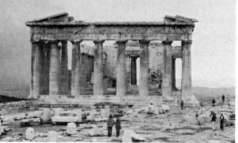

PARTHENON, C. 447–432 B.C. *Built from Pentelic marble set on a limestone base and erected on the site of an earlier temple destroyed by the Persians, the Parthenon utilized parts of the old building in its construction.*

philosophers took notions of beauty just as seriously as other fundamental philosophical issues. Plato's *Republic* states: "The man who has been properly nurtured in this area will be keenly aware of things which have been neglected, things not beautifully made by art or nature. He will rightly resent them, he will praise beautiful things, rejoice in them, receive them into his soul, be nurtured by them and become both good and beautiful in character."

"Beautifully made by art or nature." This is another key to appreciating the contributions of Greek civilization. Many earlier cultures, the Egyptian in particular, had produced a static art, built on formulas passed down from one generation to another. The early Greeks learned from their Egyptian counterparts, but they also began to incorporate visual and later emotional experience into their art.

With this fundamental innovation—looking at and refining nature—the Greeks set into motion a process that would change with each generation and would reflect new interpretations of the world and of humanity. From their art, then, much can be learned of the Greeks' philosophic and aesthetic beliefs. A monument such as the Parthenon [pp. 2–3] is more than a beautiful remnant of a lost past. It is, instead, the physical embodiment of the ideals, hopes, and realities of ancient Greek society, which remain embedded in modern Western civilization.

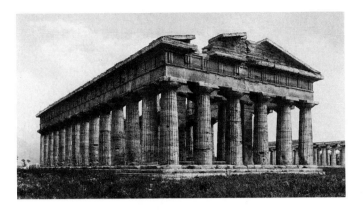

TEMPLE OF HERA II, C. 460 B.C. *The site of this temple, Paestum, Italy, was inhabited until the 11th century A.D., when it was abandoned. It was not until the 18th century that Greek ruins such as the Temple of Hera were discovered there.*

The Parthenon rises on the Acropolis, the sacred outcropping dominating Athens. An icon in the history of architecture, the Parthenon was built as a temple and dedicated to the virgin goddess Athena Parthenos, daughter of Zeus and the patron and protector of Athens.

Although building the Parthenon took only about fifteen years (447–432 B.C.), an exceptionally short time, it involved hundreds of workmen from all over Greece. One of the most ambitious building projects of the ancient world, the construction of the Parthenon, with its teams of builders and artists' workshops and the huge expenditure in both gold and labor, can be compared to the rising of the great cathedrals of the Middle Ages, built with the tithes and energy of the faithful.

Time and man have treated the Parthenon harshly. This pure white marble structure was transformed into a Christian church dedicated to the Virgin Mary in the thirteenth century and then into a Moslem mosque about 1458. Its ultimate degradation occurred in the seventeenth century, when the conquering Turks used it as a powder magazine, subsequently exploded by Venetian artillery. In addition, throughout its history its sculpture has been pillaged.

Although the Parthenon is called a temple, its function was very different from modern sacred architecture. Today's places of worship enclose the faithful and create a holy sanctuary. The Greeks worshiped differently: their altars were in the open air, and their religious rites were performed outside. In the walled rooms behind the row of columns, Greek temples enclosed large cult statues and treasuries in which gifts and offerings to the gods and goddesses were safeguarded.

Consequently, Greek temples are not closed structures but open ones; their space is delineated by a screen of columns articulating their boundaries while exposing, through the spaces between the columns, the sanctuary of the deity and the room that housed the treasure. Greek temples are welcoming—they are less about mass than about light-filled space—and they do not exclude with monolithic walls, as do some Romanesque and modern buildings.

That the Parthenon is one of the world's greatest buildings is not an accident but the result of centuries of refinement in the building of temples in Greece. First made of mud and wood and then built of stone, with the post-and-lintel construction technique of the earlier wooden structures, the Greek temple emerged through a series of almost imperceptible developments.

An ancestor of the Parthenon, the Temple of Hera II [p. 7] is set near the Mediterranean Sea at Paestum, one of the many Greek colonies that thrived in southern Italy. Built about the middle of the fifth century B.C., the basic style of the building —fluted column, pediment, roof, and carved architectural embellishment—formed many of the essential components of Western architecture until the middle of the twentieth century. The Greek architectural canons denoted stability, authority, and permanence, and as such they came to enunciate the public persona of government and financial institutions all over the Western world.

There are subtle but notable differences between the Temple of Hera II and the Parthenon. The former is heavier and squatter, and is imposing through its weight and mass. The large columns thicken in the center as though compressed by the weight of the structure they support. (This thickening of the columns in the center, called entasis, is probably a stylistic convention derived from the actual bowing of the wooden columns of earlier Greek temples.)

The Parthenon, in contrast, is the culmination of the development of the Greek temple; all its parts, even in its ruinous state, form a sublime whole. Its

height, width, columns, mass, open space, and relation to its surroundings express a sense of order and peace. Its authority is powerful but not intimidating, and the logic of its construction is immediately clear.

Because there has been so much damage and loss, it is impossible to know the exact nature and scheme of the Parthenon's sculptural program. It is known that the pediments, the metopes (the space between two blocks with vertical grooves in the frieze of a Doric order), and the central block carried sculpture, much of it painted in colors. The balance between the geometry of the architecture and the organic shapes of the sculpture originally must have been one of the most splendid features of the Parthenon.

The principal sculpture, by Phidias, which is now lost, was the colossal cult statue of Athena. Probably over thirty feet high, the imposing gold-and-ivory-embellished goddess standing in her dimly lit sanctuary could be seen through the great columns from outside the building.

THREE GODDESSES, FROM THE PARTHENON, C. 435 B.C.
In 1812, these and other fragments of the Parthenon's pediments were removed to England, where they remain today.

BATTLE OF LAPITHS AND CENTAURS, METOPE FROM THE PARTHENON, C. 440 B.C. *The metopes of the Parthenon may be the earliest carved decoration on the building, each one of the ninety-two depicting a battle scene.*

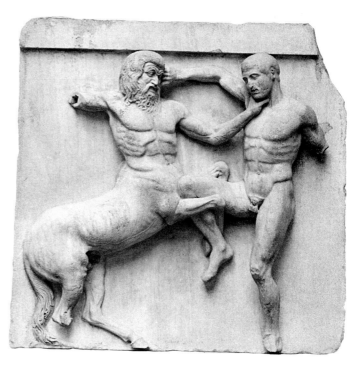

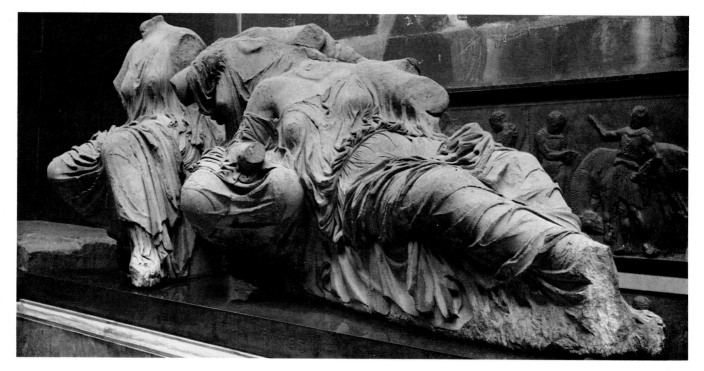

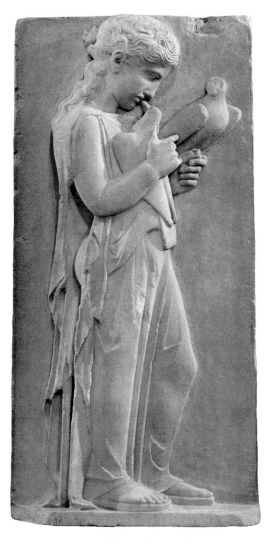

GIRL WITH DOVES, C. 450 B.C. *In antiquity the dove symbolized love and constancy, an appropriate meaning for this stele, the Greek word for "standing block" or "gravestone."*

There appears to have been an overall program for the sculpture, aimed at glorifying not only Athena but also Athens. A number of the metopes depict the battle between the centaurs—wild and brutal half men, half beasts—and the Lapiths, a tribe of peace-loving men. The Lapiths' triumph in the bloody conflict was seen by the ancient world (and later by the Renaissance) as a victory of civilization over barbarity; for the Athenians, the Parthenon centaurs surely evoked memories of their enemies, especially the Persians, who had conquered Athens not long before.

The metopes of the battle between the Lapiths and the centaurs vary in quality, but the best ones embody sculptural principles and forms that became the preoccupation of subsequent Western sculptors. In the hands of the creators of the metope illustrated here [p. 8], violent struggle has become dance, as the figures float across the surface of the relief. The battle has been elevated to art. The clash between realism and geometric form, so much a part of earlier figurative art, has become, like the Parthenon itself, a balance and harmony that can only be termed classic.

Much the same can be said of the large, deeply cut statues that occupied the Parthenon's two pediments [p. 8]. Three figures, identified as Leto, Artemis, and Aphrodite, celebrate the dynamic potential of the human form. Here drapery no longer covers form but reveals it, and the bodies assume a palpability and grandeur equal to the building they grace.

The influence of the Parthenon was vast because it stood as a symbol for civilization and rationality. Its sculpture was highly public—the official manifestation of city and cult, a statement of the ascendancy of Athens and the Athenians. But the same elevated art is found also in more private works, such as a gravestone relief [p. 9] produced about the time of the Parthenon sculpture. The depiction of a young girl bidding farewell to her doves is both tender and sad as it expresses the spirit and charm of a long-departed child.

The Greeks were masters of architecture and sculpture, but they also excelled in painting. Although no large-scale works in fresco survive, something of what Greek wall painting looked like can be gleaned from later Roman painting. However, important paintings do survive in considerable number on ceramic ware found throughout the Greek world: over twenty thousand pots are known. Used for storing oil and water, for drinking wine, for holding food, and for many other daily needs, these vessels were transformed by skillful potters and painters into some of the most splendid objects of the classical world. Vase painting expressed almost the whole range of the stories and images that interested the Greeks. Images of men and gods, of violence and happiness, of games and war are among the many subjects the Greeks could contemplate as they ate or drank or participated in religious rituals. Much of our knowledge of Greek civilization and myth comes from these pots.

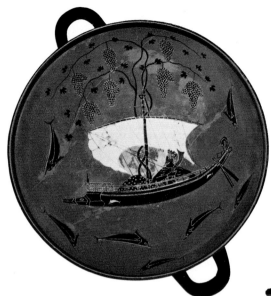

The power of divine magic appears on many painted vessels, but seldom more charmingly than on the *Dionysus Cup* signed by the painter Exekias about 550–525 B.C. [p. 10]. A footed vessel with two handles and a wide bowl suitable for aerating wine, the cup tells a story about Dionysus, who, after his capture by pirates, terrified them by flooding his ship with wine, causing a great vine to sprout from the mast, and creating illusions of wild beasts. So frightened were the pirates that they leapt from the ship into the sea, where they were instantly transformed into the dolphins shown leaping about the rim of the cup, in a pattern that, like the boat, sail, and vine, echoes the basic shape of the vessel.

The *Dionysus Cup* is painted in the black-figure style: black figures on reddish orange clay ground. In this technique, the silhouette-like black figures (with white faces if

EXEKIAS, DIONYSUS CUP, C. 550–525 B.C.
Like a number of other Greek artists, Exekias was both a master potter and a painter. His many surviving vases reveal a refined and vigorous draftsman with an original approach to composition and narration.

EUPHRONIOS, KRATER, C. 515 B.C. *The painter and potter Euphronios (c. 520–505 B.C.) signed six vases as a painter, all of the elevated quality of this Krater.*

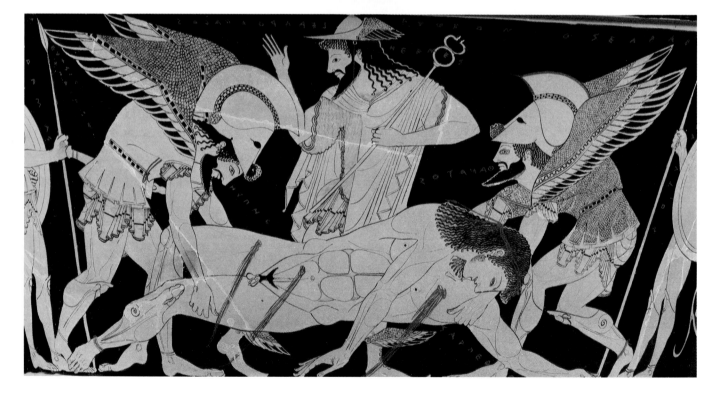

GREEK POTTERY

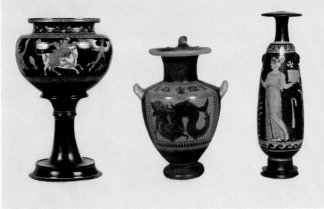

The human orientation of ancient Greek culture, combined with a refined sense of design and technique, helped produce an artistic level in Greek pottery unparalleled in the history of Western art. Greek pottery is notable for its various shapes, as well as for exploiting the material—a particularly iron-rich clay that yielded an intense orange-red and deep black when fired.

they are women) were defined and decorated by lines incised into the surface of the pot. The black-figure style was rapidly replaced, toward 500 B.C., by its negative: red figures set against a black ground, giving the artists a chance to paint the faces, bodies, and drapery with a brush rather than incising them. The result is a slightly less decorative but more complex set of images.

Both the black- and red-figure techniques were used to depict the mortal and divine tragedies that the Greeks found so compelling. Such tragedy on a heroic and divine scale is seen within the small compass of a vessel by the painter Euphronios [p. 10], made about 515 B.C. and used for mixing wine and water. Here is an example of the monumental nature of the subject matching the grandeur of the vessel's shape. The body of a fallen warrior, Sarpedon, son of Zeus, is carried from the field of battle by the twins Sleep and Death under the supervision of Hermes. Somber action is given weight and power by the great inert body of Sarpedon and the bending winged figures who struggle to lift him. The scene, with its grid of animated figures subtly echoing the shape of the pot, is raised to a level of seriousness and pathos seldom equaled in Western art.

Greek figurative art is especially vivid in the form of freestanding sculpture, which had a long development. In fact, Greek myth provides the name of the first Greek sculptor, Daedalus of Crete, who fashioned a cow to disguise the wife of King Minos so that a bull would copulate with her and the infamous Minotaur could be procreated. Daedalus's name is associated with the beginnings of monumental sculpture in Greece.

From the seventh century to the end of the sixth century B.C., monumental sculpture took the form of the *kouros* (nude male youth) and *kore* (draped maiden). Long thought to represent only deities, it is now known that many of these proud, confident, faintly smiling but generally stiff symbols represented mortals. This reflects the fundamentally human orientation of Greek art: "Although there are many marvels in this world," wrote Sophocles in *Antigone*, "the greatest marvel of all is man."

Greek athletes were the models for these figures, which were placed on pedestals outside temples as votive offerings or set as memorials on gravesites, where they represented gods, Homeric heroes, or warriors. Some are engraved with inscriptions such as the poignant lines found at the base of a kouros from Attica [p. 12]: "Stop and grieve at the tomb of the dead Kroisos, slain by wild Ares in the front rank of battle." Modeled after Egyptian sculptures, the kouroi followed established conventions. One foot placed before the other, arms at the sides, facing forward, the kouroi were based on received knowledge rather than visual analysis.

Women did not play a prominent role in ancient Greek society, and the figure of the kore from this period is schematic, with emphasis on generic forms of dress rather than having any real physicality. The *Peplos Kore* [p. 12], one of a series of maiden figures which were buried after the Acropolis was destroyed by the Persians in 480 B.C., is a wonderful exemplar of the type. Recovered from the rubble, the kore has traces of the paint that embellished her hair and dress, adding to her decorative as well as lifelike appearance.

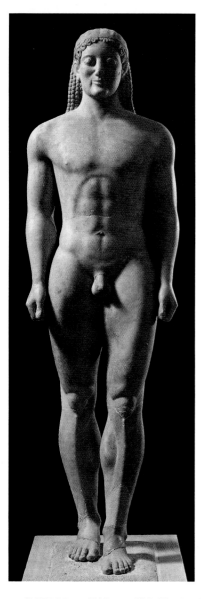

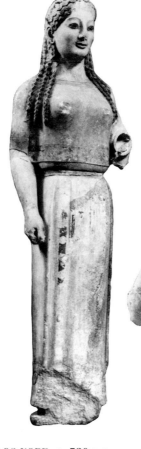

PEPLOS KORE, C. 530 B.C.
Depicting a priestess or a member of a religious cult, the Kore shows Eastern tradition through her dress, which indicates the statue's origins among the master sculptors of the eastern Greek center of Ionia.

KOUROS, C. 540 B.C. *This life-size figure of a male youth reflects an increased knowledge of anatomy, gained from watching athletes and warriors while they practiced.*

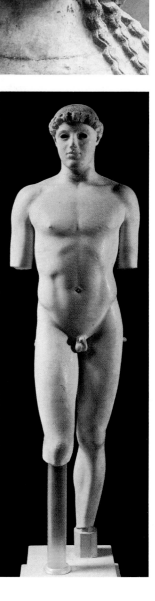

KRITIOS BOY, C. 480 B.C.
Found on the Acropolis, this statue was probably damaged by the Persians during their raid on the Acropolis in 480 B.C.

About 530 B.C., the time of the *Peplos Kore*, Greek sculptors also began experimenting with bronze casting to produce large-scale figures. But these, as well as their marble counterparts, deviated little from well-established types.

Despite their reliance on conventions, over the centuries sculptors looked closely at real human forms to better understand anatomy. They introduced subtle variations in pose and musculature in

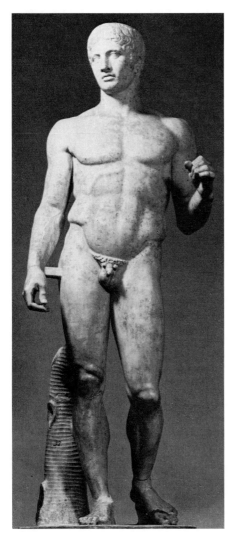

**ROMAN COPY OF THE DORYPHORUS OF POLYCLITUS,
C. 440 B.C.** *In constructing his ideal man, Polyclitus was
probably inspired by Pythagorean theories of mathematics.*

body is based on a sensitive analysis of how muscles work in the human body, but that analysis is
distilled into a canon of perfect proportions in aesthetic terms. Like the many other classical works
that were to follow, the *Kritios Boy* exists somewhere between the real and the ideal. His face manifests a new inward reflectiveness, a pensiveness
that affirms a life of the soul. His perfectly proportioned body is more naturally muscled; moreover,
his body responds as a real body would to an extended leg. This simple but consequential change
altered the rigid symmetry of the kouros and gave
figurative sculpture the potential for fluidity and
grace, for a cohesion that moves the figure into the
realm of our own experience.

For the next century, sculpture would be refined and advanced by the new awarenesses represented in this figure. During the fifth century,
standing figures not only changed appearance but
also subtly changed in function. Though still commemorative, as the kouroi had been, the sculptures
reflected individuals. The victors in games and warriors and their actions became more distinctive and
less constrained by type. Furthermore, as artists explored various theories of measure and proportion,
aesthetic questions alone could prompt the production of a work. Such was the case with the famous
Doryphorus (spear carrier) by Polyclitus [p. 13],
the fifth-century sculptor who had written a book on
measurement and proportion. Now known only
through numerous Roman copies that testify to its
fame, the *Doryphorus* established thicker and more
compact proportions for the ideal male than those
in the Riace warriors or their equally famous near-
contemporary, the figure variously described as
Zeus or *Poseidon,* of 470–450 B.C. [p. 14].

One of the masterpieces to survive from classical Greece, this figure was found in the sea near
the Greek city of Artemision. As with many great
works, the sculpture strikes a balance, but here the
balance is between extremes not only of action and
inaction but also of the specific and the general, the
momentary and the timeless. Distillation, not description, is at the heart of this work. Here the sculptor proved in a sublime manner that human actions
as well as human proportions can conform to the
universal principles of mathematics. The entire configuration describes no single moment in the sequence of spear throwing but is a seamless and

the kouros figures. About 480 B.C. the sculptor Kritios created a figure that abandoned the kouros figure type almost entirely. The *Kritios Boy* [p. 12] is
the culmination of countless earlier attempts to introduce anatomical realism within the framework of
the kouros. Free from the strict, static codes that
had inhibited earlier sculptors, the *Kritios Boy*
seems relaxed, fresh, and more convincingly
human than any of his predecessors.

Called the first beautiful nude in art, the *Kritios
Boy* inaugurates the Greek classical age of sculpture. His features are naturally integrated into the
rounded perfection of his now-turned head. His

ZEUS (OR POSEIDON), c. 470–450 B.C. *Produced roughly twenty years after the* Kritios Boy, *Zeus hurling his (now lost) spear (or Poseidon throwing his triton) shows how brilliantly fifth-century B.C. Greek sculptors solved the problem of portraying the human form in action. Found in the sea off the coast of Artemision, the* Zeus/Poseidon *is one of the finest Greek bronzes known.*

exemplify a purer system of thought. Having abandoned as too stifling the rigid conventions of the kouroi, the Greeks now searched for new ones, and at the time of *Zeus/Poseidon*'s creation, they found a perfect solution.

The diversity of action now possible for the human form is seen here, yet *Zeus/Poseidon* also demonstrates perfectly the balance struck between action and stasis, between keenly observed nuances of human anatomy and ideal proportions, between spontaneity and deliberation. Having stretched out his left arm to balance the backward motion of his spear-throwing arm, *Zeus/Poseidon* looks in the direction of his aim, his leg extended in preparation for the forward thrust needed to propel his weapon. His action is practiced and measured. It expresses supreme confidence in the sureness of his aim and the distance of his throw. This image is not so much an expression of effort as it is a celebration of perfect ability. The god, be he Zeus or Poseidon, stands as the quintessential human athlete. Man and god have become so alike that one is indistinguishable from the other.

It is not surprising, then, that identification of Greek sculptures as mortals or deities remains difficult, and athletes generally are known only by virtue of their action: the *Discobolus* (disc thrower), the *Charioteer,* and so forth.

Whether athlete or god, these figures embody a vigorously competitive spirit. Often dedicated to winners of games or competitions, the sculptures of the classical period are triumphant and supremely self-confident. But during the fourth century B.C., this mood began to change. Between 431 and 404 B.C. Sparta supplanted Athens during the Peloponnesian War. Sparta, however, was not capable of leading Greece and soon sank into a state of corruption. The Greek poleis were in decline and were absorbed into the Macedonian empire in 338 B.C.

streamlined fusion of mathematical principle and human form.

No more compelling essay on the Greek belief in governing principles can be found. Lovers of beauty, order, simplicity, and rationality, the Greeks not only wished to see the parts of the body conform to the whole but also saw that the body itself could

A new imperial age, that of Philip II of Macedonia and his son, Alexander the Great, emerged. Alexander's brief but glorious rule united the fractious Greek city-states and expanded the Greek (Hellenistic) empire. With the fall of Athens and the demise of the city-states, classical Greek art was transformed. It became eccentric and individualized, following no single ideal but yielding to the subjective impulse of artist or patron. Though still great, it was, in a sense, a poignant and moving postscript to the golden and enduring art that had come before.

In the Hellenistic period, c. 323–327 B.C., extremes of all kinds occurred. Philosophers evolved diametrically opposing views: Epicurus founded a new philosophy of pleasure, while Zeno espoused the restraint of stoicism. Great strides were made in mathematics and astronomy, as Euclid proposed his enduring theories of geometry and the astronomer Aristarchus of Samos advanced a refined heliocentric theory (that was all but forgotten or ignored in the West until the time of Copernicus). Greece continued to suffer political decline, and, one by one, Greek possessions fell to Rome. In 212 B.C. Syracuse was sacked, and in 146 B.C. Corinth and Carthage fell; finally, in 86 B.C., Athens was lost to the Roman general Sulla.

Fittingly for a period of upheaval and change, the arts were again transformed. Sculpture reached a high point of sensuality and complexity of emotion; the images became more expressive, and a transitory, often charged feeling supplanted the timeless placidity of the earlier period. Sophistication in anatomical considerations was joined by a new appreciation for texture, sensuality, grace, and voluptuous action. It should come as no surprise that in this era, when constraints were removed and artistic freedom flourished, artists suffered the earliest recorded torments of creativity. Apollodorus, a sculptor from the Hellenistic era, was nicknamed "the Madman" for consistently smashing his works out of sheer frustration.

This period of sensuality saw the female nude join the male nude as a preeminent art form. Toward the end of the classical era, in about 340 B.C., Praxiteles produced a nude Aphrodite for a sanctuary in Cnidus. Endlessly copied, this Venus helped spawn a whole host of sensual goddesses during Hellenistic times, of which the *Venus de Milo* [p. 15] is the best known. Her serene expression, high breasts, and calm pose establish her as a descendant of Praxiteles' classical work. But her soft and turning body, with its complex pose and luxurious sensuality, has gone beyond the austerity of classicism and belongs to the Hellenistic age. As Venus

VENUS DE MILO, SECOND OR FIRST CENTURY B.C. *Though among the most famous of ancient Greek sculptures, the* Venus de Milo *still stirs controversy over the date of its origin. While the type can be dated back to the fourth century B.C., the curving body and sensuous form have caused many to place this work in the late Hellenistic period.*

NIKE OF SAMOTHRACE, C. 190 B.C. *Found on the island of Samothrace in 1863,* Nike *is believed to commemorate the victory of the Rhodians over Antiochus III of Syria, C. 190 B.C.*

head of a fountain to commemorate a victory at sea, *Nike* is shown spread-winged, wind-swept, and turning, just at the moment when she has landed on the prow of a ship. The marble has been transformed into fluid drapery enveloping a soft yet muscular and active female form. Displaying craftsmanship and artistry, the sculptor has extended a thin membrane of marble to describe a wild, billowing cloth, still tugged by the breeze created in *Nike*'s wake. The quiet, contemplative balance of action and reaction that bounded the classical forms by earlier sculptors has given way here to an illusion in which the senses are engaged as never before. The texture of the flesh, the feathers, the voluminous chiton, the sound of the great beating wings, and the flutter of the robe are all vividly conveyed.

Transition, struggle, movement, tension, and emotion in the Hellenistic period have supplanted the calm, stable, harmonious world of classicism. Whereas a single moment was captured by the sculptor of *Nike*, the maker of the *Laocoön Group* [p. 17] described an epic struggle. Carved about 150 B.C., when Greece was a satellite of Rome, the sculpture was greatly admired by the Romans. Pliny the Elder considered it the finest sculpture in antiquity, and when it was rediscovered fourteen

moves, the drapes appear to slip from her body, exposing her voluptuous flesh. Her body seems pliant, inviting touch and invoking a delicate carnality. A specificity of time, place, and mood has been added to the ideal of beauty inaugurated by the classical sculptors. Venus and many other figures like her kindled an interest in the female nude that, though abandoned during the antimaterialistic period of the Middle Ages, was taken up again with enthusiasm in the Renaissance and remains part of our artistic heritage.

The *Nike of Samothrace* [p. 16] is another example of Hellenistic sculpture. Originally set at the

HEAD OF A BERBER, C. 350 B.C. *Found at the Temple of Apollo at Cyrene, this head, which originally contained eyes made of glass, was part of a life-size statue.*

LAOCOÖN GROUP, C. 150 B.C. *The fate of Laocoön, punished by the gods for having tried to protect the Trojans, anticipates the ethos of the redemptive powers of human suffering that would, in Christian times, become the basis for a new religion.*

plex twists and turns of the snakes intertwined with the figures in violent physical exertion; moreover, though frontal in view, the subject is handled so that the viewer knows what goes on in the back.

In the era that marked their decline as a political power, the Greeks began to record more often than before what they themselves actually looked like, and portraiture emerged. Most of the sculpted likenesses that are extant reveal pensive faces described in conventions that have their roots in idealized types, but which gain conviction from the subtlety and power of the emotion expressed and from the skill with which the features are specified. Perhaps one of the most beautiful of these portraits is the *Head of a Berber* [p. 16]. Though certain conventions for the hair and the proportions of the head are clearly followed, the idiosyncratic set of the eyes, the turn of the brow, and the fullness of lips in this handsome young face belonged to an individual, not to a type.

When much of Greek artists' efforts went from a balanced style to excessive stylization during the Hellenistic period, it was portraiture that retained the strongest sense of purity, saved from excess by the demands of realism.

In all of its manifestations from the earliest periods to the latest, ancient Greek art searched for a greater understanding of humankind and the forces that govern it. It was an experimental, flexible art that, within the thousand years of its existence, grappled with the many problems of representing man and the world. By so doing, it drew the perimeters of most of the subsequent history of Western art. Objectivity, subjectivity, realism, idealism, the representation of the figure, narrative, and many other tenets of Western art were introduced and nurtured by the Greeks. It was left to the Roman world to preserve and disseminate this important heritage.

hundred years later in 1506 on the Esquiline Hill in Rome, it was once more a sensation, affecting profoundly the work of Michelangelo and scores of Renaissance artists. Produced in an age fascinated by images of struggle, by tension, and by theatrical portrayals of death in battle, the *Laocoön Group* retells the story of the Trojan priest who warned his fellow Trojans not to bring the wooden horse into Troy. Seeking to thwart him, the gods sent two huge snakes who swam ashore and slowly entwined and killed Laocoön and his two sons. Their doomed struggle gave the sculptor an unparalleled opportunity to demonstrate his skill at composing the com-

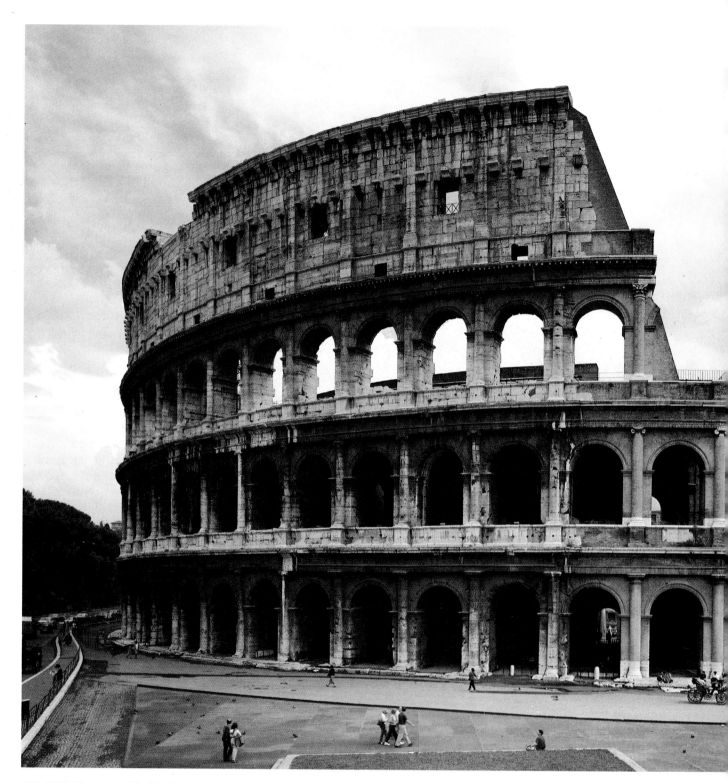

COLOSSEUM, C. A.D. 70–82. *The fame of the Colosseum lasted well into the Middle Ages. The Venerable Bede said, "While stands the Colosseum, Rome shall stand; When falls the Colosseum, Rome shall fall; And when Rome falls—the world."*

[2]

THE ROMAN WORLD

Rome, set on the banks of the Tiber River in central Italy, became a rival power to Greece in the declining years of the Hellenistic age. South of Rome, the peninsula that extended into the Mediterranean Sea was home to numerous Greek colonies that flourished at the time of Alexander the Great's death in 323 B.C. But less than two hundred years later, by 146 B.C., southern Italy as well as Greece had become Roman colonies. Rome was well on its way to becoming a vast empire.

Little is known about the ancient Latin people who first lived in Rome and were ruled by Etruscan kings. By the sixth century B.C. these early Romans had occupied the largest city of Italy. In 509 B.C. they overthrew the Etruscan tyrant Tarquin and established a republic. Rome's republican period lasted until 27 B.C.; during this time Rome annexed not only Etruria and Greece, but also Syria, Pergamum, and Egypt, and ultimately ruled most of the Western world. Of all the territories the Romans conquered, Greece was the most influential artistically. Greek art and artists were imported, emulated, copied, and mingled with arts from other cultures. When they borrowed Greek forms, the Romans adapted them to their own use.

The Ara Pacis [p. 20], or Altar of Peace, is an example of this point. At first glance this work looks characteristically Greek, but it is one of the great monuments of Roman art, built long after Greece had become a Roman possession. The people who

ARA PACIS, 13–9 B.C. *Reconstructed in 1930, the Ara Pacis reflects the grace of Greek workmanship celebrating Roman imperialism and the inauguration of a new patronage, with the emperor Augustus becoming the chief patron for the arts.*

are depicted solemnly stepping along the shallow frieze of this altar wall were celebrants in the actual procession that consecrated the ground on which the altar would stand. This procession (which took place July 4, 13 B.C.) included Caesar Augustus, the first emperor of Rome, and his family. Built on the edge of the Field of War in Rome, the altar was dedicated to peace, the Pax Augusta brought by Augustus's successful administration. With Augustus's ascendancy, five centuries of republican rule had ended; five centuries of imperial rule had begun.

In proclaiming the Pax Augusta, the reliefs were intended to remind all Romans of the virtue and efficacy of the emperor's reign. The sober, dignified, refined, and harmonious images of the Ara Pacis gave visual and historical substance to Augustan power and turned the hopeful myth of his power into reality.

Although Augustus was celebrating on the Ara Pacis a moment of Roman history, he chose to express it in the visual language of the Greeks. The refinement of Greek art was admired by the Romans, and Augustus used it to reflect the civilizing influence of his own rule. To achieve his aim, he imported the best Greek sculptors available. Working in a manner strongly reminiscent of the reliefs found on the Parthenon, these Greek artists promoted an entirely Roman idea: that of Augustus's rule and his imperial power.

In narrative relief, which came from the Greeks, the Romans often replaced mythology with their own history, chronicling the battles and victories

that continually expanded the Roman sphere of influence. The Greeks had used mythology to understand their own culture; the Romans strived to make human endeavors mythic. Indeed, the power of Roman myth has lingered in popular memory, to be recalled and depicted in word or image by later generations who mined Rome's complex history for paradigms and ideas of all kinds. From Saint Augustine to Shakespeare, from Titian to Rembrandt, from Canova to Fellini, the stories of Roman heroes, heroines, and villains have been told and retold. Images of power and decadence were so indelibly etched by Roman events that leaders as disparate as Charlemagne, Napoleon, and Mussolini adopted the symbols Rome had created.

A remarkably flexible and adaptive mingling of practicality and idealism characterizes Roman culture and distinguishes it from that of the Greeks. Whereas Greece introduced philosophy and drama, Rome gave us law and letter writing. The Greeks were master sculptors, and the Romans were great engineers. The abstract world of mathematics was a Greek fascination; the Romans contributed the more practical skill of cartography. The Greeks reflected on man's place in the higher aesthetic and philosophical orders, but the Romans created an idea of an orderly empire in which every person had a prescribed role. If the Greeks studied man and his relation to the world, the Romans studied how to organize the world, and how to run it smoothly and efficiently.

Lawyers, engineers, architects, and cartographers regulated, built, and described the ever-expanding Roman empire. Rome's writers contributed by mingling fact with fiction to glorify the republic or the empire. Titus Livius, or Livy (59 B.C.–A.D. 17), one of ancient Rome's most influential historians, provided an important factual account of Rome's early history even as he conveyed much of her mythology. What Livy presented as historical narrative, Virgil (70–19 B.C.) told as poetry. Virgil's celebration of the destiny of Rome, the *Aeneid*, is the Latin counterpart to the Greek *Iliad* and *Odyssey*. And *Metamorphoses*, by the poet Ovid (43 B.C.–A.D. 18), is second only to the Bible for its influence on Western art; indeed, the bulk of the histories and mythologies that are the backbone of Western imagery trace their origins to Ovid's work. In addition, the observations of Pliny the Elder (who died watch-

The Etruscans, whose territory once extended throughout central Italy, were at the height of their power c. 500 B.C. and for a time challenged the Romans for power in Italy. The realism of their portraiture may have influenced early Roman republican artists. The Etruscans were particularly gifted as metalsmiths—their products, such as the *Chimera of Arretium,* c. fifth to fourth century B.C., were exported throughout the Mediterranean world.

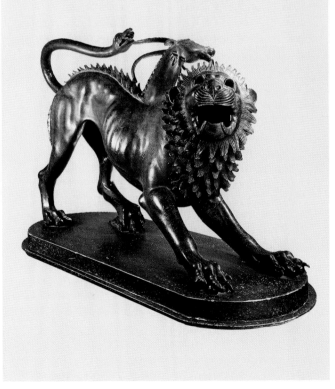

ing the eruption of Mount Vesuvius in A.D. 79) and the letters of Pliny the Younger provide factual accounts of the world that was ancient Rome.

As Rome expanded, monuments were erected to celebrate each victory and, by implication, Rome's invincibility. Triumphal arches (replete with equestrian statues), triumphal columns, and cuirass statues (showing the military leader in his armor) all publicly proclaimed Rome's power and glory and her manifest destiny. The Ara Pacis was the first Roman monument to extol Roman imperialism, but it addressed a citizenry by then well conditioned to mythmaking. It was also a citizenry besotted with Greek culture. Culturally superior to her conquerors, Greece witnessed the nearly wholesale appropriation of her civilization by the Romans. Between 272 and 133 B.C., the art treasures and the artists from Tarentum, Syracuse, Corinth, and Pergamum were uprooted and transported to Rome, where they formed part of the triumphal procession that celebrated each Roman victory. Though the first Greek treasures were used by the Romans as triumphal public displays and were placed in temple treasuries dedicated to victory, Romans soon began to acquire Greek objects privately. According to Pliny the Elder, collecting became fashionable about the time of Corinth's fall in 146 B.C. Corinthian bronzes and Greek silver were especially favored. Roman thirst for things Greek was so great that the demand exceeded the supply; vast workshops of artisans in Rome copied Greek originals with varying levels of quality and skill, and knowledge of many lost Greek originals comes from these copies.

Despite Roman infatuation with the art of Greece, the conquerors invariably put their own stamp on the artistic production under their aegis. They had a particular genius for building, and Roman ideas about architectural form, space, and function still shape the environment in which we live. Many of the materials and forms of Roman architecture—concrete and the arch, for example —were known to the Greeks, but they made only limited use of them. In Roman hands, however, these forms and materials took on new and much-expanded roles in architectural construction and aesthetics—the Romans saw potential undreamed of in Greece and the rest of the ancient world. The arch and the great plasticity of concrete (made of rubble and cement poured in forms constructed of

PONT DU GARD, LATE FIRST CENTURY B.C. *The top level of this triple-arched aqueduct supported the conduit carrying water from Uzes to Nîmes, France, a distance covering 13 miles.*

wood) allowed Roman architecture to achieve a mass and size unequaled until the huge train stations, factories, and stadiums of modern times. With size came a variety of building types and functions that have become mainstays of the architecture of the West.

Characteristically, some of the Romans' greatest achievements in architecture were practical structures designed to accomplish specific tasks. Aqueducts, such as the Pont du Gard (built in the late first century B.C.) near the Roman colony at Nîmes in southern France [pp. 22–23], demonstrate the Roman talent for both engineering and construction. The huge structure, with its triple row of arches carried on massive piers (the uppermost rising 180 feet above the valley floor), dominates the surrounding countryside. There is a minimum of architectural decoration; the form of the structure

explains its function. The simple, unadorned mass of the aqueduct, with its rows of arches, its conquest of space, its architectural honesty and muscle, is admirable even to modern eyes.

The planning demonstrated by the Pont du Gard was valued highly by the Romans because it facilitated order and control in one's life and environment. Major Roman buildings were thought through with considerable care, and planning of the various types was modified with experience and use. Highly specialized and original buildings were constructed for many events in the cycle of daily life. Great vaulted baths, like those of Caracalla [p. 24] erected in Rome about A.D. 210, were made of stone and concrete and covered with terra-cotta and expensive marble. These huge and complex structures contained hot and cold baths, dressing rooms, furnace rooms, restaurants, libraries, and myriad other chambers. The baths were a nexus of Roman civilization; they provided not only cleanliness but also a location for the important social intercourse that characterized Roman life.

Other avenues for Roman pleasure, both in the capital and in the provinces, were provided by the many specialized structures built for amusement. Large circuses for horse racing, stadiums, and other open structures were built with private and public funds for the popular, communal spectacles of athletic and gladiatorial competition that also were an integral part of Roman life. The games and combats, some held over a period of weeks, were attended by thousands on a regular basis and were often sponsored by wealthy and powerful Romans who used them to gain the allegiance of the grateful populace. Amphitheaters throughout the Roman world, many seemingly built to the same plan, accommodated the crowds.

The largest and most famous of all the surviving examples of this type is the Colosseum in Rome, erected about A.D. 70–82 [p. 18]. This gigantic building, which held nearly fifty thousand spectators, was the perfect solution to the needs of huge, often rowdy crowds, with its steeply terraced seats offering unobstructed viewing and its many large

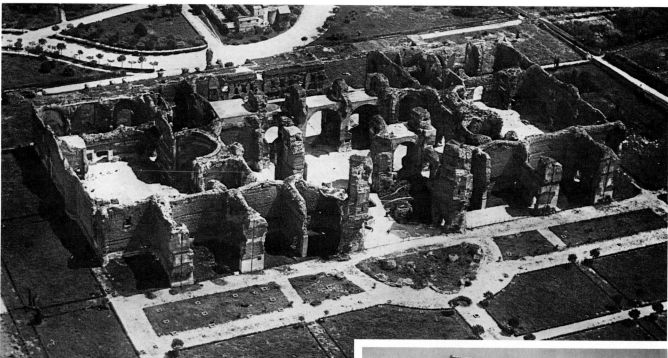

openings for entry and exit and easy access to seats. Through an ingenious hydraulic system, the floor could be flooded for sea battles; a huge cloth tarpaulin, rigged by sailors stationed near the Colosseum for this purpose, was often extended to shade the seats. Below ground level was a maze of rooms for athletes, animals, and the personnel needed to keep this vast building working. Smaller versions of the Colosseum were built throughout the Italian peninsula and in the Roman colonies. Even today these huge, imposing piles of stone are reminders of how important spectator sports, bloody or otherwise, had become to the urban population.

Of course, not all Roman buildings were centers of recreation as were the baths and the amphitheaters. Religion, in all its various forms during the long period of ancient Roman civilization, was an important part of the Roman state and its society. The construction of Roman temples again reveals much about the Roman admiration for many facets of Greek civilization, including its temples. This admiration, however, did not stop the Romans from evolving their own type of temple, which, while based on Greek prototypes, was made Roman by its high base, engaged columns set into the sanctuary wall, and deep porch [p. 24].

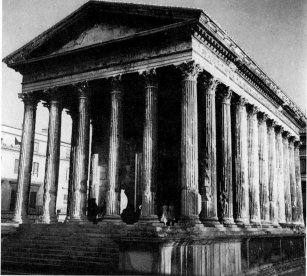

BATHS OF CARACALLA, C. A.D. 210. *(top) One of Rome's major social centers, the Baths of Caracalla remained functional until the sixth century A.D., when the city's water supply broke down.*

MAISON CARRÉE, C. 20 B.C. *(bottom) During the reign of Augustus, who was anxious to reestablish traditional religious practices, temple construction was particularly extensive. The Maison Carrée in Nîmes, France, represents one of the best-preserved examples of the fully developed Roman temple.*

Although Roman architects and patrons respected the Greeks, their confidence, ambition, and special needs propelled them to create new building types, especially well illustrated by the Pantheon [p. 25]. Completely rebuilt and enlarged by the emperor Hadrian about A.D. 118–125, it was dedicated to the seven planetary deities. Its huge size (its height, 142 feet, equals the diameter of its dome) is impressive. Although the Pantheon retains a giant porch with columns and pediment as a tribute to the Greek rectilinear temple tradition, everything else about it is original. To step from the noisy street through the many columns of the porch, and

PANTHEON, A.D. 118–125. *Although the Pantheon retains elements of the Greek temple, it is a circular Roman temple type. With minimal architectural alteration, it was made into a church and is the burial place of the painter Raphael. (Interior at left)*

then into the open, luminous space of the soaring dome, is to leave one world for the next, to experience a new and dazzling sense of space and uplifting architectural order [p. 25].

The outside of the Pantheon speaks simply, the plain brick drum of its exterior announcing the volume of the space it contains. A marvel of Roman engineering, the huge dome, clearly seen from the exterior, is opened to the sky by an oculus. Supported on walls eighteen feet thick, the dome rises effortlessly, carrying a series of deep coffers giving pattern and life to the massive form. The Pantheon, like much Roman architecture, encloses and molds vast space while imparting a sense of grandeur and importance to those who occupy it.

Grandeur was important to the Romans because of their strong sense of history and of their unique and important place in it. They built to last because they were anxious to leave a record of themselves and of their deeds. This search for immortality through mortar and stone produced particular types of monuments, such as the triumphal arch. Not a true functional structure, since it has no rooms and often straddled no road, the triumphal arch is a stone and concrete advertisement, a statement about the fame and worth of the man it sought to immortalize. Immortality was often achieved by military deeds; prowess and victory in war frequently led to fame, wealth, and power.

Triumphal arches, consequently, recount the deeds of the victorious both in words and images. The Arch of Titus [p. 27], probably erected shortly after the emperor's death in A.D. 81, is, like much Roman architecture, well suited to its task. Broad and weighty in appearance, its piers, arch, and attic bespeak gravity, sobriety, and power, all valued Roman ideals. The prototype of the triumphal arch may have been the temporary arches through which the troops passed as they entered Rome or other important cities of the Roman world. Hence, it is not surprising to find in the passageway of the Arch of Titus two reliefs (one of Titus in a triumphal car drawn by four marvelous horses [p. 26] and the other of booty taken from the Temple when Jerusalem was captured by Titus and Vespasian in A.D. 70) depicting the sort of triumphal processions that were so important to the Romans and to those who wished to keep or take power.

These arches were often crowned with life-size metal statues, sometimes of a victor riding in a chariot drawn by horses. Carved panels were placed on the front and back of the arches, and commemorative, laudatory inscriptions, sometimes in gleaming bronze letters, were also set into the arch. These arches were meant to call attention to themselves and constantly remind the onlooker of the greatness of an individual or dynasty and of their particularly worthy contributions to Roman civilization.

Much the same impulse was behind another type of monument built to glorify Rome, the storiated column. The Greek practice of erecting commemorative columns was inherited by the Romans, who, once again, made the type their own. Their predilection for grandeur of concept, scale, and organization is readily apparent in the Column of Trajan [p. 28], finished in A.D. 113 and commemorating the emperor's campaigns in Dacia. A hundred feet high, the stone shaft is decorated with a ribbon of continuous relief narration describing the exploits of Trajan and his troops [pp. 28–29]. Originally the reliefs were enlivened by paint and gilding, and the column was topped by a statue of the emperor. The whole is a gigantic, boastful monument, which, like the triumphal arch and other Roman construction, is meant to aggrandize, memorialize, and immortalize the individual and his deeds.

The Romans were seldom distracted from the realities of their own lives, even when they contem-

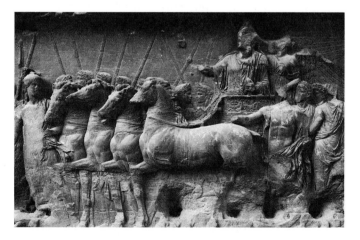

RELIEF FROM ARCH OF TITUS: THE TRIUMPH OF THE EMPEROR TITUS.

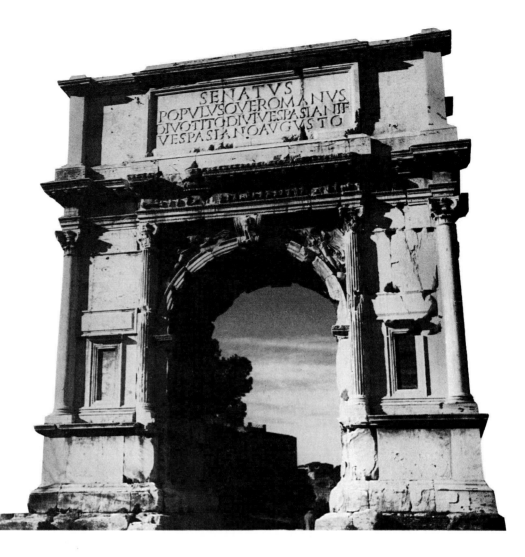

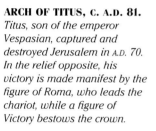

ARCH OF TITUS, C. A.D. 81.
Titus, son of the emperor Vespasian, captured and destroyed Jerusalem in A.D. 70. In the relief opposite, his victory is made manifest by the figure of Roma, who leads the chariot, while a figure of Victory bestows the crown.

plated death. This preoccupation with the present and the wish to preserve and commemorate it can be graphically seen in the tomb of M. Vergilius Eurysaces and his wife [p. 28], located just outside the ritual boundary of Rome, inside which burial was long forbidden. Adjacent to one of the city's major gates and bounded by two highways, the tomb was highly visible and public, qualities sought for the many tombs placed by the roads leading out of Rome and other Roman cities. M. Vergilius Eurysaces was a wealthy baker to the Roman state and armies and as such he wished to be remembered by building his tomb in the shape of a huge oven. To belabor the obvious, a frieze depicting the making and selling of bread runs across the top of the structure. Highly realistic, full-length portraits of the baker and his wife also appear on the tomb. The

tomb has nothing to say, however, about afterlife nor does it muse on the soul's fate, questions that would obsess the Romans later. The baker's tomb is, like the triumphal arch and the storiated column, a concrete record of the individual's earthly existence, substance, and deeds—a bizarre, and ultimately successful, struggle against oblivion.

Roman historical sense, pragmatism, and interest in commemoration fostered another distinctive Roman art form: portraiture. Arising from funerary customs that dated back to the third century B.C., Roman portraits were intended to preserve the exact likeness of the deceased. Republican Romans, like the Greeks, established the custom of commemorating or honoring important citizens by erecting a portrait statue in a public square; but Roman public portraits were just as realistic as their private ones

TOMB OF M. VERGILIUS EURYSACES AND HIS WIFE, LATE FIRST CENTURY B.C. *For those wealthy enough to afford them, Roman tombs, such as this, often became actual buildings.*

COLUMN OF TRAJAN, C. A.D. 113. *The storiated column allowed the exploits of the emperor to be shown in a continuously unfolding narrative. The many highly detailed episodes on Trajan's column commemorate his triumphal campaigns in Dacia. (Detail above)*

and avoided the idealizing tendencies of Greek public portraiture.

Family lineage, social rank, and personal history were shown in the forthright presentation of actual faces. As families expanded, replicas of portraits were made so that each family could have its own ancestor shrines. More permanent and durable materials, such as marble and stone, supplanted the early wax masks, and many of these more permanent examples survive (p. 29).

Most of these early portraits show a dispassionate, frank realism, favored, although not entirely invented, by the Romans. Yet these portraits also conform to larger, more general typologies: young man, elder, matron, girl, and so on. Guided by the

**PORTRAIT STATUE OF A REPUBLICAN
CARRYING TWO ANCESTOR BUSTS
(BARBERINI STATUE), END OF FIRST
CENTURY B.C.** *Three generations of Romans
are depicted in this sculpture, which illustrates
the Roman practice of carrying busts of
ancestors during funeral rites.*

**COMMODUS AS HERCULES,
C. A.D. 192.** *Roman sources state that the
Emperor Commodus (ruled A.D. 180–192) was
obsessed with gladiators and that he saw
himself as one. He placed his own portrait, with
the attributes of Hercules (club and lionskin), on
a colossal statue. Statues of Commodus as
Hercules were venerated as representing a deity.*

requirements of truthfulness to the sitter's appearance and affirmation of the subject's social rank, Roman portraiture sometimes reached extraordinarily high levels of artistry within the guise of artless simplicity.

Imperial portraits were as diverse and multifaceted as the emperors who had them created. Augustus, the first emperor, eschewed the pragmatic realism of republican portraiture and adopted the more idealized and timeless appeal of classical Greek sculpture, as his portrait found in Prima Porta [p. 31] demonstrates. The Roman ideals of dignity and sobriety, earnest devotion to duty, and the suppression of one's own needs for the good of the state seem to take on a greater conviction when expressed within the idealizing Greek conventions. External beauty was meant to portray moral rectitude; the idealized, remote, and correct formulation of Augustus's head does not reflect lack of imagination but rather serves to visually enunciate the Roman ideal of leadership.

The equestrian portrait, already popular in republican times, was one of the most common forms of self-aggrandizement in imperial Rome. Records show that bronze equestrian statues of emperors proliferated throughout the city and the empire, but only one example is known today, the magnificent statue of Marcus Aurelius done about A.D. 176 [p. 30]. Derived from Greek images of athletes and heroes on horseback, the type glorified their triumphs

and asserted their power and prestige. The calm and introspective character of Marcus is here transformed into the somber ruler majestically addressing his troops. Scholars note that the once-gilded horse formerly had a barbarian cowering under its upraised foreleg, figuratively describing Marcus's triumph over Rome's enemies. Triumph though he did, Marcus Aurelius spent most of his career battling the most serious invasions of Germanic tribes Rome had witnessed to date. Finally, the emperor took the unusual but not unprecedented step of inviting them to become members of the empire, attempting to absorb and assimilate them rather than conquer and enslave them.

Though well within the traditions and functions established by Roman culture, the statue of Marcus Aurelius also signals a change. Skeptical about Greek ideals of beauty and physical perfection, Marcus Aurelius did not emulate Greek forms as closely as earlier emperors had done. His mighty eques-

EQUESTRIAN STATUE OF MARCUS AURELIUS, C. A.D. 176.
Ruler from A.D. 161–180, Marcus Aurelius spent most of his ruling years in almost continuous warfare and died at an encampment in what is now Austria.

trian monument, impressive though it is, conveyed less dominance than other versions of the type had done. Somewhat large for his horse, Marcus seems subdued. His gesture lacks the impressive authority of earlier imperial images. It may be the statue's affinity with a more spiritual mentality that ultimately saved it: one of the few works to survive antiquity unburied, the statue of Marcus Aurelius was thought to be a sculpture of the first Christian emperor, Constantine. It was moved to a special

spot in front of the papal palace, the Lateran. A new myth about it sprouted: when the gold on its abraded surface again covered the whole sculpture, the Last Judgment would take place.

Through the accident of its survival, the statue of Marcus Aurelius became one of the most influential works of ancient Rome. Charlemagne adopted it in order to glorify his new Holy Roman Empire; during the fifteenth century, Donatello and Verrocchio both borrowed its forms in their monu-

ments to the mercenary soldiers Gattamelata and Colleoni. In the sixteenth century, Michelangelo moved the work to the middle of the Piazza del Campidoglio, Rome, which he had specially designed for it. Its imposing language of princely and equine authority was used by the Medici dukes, and scores of equestrian monuments descended from it well into the nineteenth century.

Imperial portraits after Marcus Aurelius's time became increasingly personal and eccentric. Perhaps none was more so than the portrait of the emperor Commodus (A.D. 161–192) [p. 29]. Shown in the guise of Hercules, Commodus's head is crowned by the gaping mouth of a lion, Hercules' emblem. Strangely animate, the emblems surround a figure of disturbing sensuality and arrogance, whose presence is made more compelling by the technical proficiency of the portrait bust. Deep drilling of the hair and beard, sharp undercutting of the lion skin, and the refined polish of the flesh areas give the portrait vivid contrasts of light and shade as well as diverse textures. With its masterly technical performance and its languishing expression, this portrait demonstrates the continuing importance of Greek art for the Romans well into the second century.

Greek influence also shaped Roman painting. Scores of Greek painters were imported to Rome, and Roman painting was once as prevalent as it is now scarce. Roman paintings recorded faces or portrayed gods and other mythological subjects; they were used as stage designs or decorations for temples (the Temple of Tellus, or Italy, for example, had a painted map); and they recounted historical events. Public baths boasted paintings among their amenities. Emperors had themselves glorified in paint, and Pliny the Elder recorded a particularly grotesque example of Nero, who ordered a colossal portrait, 120 feet high, painted on linen. (It was later struck by lightning and burned along with part of his garden.) Gladiators and gladiatorial combats were celebrated in paint. Private citizens had picture galleries in their homes and tried to outdo each

AUGUSTUS OF THE PRIMA PORTA, A.D. 14–29. *In order to succeed as the first Roman emperor, Augustus presented himself to Roman citizenry in many guises: the toga-clad citizen, for example, or here as a general, symbol of power and victory. His breastplate probably depicts an actual event: the submission of the Parthian standards to Rome in 20 B.C.*

other with their collections. One house of an immensely wealthy Roman even had a picture of a huge, chained dog at its entrance, with the sign CAVE CANEM, "Beware of the dog."

Nearly all of what was painted by the Romans has been lost. The easel pictures are now known only through a few surviving portrait panels, and the picture galleries and the fabulous temple decorations described by ancient sources have vanished. Much of what is known about Roman wall painting comes from surviving examples of domestic interior decoration. The Romans had refined taste, and they embellished their homes and country villas with elegant decorations. Exquisitely wrought furniture was set on intricately laid mosaic floors. Walls were adorned with all kinds of murals; these murals sometimes played with the architectural motifs of the room, creating an illusion of a window with a fictive scene or tricking the eye with a facsimile of a free-hanging easel picture.

Subjects for Roman murals were varied. Mythological subjects, landscapes, and large narrative scenes have been preserved. So have scenes that depict an actual event; a theater performance, for instance, has been found, as well as some still-life paintings. Most of the surviving mural paintings come from the houses in Pompeii and Herculaneum that were buried in, and preserved by, the ashes of Mount Vesuvius's eruption in A.D. 79. One of the most beautiful murals is from the villa of P. Fannius Sinistor in nearby Boscoreale [p. 33]. Painted soon after the middle of the first century B.C., the fresco depicts a young woman seated in a chair, playing the cithara (a Greek lyrelike instrument), while behind her a younger girl (perhaps her daughter) looks out shyly. Shown as though momentarily distracted, the well-defined, skillfully modeled figures are vivaciously portrayed. Broad, assured brush marks set the solid forms against a smooth, uninterrupted screen of red, implying that this image existed as an extension of the room in which it was painted. Details such as the faces, hair, and strings, as well as the inlay of the chair, are laid in with smaller but no less bold strokes of the brush, which reveal a painter skilled at drawing the overall figure, adept at describing its form and volumes in space, and particularly sensitive to the qualities of expression that animate the face. Self-assured, perhaps a bit guarded or wary, this Roman matron

seems to give us a rare glimpse into the kind of life that once went on in the now-abandoned rooms. Painted in the waning years of the Roman republic, it may be the work of an imported Greek painter or a Roman trained in Greek traditions.

Toward the end of the second century, the cherished order, stability, and confidence implied by the Boscoreale fresco and central to the Romans' view of the world and themselves began slowly to erode. Barbarian pressure on the frontiers of the empire, increasingly autocratic and unstable emperors, uncertainty in their selection, growing disorder, and a steady disintegration of urban life sent repeated shock waves through the empire. Moreover, there arose a general spiritual malaise. Disbelief and doubt in the old gods led to a search for a new and more immediately consoling religious experience, found in the various mystery religions and in Christianity, which offered, in a troubled and uncertain time, hopeful and comforting messages of salvation and afterlife. These political, social, and spiritual crises were fundamentally to alter, and then to destroy, the society and order that many Romans had believed indestructible. The traditional Roman confidence in man and his environment, seen so clearly on the Ara Pacis, could no longer be sustained in the strife-torn late Roman empire. The old pictorial conventions of realism, of the rightness of the here and now, began to be replaced by more abstract pictorial conventions.

Many of these new pictorial conventions can be seen on sarcophagi, stone boxes designed to hold the deceased, which came into vogue about A.D. 100, when interment rather than cremation became prevalent. They were decorated with a variety of subjects, many of them having at least some oblique reference to the cycles of life or to an afterlife. A sarcophagus of a general [p. 35], for example, made about A.D. 190, depicts a battle between Romans and barbarians. Battle sarcophagi borrow heavily from Rome's triumphal monuments, but they impart a different message. Undoubtedly, the battles carved on the sarcophagi were meant to advertise the deceased's virtue and prowess, in military affairs or otherwise, but this is not just a triumph of the Romans over their foes—it is also an allusion to the soul's triumph over death.

The earliest sarcophagi presented their images realistically and clearly, but by the date of the gen-

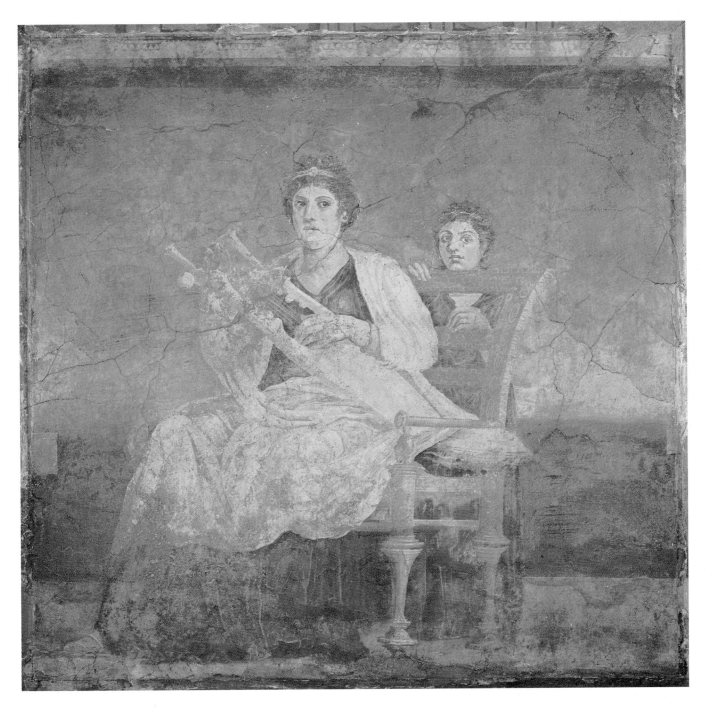

FRESCO FROM THE VILLA OF P. FANNIUS SINISTOR NEAR BOSCOREALE, MID-FIRST CENTURY B.C. *Boscoreale, about a mile north of Pompeii, was a popular spot for country villas for the Romans. Buried in the ashes of Vesuvius, the villa was excavated in late 1900 and the paintings were sold.*

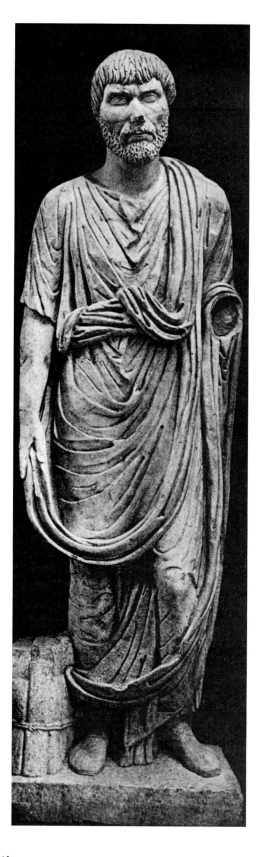

eral's sarcophagus, Roman art had undergone a fundamental transformation—there was now much spatial ambiguity. For example, it is not possible to see exactly where or on what the fighting figures stand or move. The body is handled in a more schematic, less anatomically correct way, and the many figures clinging to the surface of the sarcophagus form a series of clashing abstract patterns. The artist, and by implication the patron, is no longer so obsessed with the need for realism. Pattern, expression, violent action, and an uncertainty about place and time are the major characteristics of this relief. The old harmony and decorum of Roman art and life here begin to dissolve.

These changes in Roman art are best seen in portraiture. In the late empire the accurate reproduction in stone of one's appearance and the suggestion of the physical and social circumstances surrounding one's existence were no longer great concerns. Instead, the face became a mirror of the soul, a vehicle for the expression of the workings of the mind. The self-confidence and certainty of the Ara Pacis were replaced by a sense of foreboding and anxiety; deep and often contradictory emotions replaced the self-possession of the earlier faces. The new faces often suggest a search for spiritual illumination and salvation that can no longer be found in this world or under the casual protection of the old gods.

The new image of man and his place is clearly seen in many carvings of Roman citizens. An especially haunting one is a portrait statue [p. 34], perhaps of one Vincentius Ragonius Celsus, done at the end of the fourth century A.D. The toga is now so divorced from reality that its folds turn into patterns covering the body known to be beneath, but unseen. Weight and volume no longer matter; the body is as much symbol as reality. Here a new pictorial convention, that of the Middle Ages, has begun to develop. The patterned beard and stylized hair frame a plaintive face filled with spiritual longing. The huge, upturned eyes, common to many portraits of the late empire, look not into the world but toward the heavens.

PORTRAIT STATUE, PERHAPS OF VINCENTIUS RAGONIUS CELSUS, A.D. LATE FOURTH CENTURY. *The face and figure of this roughly carved statue have become schematic conventions of earlier, more realistic Roman forms.*

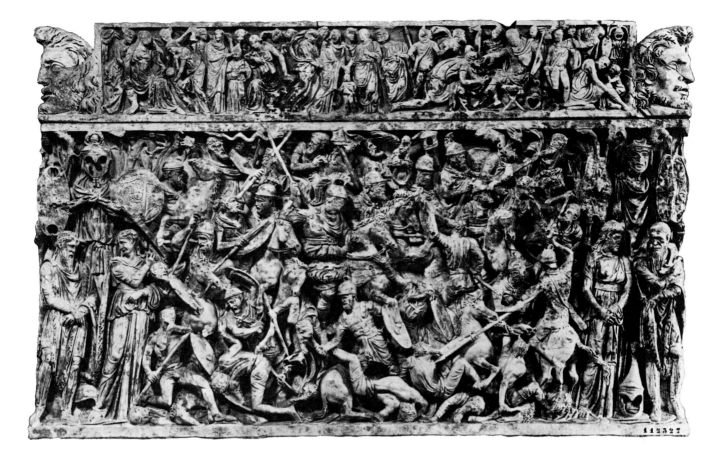

SARCOPHAGUS OF A ROMAN GENERAL, C. A.D. 190.
Sarcophagi were often carved on speculation with only portraits and minor carvings put in after their purchase. Here the general's face, near the center of the composition, remains blank, perhaps because there was no time for the sculptor to finish it.

At one time such portraits were considered crude and were thought to be the products of Roman decadence, but today their angst and uncertainty, expressed through such a direct, simplified style, strike a responsive chord. Moreover, they are now viewed not only as representative of the old and crumbling Roman world but also as harbingers of the new religion that was to sweep across much of the empire, Christianity.

Though the Roman empire collapsed, it did not vanish, and its memory endures even today. Rome's legacy is both complicated and enormous. We think, write, and speak in a language derived from the Romans, and we have inherited not only the words but the concepts of virtue and decadence from the evidence of Rome's history. What more striking exemplar of virtue survives than that of Lucretia, who committed suicide rather than dishonor her family? What emblem of power is better known than the word *caesar*, from which *czar* and *kaiser* are derived, and whose symbols of authority were borrowed for centuries? What more venal characters can we remember than the emperor Caligula, regarded by his contemporaries as a true monster, who reveled in tortures and executions and who was stabbed to death by a disgruntled soldier after less than four years of rule? Yet, the myth of Rome's glory and her contributions to our civilization outshine the deeds of any of her citizens. Roman law, engineering, town planning, architecture, and many other fields of endeavor and thought nurtured the growth of Western civilization and art.

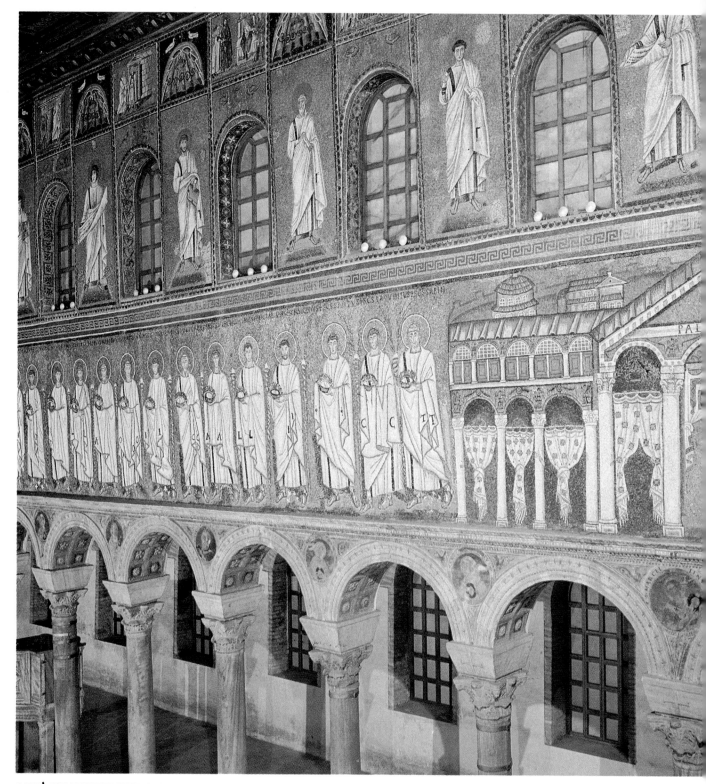

SANT' APOLLINARE NUOVO, RAVENNA, ITALY, C. 504. *Theodoric the Great, the church's patron, was founder and king of the Ostrogothic kingdom in Italy (493–526) and was an Arian Christian. His reign was marked by religious tolerance and prosperity.*

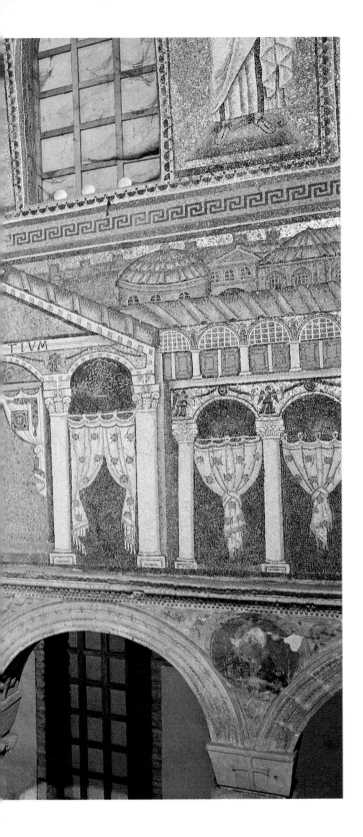

[3]

THE TRIUMPH OF FAITH: WESTERN ART TO 1100

Long before the Roman empire collapsed, an event occurred that would affect not only Rome but all subsequent Western culture. During the reign of Augustus's successor, Tiberius, Jesus was crucified in Jerusalem. The many executions during this time, including that of Christ in Palestine, were of little concern to an emperor retired to the island of Capri, and Christ's death had no immediate impact on Rome. His small band of followers, however, continued to preach his message and steadily gained converts, and eventually Christianity spread to Rome, where it joined numerous Eastern mystery cults practiced there. Christianity's monotheism began to threaten the authority of the Roman emperors.

In A.D. 64 Nero blamed the Christians for the great fire he himself most likely started and ordered Paul, the Christian leader, beheaded. Among successive emperors, some were tolerant, but others, like Decius, made a concerted effort to eradicate the Christians. All efforts to halt the spread of Christianity failed, however, as one group of martyrs inspired the next to become believers. Finally, on June 15, A.D. 313, the emperor Constantine issued an edict ordering full tolerance of all religions. This act, and Constantine's own conversion, established the foundations for the subsequent dominance of Christianity throughout Europe.

In contrast to the pluralistic pagan sects, Chris-

tianity forbade its faithful to worship at the shrines of other deities; it was, its adherents believed, the one true religion. In A.D. 392 Ambrose, bishop of Milan, issued the decree that closed the temples and banned pagan sacrifice and all household gods, making complete the triumph of Christianity as the Roman empire collapsed.

In A.D. 330 Constantine had moved his capital to the East, to Constantinople, while in the West, Roman unity was destroyed by invading barbarians. Then, from roughly A.D. 500 to 900, Europe passed through the period that has been called the Dark Ages. Cities were abandoned or destroyed; bronzes were melted down for weapons; and marble sculptures were thrown into lime kilns to support the agrarian culture that supplanted the urban one. During the darkness of this period, the mystical light of faith guided Western culture and offered a new and different interpretation of human history and destiny.

All past events were viewed as leading up to Christ's death on the cross, and all subsequent events were thought to have been shaped by it. History was considered part of God's plan, which revolved around Christ's sacrifice; human salvation depended on this event. It is no surprise, then, that the Crucifixion became the most frequently depicted subject of Christian art for centuries to come. The message of the Bible eclipsed all others, and Christian art derived its subject and meaning from that text.

An example of this is the ninth-century cover of the *Lindau Gospels* [p. 39]. Late Roman artists had already abandoned the historical specificity favored by their forebears. Christian artists went even further in the direction of a dematerialized, symbolic imagery. Thus, Christ is not shown as dead on the *Lindau Gospels* cover, as history and reason would require, but alive and triumphant over death, as dogma dictates. The figures surrounding him—the mourning angels above and the weeping humans below—do not move in any space related to the actual event of the Crucifixion, but float on the gilded surface, suspended from reality. Design and subject matter are the important elements of this image's formulation. The cover of the book is a map to a new, hierarchical vision of the world: the celestial, spiritual world above Christ's head and the physical world beneath his arms.

This is a perfect example of a new, symbolic reality, based not on nature but on faith. The material world, including man, had no meaningful place in the system of representation that was intended to make the elements of faith visible to the faithful. Indeed, humanity's place was seen as so low on the hierarchical ladder that representations of actual people ceased to matter, and a whole panoply of human images disappeared from the artistic lexicon. The large-scale civic sculptures, the portraits, the wall paintings, the depiction of figures both real and ideal, which were for more than a thousand years the preoccupation of Greek and Roman artists, were gone.

In 312, the year of Constantine's conversion to Christianity, the human figure still existed in the visual arts, and by 1200 it had been reborn. But in the intervening centuries, during Europe's Dark Ages, it all but disappeared. In these years Rome was transformed from a pagan to a Christian capital, while her empire disintegrated into small kingdoms susceptible to invasion. Waves of new peoples with different art forms swept into Roman provinces, and all were affected by the growing influence of Christianity. The faith not only influenced subject matter but also the very form of art. Antimaterialistic and highly ritualistic, Christian art easily adapted itself to the schematic, abstract style already developed in Rome.

Local traditions were incorporated in various regions at different times, much as in the Roman era. Christian art shared with Roman art a fundamentally aggregate nature. Pieced together from varied components, it lacked the cohesion that marked Greek art and reflected the more cumulative appearance of certain Roman works—the triumphal arches and columns, for example. A basic tendency of Roman thought was to make people secondary to the empire to which they belonged; in Christian thought, man became so secondary in relation to God as to become inconsequential for representation. Man remained the object, but not the subject, of art for nearly a millennium.

FRONT COVER OF THE LINDAU GOSPELS, C. 870. *The age of Charlemagne inaugurated a high level of artistry in the production of book covers. Charlemagne's descendant Charles the Bald (843–877), considered the greatest patron of the ninth century, most likely commissioned the front cover of the* Lindau Gospels *from his favorite abbey, Saint-Denis.*

For Western architecture, Christianity had both immediate and far-reaching consequences. When, after Constantine's edict, Christians began to plan their own churches, they at once rejected the traditional temple form the Romans had inherited from the Greeks. This type was synonymous for Christians with the old pagan religions, whose gods were intimately associated with the state's persecution of Christians. For the growing number of Christians, new, untainted building styles had to be found.

The basilica, known to every Roman, soon proved to be a suitable model for a structure meant to house the Christian rituals. It had been a civic building, not the home of a particular pagan cult. And it had a considerable amount of interior space. This was important because, unlike the Greeks and Romans, whose rituals were performed at outdoor altars set before the temples, Christians worshiped indoors, away from public view. Their rituals were to be the focal point of their sacred architecture.

Although there seems to have been no standardized Roman basilica plan, most of these structures were large rectangular halls with broad naves ending in apses, flanked by colonnaded aisles and covered with timber roofs [p. 40]. The new churches were entered at the opposite end of the nave from the altar, which was sometimes placed in an apse. The major illumination was provided by windows in the clerestory level (the section of wall rising above the aisles). The entire plan, which worked so well that it immediately established the architecture of the Catholic church in the West, was

RECONSTRUCTION OF THE BASILICA ULPIA (OF THE FORUM OF TRAJAN), C. 112. *The Basilica Ulpia (its name comes from Trajan's family) stood in the Forum of Trajan, a monumental urban center built at the beginning of the second century* A.D. *The length of the monumental basilica was about 400 feet and its interior was demarcated by two levels of giant marble columns which supported a deeply coffered roof. The building was an architectural metaphor for Roman civilization near the zenith of its power.*

one of simplicity and ingenuity. It was impressive, dignified, and Roman, but it was also Christian and well suited for its new function.

Large numbers of worshipers could be comfortably housed in the churches based on the basilica plan: the crowds could look down the nave and aisles of the building and see the sacred rituals performed; and the architecture of the basilica type of church provided the measured and somber setting to which Romans, of whatever faith, were accustomed [p. 41]. Some of these early Christian churches grew to considerable size. The enormous Old Saint Peter's, built by Constantine but razed in the sixteenth century to make way for the present church, had four aisles, a transept (the transverse arm of the church) with an apse, and a large, colonnaded atrium, the whole probably placed on a high base that may have been a survivor from the old Roman temple type.

During the eleventh and twelfth centuries, the construction of large churches in the West quickened. Although important churches were built from the sixth to the eleventh century, they were not numerous, nor does there seem to be much commonality among them. On the whole, this still-obscure period of the Dark Ages is not prominent in the history of Western architecture, despite certain developments, such as the flowering of the arts under Charlemagne.

As they did in the adoption of Roman architectural types and forms, whenever possible the Christians utilized established Roman conventions in the other arts; by so doing they could add the authority of antiquity and tradition to their new images. In the case of sculpture, modification was not difficult, because it had already undergone many fundamental changes by the third century. Sculpture had rapidly moved away from the realism and harmony of earlier periods toward a more abstract conception that dematerialized the human form and its earthly environment. Pattern and spatial and figurative ambiguity were replacing the Romans' cherished fact. Roman sculpture indeed had become what might be called medieval long before it became Christian.

The flattened, writhing, generalized mass of form seen on a first-century A.D. Roman general's sarcophagus began to appear on Christian sarcophagi. The *Good Shepherd Sarcophagus* [pp. 42–43] from the late fourth century is decorated with

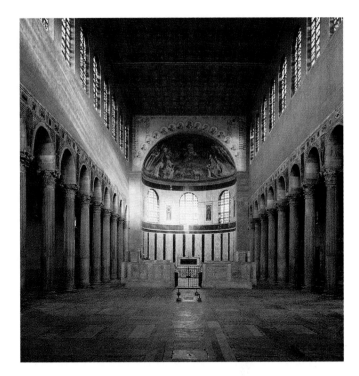

INTERIOR OF SANTA SABINA, 422–432. *The church of Santa Sabina is one of the very few Early Christian basilicas to retain much of its original appearance. The marching columns, the large, luminous apse, the clerestory windows, and the timber roof were characteristic of churches built by the Early Christians.*

Christian symbolism derived from pagan types. The youthful, protective Good Shepherd carrying the helpless sheep on his shoulders is an ancient symbol of protection and compassion, here transformed into an image of Christ. The vines and the cupids harvesting the grapes had long been associated with the very popular and ancient orgiastic cult of Bacchus, but here they are symbols of the Eucharist. Together, the symbol of the youthful Good Shepherd/hero/Christ and the allusion of rebirth in the Eucharistic grapes suggest salvation, a most appropriate motif for the sarcophagus of a Christian.

The vigorous but crude conception and carving of the figures of the *Good Shepherd Sarcophagus* foretell the development of Western art for centuries to come. The old, classical conventions so solidly rooted in the human form, in harmony, and in beauty were undergoing fundamental transformation as art hovered between representation and pattern, between figure and symbol.

This transformation of Roman art into the art of

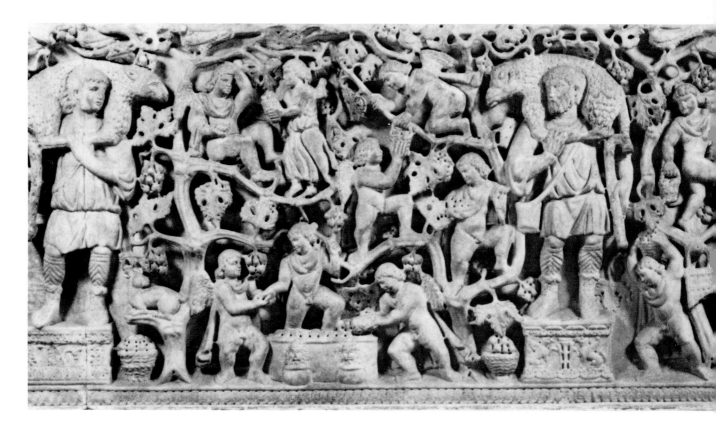

**GOOD SHEPHERD SARCOPHAGUS, LATE FOURTH
CENTURY.** *Such sarcophagi were often mass-produced in
specialized workshops. The Good Shepherd, a blend of pagan
and Christian symbolism, was a popular image among the
Early Christians and it appears on many sarcophagi and
catacomb paintings.*

the Middle Ages is well illustrated in Ravenna, a city
on the eastern coast of Italy about eighty miles
south of Venice. Ravenna had been the capital of
the Roman empire after the fall of Rome in 410, and
in the late fifth century it became the capital of the
Ostrogothic kingdom under Theodoric. After its
conquest by the troops of the emperor Justinian,
who ruled from Constantinople (the seat of the East-
ern empire), it was transformed by art and military
force into the center of imperial authority in the
West. Ravenna thus became an important city both
geopolitically and symbolically. Its various rulers
greatly enriched the city during the fifth and sixth
centuries, and its many buildings and their decora-
tion demonstrate a striking confluence of ancient
Rome, the Gothic north, and the Eastern world of
Justinian and his court.

In the first years of the sixth century, Theodoric

built a church for his palace in Ravenna [pp. 36–
37]. This impressive structure is a classic Roman
basilica type, with two side aisles, a wooden roof,
and an apse. In this church Theodoric, although an
Arian Christian, consciously paid tribute not only to
the early Christian churches of Rome but also to the
heritage of Roman civilization from which they
sprang and which he and many of his northern con-
temporaries so admired and wished to emulate.

Theodoric commissioned numerous mosaics
to decorate his new church. Mosaic had been highly
developed in Rome and used as decoration for civic
basilicas. In Ravenna, however, the mosaics de-
picted not secular but religious themes. In the mo-
saic *Miracle of the Loaves and Fishes* [p. 44] in
Theodoric's church, the youthful Christ owes much
to the imagery of the Roman emperor. Dressed in
royal purple and crowned with a halo, he dispenses
loaves and fishes with imperial majesty, just as
Theodoric must have done when giving donations.

Not only the subject matter but also the style of
mosaics changed. The realism and precision of
Roman art were replaced by an abstract, highly
schematic vision. The illusionism of Roman light
and volume lingers only in the vestigial rocks and

in the late eighth or early ninth century, is one of monasticism's most celebrated accomplishments. Here the veneration of the Word produced an art obsessed with the very letters that make up Christ's name. The Greek letters *XP* stand for "Christ," and they are magnified and imbedded within a design that seems like a Gregorian chant—monodic, complex, and hypnotic. The human image is subsumed completely. Linear, intricate, and as animate as any portrayal of a natural action, this work epitomizes the attempt to make ideas—spiritual ideas—concrete through symbolic means.

In another part of Europe, stretching from Barcelona to Hamburg and from Rome to Utrecht, a new empire grew, ruled by Charles the Great, or

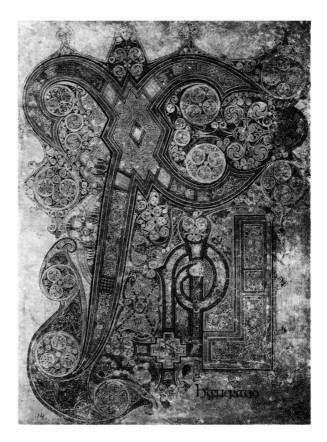

BOOK OF KELLS, EIGHTH OR NINTH CENTURY. *Begun at a monastery on the Scottish island of Iona, which was destroyed by Viking invaders about 795, the* Book of Kells *was moved to the monastery of Kells in Ireland, where it was completed. Celebrated for the intricacy of its designs, it is also unusual for the diversity of subject matter and for the inclusion of several full-page illustrations within a single book.*

trees set in the strips of mosaic. The *Miracle of the Loaves and Fishes* is nonetheless a sophisticated image. The glittering mosaic emphasizes the hierarchic, otherworldly nature of the subject. Against the spaceless, timeless gold in the background, Christ and his attendants are depicted with impassive, masklike faces. They are more divine than human and there is a quality about this mosaic that perfectly expresses the mystery of the great miracle that has just taken place.

In the period of upheaval that marked the decline of the Roman empire, during which Rome was attacked numerous times, the monastic movement developed as a means to escape the danger and decadence of urban life. Monasticism spread rapidly over Europe, reaching as far as the Celts in Britain. Churches and monasteries became the new centers for authority and preserved much of what has survived of ancient learning.

Somewhere, perhaps in the area off western Scotland called Iona, secure from the world until the Norse invasion, was a monastery and scriptorium, where writing, reading, and copying went on. The scribes of Iona dedicated their finest efforts to the Holy Word. The *Book of Kells* [p. 43], produced

Charlemagne (742–814), who consciously tried to restore a Christianized Roman empire and revive the glory of Rome. The Holy Roman Empire was formally established when Pope Leo III crowned Charlemagne emperor on Christmas Day, A.D. 800. With Charlemagne, Europe emerged from the Dark Ages and began to revive culturally. Charlemagne's emulation of Roman art is evident in a small bronze equestrian statue [p. 45]; his seal carried the motto *Renovatio Romani imperii* (Restorer of the Roman Empire). His allusion to Roman equestrian portraits

MIRACLE OF THE LOAVES AND FISHES, SANT' APOLLINARE NUOVO, RAVENNA, ITALY, C. 504. *The Miracle of the Loaves and Fishes is depicted from the third century on in various forms. Christ's feeding of the multitude through the miraculous multiplication of loaves and fishes was viewed by the Early Christians as a prefiguration of the Eucharist.*

four centuries after the demise of Rome gives a hint of how firmly the conceptions of Rome and empire were linked. The miniature size of Charlemagne's bronze is also revealing; it reflects, perhaps, the dwarfed size of his empire.

Charlemagne is credited with preserving much of what is known of antiquity. His monks collected, stored, and transcribed ancient texts in their scriptoria and libraries. Artistically, the Carolingian period (named after the emperor) is best known for its splendid covers for Bibles and Gospels, such as the one mentioned at the beginning of this chapter. Another example is a carved ivory depicting the Crucifixion, surrounded by enamel and precious stones, which was made at Metz in northeast France about 840 [p. 45]. Both of these examples show the human figure reintroduced into the artistic vocabulary, but in a decorative and symbolic manner.

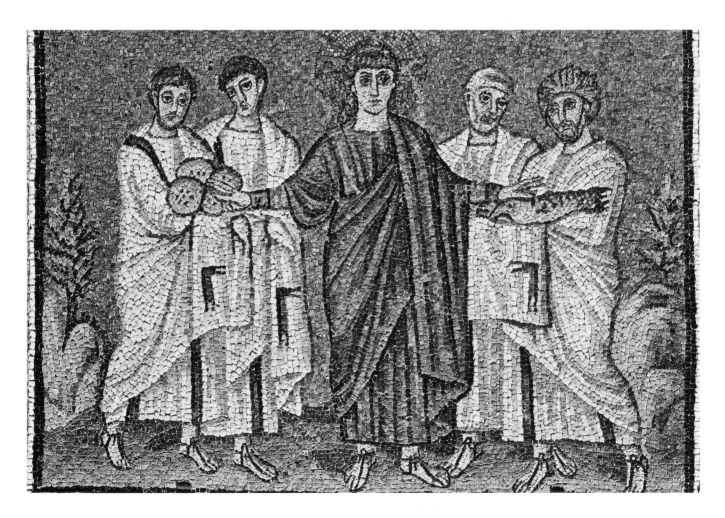

Admirable for the use of pattern and abstracted form to make pleasing configurations, the Gospel covers do not interpret the figure but use it to propagate a preordained truth.

The images contained within these covers also portrayed figures, but always in a schematic and nonillusionistic fashion, as a page from the *Codex Aureus* [p. 46] of 870 shows. Here saints surround Christ, who is placed in an aura of light and color (called a mandorla, a device used for more than a thousand years to depict Christ's sanctity). The whole work is a well-conceived and splendid arrangement of pattern and color: green, red, and blue play a tightly orchestrated rhythm in this mingling of image and symbol, isolating yet unifying each of the parts. The four Gospels are represented by their authors, who look to Christ for guidance, and each Evangelist is represented by his symbol: the lion for Saint Mark, the ox for Saint Luke, the eagle for Saint John, and the winged man for Saint Matthew. Attributes—halos, the color of the gown, and hair color —are the means of identification in this complex, transcendental system of Christian ideas.

The large-scale narrative wall paintings that Charlemagne revived inside churches are lost, but precious reliquaries and objects connected to the Mass survive. A fascinating reliquary of the ninth century is that of Sainte-Foy (Saint Faith) [p. 46], a young Roman girl who had been martyred for refus-

CRUCIFIXION, BOOK COVER, c. 840.
A masterpiece of Carolingian art, this Gospel cover was produced at Metz during the reign of Louis the Pious (814–840). Louis's half-brother, Drogo, was Archbishop at Metz and supported the production of the finest ivory carving, cloisonné enamelware, and jeweler's art, all of which are incorporated into this assembly.

CHARLEMAGNE, BRONZE STATUETTE, NINTH CENTURY.
Debate about the identity of this rider continues, though it is generally accepted as a portrait of Charlemagne. We know that Charlemagne wore "a garment woven of gold, shoes embellished with gems, a gold fibula to pin his mantle, a diadem of the same metal," according to Bishop Einhard. Charlemagne brought an equestrian statue of Theodoric back from Ravenna, and the Roman derivation of this statuette is obvious.

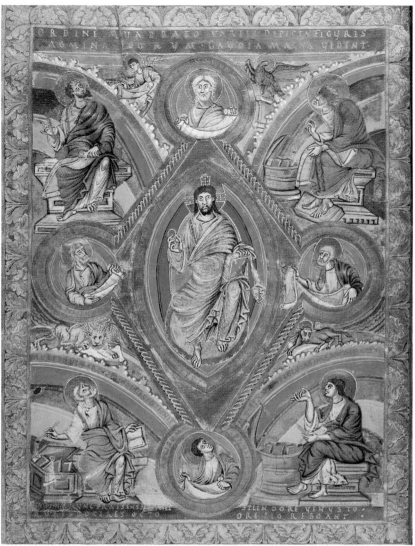

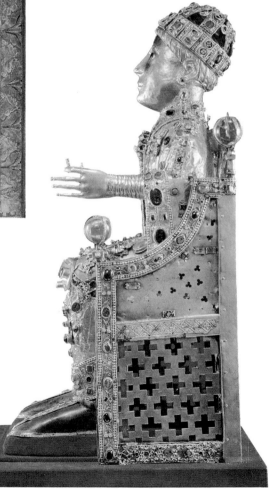

**CHRIST IN MAJESTY, FROM THE CODEX
AUREUS, 870.** *A* Codex Aureus *(or Golden
Gospel) was a particularly luxurious manuscript
type produced for royalty during the Carolingian
and Ottonian times. This page comes from a*
Codex Aureus *made for Charles the Bald (843–
877) and is notable for having adapted the
forms of antiquity to an entirely new, decorative,
and symbolic pictorial language.*

SAINTE-FOY, RELIQUARY STATUE, NINTH CENTURY. *This
reliquary statue of Sainte-Foy, whose bones were stolen from
the south of France by a Benedictine monk in the ninth century,
was among the major attractions at the Abbey of Conques. Like
other reliquaries, it is an exercise in the goldsmith's craft rather
than a work of sculpture.*

ing to worship pagan idols. In an ironic twist, descendants of those whom she had converted to Christianity turned Sainte-Foy's remains into a golden idol composed of pieces taken from various sources. Her face is probably made from a golden mask of a late Roman emperor; her jewel-encrusted body has engraved Roman gems. Her imperious posture derives from late Roman imperial imagery. Her authority is not temporal, however, it is spiritual; and this is not a portrait statue, it is a reliquary. To look at it one would not know that it holds the severed head of a little girl who became a saint for her faith; the makers of Sainte-Foy's reliquary were interested not in commemorating her as a human being but in transforming her into an icon. Her reliquary is one of the earliest examples of a type that remained an important art form for over a thousand years: reliquary makers all over Europe encased fragments of saints' bodies (their tongues, fingers, bones, and hair) in ornate, precious containers that preserved them for veneration.

After Charlemagne died in 814, his empire was passed on to his sons, and it lasted (though in somewhat altered form) until the tenth century, when it fell apart from internal strife and external attack. A new, powerful ruling dynasty emerged with Otto, who was crowned king of Lombardy in 951 by the pope. Otto's empire stretched from Hildesheim in northern Germany to Lombardy in Italy. Hildesheim was one of the most creative centers of Otto's empire, and perhaps because his patronage was imperial, the art produced in Hildesheim was occasionally a reflection of antiquity.

A striking example of antique revival is the column commissioned by Bishop Bernward of Hildesheim in the early eleventh century [p. 47]. It used as its model the Column of Trajan, which would, sometime in the twelfth century, be declared a treasure by the Roman senate. Bernward's Column was cast by the lost-wax process, not carved in stone as was Trajan's, but it follows the latter's plan. Spiraling along its surface are Old and New Testament scenes. The authority and historicism of Rome's ancient model were used to give meaning and context to the religion that helped bring down Trajan's empire.

Other images created in the Ottonian period have no ancient derivation but are far more seminal. About 975 Archbishop Gero of Cologne ordered the

COLUMN OF BISHOP BERNWARD, C. 1015– 1022. *Originally executed for the Abbey Church of Saint Michael, this column was clearly inspired by antiquity. Its spiraling reliefs displayed events from Christ's life and culminated with a now lost Crucifix at the very top. The present capital is a cast imitation, reproduced in 1871, of the lost original.*

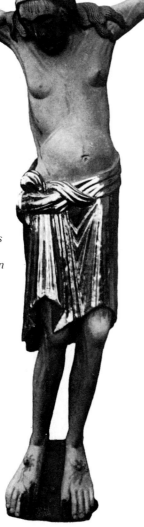

GERO CRUCIFIX, C. 975. *As with many other large-scale sculpted works, the inspiration for this life-size work was its function as a reliquary. At the back of Christ's head is a hollow which stored the consecrated host used during the Mass.*

Book of Kells than with any figural sculpture we know from antiquity. The *Gero Crucifix* foreshadowed the developments of the eleventh century, when sculpture was revived in carvings for churches. The churches built after 1000, while still fundamentally indebted to the basilica type (with nave, side aisles, and apse) incorporated other characteristics that, with local modifications, can be seen all over Europe [p. 49]. One of these characteristics was the development of chapels, either radiating from the apse or from the transept or from both. The growing cult of saints and the practice of every priest saying Mass every day meant that the simple basilica type, with its single apse, was no longer entirely suitable. Instead, new spaces had to be developed that would accommodate reliquaries and allow the faithful to participate in the religious services that focused on them; this was especially true in churches frequently visited by pilgrims intent on seeing certain relics.

Churches grew in complexity as well as in size. They developed new ground plans and architectural articulations. The simple, unidirectional flow of space from the entrance on the west end of the basilica to the altar in the east was now modified. The new churches slowed the movement through the nave by dividing and subdividing it into carefully articulated compartments. Heavy piers and columns carrying ponderous round-headed arches marked square bays along the nave and transept. The weight and surface of the wall were stressed, and the individual units of space and decoration had a new aesthetic and structural independence. These churches appeared not as a single, organic whole, but rather as a series of units skillfully added together. In their gravity and rudimentary architectural power, the interiors of these churches recalled the grandeur of Roman buildings [p. 49], but many of them also had a fortresslike mass and weight that reflected the uncertainty of the times.

At first these churches had timber roofs, but they gradually gave way to stone vaults. Barrel vaults, groin vaults, and rib vaults provided a new unity and weight. The rib vaults carried the articulation of the individual bays from one side of the nave to the other and thus further compartmentalized the churches [p. 52]. This love of division, of segmentation, is also seen on the exteriors of the

first life-size wooden crucifix still known today [p. 48]. The crucifix shows a suffering, dying Christ, his outstretched arms pulled by his sagging weight, his knees turned as his body sways, his head sunken in death. This work marks a turning point: monumental sculpture was reemerging in Western art. But this crucifix is not a refined, polished, technically proficient depiction of the human body. Within the received schematized conventions, the artist created bold, expressive forms, which in their employment of patterning and abstract treatment of hair and cloth have more in common with the designs of the

ABBEY OF CONQUES. *Conques was situated on a pilgrimage route that led from Le Puy to Santiago in Campostela. Begun around 1050 and finished about fifty years later, the Abbey of Conques was the destination of many pilgrims who came to worship the relics of Sainte-Foy, which were used to perform a number of miracles.*

churches, which often are majestic in their size, weight, and volume [p. 51]. The basic structure of the church is visible from the outside.

The abstraction and force of these churches are also characteristic of the sculpture of the time. Whether on the facade or inside, this sculpture illustrated the Christian drama, which worshipers knew from sermons and, if they were literate, from the Bible and other religious writings. Stone carvings made the Word manifest and gave shape and immediacy to the viewer's knowledge and imagination. Sculpture also served to decorate and modulate the austere, monolithic churches.

The embellishment of churches with carvings on capitals, piers, jambs, and portals marked the

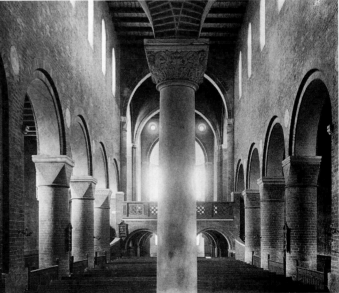

PRAMONSTRATENSIAN CHURCH, C. 1200. *This brick church's weighty piers, smooth brick wall surface, and luminosity ultimately depend on Roman architecture, especially the basilica.*

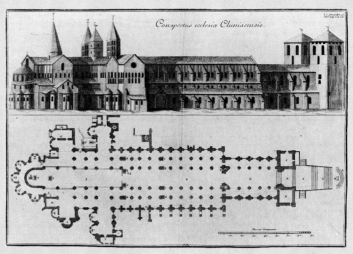

Conspectus ecclesiæ Cluniacensis.

Monasticism, the removal of like-minded monks from the temptations and upheavals of worldly life, gained momentum during the years that the Roman Empire collapsed. Saint Benedict (c. 480–543), founder of the Benedictines, established the order that would become the norm for most of Europe until the twelfth century, when the Cistercian and Franciscan orders superseded it. The monastery at Cluny, founded in A.D. 910, followed the Benedictine rule and became the order that was the most powerful religious force in Western Christendom to the middle of the twelfth century. By 1157 there were 314 Cluniac monasteries scattered throughout Europe, all of them under the administration of the Abbey of Cluny, which was one of the great glories of the Middle Ages. Established

by Duke William of Aquitaine, it was destroyed by the anticlerical Napoleonic forces in 1790. In its prime, the noble Abbey church was a perfectly designed setting for the elaborately conceived ceremonies of prayer and chant which made up Cluniac ritual. The Abbey's massive tunnel vaults echoed and reechoed with the devotional music, with its rhythms, inventions, and repetitions that were at the heart of monastic life.

Monastic communities were largely self-sufficient and involved vast building complexes that included dormitories, convents, workrooms, storerooms, churches, schools, barns, and hospitals, all neatly and efficiently arranged. The Abbey of Cluny was the largest ever built.

NOTRE-DAME-LA-GRANDE, POITIERS, c. 1150. *Such extensive sculptural decoration on the outside of a church, one of the most important innovations of the eleventh and twelfth centuries, became a characteristic feature of large churches for the next several centuries. At Poitiers the flattened pattern around the portals and upper niches emphasizes the massiveness of the architecture.*

ABBEY CHURCH, MARIA LAACH. *This Benedictine abbey church was begun in 1093 by Count Palatine Henry II.*

DURHAM CATHEDRAL, C. 1100. *Durham Cathedral was begun by the Normans about 1100. The incised patterns decorating its massive piers are related to types of ornamental design produced by the Barbarians, reviving their severity. Especially noteworthy are the rib vaults (which anticipate those used in later cathedrals) and the arcade below the aisle windows.*

first widespread revival of stone sculpture since late antiquity [pp. 54–55]. In the northern European countries, the form and feeling of the sculpture, while radically different, were still partially indebted to the antique world. Roman sculpture, especially the sarcophagi of the late Imperial and Early Christian periods, was still abundant in northern Europe. The sculptors of the eleventh and twelfth centuries must have studied the extant Roman works with considerable attention; the Roman art, with its abstract, flattened figures and vigorous narratives, was to influence strongly many of the artists of this nascent revival of sculpture. But the artists working in the north of Europe also brought the ornamental, decorative vision of their wandering ancestors to their art. The figure, either alone or in groups, tended toward a sort of organic calligraphy reminiscent of the Celtic manuscript page and the patterns of barbarian jewelry [pp. 54–55].

Perhaps the most striking monuments left by these tenth- and eleventh-century sculptors are found in Burgundy, France. Here, in the churches at Vézelay and Autun, are several carved stone lunettes of great power and originality, which are particularly appealing to modern tastes formed by highly expressive, abstract art.

At Autun, the *Last Judgment* [p. 53] in the tympanum of the cathedral of Saint-Lazare is signed by the sculptor Master Gislebertus, who probably carved it about 1150. Exactly who this man was is unknown, but his signature represents a rare escape from the anonymity that conceals

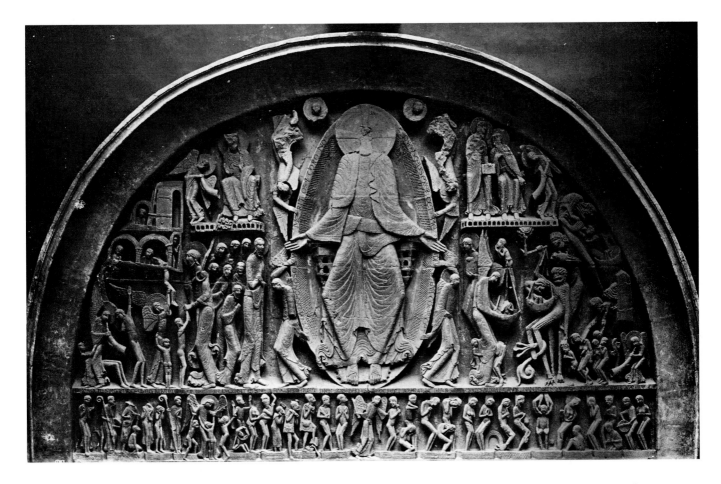

LAST JUDGMENT, TYMPANUM, SAINT-LAZARE CATHEDRAL, C. 1150. *Gislebertus, the sculptor who signed this tympanum, seems also to have worked at the great Abbey of Cluny and at the church of Vézelay. His is one of the earliest names to be convincingly linked to a highly individualistic body of work.*

the identity of most of the artists of his time; there is no mistaking the dynamic and highly inventive artistic personality that so strongly stamps his work at Autun.

In the *Last Judgment,* everything centers on the flattened, elongated, spectral figure of Christ dispensing judgment. Around this frightening figure the tumult of Judgment Day unfolds. The souls of mankind appear in the long register at the bottom of the tympanum, where they are either welcomed into heaven, at the left, or, at the right, damned to hell.

The sculpture of the period, much of it carved into the capitals of churches and their cloisters [p. 54], was contemplated with distracting fascination, as this famous passage of Saint Bernard of Clairvaux (1090?–1153) makes clear:

And in the cloisters, under the eyes of the brethren engaged in reading, what business have those ridiculous monstrosities, that misshapen shapeliness and shapely misshapenness? Those unclean monkeys, those fierce lions, those monstrous centaurs, those semi-human beings. Here you see a quadruped with the tail of a serpent, there a fish with the head of a goat. In short there appears on all sides so rich and amazing a variety of forms that it is more delightful to read the marble than the manuscripts and to spend the whole day in admiring these things, piece by piece, rather than in meditating on the Divine Law.

It is clear from his words that Saint Bernard found the works he chastises fascinating and averted his eyes from them only with difficulty. He finds their powerful presence in the cloisters an ever-present danger to the monks, who might fall under their spell.

Gislebertus and his contemporaries could also carve in a much more touching, if no less abstract, manner, as is evident from a series of capitals he

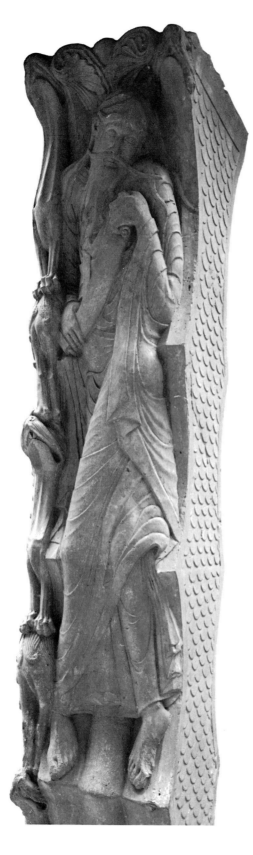

THE PROPHET JEREMIAH, SAINT-PIERRE CATHEDRAL, C. 1130. *The fantastically elongated figure of Jeremiah twists across the pillar with an anguished energy. Like much of the rest of the rich and skillful carving at Saint-Pierre, which dates from the first decades of the twelfth century, the figure is a triumph of both conception and execution.*

did for Saint-Lazare. The urgency of the *Flight into Egypt* [p. 55], with its intent figures, sped along by the series of wheel decorations, is a memorable image of considerable charm and vivacity. This little capital reveals an innate understanding of and sympathy for humankind absent from the ferocious mechanism of the *Last Judgment* on the tympanum of the same church.

In the nearly thousand years since Constantine became a Christian, the world had changed indeed. Wars, invasions, and migrations had sundered forever the fabric of the exhausted Roman empire.

CAPITAL, DECONSECRATED CLUNIAC CHURCH, MARS-SUR-ALLIER, C. 1000. *The sculptor of this capital, like many of his contemporaries, was particularly skilled in the decoration of architectural form with abstract shape. Here the charming, grotesque monsters complement and enhance the shape of the capital but never mask its functional shape.*

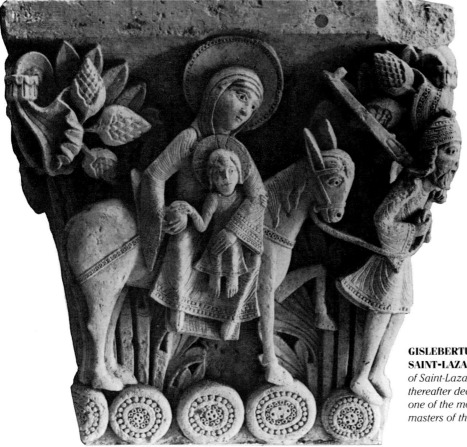

GISLEBERTUS, FLIGHT INTO EGYPT, CAPITAL, SAINT-LAZARE CATHEDRAL, C. 1150. *The cathedral of Saint-Lazare was begun around 1120 and shortly thereafter decorated with the carving of Gislebertus, one of the most skillful, expressive, and individualistic masters of the twelfth century.*

Christianity had changed man's faith and philosophy; life was now conducted in new and different patterns. Pilgrims to the Holy Land replaced the Plinys and Plutarchs who had wandered to see the curiosities and wonders of antiquity. Attention was turned from the earth toward heaven.

Kinship and mutual allegiance now bound kings to landed princes, who in turn were bound to protect their vassals in exchange for service. These narrow feudal circles replaced the broad network of citizen and empire, yet feudalism offered stability in the face of imperial collapse. Urban centers decayed as their inhabitants left in search of safety in the isolated countryside. Rome had trained Augustine and Jerome, the early Christian thinkers, but their intellectual offspring were educated in the restricted enclaves of the monasteries. Roman technology and engineering skills were lost, scientific pursuits were abandoned, and a money economy generally disappeared. Life had a harsher, narrower

scope and a more limited intellectual horizon.

Artistic imagination and creativity did not, however, come to a halt during this period of Western history. Many new art forms were developed, which fulfilled new functions and ambitions and expressed new meanings. The old Roman basilica furnished the architectural model for the new church, and the period from the sixth to the twelfth centuries saw the formation of Western ecclesiastic architecture in its definitive form. This architecture was a brilliant combination of function—in its direction of movement toward the altar and display of relics in the chapels—and symbolism—in its expression of the faith's majesty, glory, and absolutism. Toward the end of the era, the fortresslike monastery churches accurately reflected the harsh and authoritarian reality of both faith and society. Yet, this difficult period also laid the foundations for an uncommon flowering of creative energy and faith: the age of cathedrals.

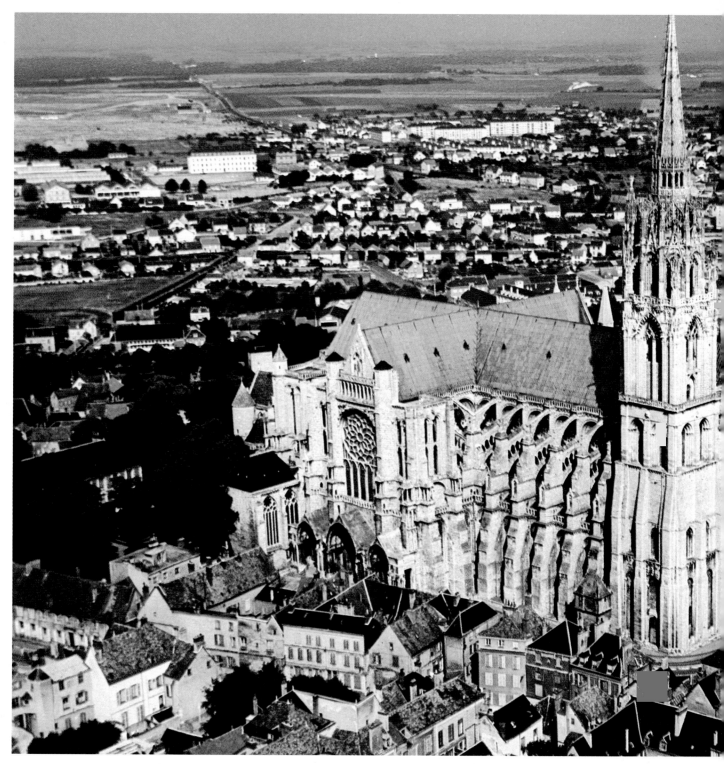

CHARTRES CATHEDRAL. *Towering above all other buildings of the city, medieval cathedrals, such as the one at Chartres, were among the most important economic enterprises of their era.*

[4]

THE AGE OF CATHEDRALS

Writing in 1145, a French abbot vividly described the collective fervor with which cathedrals were then being constructed: "Who has ever seen! Who has ever heard tell, in times past, that the powerful princes of the world, that men brought up in honor and in wealth, that nobles, men and women, have bent their proud and haughty necks to the harness of carts, and that, like beasts of burden, they have dragged to the abode of Christ these wagons, loaded with wines, grains, oil, stone, wood, and all that is necessary for the wants of life, or for the construction of the church?"

By the twelfth century the cathedral had become the focus of urban life. The new cathedrals were remarkably different in appearance and emphasis from their forerunners—the sturdy, practical, and earthbound earlier churches. Like the mystical and ardent faith of their builders, the buttresses, piers, and towers of these cathedrals pushed toward the sky, as though seeking to escape the material world at their foundations. Inside the cathedral, reality was transformed into a transcendent embrace of light streaming through curtains of stained glass that seemed suspended from heaven [p. 58]. Within these gossamer walls, the cathedral affirmed the reality of God and man's place in His cosmos.

Between 1100 and 1400 the pulse of Western Europe quickened. Flourishing cities, increased manufacturing, expanded trade, and the rise of universities all contributed to a revival of urban society

REIMS CATHEDRAL, INTERIOR FACING WEST, THIRTEENTH–FIFTEENTH CENTURIES. *Gothic cathedrals were large, complicated, labor intensive, and very expensive to build. The nave of Reims Cathedral demonstrates how Gothic architects achieved a superb harmony of tall piers, columns, and vaults, all realized with a sense of litheness and grace that belies the massiveness of the structure which they compose.*

on a large and complex scale. Western society seemed sufficiently renewed in spirit to establish systems of thought that found a place for mankind within them. The prevailing social orders of feudalism and urban life offered a stability that allowed the investment of time, money, and effort in large-scale urban building projects, of which cathedrals

were the most spectacular and important. These cathedrals and their sculptural decoration expressed the faith, aspirations, and knowledge of the societies that erected them. To give tangible form to intangibles was the paradoxical quest that drove men to build cathedrals encapsulating their spirit and mentality.

Unlike the many styles of art that had emerged anonymously from previous art, the Gothic cathedral had a distinctive and identifiable beginning in France. Near Paris the abbey church of Saint-Denis lay in disrepair when Abbot Suger was elected in 1122. His most famous act was to restore the cathedral, for, in so doing, he inaugurated the Gothic style of architecture. In rebuilding the cathedral, Suger employed pointed arches and cross-ribbed vaults; he introduced tall windows through which the entire church could be pervaded by what he called the "light of Divine essence" [p. 59]. Saint-Denis, consecrated in 1144, spawned many subsequent cathedrals. The impact of Saint-Denis was first felt in the area around Paris known as the Ile-de-France. The cathedrals of Noyon, Laon, and Notre-Dame were all consecrated within twenty years of Saint-Denis. Soon the Gothic style spread throughout Europe, to Italy, Germany, and England.

Because light was associated with divinity, truth, and the generating principle of the universe, Gothic cathedral builders developed a passion for it. Light was viewed as the link between the spirit and the body. Light could pass through glass without breaking it; it could dispel darkness. Generations of architects and builders strove to increase the size of their windows and pare down the structural supports to mere skeletons to allow more light inside.

Soaring skyward, Gothic cathedrals were built by adding unit upon unit. Glass windows did not grow larger by using larger panes of glass, but more of them. Sculptures adorning these cathedrals did not grow more monumental, but more numerous. The decoration of Gothic cathedrals grew more intricate, complex, and comprehensive. Cathedrals became the physical manifestation of the pervading intellectual system of the day: scholasticism. Saint Thomas Aquinas (d. 1274), whose encyclopedic mind organized and reconciled religion with ancient Aristotelian philosophy, established a foundation of thought analogous to the cathedral in its

compilation of countless elements. Echoing Plato's ideal, Aquinas affirmed the notion of functional art: "There is no good use without art." Beauty emerged once more as a positive force: no longer a temptation from the devil and an expression of base carnality, beauty was again seen as good and, like goodness, sanctity, and light, a manifestation of divinity.

Saint Thomas Aquinas taught in universities, and his thought reflected the intellectual revival of Europe. In earlier periods subjects such as Roman and canon law, medicine, and philosophy had been kept alive only at monastic schools or had been imparted to small numbers of students by a great master. But the thirst for education among the new urban dwellers caused a resurgence of the universities: seventy-nine were founded between 1100 and 1500, including those of Pavia, Bologna, and Paris (all established in the twelfth century). Oxford, Cambridge, and the University of Padua were all established in the early thirteenth century. Scores of universities followed, most of them using scholastic methods. The skills of reading, writing, logic, mathematics, law, and medicine were regained, but the prominent role of religion prevented any real attempt to explore reality for its own sake, and science languished. Thus astrology and alchemy took the place of astronomy and chemistry.

The ardor that built the great cathedrals arose in the cities of Europe during the twelfth and thirteenth centuries. These huge structures, the churches of the bishops, were built with massive amounts of labor and lucre. They were, moreover, urban, unlike so many of the earlier churches, which were attached to monasteries, purposely built away from centers of population and their many temptations. The building or remodeling of a cathedral was a spiritual and patriotic endeavor, and cities vied with each other to build the largest, most splendid, and most costly structures.

The church at Chartres [pp. 56–57], about forty miles southwest of Paris, is perhaps the most perfect example of the new cathedral. From the very earliest times, perhaps even before the coming of Christianity, the site of the church at Chartres had been a pagan holy place. Later a grotto seems to have been there that had an image of the Virgin and a well with miraculous healing qualities. This well, its powers derived from the fact that several early

CHOIR AND AMBULATORY, ABBEY CHURCH OF SAINT-DENIS, 1140–44. *The abbey church of Saint-Denis was sponsored by the French king and preserved the relics of France's patron saint. The church of Saint-Denis is all that survives of Abbot Suger's rebuilding of the abbey, which inaugurated the Gothic style.*

martyrs had been drowned in it, appears to have been incorporated into the crypts of the various churches that replaced each other on the site.

The sanctity of the church site was further increased about 870, when it received a notable relic —the *sancta camisia*, the holy dress that the Virgin wore while giving birth to her son. With its miracu-

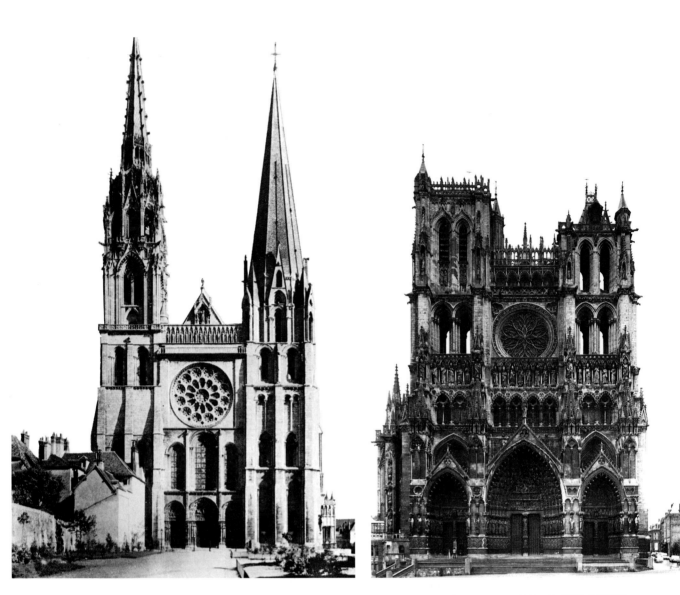

CHARTRES CATHEDRAL, WEST FRONT, TWELFTH CENTURY. *The two towers of the west front of Chartres are of different periods. The northern, on the left, was begun about 1135 but completed only in the sixteenth century, with an elaborate upper level. The foundation of the more sober right tower, the southern, dates from about 1145.*

AMIENS CATHEDRAL, WEST FRONT, THIRTEENTH CENTURY. *The complex, highly decorated west front of Amiens Cathedral (begun 1220), with its deep, carved portals and plethora of architectural and figure decoration, is a dominating presence. Especially noteworthy is how the west front alternately encloses space and is punctured by it.*

lous healing power and a famous relic, Chartres soon became a major pilgrimage site. The economic benefits of such pilgrimages, and the constant building and maintenance of the large church, helped to make Chartres a wealthy city.

There is evidence that a church existed at the site in Chartres as early as the fourth century. After a fire in 1020, a new church was constructed, but this too fell victim to a blaze, in 1194. When it was

discovered that the Virgin's dress had miraculously survived the fire—sure proof of its holiness—it was decided to build the cathedral that still enshrines the holy site today.

Rebuilding the church, incorporating parts of the surviving portal and towers of the old structure, was a great and enormously costly effort. It was fueled by faith and sustained by numerous donations. Entire communities cooperated in the erec-

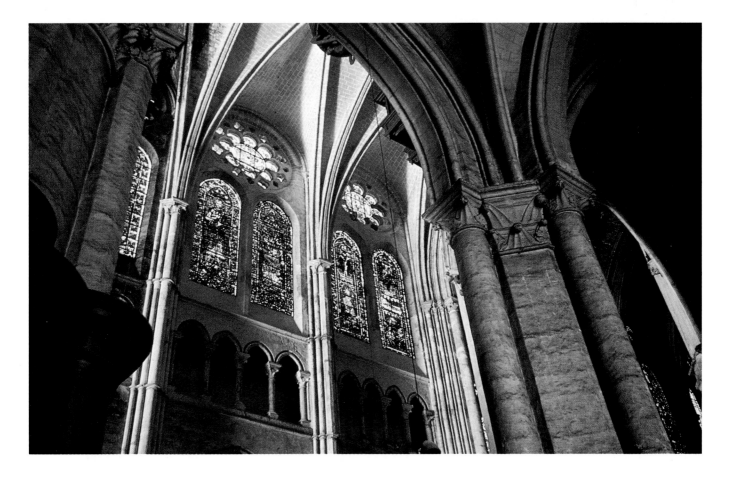

tion of the major cathedrals, and this held true for Chartres as well. Indeed, the building of the French cathedrals was one of the principal economic endeavors of the age.

The main structure of the cathedral at Chartres was rebuilt in an exceptionally short time. By 1220 the aisles and nave were substantially complete. In 1260 the church was dedicated, finished with donations from the French royal family. Thus it was restored only sixty-six years after its predecessor had burned.

What emerged from the rebuilding was a new architectural lexicon and one of the most remarkable affirmations of faith in the West. In Chartres and in several other contemporary cathedrals, such as that of Amiens [p. 60], a sustained architectural aesthetic unseen since the Roman empire emerged, capable of producing buildings that rivaled, and yet were vastly different from, those of the ancient world.

To enter Chartres is to enter an ethereal, glowing ambience [p. 61]. The heavy, authoritarian

CHARTRES CATHEDRAL, INTERIOR, THIRTEENTH CENTURY. *The vaults, which are about 120 feet above the pavement, seem to rise effortlessly on compound piers composed of octagonal and round elements. The interior of Chartres is an accomplished harmony of architectural grace and refinement on a large scale.*

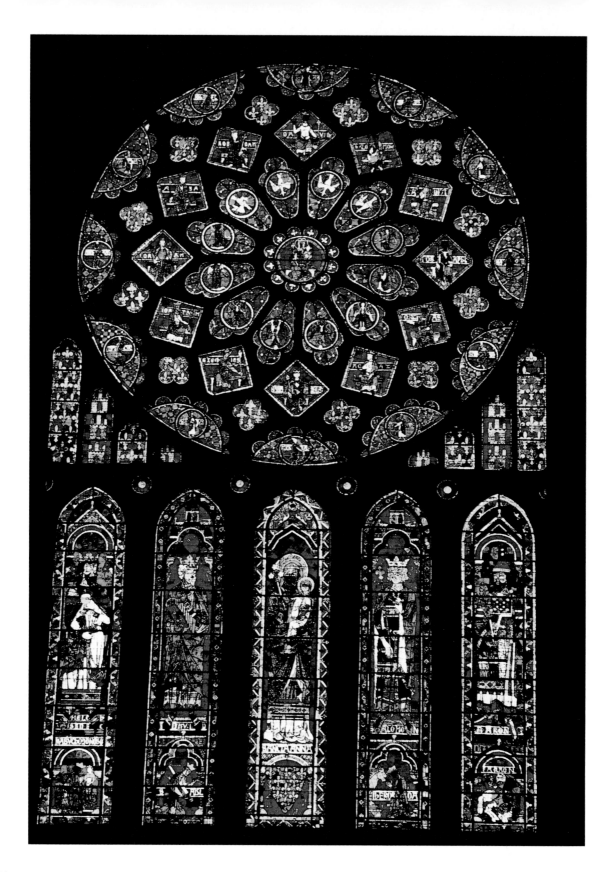

CHARTRES CATHEDRAL, NORTH ROSE WINDOW (DETAIL), C. 1235. *Chartres Cathedral still contains an extensive and varied fenestration of stained glass. Aside from the many images of Christ, the Virgin, and the saints, the windows at Chartres illustrate the Labors of the Months, the work of the trades, Virtues and Vices, and stories from both the Old and New Testaments. The complex iconography of these windows was probably devised by clerics.*

voice of the earlier basilica church has been replaced by soaring columns and piers, by huge windows with radiant stained glass, and by towering rib vaults. Lightness, grace, and a spiritual, heavenward thrust uplift the soul. The feeling is made possible by the utilization of several architectural features that, while known to previous builders, appear at Chartres in dramatically new combinations. The compound pier, made up of bundled shafts and columns, breaks up the surface of the support and makes it look less massive. The pointed arch gives power and emphasis to the upward movement of the walls. The rib vault, which replaced the old, heavier groin or barrel vault, more lightly and gracefully covers the church. And, finally, the flying buttress allowed the architect to turn the piers and

walls into a skeleton, or armature, enclosing space made luminous by stained glass, one of the glories of the age [p. 62].

The decoration of Chartres and other contemporary cathedrals is a compendium of medieval knowledge and a book of instruction for the faithful. Stories from the Old and New Testaments; "mirrors" of Nature, Instruction, Morals, and History; Labors of the Months; figures of saints, martyrs, confessors; and many other images and stories (there are ten thousand figures in stone and glass on the cathedral at Chartres) are found everywhere [p. 62]. Such a comprehensive and detailed program emanates from and reflects the sort of mind responsible for scholasticism and medieval philosophy and theology; Chartres's complex universe of faith and learn-

AMIENS CATHEDRAL, PORCH ON WEST FACADE (DETAIL), 1236–70. *One of the earliest examples of daily life interwoven into a sacred context, the quatrefoil decorations along the porch of Amien's Cathedral offer a complex program of sacred and secular imagery. Besides episodes of the Old and New Testaments, Virtues and Vices are paired with representations of occupations and months of the year. March, portrayed by the man digging, is at the lower left.*

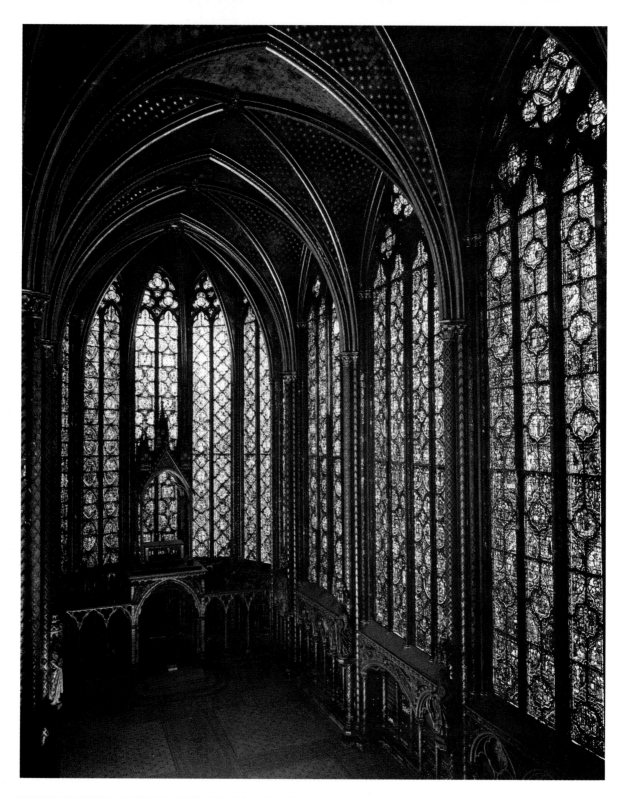

SAINTE-CHAPELLE, INTERIOR, 1243–48. *Sainte-Chapelle is a luminous stone and glass reliquary built to house vestiges of Christ's crucifixion. Constructed by Louis IX (later canonized), the building is an armature for the large and dazzling expanse of stained glass.*

OLD TESTAMENT FIGURES FROM THE WEST PORTAL, CHARTRES CATHEDRAL, C. 1150. *Each of these figures is cut so deeply that it is almost freestanding. Attached to the actual column only on the back, they seem to be the living counterparts of the elongated columns before which they stand.*

ing and its search for definition and knowledge of man and divinity are the ideas and beliefs of the Middle Ages turned into stone and glass.

Perhaps the best example of French interiors of the thirteenth century is found in Sainte-Chapelle in Paris [p. 64], a chapel built to house the relics of Christ's Crown of Thorns. In Sainte-Chapelle, constructed about 1245 by the crusading King Louis IX, who after his canonization became the patron saint of France, the interior merges with the exterior as light is filtered through the red and blue stained-glass windows held in the delicate web of the chapel's stone armature. Walls no longer exclude; instead, the building is a glass cage of slender piers, webbed vaults, and vast areas of glowing glass. Sainte-Chapelle is a Gothic dream, a whole building turned into an exquisite, ethereal reliquary housing Christ's Crown of Thorns.

The stained glass of Sainte-Chapelle and many other French churches of the thirteenth century is remarkable not only for its extent but also for the beauty of its colors and forms. Although colored and painted glass had been known since antiquity and was utilized in early Christian churches, its greatest flowering came in the age of cathedrals, when the technique of making colored glass was brought to a high level. Metallic oxides such as copper and iron were added to the molten glass to give

it color. Then the glass was cut to a design sketched on a white board, painted, and fired again. Each piece was then fitted into lead strips and the whole ensemble put into a frame and inserted into a window. This very complicated operation called for much skill in the making, painting, and assembling, and especially in the designing, of the complicated and often huge windows. Although the windows are often figurative, from a distance their major effect is decorative and emotional. Like huge, softly glowing kaleidoscopes, the hundreds of tiny points of light and color seem to hover mysteriously above the onlooker, who stands dwarfed by the soaring architecture of the church, splashed all in red and blue by the magical light emanating from the windows. To stand in a cathedral illuminated by such light is to feel something of the age of spirituality that brought this art into being.

The age also witnessed a renewed interest in sculpture, which was now needed in quantity to decorate the exteriors of the vast new cathedrals. The earliest sculptures on Chartres survive from the preexisting church's west portal and can be dated about 1150 [p. 65]. The attenuated, reed-thin figures are probably kings and queens of the Old Testament. Attached to the columns, they are marvels of architectural decoration. The figures' robes seem incised rather than carved, and brilliant pattern and harmony prevail. Each face looks out with a new-found humanity and gentleness, something alien to the agitated figures and howling devils of Autun or Soissons. The constant tension between figure and column, between the expression of the human body and face and the image's role as a sort of caryatid, is part of the appeal of these beautiful wraiths.

But within a hundred years after these figures were carved, the sculpture at Chartres, and in Europe in general, changed direction. The Old Testament figures from the north portal at Chartres [p. 66], the last part of the cathedral to be built, begin to abandon their columns and to move with a new and startling ease. Their bodies are heavier and fuller, they look to the side or straight ahead, and their arms and hands move with a hitherto unseen fluidity. They now seem to be aware of our presence and to be more firmly fixed in our world. Moreover, each figure has gained a certain identity; individuality and personality are about to overcome style and pattern. Thus the human image is once again beginning to emerge from its centuries-long subservience to symbol.

OLD TESTAMENT FIGURES FROM THE NORTH PORTAL, CHARTRES CATHEDRAL, THIRTEENTH CENTURY. *These Old Testament figures are, from left to right, Melchizedek, Abraham and Isaac, Moses, Samuel, and David. Although still related to the columnar figures of the west front, the figures here are carved with a depth that helps to free them from the columns to which they are still attached.*

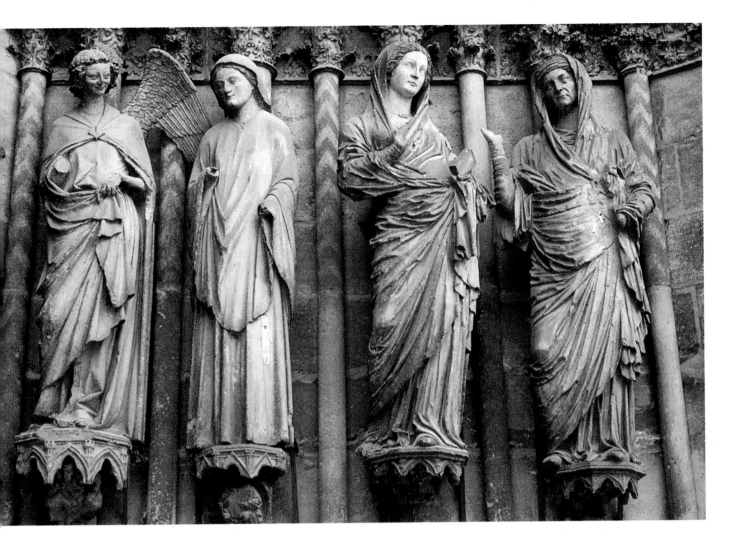

REIMS CATHEDRAL, WEST FACADE, ANNUNCIATION AND VISITATION, C. 1230–40. *Throughout the Middle Ages, many objects, from buildings to sarcophagi, made during the long period of Roman occupation remained a part of everyday life. The artist who carved the* Visitation *at Reims looked at surviving Roman sculpture with a fresh eye as he attempted to adapt some of the gravity of its imagery and the complexity of its carving for his own statues.*

The developing realism of sculpture can be clearly charted at Reims Cathedral, the vast and significant repository of architecture, stained glass, and sculpture in which French kings were crowned. On the west facade of Reims two pairs of figures of the Annunciation and the Visitation stand side by side [p. 67]. The *Visitation* group of the Virgin and Saint Elizabeth, rejoicing in each other's pregnancy, seems to have been carved about 1230. The two adjacent figures of the angel and the Virgin forming

the *Annunciation* group may date from about a decade later and are by a different sculptor.

The artist responsible for the *Visitation* figures must have studied Roman art with some care, for his figures resemble the toga-clad sculptures, either freestanding or on sarcophagi, that were still scattered about the former Roman provinces. Nonetheless, although the complex fold patterns of the garments and something of the stance of the two figures recall Roman sculpture, the resemblance is superficial; the sculptor simply did not have the Roman artist's full understanding of the mechanics of the human body nor the skill to depict it. Instead, the drapery in the Reims *Visitation* group acts as a cloak hiding the sculptor's inability to deal with the volume and articulation of the bodies beneath.

The artist responsible for the *Annunciation,* in contrast, had a much fuller comprehension of the

EKKEHARD AND UTA, C. 1246, NAUMBURG CATHEDRAL. *Margrave Ekkehard von Wettin and his wife, the Marchioness Uta, were among the ten founders of the Naumburg Cathedral in 1028. They were named in a document prepared by Bishop Dietrich of Naumburg in 1249, and their effigies, as well as those of the other founders, were placed in the west choir of Naumburg Cathedral to visually trace Naumburg's lineage back two hundred years.*

THE BUILDING OF CATHEDRALS

The building industry that supported the construction of some five hundred monumental churches in France alone c. 1250–1400 was one of the marvels of medieval Europe. Requiring not only great sums of money (Chartres and Amiens Cathedral are estimated to have cost tens of millions of dollars in today's currency) but also vast amounts of material, the Gothic cathedrals challenged the engineering knowledge of Europe's architects.

Building technology varied with each site and changed over time. Stonemasons—and associated workers such as stone carvers, mortar mixers, quarry men, carpenters, tilers, bricklayers, and assorted laborers— generally worked twelve-hour shifts in the summer and nine hours in the winter. Construction usually took several generations to complete.

Although the construction of cathedrals was rarely considered a worthy subject for artists to paint, there are numerous surviving portrayals of historical events in contemporary settings that give an idea of the building techniques involved.

CONSTRUCTION OF THE TOWER OF BABEL, *mid-thirteenth century.*

nature and workings of the human body and the techniques to render it realistically. The form of the Virgin's body, visible through the layers of heavy cloth, and the potential for movement that the figure exudes make for a remarkable new vivacity and energy. Both the smiling angel and the animate Virgin of the Reims *Annunciation* are among the first examples of the revival of realism that so characterized the next century.

The transition from decorative symbol to lifelike presence was idiosyncratic and depended upon both the skill of the artist and the function of the sculptures he was required to make. In Germany, the Naumburg master carved precocious figures when he portrayed the founders of Naumburg Cathedral in stone. Personality and humanity radiate from the sculptures of the Margrave Ekkehard of Naumburg and his wife, Uta [p. 68], who were two of the ten founders of Naumburg Cathedral. Their place among the elect is marked forever in stone atop pilasters surrounding the main altar of the cathedral, built about 1246. Life-size, these carved figures are miraculously lifelike, not only in their external traits but in their internal characteriza-

tions. Ekkehard is a solid German citizen, reflecting serious, grave, and practical virtues, not dissimilar to those of Roman republicans of a thousand years before. The beautiful Uta draws her cloak up to her chin in a gesture reminiscent of that used to signify a Roman matron's virtue. Yet these figures would not for a moment be confused with those of ancient Rome. Ekkehard and Uta belong to the world of chivalry, the time of knights and ladies.

The gifted team of sculptors who created Ekkehard and Uta had an excuse to look at nature because they were representing historical personages. The material of Uta's garment is shown as convincingly soft and pliable by the pressure of her hand, while her bony, tapered fingers are described with unsurpassed skill. The projection of her arm beneath the pulled-up robe is an astounding bit of illusionism. Ekkehard is lost in thought, his sword set firmly before him, distractedly pulling the strap of his shield over his shoulder.

Personality, persona, and temporality are vital to these images. Yet for all their verisimilitude, Ekkehard and Uta belong to their sacred setting. They pay homage to the altar at the heart of the building they helped establish; the only excuse for their presence within its sacred precincts is their historical role as founders of the cathedral. In fact, both Ekkehard and Uta had died more than two hundred years before these sculptures were made; their lifelike appearance has far less to do with portraiture than it does with symbolism, since their purpose was to demonstrate the historical origins of Naumburg and its cathedral.

The Naumburg master, like other carvers of the period, followed developments that originated in France. French carvers excelled not only in large-scale works but also in the small-scale, privately owned precious objects produced by the workshops active in and around Paris. Of all the objects they produced, none were more popular than those that depicted the Virgin. A cult of the Virgin developed between 1200 and 1400. The Virgin gained popularity for many reasons: she was the chief intercessor between human beings and Christ, and she could

express the qualities of beauty, grace, fertility, warmth, motherhood, nurturing, and protectiveness. Queen of heaven and earth, the Virgin guarded those in her care, and statues and paintings of her flourished.

The times fostered handsomely illuminated manuscripts, and during the thirteenth and fourteenth centuries manuscript illumination reached an extremely high level of skill and refinement. Increasingly, wealthy patrons wanted a wide variety of manuscripts, ranging from those illustrating the holy texts to secular fiction, chronicles, scholarly treatises, and professional manuals. Even after the invention of printing in the late fifteenth century, connoisseurs of books wanted these unique volumes, written and illustrated by scribes and painters of uncommon skill. These books were luxury items and as precious as gold and gems.

One of the most beautiful of these is *The Hours of Jeanne de Navarre,* an illustrated prayer book illuminated by Jean Le Noir. As its title declares, this was made for Jeanne de Navarre, daughter of Louis X, the king of France, and its sumptuousness and elegance reflect the ambience of the French cóurt. In 1329 Jeanne was crowned queen of Navarre; the manuscript dates from about a decade later. The space of each of the illuminations [p. 70] of *The Hours of Jeanne de Navarre* is carefully held in check; deep spatial recession, which would shatter the plane of the page, is stopped by a decorative pattern that fills the background.

The balance between text and image in these manuscripts has seldom been equaled in the long history of the illustrated book. The illumination, no matter how finely wrought and gilded, was never allowed to predominate—instead there is a marvelous symbiosis among picture, text, and ancillary decoration.

The illuminators were interested in patterns that would complement the flatness of the page and its text. Exquisite multicolored borders and meandering tendrils enclose the illustration and decorate the page with elegant two-dimensional forms. Often the illuminator had a keen eye for nature, which appears not only in the form of foliage but also in lively little animals that perch on and about the decoration. These birds and animals are described with a vivacity and naturalness that can only be the result of much observation and study from life, which was not a frequent practice of artists before the fourteenth century.

The seemingly inexhaustible potential of the great cathedrals for variation in design and for a fusion of sculpture, architecture, colored glass, and other decoration satisfied the artistic, civic, intellectual, and spiritual aspirations of Northern Europe for well over three hundred years. Devoid of any classical traces, wholly indigenous and unique to their time and place, these towering, graceful structures grew larger and more delicate. Their size was limited only by the capacity of the buttresses, ribs, and vaults to sustain them. (Indeed, more than one cathedral collapsed under its own weight as ambition exceeded the laws of physics.)

Even long after cathedrals ceased to be built, they continued to influence thought and taste. After the Italians of the sixteenth century had developed a new classical building style, they derided the complex older buildings as "Gothic," implying they had been built by barbarians. In contrast, subsequent ages, particularly the nineteenth century, looked on Gothic cathedrals with romantic nostalgia, as survivors of a purer, more spiritual age.

The Gothic cathedrals and the luxurious arts produced for the courts nonetheless signified a materialistic urge that could not be denied, even in an age dominated by spiritual concerns. That urge to give material form to human hopes and interests led inexorably in a more human direction. The earliest impulses were felt in Italy, where between 1250 and 1400 a new artistic age was dawning.

JEAN LE NOIR, THE ADORATION OF THE MAGI, FROM THE HOURS OF JEANNE DE NAVARRE, C. 1339. *The* Adoration of the Magi *was a traditional subject portrayed in books of hours, such as this one made for Jeanne de Navarre, daughter of Louis X and Queen of Navarre from 1329–1349. She is shown kneeling in the margin decoration below the main scene. This scene typifies the elegance of the French courts, which set the style for much of Europe in the Middle Ages.*

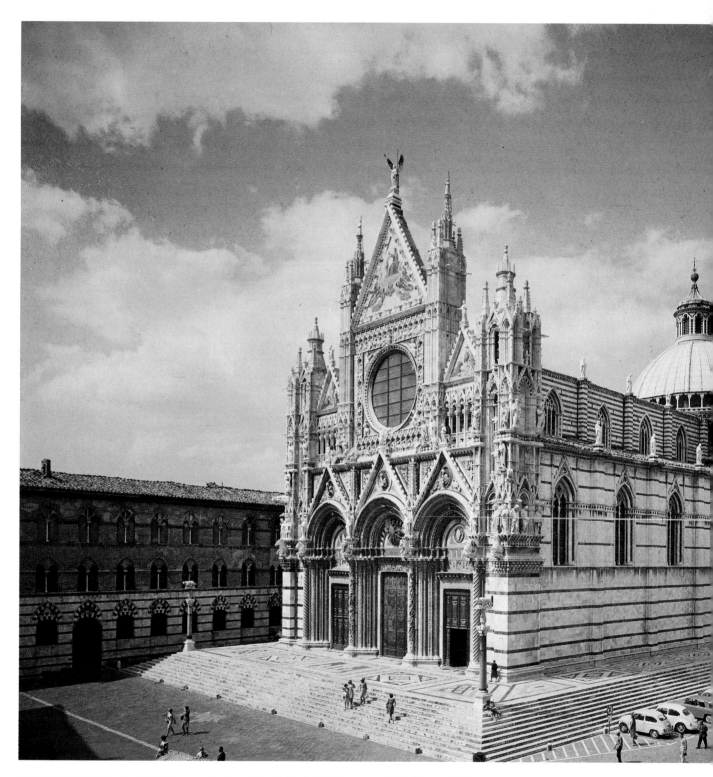

SIENA CATHEDRAL, C. 1200. *The construction of the Cathedral of Siena, one of the largest in Tuscany, coincided with the apex of Sienese wealth and power. Everything about the cathedral, from its size to its rich carving and elaborate decoration, proclaimed Siena's importance and wealth.*

[5]

THE DAWN OF A NEW ERA: ITALIAN ART, c. 1250–1400

At about the same time that Chartres, Reims, and many of the other great cathedrals were being built in Northern Europe, there was a resurgence of art in the cities of the Italian peninsula. After the collapse of the Roman empire, the urban centers of Italy were depopulated as their inhabitants fled to the countryside for safety. But during the eleventh century, urban life began to flourish once again. Soon the peninsula was dotted with a number of important cities, some of them becoming major centers of European population and wealth. Florence, Siena, Naples, Milan, and Venice formed small city-states, each with its own customs, dialect, and governmental system. So independent were these cities that it was only in the 1860s that the peninsula became a nation united under a central government.

The Italian city-states were part of several larger regions. The most influential of these areas was the central Italian one, Tuscany. Tuscan cities—Lucca, Pisa, Siena, and Florence—gave birth to the artists and thinkers considered the seminal figures of the early Renaissance. Their creative accomplishments have rarely been equaled in the history of art: Dante

(1265–1321) writing his *Divine Comedy* in Florence about 1300; Giovanni Pisano carving marble reliefs in Pisa; and Giotto painting frescoes in Padua. Artistic personality and the notion of individual humanity were emerging from a long sleep of anonymity. Dante wrote about essentially human concerns; similarly, Pisano and Giotto portrayed human themes, though within the conventions of religious art. The symbolic, abstract, and remote imagery of the past was being supplanted by a more tangible reality. Though still holy, the characters these artists portrayed displayed a physical and emotional accessibility that brought the world of the onlooker and that of the image closer together than they had been for centuries. The works of these artists became the models for the geniuses of the Italian Renaissance in the fifteenth century.

Giotto and his fellow artists were building on foundations that had been laid just one generation before by such important artists as Nicola Pisano and Cimabue. But the atmosphere for change had been established even earlier, by the great mystic Saint Francis of Assisi (d. 1226). Born into wealth, Saint Francis had rejected it, choosing instead a life of poverty, asceticism, and piety. His magnetism won him numerous followers and his order of mendicant friars established chapters throughout Europe. A gifted writer, Saint Francis composed canticles to the sun and the moon, which stressed the beauty of God's creation and love for humanity as well as for all other living things and helped to reconcile humans to their material existence. Saint Francis also emphasized the human side of divinity. His impact on the arts was profound: he paved the way for the re-ideation of religious subjects by Nicola Pisano, Giovanni Pisano, Giotto, and Duccio.

All these artists contributed to the decoration of the many new cathedrals then being built in the Italian peninsula, where the spirit of the massive, space-enclosing architecture of Rome had never quite died. Roman architecture and something of its proportions and articulation were carried forward in much subsequent building of all types. This heritage and the Mediterranean tradition of large areas of wall space and a minimum of stained glass produced a type of cathedral that, while it is contemporary with Chartres and the others in France, can be termed particularly Italian.

Whereas Chartres is soaring and light-filled, the

SIENA CATHEDRAL, INTERIOR. *The interior of Siena Cathedral contains a decorative ensemble of considerable complexity and beauty. The marble striping of the compound piers and columns and the figurative pavement of black and white marble inlay help to break up and enliven the large interior space of the massive structure.*

cathedral (c. 1200) in the Tuscan hill town of Siena, for example, is earthbound, weighty, dark, and measured in space and rhythm [pp. 72–73, 74]. At heart it remains a basilica, although one with many modifications, including the banding of the exterior and interior with alternating stripes of dark green and white marble, a device that enlivens the mass of the church and, on the outside, makes the building vibrant against the bright sun and blue sky of the Italian day. The facade [p. 75] of the cathedral is extensively decorated with sculpture, but the major differences between it and the French cathedrals are readily apparent. The facade of Chartres, for example, is punctuated with deep porches with extensive sculptural decoration; there is a depth, volume, and alternation of deep shadow and highlight, a convexity and concavity, in contrast to the much flatter front of Siena Cathedral.

At Chartres the figural decoration echoes the architecture on which it is placed, even though some of the last figures carved for the church start to move away from their columns. On the facade of Siena Cathedral (which, like many other cathedrals, was partially financed by the city) the relation between figure and architecture is of a much different order, due mainly to the creative genius of Giovanni Pisano, the sculptor responsible for its overall decoration. The son of the outstanding sculptor Nicola Pisano (fl. 1258–78), Giovanni is one of the earliest identifiable major artists of Italy. Working in the last decades of the thirteenth century and the first years of the fourteenth, he prepared much of the groundwork for the development of sculpture throughout Italy.

Giovanni Pisano (c. 1245/50–1314) liberated the figure on the facade of Siena's cathedral. His sibyls and Old Testament heroes [p. 77] move, gesture, and glance in many directions all over the massive structure; they engage in a silent dialogue with each other and with the spectator standing below. The figures have become agitated and passionate personalities, whose character and mood arise from the artist's brilliant, often summary carving.

At Siena Cathedral it is clear that Giovanni Pisano was building on the accomplishments of his father, who founded a school of sculptors that would dramatically change Italian sculpture. Nicola's best-known achievement is a series of carved

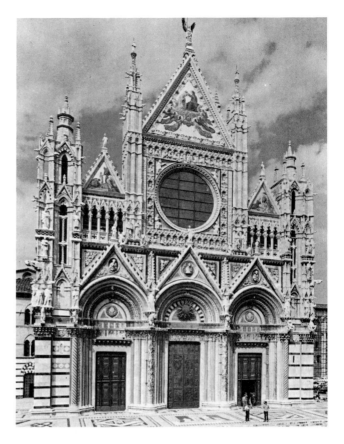

SIENA CATHEDRAL, FACADE. *The facade of Siena Cathedral may be likened to an elevated stage upon which the animate figures of Giovanni Pisano's holy personages (now removed to the Cathedral Museum and replaced by copies) participated in a spirited dialogue among themselves. The facade of Siena Cathedral was completed in 1284 and it is about that time that Giovanni Pisano began to work on it both as an architect and as a sculptor.*

pulpits, including one for the baptistery at Pisa and a later one for Siena Cathedral. His pulpit at Pisa stands as a forum wherein recognizable human figures are ennobled and perfected by their presence within a holy context. These are the first such figures since Roman times. That they are largely symbolic keeps them within the realm of tradition; that they embellish the pulpit with such a high degree of realism marks them as revolutionary.

Placed in the baptistery where infants enter the faith, Nicola's pulpit [p. 78] was the stage upon which the Word of God was pronounced. The pulpit, with its imagery, is a literal and symbolic materialization of divine power. Supported by bases of lions (which signify the Resurrection), a series of prophets and evangelists flank personifications

"It started in the East, either because of the influence of heavenly bodies or because of God's just wrath as a punishment to mortals for our wicked deeds, and it killed an infinite number of people. Without pause it spread from one place and it stretched its miserable length over the West. And against this pestilence no human wisdom or foresight was of any avail."

So reads Boccaccio's introduction to his *Decameron,* written in the wake of the Black Death of 1347–50, which reduced Europe's population by more than one-third. The uncertainties and brevity of life clearly concerned the unknown Tuscan painter who created this *Triumph of Death* for the Camposanto at Pisa, a burial ground. Though opinion remains divided as to the date and authorship of this work, its eloquent portrayal of life confronting death remains a powerful visual analogue to Boccaccio's timeless words.

of virtues: Temperance, Charity, Fortitude [p. 78], Faith, as well as a figure of John the Baptist, the patron saint of baptisteries. Rising nobly from a base of red marble columns are the glowing narratives carved from white Carrara marble.

Nicola has given human forms various roles to play—from the grotesque figures of "unbaptized" humanity crouching at the base of the central column, to the dignified magisterial figures of biblical characters such as Mary and Joseph and the adoring kings [p. 78], to the personifications of virtues, ideas, and history.

Nicola's pulpit, a masterpiece of design, architecture, sculpture, narrative, and symbol, marks the gradual translation of the dematerialized, spiritualized language of Christian dogma into a vernacular with humanity as its subject as well as its object.

Nicola was soon in demand to produce other pulpits, the most famous of which is the example in Siena Cathedral. Giovanni, his son, carried on the family trade and produced the vivid sculptures that preside over Siena from atop the cathedral.

Nicola and Giovanni Pisano are important not only for founding a great school of sculptors and for producing the greatest carved masterpieces of the late thirteenth and early fourteenth centuries but also for adding two fundamental sources for later artists: antiquity and individual experience. Although Nicola and Giovanni adopted poses and models from the ancient world with no real mind to reviving antiquity as a cultural model, they inaugurated a return to artistic consciousness of the works of antiquity that would last for hundreds of years to come.

GIOVANNI PISANO, OLD TESTAMENT FIGURE (MIRIAM OR MARY, SISTER OF MOSES), c. 1290. (left) *This figure is a fine example of Giovanni Pisano's facade statues from Siena Cathedral. The energy and latent power of the body and face make it one of the most expressive and dramatic of the thirteenth century.*

GIOVANNI PISANO, SIBYL, c. 1290. (right) *Even though this figure has been removed from its location on the facade of the cathedral, its original role as a participant in a vigorous visual dialogue with Giovanni Pisano's other lively statues is still clear.*

While Nicola and Giovanni Pisano were embellishing Tuscan churches with new forms of sculpture, a generation of artists was reviving painting, which had virtually ceased throughout Italy with the collapse of the Roman empire. Manuscript illumination and some fresco paintings were done before the thirteenth century, but it was only about 1250 that there was a widespread revival of the pictorial arts. The earliest of the pioneering painters was Cimabue (c. 1220–c. 1302), a Florentine who was to help establish his city as one of the principal art centers of the West. The Christ of his great *Crucifix* [p. 79], painted for the Franciscan church of Santa Croce in Florence, demonstrates an emerging realism and humanism unseen since Roman times. In the *Crucifix* one senses that the old pictographic

NICOLA PISANO, ADORATION OF THE MAGI (DETAIL OF PULPIT), C. 1260. *In Nicola's time an ancient Roman sarcophagus incorporated in the facade of Pisa Cathedral provided the model for the seated Virgin in his* Adoration of the Magi. *The connection between the goddess Phaedra on the sarcophagus and the Virgin of Nicola's pulpit was noted by the Florentine biographer Vasari in the sixteenth century.*

NICOLA PISANO, PERSONIFICATION OF FORTITUDE (DETAIL OF PULPIT), C. 1260. *An ancient Roman sarcophagus, brought to Pisa in the eleventh century and reused as the tomb of the Countess Beatrice, became one of Nicola's sources of inspiration for his pulpit figures. Nicola modeled the Christian virtue Fortitude on the ancient hero Hercules, depicted on the sarcophagus.*

NICOLA PISANO, PULPIT, BAPTISTERY OF PISA CATHEDRAL, C. 1260. *Active 1258–78, Nicola Pisano and his shop appear to have specialized in pulpits, which he supplied to his native Pisa and nearby cities such as Siena. The use of pulpits for delivering sermons had been traditional for centuries, but Nicola set new standards for embellishing their surfaces with narrative relief panels and other figural decoration.*

CIMABUE, CRUCIFIX, c. 1290. *Such huge crucifixes (this one is more than 18 feet high) originally hung above the major altars of large churches. Cimabue was one of the founders of the Florentine school and an important influence on painting all over Tuscany in the late thirteenth and early fourteenth centuries. This photograph was taken before the painting was badly damaged in the flood of 1966.*

TUSCAN ARTIST, CRUCIFIX, LATE 1200s. *Before Cimabue's* Crucifix, *Christ had been shown as alive, the triumphal hero unscathed by the Passion depicted in the little scenes placed around His torso. Cimabue's* Crucifix *not only presents Christ as dead, it also does away with the traditional depiction of the Passion.*

symbols, the fossilized remains of Roman illusionism, are giving way to new and more naturalistic observations that tie the figure to our world.

On earlier crucifixes Christ was depicted as a hierarchical, dominating, immortal presence, unscathed by crucifixion [p. 79]. In contrast, Cimabue's Christ is dead. His giant, ponderous, but beautifully articulated body hangs limp on the cross, all signs of life extinguished. This difference in the interpretation of Christ is fundamental: the triumphant, living Christ offers the worshiper proof of His divinity and power; the lifeless, hanging Christ by Cimabue evokes pity and sorrow for the pain and sacrifice of the Passion and Crucifixion. It also offers comfort, however, for Christ has become more like the worshipers themselves, a human being who has lived and died, but who will be re-

born. This new empathetic relation with Christ is a direct reflection of Saint Francis and his teachings, as propagated by the preaching and writing of the Franciscans, who encouraged direct and immediate religious experience.

Such a religious experience must certainly lie behind the work of Giotto (c. 1266–c. 1337), who rethought religious imagery. So compelling was his vision that the sacred drama in which the images participate was itself fundamentally changed by his art. In his religious narratives Giotto turns the old icons into stories that relate directly to the observer and to his world. The directness of the Franciscan vision and the increasingly human-centered life of the cities are reflected in Giotto's unceasing preoccupation with the human figure.

Giotto's first known work, which dates from the

GIOTTO, OGNISSANTI MADONNA, C. 1310. *The exact date of the* Ognissanti Madonna *is unknown, although it must come from quite early in Giotto's career. From this painting and others by Giotto, a new, more dramatic, and more realistic style radiated throughout the Italian peninsula.*

rative and narrative scheme for this chapel was to strongly influence the subsequent history of the painted chapel, one of the most important types of Renaissance art. Giotto's frescoes narrate the Christian drama from the lives of the Virgin's parents to the Last Judgment in a series of paintings that reinvent the way the story is told.

The flinty gray world of the *Lamentation* [p. 81], with its descending stony ridge and barren ground, is the perfect environment for the unfolding scene of desolation and grief. Giotto had the ability to set his scenes at the apex of drama and emotion. Here Christ's body has just been placed on the ground, and the reality of his death is only now registering on his small band of followers.

Earlier painters would have made the figures display a generalized agitation meant to stand for grief [p. 81], but Giotto finely differentiated emotion. The numb Mary Magdalene at the feet of Christ, the contorted John the Evangelist flinging his arms back in horror, the devastated Virgin desperately searching Christ's face for some sign of life, and the anonymous boulderlike figures whose very inertia and weight somehow express depression and grief all add particular and subtle notes of sadness to this scene. Heaven and earth are in mourning as the shrieks of twisting, wailing angels mingle with the moans and sighs of Christ's followers. This fresco, like so much of Franciscan literature and thought, makes a direct, sensory impact. In the *Lamentation* and the other frescoes in the Arena Chapel, Giotto has established a new and direct rapport between the spectator and the work of art. No longer iconic, his paintings build a bridge of images and emotions between subject and viewer.

In Siena, similarly important but less spectacular developments were taking place. In 1311 the cathedral, recently ornamented with Giovanni Pisano's facade sculptures, received a new and glamorous double-sided altarpiece [pp. 82–83], the *Maestà* (Majesty) by Duccio di Buoninsegna (fl. 1278–1319), the city's leading painter. The completion of this painting was a major source of civic pride. A holiday was declared, and the huge altarpiece was carried in procession, accompanied by musicians and blazing tapers, through the narrow streets of Siena up to the cathedral. Duccio's name appears on the inscription at the base of the Madonna's throne, a rare honor.

early years of the fourteenth century, was hailed by contemporaries as a decisive break with the past. His *Ognissanti Madonna* [p. 80], done for the church of the same name in Florence, presents a weighty Madonna and lively Child, and volumetric saints whose overlapping bodies create layers of space within the space-enclosing architecture of the throne. These make the image a living presence that exists not in a symbolic space but in the world of the observer and communicant.

Giotto's masterpiece is the fresco decoration of the Arena Chapel [p. 81] in Padua, a city about forty miles southwest of Venice. Here he was given the task of completely decorating the bare, smooth walls of a small chapel attached to the home of one of the city's leading citizens. Giotto's overall deco-

GIOTTO, ARENA CHAPEL, PADUA, c. 1305. *The Arena Chapel (so called because it was built on the site of a Roman arena) was commissioned by Enrico Scorvegni, one of Padua's wealthiest citizens. In Dante's* Inferno *one of Scorvegni's ancestors, licked by flames and tormented by the burning sand on which he sits, is placed in the circle of Hell reserved for usurers.*

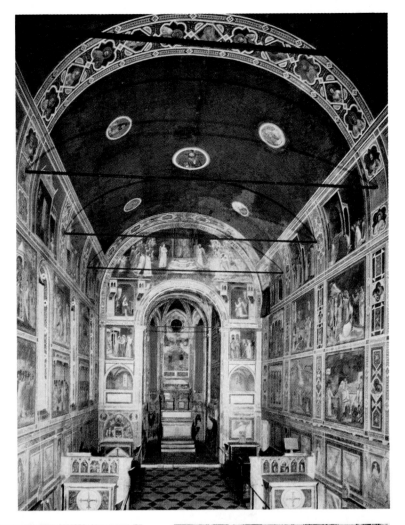

GIOTTO, LAMENTATION OVER CHRIST, c. 1305. (below left) *Giotto's innovative and authoritative frescoes in the Arena Chapel conclusively demonstrated the revolutionary nature of his art. The frescoes of Christ's birth, death, and resurrection reflected and amplified the chapel's sepulchral function.*

TUSCAN ARTIST, THE BETRAYAL, CRUCIFIX DETAIL, LATE TWELFTH CENTURY. (below right) *During the twelfth century, lively schools of painters flourished in several Tuscan cities. It was from these fledgling artistic origins that the first great figures of Italian painting—Cimabue, Giotto, and Duccio—arose.*

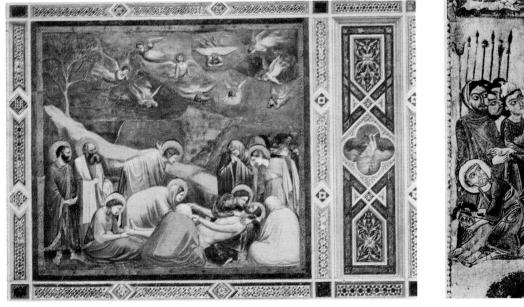

DUCCIO DI BUONINSEGNA, MAESTÀ ALTARPIECE, FRONT, 1311. *In the sixteenth century, the* Maestà *was removed from the high altar of Siena Cathedral. Eventually the front and back were separated and a number of pieces were sold or lost.*

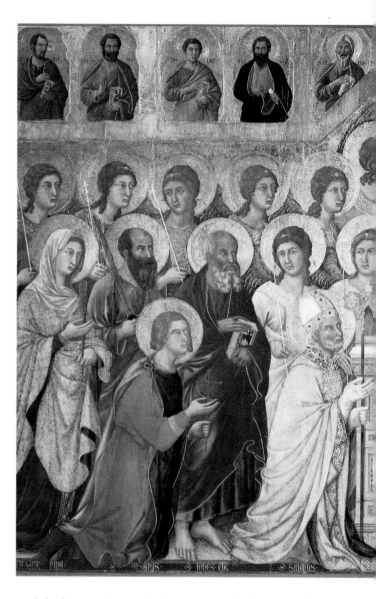

The front of the *Maestà* is a blaze of gold and color, a large, expensive, and impressive display of the wealth and devotion of Siena and her citizens. The exquisite Madonna and the rows of svelte angels and saints are painted with a delicacy unmatched in the history of Italian art. They also, perhaps under the influence of Giotto, have a corporeality and presence not seen before in the art of Siena. Adopting the ideas of Saint Thomas Aquinas, Duccio and his fellow citizens equated beauty with holiness and goodness. Sienese artists, in particular, pursued ideals of grace and refinement. The sumptuous colors, the elongated and sinuous silhouettes of the figures, and the liberal use of shimmering gold transport the viewer toward an ethereal world. Duccio's altarpiece is an inspiring vision that confirms one's faith with its melodious, lilting beauty; it is the painterly equivalent of the great cathedral at Chartres.

Siena's wealth of genius seems virtually unceasing, as the works of Duccio's followers Simone Martini and Ambrogio Lorenzetti demonstrate. Simone's gifts are perhaps best exemplified in his elegant *Annunciation* [p. 84], painted in 1333 for the cathedral of Siena. The first Annunciation known to be the subject of an altarpiece, Simone's version inaugurates the subject with splendid perfection. Set against a dazzling, light-reflecting void of gold, the holy drama occurs in a single instant. Wings still beating, plaid cape still aflutter, the divine laurel-crowned messenger offers a branch to Mary, who, in a very human reaction, recoils with fear at the apparition before her. Pulling up her robe to her cheek in a gesture of fear or modesty, the Virgin turns away, her body describing a series of graceful, languid arabesques, more contour and rhythm than volume and mass. The void between the two protagonists is stark and empty, giving power to the sparse props that add meaning to the event: the lilies, the branch, and the Holy Ghost above.

Though human emotion informs this drama, its actions are performed by beings so perfect, so refined, so graceful and delicate, as to be, like Duc-

cio's heavenly court, beyond and above reality. While her throne and her book place the Virgin nominally in a world that has mass and volume like ours, the spacelessness of the gold ground and the artifice of the entire setting suspend the scene above reality. Rationality and irrationality are woven together, as line defines volume here and denies its existence there, as gold implies space in one spot and affirms a flat surface in another; irreconcilable differences somehow coexist here. Nature and visible reality could not arbitrarily enter sacred pictures, but were adapted selectively and with sophistication by Simone, making him the unsurpassed master of religious narration of his time. An original follower of Duccio, Simone also had an

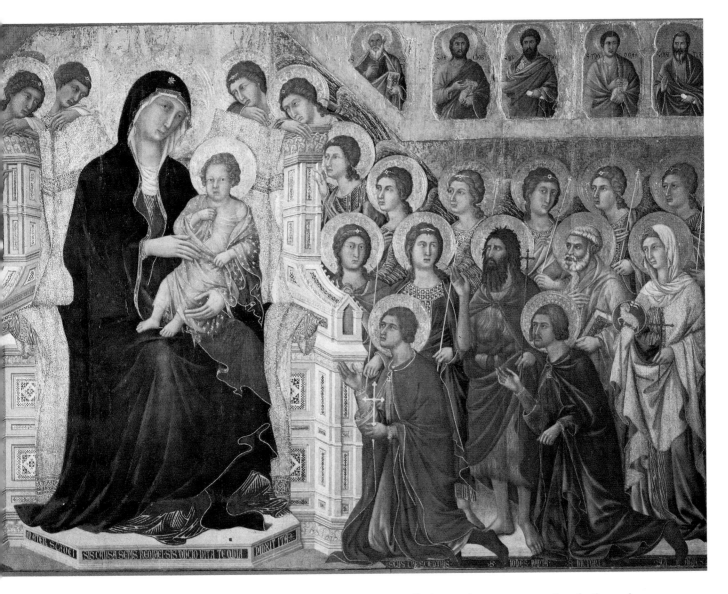

important impact on later developments in Italian art.

The humanization of early fourteenth-century religious imagery is especially well expressed in Ambrogio Lorenzetti's *Rapolano Madonna* [p. 85]. A younger contemporary of Simone and brother to an equally gifted painter, Pietro Lorenzetti, Ambrogio, like Giovanni Pisano, like Simone, and like Giotto in Florence, used his personal experience, his intuition, and his own understanding to imbue religious subject matter with accessibility and emotion. His *Rapolano Madonna* is a fundamentally human essay on the love of a mother and child for each other. Pressing her cheek to her son's, the Madonna has a faraway, mournful look. Symboli-cally her sadness presages her forthcoming sorrow, when Christ will die on the cross. This is conveyed in human terms and speaks of the sadness every mother feels, knowing that her child will someday part from her to begin a life of his own. As her hands clasp his body, and his arm reaches tenderly around her neck, the two figures become a lyrical visual poem about human affection, their emotional ties given formal expression by the graceful linear rhythms that bind them together into a whole.

By the middle of the fourteenth century, Giotto had moved painting toward a new reality, Giovanni Pisano had charted new and expressive possibilities for sculpture, and Duccio had allowed the wor-shiper a glimpse of the beauties of heaven. Paint-

SIMONE MARTINI, THE ANNUNCIATION, 1333. *The side panels of this work are by Simone's brother-in-law, Lippo Memmi, and it is likely that they are not an original part of the work. Simone's* Annunciation *was probably part of a Marian cycle that once decorated the side altars of Siena Cathedral.*

ings and sculptures were once more concerned with beauty, with the human figure, and with a dialogue between spectator and work of art.

But progress toward these goals was not simple or linear. In 1348 a calamity struck Europe such as had never been witnessed there. The bubonic plague spread from Messina in Sicily, moved

through Italy, north to Paris, Flanders, England, and to Scotland and Ireland. Twenty million people died. Whole cities were emptied of inhabitants, and many had their populations reduced by one-third to one-half. "And no bells tolled," wrote Agnolo Tura of Siena in his chronicles, "and nobody wept no matter what his loss because almost everyone expected death. . . . And people said and believed, 'This is the end of the world.' "

Besides the economic and social disruption caused by the plague, there was an artistic upheaval. Many of the promising and inventive artists who had inaugurated new and distinctive styles,

like the Lorenzetti brothers in Siena, fell victim to the Black Death. The new generations of artists were faced with diminished expectations as economic resources declined with the fall in population.

Of the artists who worked in mid-century Florence, Andrea di Cione, called Orcagna, has been singled out as exemplifying the pessimistic, anti-materialistic world view that emerged in the wake of the Black Death. His *Strozzi Altarpiece* [p. 86] is a gripping image, but it has none of the accessibility of Giotto's *Ognissanti Madonna.* In place of a well-defined space is ambiguity; instead of direct communication, there is iconic remoteness. Working to develop the new realism introduced by Giotto, Orcagna was also strongly influenced by other innovations that occurred before the plague struck, particularly the spatially ambiguous style created by Simone Martini. Orcagna's *Strozzi Altarpiece* probably would have had its particular blend of realism and abstraction regardless of the cataclysm that had preceded it, but the fact that the altarpiece was painted within a decade of the plague has indelibly fused the two in the popular imagination. Its stern and sober appearance, highly keyed colors, and austere symbolism seem to exemplify perfectly the chastened temperament of a city that had endured devastation.

Endure, however, it did. It is well to remember that as Orcagna was painting his *Strozzi Altarpiece,* Giovanni Boccaccio was writing *The Decameron.* In the wake of the plague, *The Decameron* is an acknowledged affirmation of life, sensuality, and enjoyment in the face of death. Written in the vernacular, it marks another turning point, where life itself becomes the subject of art. Boccaccio's friend and fellow writer Francesco Petrarca (1304–1374) was also active in the second half of the century. Petrarch, considered the father of humanism, abandoned Saint Thomas Aquinas's scholastic method of learning as too confining and supported the use of Cicero, Virgil, Horace, and other ancient texts as sources for models of thought and action. Petrarch so admired the ancients that he had himself crowned poet laureate in Rome and established a precedent for later humanists by vigorously involving himself in current affairs.

In the waning years of the fourteenth century, those affairs were complex and often violent. Cities

AMBROGIO LORENZETTI, RAPOLANO MADONNA, c. 1335–40. *The principal intercessor between humanity and God, the Madonna was greatly revered during the Middle Ages and the Renaissance. Though a sacred figure, she also embodied ideals of feminine beauty and motherhood. The theme of the Virgin and Child was a particularly fruitful one for Ambrogio Lorenzetti, who produced at least five versions of it.*

battled to expand their territories. Florence had transformed Pisa and Lucca into Florentine possessions. At the same time Florence was divided into factions from within and threatened by the expansionist policies of Milan to the north. As she was recovering from devastating reverses, including war, plague, and flood (Florence had half the population in 1400 that she had in 1300), Florence con-

**ANDREA DI CIONE (CALLED ORCAGNA), STROZZI
ALTARPIECE, 1354–57.** *A sculptor as well as a painter,
Andrea di Cione was the most successful artist active in
Florence after the Black Death of 1348. This altarpiece is still in
place in the Strozzi family chapel of Santa Maria Novella.*

tinued to develop. Her cathedral, Santa Maria del
Fiore, was being built even as Siena's proposed ex-
pansion was languishing. Old projects that had lain
fallow were revived. The most famous of these was
the project to decorate the Florentine baptistery.

Situated to the west of the Cathedral, the bap-
tistery dates to c. 1100–1150. It is regarded as the
oldest building in Florence, and its embellishment
was a particular source of communal pride. With
the increased wealth and resources Florence en-
joyed in the early fourteenth century, the first of
three sets of bronze doors had been commissioned
from the sculptor Andrea Pisano (unrelated to the

illustrious Giovanni Pisano). Recounting episodes
from the life of John the Baptist, Andrea's doors
were signed and dated 1330. Supported by funds
from the merchants' guild, the bronze door project
was halted by the Black Death. When the mer-
chants' guild decided to revive its patronage in
1401, it held what was to become the most famous
competition in the history of art.

In order to choose the artist worthy of receiving
the commission for the second set of bronze doors,
the merchants' guild selected six artists and gave
each a year to design and cast a bronze panel rep-
resenting the same story, the Sacrifice of Isaac,
taken from the Old Testament. Such ambitious com-
missions were rare and offered years of employment
and great fame to the winner, so the six artists who
competed included the most experienced bell
founders, wood carvers, and goldsmiths of the re-

gion. Though the two finalists were virtually unknown, the panels they produced may be viewed as key monuments of the early Renaissance [p. 87]. Filippo Brunelleschi (1377–1446) and Lorenzo Ghiberti (1378–1455) were both trained as goldsmiths; Brunelleschi had joined the goldsmiths' guild three years earlier, in 1398, but Ghiberti had not yet joined when he submitted his panels.

Both artists looked closely at ancient models, but both also relied on personal inventiveness to bring a traditional subject to life. Brunelleschi's is the more dramatic of the two. In his version, Abraham (whom God had instructed to sacrifice his only son as a test of his obedience) is about to cut the boy's throat; his hand is stayed only at the last instant by the angel rushing to stop him. Anxious to make use of the quatrefoil (a shape achieved by fusing four half circles with a square), Brunelleschi aggressively aligned his forms with the edges of the panel, giving the whole image energy and power. Brunelleschi's knowledge of antiquity is evident; he quotes from an ancient Roman bronze of a thorn picker at the lower left and the viewer is given a chance to appreciate his abilities to model the human form with Isaac as well as the attendant at the lower right.

Ghiberti, the winner, approached the image with a refined sense of grace shared with his northern contemporaries. His composition is subtler, gentler, and more compact. His Isaac is turned frontally, so his beautiful youthful nudity can be shown to its best advantage. The angel soars out from behind him, transforming the flat surface of the quatrefoil into air and space. Ghiberti's angel stops Abraham much earlier than Brunelleschi's, leaving the viewer free from dramatic tension to enjoy the image for its beauty, its lovely swirling drapery, its contrast of the two calmly talking attendants to the left and the three more actively engaged figures to the right. While all the emphasis hovers around

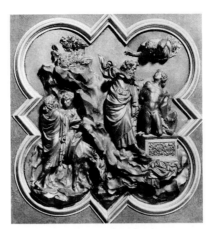

LORENZO GHIBERTI, SACRIFICE OF ISAAC, 1401–2. *Ghiberti was twenty-two years old when he entered the competition for the Florentine Baptistery doors in 1401 and forty-six when the final project was completed in 1425. The total cost was 22,000 gold florins, which equaled the annual Florentine defense budget.*

FILIPPO BRUNELLESCHI, SACRIFICE OF ISAAC, 1401–2.

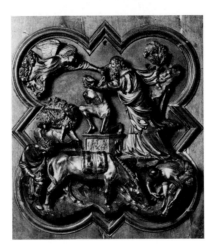

Isaac, it is Abraham who is at the heart of the story. His sacrifice is what counts, and so Ghiberti has brilliantly placed him in the center. On the basis of sheer elegance and polish, Ghiberti's panel deserved to win.

That Ghiberti won can be seen as an expression of the judges' conservative tastes. His style is steeped in well-established traditions. Ghiberti may also have won because his casting technique saved metal, making the whole production less costly, no doubt an important concern to the guild, which would have to pay for the venture. The choice of Ghiberti can also be argued as closing a period rather than as opening a new one. After all, Ghiberti was working for a venerable civic enterprise; his product had the same function as that of Andrea Pisano, his predecessor, and it used the same materials. And yet Ghiberti's panel, with its tightly knit figures, its cohesive composition, and its allusions to air and space around the figures, looks forward to the next century. Building on the foundations laid by Giotto and his contemporaries early in the century, both Ghiberti and Brunelleschi helped set the stage for one of the most amazing epochs of the art of the West, the Italian Renaissance of the fifteenth century.

Both artists were destined to make their mark. Ghiberti remained at work on the baptistery doors (he received the commission for the third set as well) for the next fifty years, and his efforts earned him immortality. Brunelleschi, who gave up sculpture for architecture, literally transformed his native city with Renaissance buildings.

VIEW OF FLORENCE. *Brunelleschi's Dome, the largest in Western Europe at the time of its completion, still dominates the skyline of Florence.*

[6]

THE EARLY RENAISSANCE IN ITALY

In 1401, when Ghiberti won the competition for the bronze doors of the baptistery of the Florence cathedral (the Duomo), the city was not much different than it had been a half-century earlier. The town hall, the Duomo, and the principal churches had all been built or begun in the previous century, and the intellectual and cultural environment was much like that of other medieval Italian cities. But by 1425, when Ghiberti embarked on his second set of baptistery doors, Florence had been transformed, not only by Ghiberti's new embellishments but by Brunelleschi's architecture, Donatello's sculpture, and Masaccio's painting, all of which reflected the new understanding of humanity that formed the basis of the Renaissance. In twenty-five years, Florentine culture had decisively shaken off the past. Though within the framework of traditional forms, artists presented images that looked to the future. Art no longer humanized faith but reflected humanity.

Florence had remained a particularly fertile environment for artistic development, thanks to the ambitious, intelligent, and optimistic attitudes of its inhabitants. Despite wars with rival cities, internal revolts, plagues, and failed business enterprises, Florence thrived. Florentine bankers were the leading creditors for Europe, giving the city the financial resources to build and expand; the Medici bank,

through skillful management, amassed one of the largest fortunes in Europe during the fifteenth century. Florentine citizens began to regard themselves with a self-confidence and self-importance last experienced in antiquity, and the consequences for the arts were fundamental: humanity stepped once more to center stage as the focus of art and thought, and themes that had been neglected since the last years of the Roman empire were revived. The portrait, both painted and carved, again immortalized individuals, and the human figure was once more sculpted in the round. The nude, as an expression of ideal beauty, reemerged. Architectural form and proportion not only reflected antique models but were based on a human scale. Ancient sources, both visual and written, gained renewed credence and importance, as thinkers, writers, and artists searched for alternatives to scholasticism.

Florentines were proud of their city and boasted of its economic and artistic power:

> Our beautiful Florence contains within the city in this present year [1472] two hundred seventy shops belonging to the wool merchants' guild . . . also eighty-three rich and splendid warehouses of the silk merchants' guild . . . the workshops of the stonecutters and marble workers in the city and its immediate neighborhood . . . fifty-four. . . . Go through all the cities of the world and nowhere will you ever be able to find artists . . . equal to those we now have in Florence.

So wrote Benedetto Dei, a Florentine merchant, to a rival Venetian in 1472. He was rightfully proud of Florence, for it was home to an astounding number of geniuses—architects, sculptors, painters, writers, leaders, and thinkers who saw themselves at the forefront of a new age. It was, moreover, an era when collective values were balanced by the importance of individual ideals. In Florence, Pico della Mirandola wrote his influential essay on the dignity of man in 1486, a document still regarded as the quintessential written work of the Renaissance. In Pico's essay, man is portrayed as the molder of himself, who, through his own efforts and self-improvement, could become divine—a radical and revitalizing departure from medieval thought, in which God controlled everything, including human destiny.

The first stirrings of Renaissance ideals in Florence occurred within the traditional framework of religious art. One of the earliest expressions of a newly humanized religious imagery came from Donatello. Nine years younger than Brunelleschi (Donatello was born about 1386), he began his career around 1403 as an assistant to Ghiberti on the baptistery doors. While Ghiberti refined and polished his narrative reliefs, Donatello went on to carve the freestanding figures that forever changed the direction of sculpture in Florence.

About 1416 Donatello joined other sculptors in fashioning figures of patron saints, commissioned by various guilds for the niches in the walls of Orsanmichele, an oratory church not far from the Duomo. His *Saint George,* made for the armorers' guild, is a fusion of symbol and reality that demonstrates Donatello's extraordinary vision [p. 92]. According to legend, Saint George was a knight who had rescued a maiden from a dragon and converted her family to Christianity. Donatello shows him victorious, his posture and expression displaying his courage. Here Saint George transcends both his material and symbolic origins and becomes real. Saint George is not simply a saint but a hero, and with this sculpture Donatello has taken one of the first decisive steps in the direction of the rehumanization of art.

While Donatello created a new race of heroes for the Renaissance, Brunelleschi became one by solving the problem of the cupola of the Duomo; many contemporary sources point to the cupola as fifteenth-century Florence's greatest achievement [p. 88]. The Duomo (Santa Maria del Fiore) had been completed by 1400 except for the cupola. The enormous expanse that the dome was required to cap surpassed the architectural and engineering abilities of the Duomo's architects. Conventional scaffolding could not span the 140-foot diameter, and conventional building techniques could not support the size and weight of the required dome.

After his defeat by Ghiberti in the competition for the bronze doors, Brunelleschi went to Rome, where he made a careful study of ancient building techniques. He especially scrutinized the Pantheon, and he used what he had learned to achieve brilliant results for the cupola in Florence. In 1417 Brunelleschi submitted a model of the cupola, consisting of two shells, one inside the other. The smaller, inner shell was thicker and supported most of the weight;

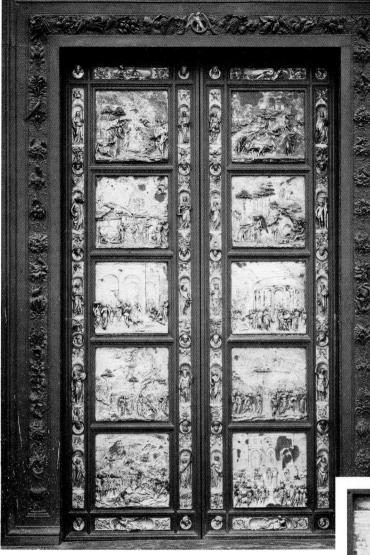

LORENZO GHIBERTI, GATES OF PARADISE, C. 1425–1452. *Michelangelo said that Ghiberti's massive bronze doors were worthy to be the gates of paradise. Illustrating scenes from the Old Testament, they were among the most costly and famous works of their time. Ghiberti included portraits of himself (above) and his son on the door's frame.*

DONATELLO, SAINT GEORGE, C. 1415–17.
This monumental sculpture shows the renewed emphasis in the early Renaissance on the dignity of humanity.

Contemporary ideas about art and artists would have been incomprehensible to the people who lived during the Renaissance. An artist, it was believed then, was made, not born. Most boys who were trained to be artists were chosen not because they were thought to be talented, but rather because they were a relative of the artist. In their social and economic status, artists were regarded as no different from other craftsmen and they belonged to a guild that regulated and supervised their activities.

Young boys were apprenticed to a master whom they served until they were proficient in the technical and artistic skills needed to become an independent artist. The making of art was a cooperative venture with the master designing the project and then working with the apprentice to carry it out. The apprentices

it was joined to the thinner, outer shell with common ribbing. A stairway between the shells (where one can still walk) was used instead of scaffolding for the workers. Brunelleschi's ingenious model convinced the superintendents of the cathedral, who gave him permission to proceed.

learned their trade by imitating the style and technique of the master. The engraving *Occupations Under the Influence of the Planet Mercury* (c. 1460) provides a glimpse into the atmosphere of the workshop as goldsmiths, fresco painters, sculptors and other craftsmen work on their creations, such as the Florentine lamp (c. 1520, at right), and mortar (c. 1450, at left) which filled Renaissance homes and palaces.

Before the eyes of his fellow Florentines—some skeptical, some curious, and some no doubt admiring—Brunelleschi assembled a vast supply of bricks, stones, tiles, and timbers, which prompted comment that Brunelleschi was building a whole city in the sky. As brick joined with brick in a complex herringbone pattern to carry weight away from the ribbing, Brunelleschi solved numerous problems, such as guttering to drain off water, and openings to provide light and to reduce wind force.

The cupola remains today the most famous shape in Florence's skyline and is regarded as a triumph of individual will, brilliance, and ingenuity. Presiding over the Duomo with grace and energy, the cupola is truly a transitional monument: its graceful ribbing, its composition out of disparate parts, and its egglike proportions are still medieval in their origins, but its cohesive unity proclaims a different future.

That future emerged in another sacred setting, the Old Sacristy of San Lorenzo [p. 94], built between 1421 and 1428, where the collective patronage that had supported the building of the cupola was supplanted by the family patronage of Giovanni de' Medici and his son Cosimo. Discreet, perceptive, and learned, Cosimo controlled the largest fortune then in private hands and used it to elevate the Medici to the first family of Florence. His patronage was legendary. With Medici money, the Old Sacristy (as opposed to the "New" Sacristy, by Michelangelo) of San Lorenzo became the first of the revolutionary architectural spaces of the Renaissance.

Here the aesthetic of the Middle Ages, in which individual forms were subsumed into collective anonymity, was decisively abandoned and replaced by the simple, comprehensible, and elemental language of geometry: the perfect circle, square, and hemisphere. Centrally planned, the Old Sacristy has the dignity and cohesion of the Pantheon, but a less grandiose and more human dimension.

The Old Sacristy has sparing decorations added by Donatello, punctuating its smooth white walls, which are otherwise articulated only by the cool accents of *pietra serena*, a native gray stone, describing the junctures of walls, pendentives, and dome. Plain yet elegant, this sacristy honors and elevates the individual who steps within its boundaries and reflects the innovative genius of the patron and architect who produced it.

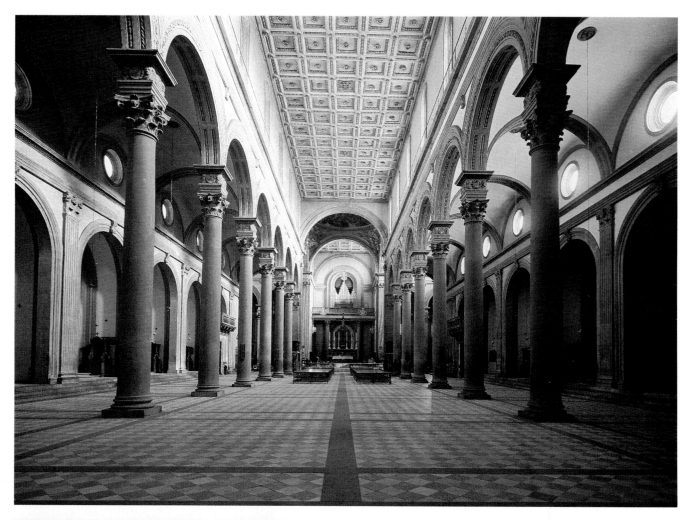

FILIPPO BRUNELLESCHI, NAVE AND CHOIR, SAN LORENZO, C. 1425–79. *In contrast to the physically and psychologically overpowering Gothic cathedrals, San Lorenzo has a more human scale, in keeping with the spirit of the Renaissance.*

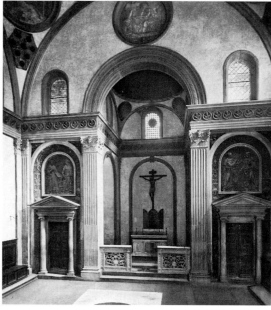

FILIPPO BRUNELLESCHI, OLD SACRISTY, SAN LORENZO, 1421–28. *In this Medici burial site (distinguished from the new one designed by Michelangelo in the sixteenth century) Brunelleschi introduced an austere and classically inspired architecture in Florence.*

Giovanni and Cosimo de' Medici also contributed to the rebuilding of the main body of San Lorenzo, which was in disrepair; they gave so much money that the church became a virtual Medici property [p. 94]. In rebuilding the church, Brunelleschi adapted both ancient and Romanesque forms. One glance at its grand and austere interior reveals that the church is derived from the basilica plan that the early Christians had adopted from pagan Rome. Space and structure exhibit a new clarity, logic, and scale.

San Lorenzo's proportions and colonnaded aisles lend a comprehensibility and predictability to the interior. It is lighted not by stained glass, as medieval cathedrals had been, but by round clerestory windows that provide both light and shadow to the space and give it a special vitality. As with the sacristy, the architecture of the church is its own justification. It eschews embellishment through stained glass, murals, or sculpture, as had been the practice in earlier cathedrals.

San Lorenzo and other Brunelleschian churches, with their sparse interiors, helped establish the fashion for the new simple, single-paneled altarpiece that accents but does not dominate the chapel it adorns. A new generation of artists supplied altarpieces for these Renaissance churches, which in Florence included Santo Spirito and San Marco. These artists built on the example supplied by Masaccio, a painter as revolutionary as Brunelleschi was as an architect.

Masaccio (1401–c. 1428), like Brunelleschi and Donatello, wanted to endow religious imagery with both human accessibility and spiritual dignity. He was the first Florentine painter since Giotto to turn away from the decorative, ambiguous images of the Middle Ages. Though Masaccio lived about twenty-seven years, his grand vision, which ennobled humanity and cast sacred figures in a similarly heroic mold, fused the sacred and the secular realms in a seamless and unique fashion. His surviving oeuvre is small, consisting of a few altarpieces, a modestly sized fresco, and parts of a larger fresco cycle.

Masaccio's approach can best be noted in the scenes he contributed about 1425 to the Brancacci Chapel in Santa Maria del Carmine. Located in a working-class neighborhood, Santa Maria del Carmine was not a particularly distinguished church, but when Masaccio produced his frescoes of the life of Saint Peter, he provided a textbook for painters that was admired and utilized for more than a hundred years. It nurtured such artists of the next century as Michelangelo, who stood before it in admiration and copied its figures. Masaccio did not execute all the frescoes, however, and the cycle remained unfinished after his death; his contribution was unfortunately damaged by a fire in the eighteenth century.

Nevertheless, in the recently restored *Tribute Money* [pp. 96–97], for example, we can see that the artist has surrounded his heroic characters with a space and setting that are extensions of the visible world. Light, atmosphere, and the newly learned laws of perspective endow the landscape and the action with the feeling of a particular place and moment in time; thus the viewer can relate to the work as an extension of his own world. On a late autumn day in a landscape remarkably like Tuscany, Christ and his followers debate the issue of paying Caesar his tribute. To the left, Saint Peter converses with Christ; in the background he goes to the fish as Christ has instructed him; and to the right he delivers Caesar's tribute with the coins taken from the fish. The story seems to have both sacred and civic messages, and more than one scholar has suggested a connection between it and the institution of a new Florentine tax.

Masaccio's characters gain their dignity and authority not from their halos, which seem to be present merely out of tradition, but from the moral authority inherent in their personalities. Stern, somber, self-disciplined, and wise, these are men chosen by God for their virtue; they do not appear virtuous because they were chosen by God. Masaccio seems to be reflecting back to his contemporaries their own values, their own beliefs in communal debate and individual action.

In the *Tribute Money* and in *Saint Peter Healing with His Shadow* [pp. 96–97], Masaccio has used contemporary settings and figures to give immediacy and specificity to a biblical tale. In so doing and in his creation of fictive space through rational systems of illusion (perspective, both linear and aerial), Masaccio helped set the stage for following generations. Later artists developed his massive, space-defining figures into a style that was much less grandiose, heroic, and somber, and that became more decorative or lifelike. Only rarely did

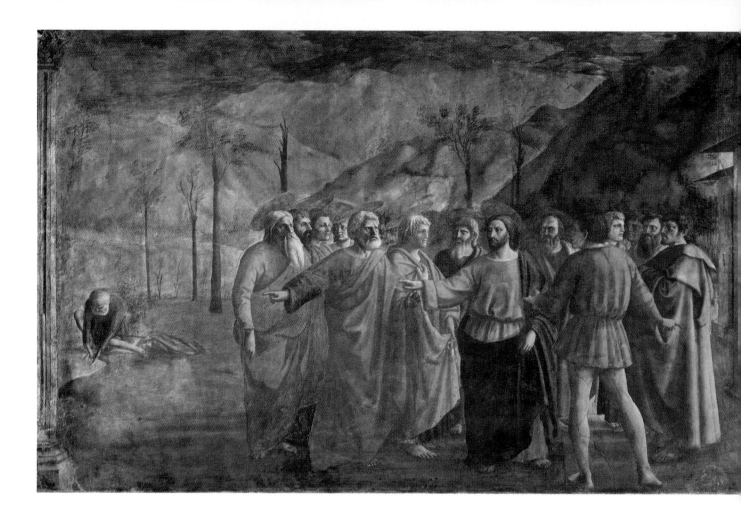

MASACCIO, TRIBUTE MONEY, C. 1425. *In this biblical episode, Masaccio portrayed noble characters whose serious actions were meant to be viewed as models for Florentines.*

these artists strike Masaccio's sonorous notes; like Beethoven, with whom Masaccio has sometimes been compared, Masaccio stood alone, his serious vision beyond the capacity of most artists. Yet Masaccio provided his followers with a means to model a figure through light and shade, giving it dimension, visual power, and personality.

Two of Masaccio's most gifted followers were Fra Filippo Lippi and Fra Angelico. Both were supported by Cosimo de' Medici, and they reflect the extremes of secularity and sacredness that religious painting in Florence could reach. Fra Filippo Lippi, an orphan reared in the monastery of Santa Maria

del Carmine, proved an unwilling friar but an able painter. Cosimo not only found work for Fillippo but also obtained a dispensation for him to marry the nun by whom he had a son, the painter Filippino. For Cosimo, Lippi painted the remarkable *Coronation of the Virgin* [p. 98], c. 1440, which completely humanizes this sacred event. The pageantlike assembly is casually if reverently arrayed, and each participant is a characterization of the earthy, practical citizens of Florence. Though glorious and awesome, this image is wholly of this world. The human characters reenact an event that took place in heaven, but they cannot transcend their fundamentally earthly realm.

Perhaps troubled by a guilty conscience, Cosimo, like other money lenders, expiated his sins by giving enormous sums to public or religious enterprises. From 1434 to 1471 his ledgers account for the enormous sum of 663,755 florins spent on taxes,

MASACCIO, SAINT PETER HEALING WITH HIS SHADOW,
c. 1425. *By placing the occurrence of this miracle in a*
contemporary Florentine setting, Masaccio endowed the image
with a greater psychological immediacy.

charities, and buildings. A huge portion of it flowed into San Marco, where Cosimo overcame the prior's protestations over his generosity by saying, "Never shall I be able to give God enough to set him down in my book as a debtor."

At San Marco, Cosimo befriended and admired the diminutive and gifted friar Fra Angelico, whose piety was translated into masterpieces of devotional art. Vasari, the sixteenth-century Florentine biographer, said of him: "Fra Giovanni [Angelico] was a man of great simplicity, and most holy in his ways. . . . Some say that Fra Giovanni would never have taken his brushes in hand without first offering a prayer. He never painted a crucifix without tears streaming down his cheeks." Gently beatific, Angelico's paintings are the artistic expression of perfect piety. One of his most profound works is the *Descent from the Cross* of 1434 [p. 99]. Within a pristine Tuscan landscape, Christ is lowered from the cross. As Mary Magdalene reverently kisses Christ's feet, John the Evangelist assists Nicodemus in lowering the sacred body. Cosimo's namesake, Saint Cosmas, shows the crown of thorns and the nails, while a host of mourners crowds around the Virgin to the left. Hushed, respectful, and completely devout, the assembled figures present a scene that equates clarity of form, purity of color, and rationally conceived proportions with transcendent spirituality. The mode of expression is dignified, rational, and human.

Patrons such as Cosimo also extended their patronage to art that embellished their private lives.

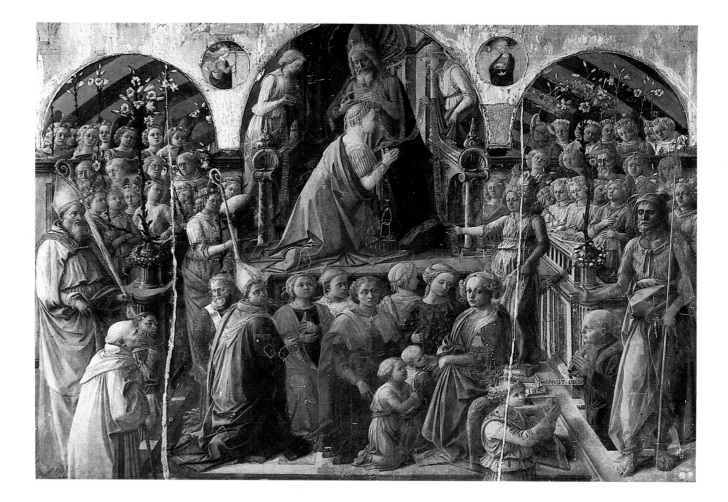

FRA FILIPPO LIPPI, CORONATION OF THE VIRGIN,
C. 1440. *An orphan raised in a monastery, Lippi was not well*
suited to monastery life. The Renaissance biographer Vasari
tells us that Lippi's patron, Cosimo de' Medici, tried to keep
Lippi locked in a room so he would concentrate on painting
instead of satisfying his lust for women.

Perhaps the most famous sculpture commissioned
for personal enjoyment is Donatello's *David* [p.
100]. Undated, it was probably made about 1440
for Cosimo de' Medici. An avid collector of ancient
texts; a friend of Leonardo Bruni, the chancellor
of Florence; and the founder of the famous Neo-
Platonic Academy with Marsilio Ficino, Cosimo was
"king in everything but name," according to Pope
Pius II. Would not David, the future king of Israel,
have been Cosimo's ideal symbol?

But *David* is striking not only as a symbol. The
figure was the most advanced, sensitive, and beau-
tiful portrayal of the nude human body since antiq-
uity and the first sculpture meant to be seen in the
round since the ancients made the human form
their principal subject over a thousand years before.
Gone is any medieval residue of sin or shame as-
sociated with the human form. It stands before the
viewer independent of any justification except itself,
and unabashedly nude. *David*'s soft, pubescent
flesh seems all the more exposed and set off by his
boots and hat.

This seductive youth may be viewed as Dona-
tello's dialogue with antiquity. Aware of Roman
uses of the nude figure, Donatello quoted the an-
cients but changed the emphasis. *David* is not sim-
ply nude (as were the athletes) but naked, like a
vulnerable young boy. He is the biblical David. Nei-
ther does *David* project the idealized neutrality of

FRA ANGELICO, DESCENT FROM THE CROSS, c. 1434.
A friar connected with the monastery of San Marco, Fra Angelico devoted his work to embellishing San Marco with sacred pictures.

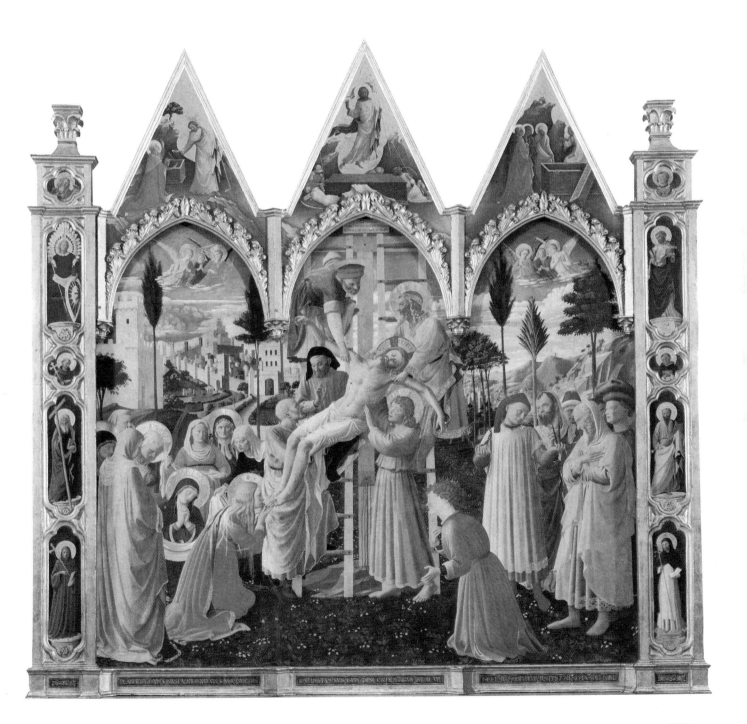

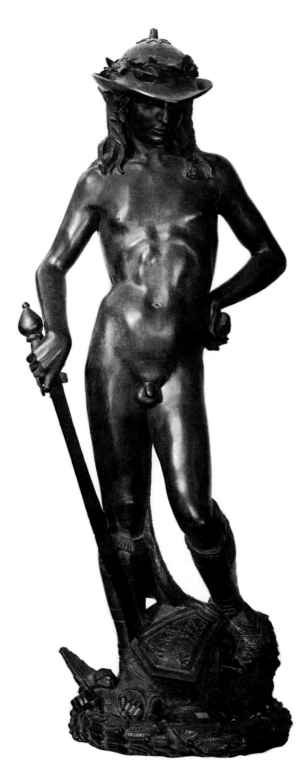

DONATELLO, DAVID, C. 1440. *The first life-size sculpture in Western Europe meant to be seen in the round since antiquity, Donatello's* David *served as a model for many later sculptors, including Michelangelo and Bernini.*

antique sculptures; instead, his quiet, meditative stance relates to an action completed: the triumph over Goliath, whose severed head lies at his feet. *David* is set in time and place, he is reflective, and his meditations engage our thoughts beyond the concept of universal beauty to notions of transience and mortality. In this work Donatello demonstrated his familiarity with antiquity, his understanding of narrative, and his knowledge of human anatomy: all are fused in a single, revolutionary sculpture.

Where *David* originally stood is not certain, but most scholars believe that he graced the colonnaded, Roman-inspired atrium of the Palazzo Medici commissioned by Cosimo from the architect Michelozzo. *David* was probably situated so that he functioned both as a private and a public image. For the Medici, *David* would have been an object for private delectation, satisfying their taste for precious, well-wrought, sensuous objects. At the same time, *David*'s nudity underscored his moral victory: naked and vulnerable, he won because God was on his side. Having him in their courtyard placed him clearly within private Medici precincts and identified his moral virtue with theirs; but having him visible through the gate made a clear public claim of Medici wealth, sophistication, morality, and civic leadership. *David* ultimately became a public Florentine monument when the Medici were expelled from Florence at the end of the fifteenth century.

Other monuments were created that proclaimed and honored Florence's outstanding citizens. One of the most famous of these is the monument to Florence's great chancellor, Leonardo Bruni. In 1444, when Bruni died, his fellow citizens decided to erect a memorial to him. Bruni deserved their tribute; a humanist, he had studied Greek and Roman texts for models of civic behavior in face of the expansionist policies of the Milanese, who threatened Florence until 1440. Bruni also wrote a great history of Florence, considered the first history in the modern sense of the term.

To honor Bruni, the Florentines did not erect a portrait statue. In 1444 they were too imbued with Christianity to consider such a completely secular monument. Instead, they created a new kind of tomb, and for its setting they chose one of the oldest and most revered churches in Florence, Santa Croce.

Set along the church's right aisle, the Bruni

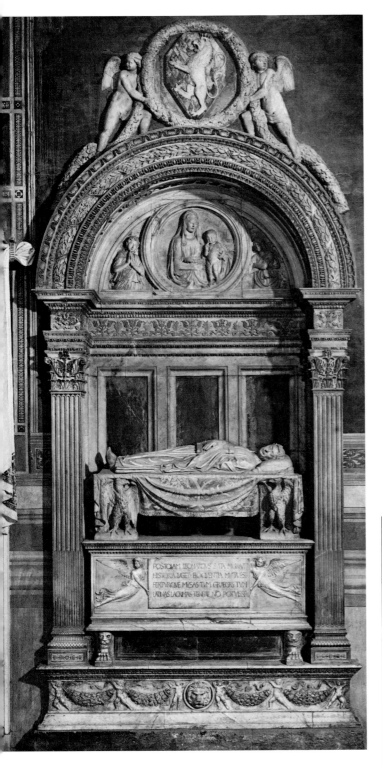

tomb by Antonio Rossellino (1427–1479) [p. 101] is a remarkable fusion of secular and sacred ideas. Its elegant pilasters, classical entablature, and graceful lunette all owe their language to antiquity. Bruni's effigy is the principal aspect of the assembly, and it is set atop a sarcophagus styled after the antique. The bier is held aloft by eagles, which have both ancient and medieval significance as emblems of victory and resurrection. The sarcophagus is emblazoned with two figures that could be ancient genii as well as angels, and they hold up an inscription that is not the usual medieval reminder of mortality but an eloquent testament to Bruni's accomplishments: "At Leonardo's passing, history grieves, eloquence is mute and it is said that the muses, Greek and Latin alike, cannot hold back their tears." Hardly a sacred thought enters the assembly. Bruni holds a copy of his own book rather than a Bible or Psalter, and he is crowned by laurel leaves, an ancient victory symbol. Only the lunette is reserved for a purely sacred emblem: the Madonna and Child bless and protect this great humanist in his final resting place.

The Bruni tomb helped establish a fashion for tomb monuments incorporating many secular and humanist themes. Bruni's tomb was created by his fellow Florentines, others were privately commissioned, and many depended on ancient models.

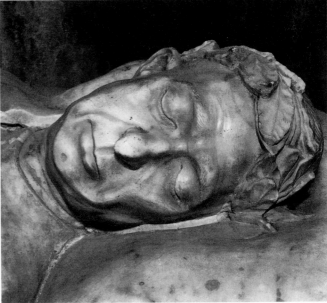

BERNARDO ROSSELLINO, TOMB OF LEONARDO BRUNI, c. 1445. *Emphasizing the dignity of Bruni as a humanist and a scholar, the tomb includes antique Roman symbols; it inspired subsequent tombs in Renaissance Florence.*

SANDRO BOTTICELLI, YOUNG MAN WITH A MEDAL,
c. 1470s. *Medals such as the one depicting Cosimo de' Medici,*
held up by this unidentified young man, became an important
form of portraiture during the Renaissance.

The new secular spirit, reflected by Donatello's *David,* affirmed individual value in numerous ways. Portraiture, documenting and celebrating individuals, emerged again after centuries of neglect. Donors stepped confidently and aggressively into the realm of sacred images; public monuments to individuals became more common and more expensive; and privately commissioned art works were made for aesthetic as well as didactic or religious purposes.

By the middle of the fifteenth century, the portrait had become a new assertion of individuality. It is no accident that it reached an elevated level of skill and sophistication in Renaissance Florence, a city increasingly dominated by men eager to assert their specific identity and to have it recorded for posterity. These men were to make Florence one of the most important commercial, artistic, and cultural centers of the Western world.

It was not until about 1430, however, that portraits began to closely resemble their sitters. Previously, the portrait had been generic in nature: various ages (youthful, middle-aged, old) and different types (citizen, soldier, and so forth) would be portrayed in painting and sculpture, but, for the most part, there was little attempt or desire to accurately reproduce the particular topography of the sitter's face.

First in Florence, and then throughout the rest of the Italian peninsula, this concept of the portrait started to change. By about 1430, portraits had begun to represent the human face in a highly stylized way. As the century progressed, the portrait became more revealing and engaging. The face turned from the strict profile to a three-quarter view that disclosed much more of the sitter's expression —the subject now met the viewer almost eye to eye. Botticelli's *Young Man with a Medal* [p. 102] is a masterpiece of this type. Here the artist has begun to come to terms with the sitter's mood and character. One can glean little about a sitter in a profile portrait other than his age and the details of his dress, but in Botticelli's painting the melancholy mood of the sitter is directly communicated, and there is a silent dialogue between sitter and observer. The faithfully reproduced human face is shown as a worthy subject for painting and sculpture, and the way in which it reveals character is now being actively rethought. The wonderfully asymmetrical face of the young man holding the medal, which itself contains a portrait of Cosimo de' Medici, is infused with newfound life and feeling.

It is in sculpture that perhaps the most direct communication of this new interest in the individual and the particular physical and psychological elements of his or her makeup is found. The humanists of the fifteenth century, with their avid interest in antiquity, knew that the Romans had marble portrait busts of their ancestors in their homes, and it may have been in imitation of this practice that they began to commission their own portrait busts in stone and terra-cotta.

PIERO DELLA FRANCESCA, THE DUKE AND DUCHESS OF URBINO, AFTER 1474. *A ruler of a particularly cultivated court at Urbino in Umbria, Federico de Montefeltro was one of the great generals of his day and an enlightened patron of the arts. The death of his wife, Battista, in 1472 during childbirth prompted numerous posthumous commemorations, most likely including this one.*

The patrons of these busts wanted verisimilitude, and fifteenth-century sculptors, especially the Florentines, studied Roman examples for their realism. Roman busts were highly accurate records of the face, but often lifeless statements of fact without personality. It was the character of the mind, perhaps even more than the forms of the face, which so fascinated the Renaissance patron that he wished to preserve it in stone.

The portrait soon served many functions in the Renaissance. One of its principal tasks was to record and transmit the images of rulers and their power. This was astutely done by Piero della Francesca in a double portrait that is one of the most famous of all Renaissance paintings [p. 103]. Its subjects are Federico da Montefeltro and Battista Sforza, the duke and duchess of Urbino, who are shown on an elevation overlooking the panoramic landscape of their domains. The strict profile of their faces admits of little contact with the viewer, but the message of their power, wealth, and status emanates clearly from their dominating positions, the vast unfolding landscape that they rule, and the style and costliness of their jewels and clothes. The face of Federico—with its nose damaged in a joust, thin lips, and protruding jaw—is especially candid. Here, devoid of any hint of spirituality or religious association, is the self-reliant ruler firmly in charge of his destiny.

PIERO DELLA FRANCESCA, SIGISMONDO MALATESTA ADORING SAINT SIGISMUND, TEMPIO MALATESTIANO, 1451. *The Tempio Malatestiano, in which Malatesta's fresco portrait was painted, is the only known church dedicated to an individual, and prompted Pope Pius II to complain, "It seems a temple for worship not of Christ but of the pagan gods."*

That a prince could be both a despot and the hero of a cult of personality is proved by another of Piero della Francesca's patrons, Sigismondo Malatesta, the lord of Rimini, a city in central Italy on the Adriatic coast. In his portrait by Piero [p. 104], Sigismondo is presented in the center of the composition and placed closest to the viewer. He kneels in adoration (the sincerity of which Piero somehow makes us question) of his patron saint, Sigismund.

The real subject of the fresco, however, is the ambitious and egomaniacal Sigismondo, who built as a memorial to himself and his mistress the beautiful church in which his portrait is placed. It is easy to imagine that in an instant Sigismondo will stand, turn his back on the saint, and leave with his sleek dogs at his heels. It is the prince, not the saint in the wings, who captures and holds one's attention: this is a portrait of secular character and power in a sacred setting.

One of the secular heroes of the Renaissance was the soldier of fortune, the *condottiere*. Because many of the city-states of the Renaissance had only small standing armies, the soldier of fortune with his band of mercenaries was often needed for protection or for help in conquering or subduing terri-

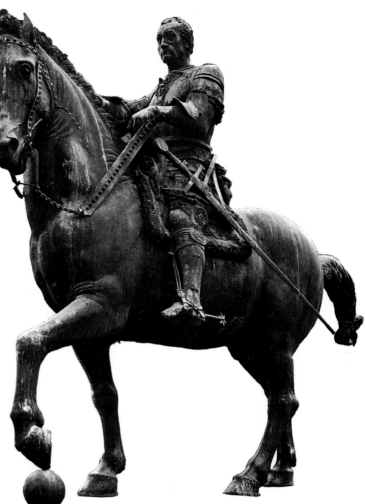

DONATELLO, GATTAMELATA, 1445–53. *The first larger than life-size equestrian statue since antiquity, the* Gattamelata *was the direct inspiration for many subsequent depictions of rulers on horseback, including sculptures by Verrocchio, Leonardo, and Giovanni Bologna.*

tories outside the city walls. These men, who sometimes became popular heroes, were the subjects of paintings and sculptures that glorified their power. Both the duke of Urbino and Sigismondo Malatesta were famous soldiers.

But the first, and definitive, image of the mercenary was made in bronze, not paint. This image [p. 105], which set the pattern for subsequent depictions of the soldier-hero right down to the early years of the twentieth century, was made to commemorate Erasmo da Narni, called Gattamelata. Standing in the piazza of the principal church of Padua, Donatello's life-size bronze is the perfect embodiment of power and dominance. Confident, fearless, Gattamelata sits astride an enormous stallion, bred to carry the heavily armored rider and itself an image of physical power and virility. The horse and rider seem as one as they advance with energy and determination, created by the cadence of the horse's feet, its arched neck, and the strong diagonal of the soldier's baton and great two-handed sword. Gattamelata's face is a mask of power and authority: with his massive jaw, huge

brow, and close-cropped hair, he looks like a determined boxer. The willfulness and potency of the physical and psychological elements of Donatello's heroic portrait, although perhaps indebted to a Roman equestrian statue such as that of Marcus Aurelius, were not possible before the fifteenth century, with its fascination with the potential and character of the individual.

Fifteenth-century society in Italy also emphasized the secular and individual nature of man through human-centered city planning and architecture, and numerous ideas for rationally planned, commodious, and efficient cities were developed. The old warren of unplanned medieval streets and the sometimes haphazard location of important civic and ecclesiastical centers no longer sufficed. Most of these fifteenth-century plans, some of them

**PIERO DELLA FRANCESCA, INVENTION OF THE TRUE
CROSS AND RECOGNITION OF THE TRUE CROSS,
c. 1452–57.** *Illustrations of the legend of the True Cross were
immensely popular in Tuscany during the late Middle Ages and
the Renaissance.*

types of miniature utopias, were never built, since
they involved too much labor, money, and personal
commitment, but there survives at Pienza, a small
town in Tuscany, a tiny but almost perfectly realized
example of the sort of town the Renaissance wished
to build. The prime mover behind Pienza was a
native of the town, Pope Pius II. When Pius as-
cended to the papacy in 1458, he changed the name

of the town from Corisgnano to Pienza to honor himself and began the rebuilding of the town center to make it more modern and worthy of the great honor he had bestowed on it.

Under the direction of an architect, probably the Florentine Bernardo Rossellino, the civic, domestic, and ecclesiastical buildings of Pienza began to take shape between 1459 and 1464. A new and luminous cathedral, a town hall, a bishop's palace, and a large palazzo for the Piccolominis, Pius's family, were built, all connected by their mutual access off the main piazza of the newly renamed city.

The human scale and proportions of the buildings, their beautifully spaced and harmonious relation to one another, and the sense that they are all

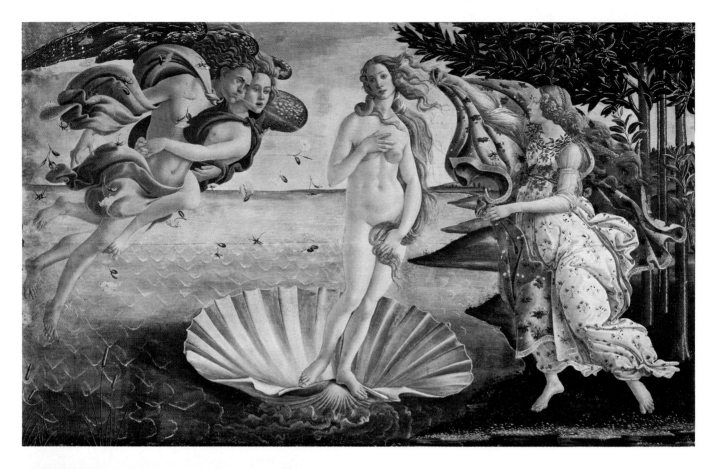

SANDRO BOTICELLI, BIRTH OF VENUS, AFTER 1482.
This Venus is one of the earliest treatments of the female nude in the Renaissance; it was painted for the Medici family.

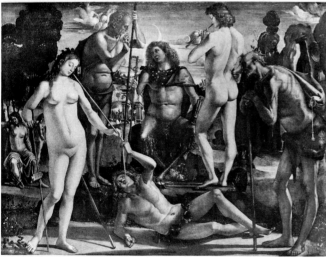

LUCA SIGNORELLI, SCHOOL OF PAN, C. 1496
(DESTROYED 1945). *One of several works painted for Lorenzo de' Medici, this large panel painting (nearly 6 x 6 feet) embodies two of the patron's interests: music and classical mythology.*

part of a thoughtful and rational scheme give the viewer standing in the piazza a deep satisfaction at the rightness of the whole plan. Here human beings seem in charge, capable of ordering their environment and making it welcoming and life enhancing. The Renaissance maxim that "man can do what he will" nowhere seems truer than in this small piazza in the tiny and remote hill town of Pienza. These few buildings of great dignity set in a landscape of rare beauty impart a confidence in humankind and an optimism about its nature and future that is, regrettably, lacking in much subsequent art and architecture.

The image of an ordered, calm world is captured in many paintings from the fifteenth century, but perhaps nowhere better than in the streets filled with handsome buildings in Piero della Francesca's

fresco cycle of the True Cross in the church of San Francesco in the Tuscan town of Arezzo [pp. 106–107]. Here a rational environment like Pienza is turned into the artistic vision of one of the most distinguished painters of the 1400s, who himself expressed in his paintings a hopefulness about humanity and the world which it inhabited.

This fifteenth century world witnessed the development of the city into a secure environment fit for a gracious and comfortable way of life. Families like the Medici were made wealthy and powerful by banking (an occupation much practiced by the level-headed and practical Florentines) and commerce. The earliest family homes, or palazzos, were tall, narrow, fortresslike structures with slit windows and cramped rooms. As the cities became safer, however, the need for such strongholds decreased and more comfortable dwellings began to predominate.

The new palazzos were more than houses. Certainly they were often residences, but they were also the seats of the family businesses, which were frequently conducted from large rooms on the ground floor. The families were large extended clans whose members were all usually associated with the same business.

The palazzos built for these families often have a facade of three stories, varying in the size and texture of the stone and in the classically inspired orders that decorate it. These buildings are the ancestors of the great urban houses that were to be a feature of Western cities until the early part of this century. Sober, august, and large, they broadcast their owners' wealth and social position to all who passed by their impressive facades.

The design of urban dwellings became an important architectural problem, which noteworthy architects from Brunelleschi onward sought to solve in ever-changing and inventive ways. Not since the Romans had the dwelling of the individual family taken up so much time, effort, and money, with such successful and widespread results. The palazzos of the fifteenth century remain among the triumphs of Western architecture.

Many furnishings were needed for the interiors of these new homes, and furniture, wall hangings, pottery, portraits, small decorative bronzes, and many other art objects were commissioned in considerable quantity. Renaissance homes had large

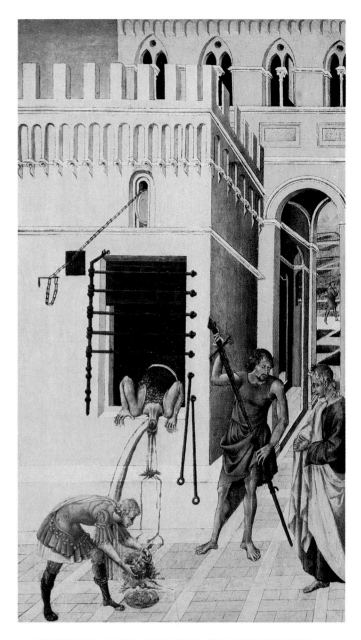

GIOVANNI DI PAOLO, BEHEADING OF SAINT JOHN THE BAPTIST. *Giovanni di Paolo was one of the most gifted members of Siena's highly independent and eccentric school of painters; his fantastic imagery is a precedent of that of the Surrealists in the early twentieth century.*

amounts of wall space, and walls were often decorated either with frescoes or with paintings on wooden panels or canvas. The *School of Pan* [p. 108] by Luca Signorelli and Botticelli's renowned *Birth of Venus* [p. 108] are two of many examples of the sort of panel made for the Renais-

GIOVANNI BELLINI, SAINT FRANCIS IN ECSTASY, C. 1485.
*The Venetian school founded by Bellini took a poetic approach
to painting and was noted for its landscapes.*

sance home. The mythological subjects common to
both were favored by humanists, who enjoyed their
derivation from the classical past, and by patrons,
who appreciated the nudity and mild eroticism.

Signorelli's superb figures, set in the fading
light of a late afternoon, are perfect foils for the

melancholy Pan, who listens to his follower's pipes.
The beauty of Signorelli's world is matched by Bot-
ticelli's Venus, formed with a sensuous and elegant
line of unmatched perfection, who rises from the
waves. These two works by Signorelli and Botticelli
demonstrate to what levels decoration for the do-
mestic interior could rise in the fifteenth century.

As Florence built its culture, guided by erudite
readers of ancient texts as well as by merchants
eager to gain the benefits of prestige and the salva-
tion of their souls through their philanthropy, art

developed in new and indigenous styles throughout the rest of Italy. In Siena, a host of genial, mystical visionaries, including Sassetta (c. 1392–1451) and Giovanni di Paolo (c. 1400–1482), culled and reinterpreted the traditions handed down by Duccio and Simone Martini. If Florentine painters used verisimilitude and rational systems to codify reality in their religious works, the Sienese used imagination to transcend it. Giovanni di Paolo's *Beheading of Saint John the Baptist* [p. 109] shows exaggerated perspective, veering off into an infinite hallucinatory landscape. Gruesome in its presentation, the scene remains expressively convincing, all the more so for being so unreal. Giovanni's thin, wraithlike figures, the toylike prison, and the fantastic space point to the triumph of spiritual narrative over the pragmatically real world created in nearby Florence.

During the fifteenth century, Venice developed a wholly different but equally independent tradition. Its greatest painter, Giovanni Bellini (c. 1430–1516), was also the founder of the Venetian school. Bellini's *Saint Francis in Ecstasy* [p. 110] may well be his most original work. In this painting, the transcendent mysticism of Saint Francis that had inspired generations of artists also inspired Bellini, but in a unique way. A lover of nature who celebrated the beauties of creation in some of the most lyrical poetry of the thirteenth century, Saint Francis is placed within his natural setting by Bellini. Standing transfixed, Francis communes with God through nature, which is as steeped with holiness as the saint himself. The rocky cave, the grassy knoll, and the distant hill town are bathed, together with the saint, in a holy light that picks out the irregular and natural pattern of growth. As it illuminates, it seems to suspend time: a single hushed moment in this world lifts us to another.

Here is an altogether different world from what had gone before: if Florentine artists developed religious imagery more secular than before, and if Siena presented a vision more dreamlike and mystical, then Venice, with Bellini, offered one of the most poetic, elegiac paeans to nature ever painted. Finished in the waning years of the Renaissance, Bellini's picture inspired many followers but had no equal.

In the fifteenth century, Bellini and his contemporaries working in the burgeoning, increasingly worldly cities of the Italian peninsula began to expand the dimensions of art. The paintings, sculptures, and buildings by these artists explored the sacred and secular worlds with a remarkable and novel acuteness and sense of nuance. The newfound interest in the material world, the growing recognition of the individuality of its inhabitants, and the increasing ability of artists to portray the delicate shades of spirituality and emotion signal the birth of many new beliefs and feelings destined to have a profound and far-reaching influence on the subsequent development of Western art.

PIETER BRUEGHEL THE ELDER, <u>HUNTERS IN THE SNOW</u>, 1565. *One of a series of paintings portraying the months and seasons, of which only five works survive, this scene was painted for the banker Nicolas Jonghelinck of Antwerp. Brueghel's series is a deliberate reaffirmation of reality in contrast to the artificiality and mannered style that had gained popularity in Italy.*

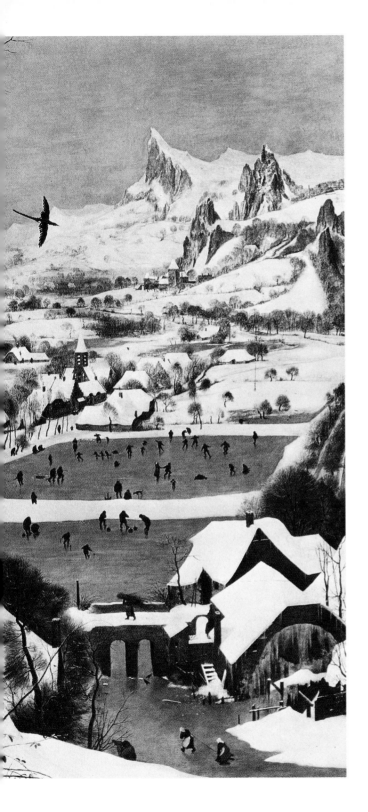

[7]

THE NORTH IN THE FIFTEENTH CENTURY

In 1489, shortly after the Florentine humanist Pico della Mirandola had declared that man was nearly divine and the master of his own destiny, Hans Memlinc produced the *Shrine of Saint Ursula* for the hospital of Saint John in the Flemish city of Bruges [p. 115]. Pico's laudatory words about humanity, however, would have seemed strange to the Flemish patrons who commissioned Memlinc to enshrine some relics of this fourth- or fifth-century virgin martyred with eleven thousand others in Cologne. To Memlinc's patrons, humanity was unchanged since the time of Adam—deeply flawed and in need of the divine protection offered by saintly relics. Memlinc's shrine affirms the strength of those traditional beliefs. In the form of a Gothic cathedral, it is embellished with scenes from Ursula's life. Three of the episodes are set in fifteenth-century Cologne and depict with remarkable accuracy the city's cathedral, then under construction.

For fifteenth-century Northern Europe, cathedrals remained vital repositories of urban culture, weaving the origins of each city, its patrons, and its inhabitants into an overall schema fundamentally unchanged since the onset of Christianity. Humanism, with its revival of ancient texts and its search for models outside traditional sacred books, was not yet evident in art works like Memlinc's shrine. Made about ten years before the start of a new cen-

tury, this toylike structure with its charmingly painted narratives reflects a system of thought in which the past becomes a dream and a refuge from the dangers of the present. It builds on and looks back to the accomplishments of the great innovators of the early part of the century, Jan van Eyck and Rogier van der Weyden.

These Flemish masters, working in a culture that accepted the material world as a manifestation of divine creation, found a means to describe nature, people, and light in a manner still astonishing. In so doing, they anticipated the Italians in the exploration of landscape and in the development of the portrait. Their vision, unconstrained by the conventions of classical art or the generalizing forms adopted by the earliest masters of realism in Italy (such as Giotto), was meticulous, precise, and comprehensive.

Nature and humanity were faithfully recorded by van Eyck, Rogier van der Weyden, and their followers, such as Memlinc. Thus, while van Eyck and Rogier placed a renewed emphasis on humanity in their portraiture, they treated their subjects with unsparing frankness and honesty. They set the standard for verisimilitude by which all subsequent realism has been measured, and they reminded their viewers that humanity, though important, was not perfect; the imperfections on the exterior were mirrors for more serious flaws of human nature. A general pessimism about human nature kept Northern thinkers from leaping to Pico's optimistic conclusions about man.

But the determination to face life as it really was yielded a legacy just as important and enduring as Italy's Renaissance. Northern artists tended to examine humanity in a broader context, looking at the environment in which people lived and at the social fabric that people created for themselves. Though humanity was often found wanting, the keys to understanding life offered by artists in the North were important to Western culture. Later images of social satire, themes of mortality and suffering, the exploration of the human psyche, and landscape both urban and natural all trace their origins to the arts of Northern Europe in the fifteenth and sixteenth centuries.

As in Italy, the resurgence of art independent of cathedral decoration—paintings, sculptures, as well as prints and drawings—occurred in both courtly and urban settings. The duchy of Burgundy and that of Jean of Berry (1340–1416), together with such great European cities as Brussels, Ghent, Louvain, Nuremberg, and Munich, supported an outpouring of art similar in type and number to that of Italy.

This flood of artistic creation—mainly altarpieces, portraits, images of saints, and tombs—was partially destroyed by iconoclastic outbursts in the sixteenth century. To what extent overzealous Protestant reformers, anxious to rid themselves of images representing Catholic idolatry, eradicated the legacy of the fifteenth century will never be known. But what survives reveals a culture clinging to faith, wishing to see clearly and accurately the embodiments of this faith. Equally important, patrons wished to be seen in order to be remembered; thus portraits of donors in altarpieces abounded.

Other sacred objects proliferated as well. Lavish prayer books were commissioned by the nobility, while cheaper models served the less wealthy. Beautiful Madonnas protected believers, and saints acted as intercessors and guarded the faithful from particular illnesses or problems. Art existed to embellish the rituals of life and death; it made the mysteries of religion more comprehensible by giving them concrete, visible form.

The arts of this period show a complexity that is medieval in spirit. Pattern and ornament play a conspicuous role in the conception of each image, and the individuals within the images are still part of a larger whole. Even portraits are the sum total of the face's many parts, while humanity was viewed as part of the whole fabric of creation. Though forceful individuals staked their claim to high social status and achieved immortality in portraiture, they, like the sacred subjects that often overshadowed their portraits, remained remote, internalized, and removed from the viewer's world. Despite the detail with which the carver or painter described holy figures, they remained beings of another dimension.

This was a higher reality, laden with meaning. No tree, no flower, no detail was too small to partake of some greater significance within the larger whole. The beauty these artists reflect is not the beauty of their invention but that of divinity made manifest. Finally, these works are beautiful in a medieval sense; their multiplicity of form and their complexity, as well as their material richness,

**HANS MEMLINC, SHRINE OF SAINT URSULA,
1489.** *In 1489 the bishop of Sarepta had the
relics of Ursula, a fourth-century saint, deposited
into this reliquary shrine. A famous beauty,
Ursula was martyred in Cologne by pagans,
after refusing the offer of marriage to Julian,
prince of the Huns.*

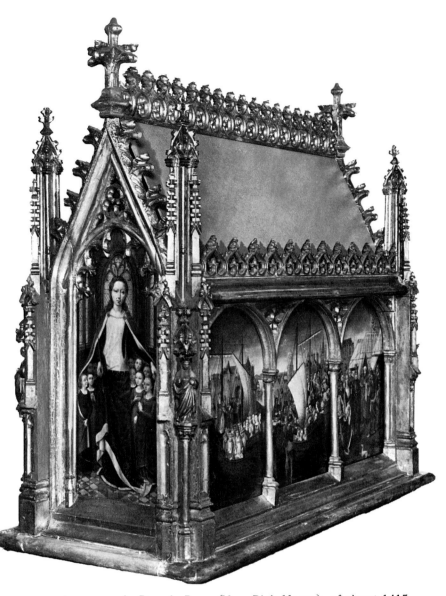

endow them with the splendor associated with the spiritual. The adjustment of parts, the harmonious relation to the whole, and the concentration on the human form that characterized Italian art of the period were not concerns of Northern art.

The birth of painting north of the Alps occurred in the court of Jean, the duke of Berry. Three brothers of notable talent and abundant invention, Pol, Jehanequin, and Herman Limbourg, worked for the duke from 1411 until his and their deaths in 1416 from the plague. Although the Limbourgs' lives are well documented compared to those of other artists of the fifteenth century, very little is known about their training. Two of the brothers were apprenticed to a Parisian goldsmith when they were quite young, but little else is known about how their original style evolved. It seems likely, however, that the brothers went to Italy, where they saw art in Florence and perhaps Siena. When the trip took place is uncertain, but it was surely one of the earliest of such journeys in what was to become a centuries-long and fruitful dialogue between the art of Italy and Northern Europe.

The duke must have been pleased with the brothers' art for he gave them commissions for the illustration of several important manuscripts. Whether religious or secular, the illuminated, or illustrated, manuscript was an object of luxury. The duke's love of illuminated manuscripts and the Limbourgs' talents intersected, and resulted in a monument of surpassing quality, the *Très Riches Heures du Duc de Berry* (Very Rich Hours), of about 1415. This book of hours contains a series of calendar pictures that are strikingly novel. It was traditional for books of hours, which contain liturgical text meant for private prayer and meditation, to begin with twenty-four small illustrations of the signs of the zodiac and the labors of each month. But the Limbourgs disregarded this tradition and instead painted a comparatively large picture of each of the labors, with the complicated astrological information placed in an arch above each picture [p. 116]. Thus these calendar pages escaped the often narrowly conceived world of manuscript illumination to become, despite their miniature format, major

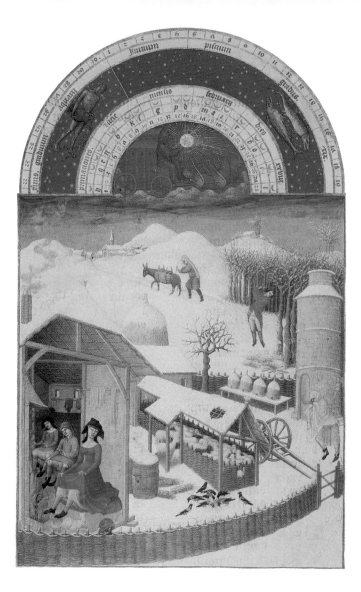

LIMBOURG BROTHERS, FEBRUARY, FROM *LES TRÈS RICHES HEURES DU DUC DE BERRY*, c. 1415. *Winter's hardships during the year's coldest month are eloquently expressed in this portrayal of rural life. It is one of the few scenes that does not include a ducal manor as a setting, showing instead the humbler existence of peasants.*

cold, gray world of distant villages and fields is contrasted with a peasant family warming themselves at the little fire in their hearth. There is a genius for realistic depiction here that came to be an integral part of the Northern tradition. In the February scene the carefully observed beehives, whose tops are covered with snow, the frozen haystacks, the barren trees, and the birds eating the grain left for them by peasants demonstrate a new interest in and love for the natural world. There is also a feeling of joy in the coziness of the little house and delight in the beauty of the snowy landscape.

Philip the Bold, the duke of Burgundy from 1363 until his death in 1404, concentrated his patronage on the charterhouse of the Carthusians, the Chartreuse of Champmol, located just outside Dijon. Its cornerstone was laid in 1385, and vast sums of money supported the construction of a monastery, a large cloister, and a side cloister designed as the burial site for the dukes. The lavish decorations included masterpieces by Claus Sluter (c. 1350–1406), still regarded as the foremost sculptor of the North in the fifteenth century. For the large cloister, Sluter designed and carved a monumental assembly of architecture and figures that had at its base the *Well of Moses*, a fountain of life from which emerged a crucified Christ whose blood would wash away the sins of the faithful [p. 117]. A few fragments are all that remain of the crucifix, but the well, together with its attendant Old Testament prophets Moses, David, Jeremiah, Zechariah, Daniel, and Isaiah, is still intact. A marvelous fusion of architecture, ornament, and form, the Moses well is a masterpiece of design and characterization. Its hexagon shape provides settings for six figures. Each figure seems to be a living individual, with

works of art. These pages are, in fact, among the earliest and finest incunabula of Northern art.

The panoramic landscapes of the Limbourgs' calendar pages are inventive and charming. They realistically show the buildings (some of them owned by the duke) and activities of both nobility and peasants. The Limbourgs observed and analyzed the world about them and found new pictorial conventions and techniques to set down their observations. Like all major artists, they borrowed motifs, techniques, and styles, but modified what they took. They infused the landscapes of their great book of hours with highly refined observation, accurate detail, and a real feeling for the land and for the people who worked and lived on it. This is especially evident in the February scene, where the

CLAUS SLUTER, WELL OF MOSES, 1396–1405. *To make these figures even more lifelike, Jean Malouel, an uncle of the Limbourg brothers, was hired to complete the sculptures by painting them. Moses' robe was gilt; and Jeremiah, the scholarly prophet (at the left), sported a pair of copper spectacles.*

distinctive character and mood, alternately brooding, meditative, or argumentative.

The most striking of these figures is Moses, magisterially enveloped by voluminous robes yet more dignified than any Roman patrician in similar dress. His beard and hair are a torrent of curls divided neatly in half. He grasps the tablets of the Ten Commandments in his right hand, and a scroll unfurls in his left hand that carries the text "The Children of Israel do not listen to me." Larger than life size, Moses and his companions are described with a profusion of detail that threatens to, but does not, overwhelm the integrity of each figure. Above them, along the entablature, a series of angels in a more repetitive pattern forms a celestial crown.

In his *Well of Moses,* Sluter rethought the relationship between figure and setting. These prophets are not merely the descendants of the pillar figures of the cathedrals grown more lifelike and liberated from their setting; they are, instead, human beings who have stepped from the real world onto the symbolic setting of the well. They wear the costumes of the prophets, and they so convincingly act their parts that we come to believe their holiness despite their obvious realism.

After Philip the Bold died, his grandson Philip the Good (duke of Burgundy from 1419) attracted the next generation of important artists, including Jan van Eyck. The realism and detail of the art of the Limbourg brothers parallel, and probably influenced, the remarkable work of van Eyck. His precocious realism appealed equally to the princely patrons and to the wealthy merchants of the Low Countries (the dukes of Burgundy ruled Flanders until the 1470s). Here, in the flourishing commercial centers of Bruges and Ghent, developed an art of great realism and crystalline clarity. The presiding genius of this new art, Jan van Eyck was an artist whose reticence and delicacy produced lasting visual and intellectual images.

Van Eyck's legacy includes several paintings that, like contemporary works in Italy, reflect the increasing secularism of a burgeoning commercial society. This is nowhere better seen than in one of the most famous of his works, *Giovanni Arnolfini and His Bride* [p. 118]. What is most striking about this diminutive painting is the realism of its microcosmic world. The startling fidelity of the figures of Giovanni Arnolfini (an Italian financier from the Tuscan city of Lucca working in Bruges) and his wife and the surrounding objects is one of van Eyck's greatest achievements. He was aided in his

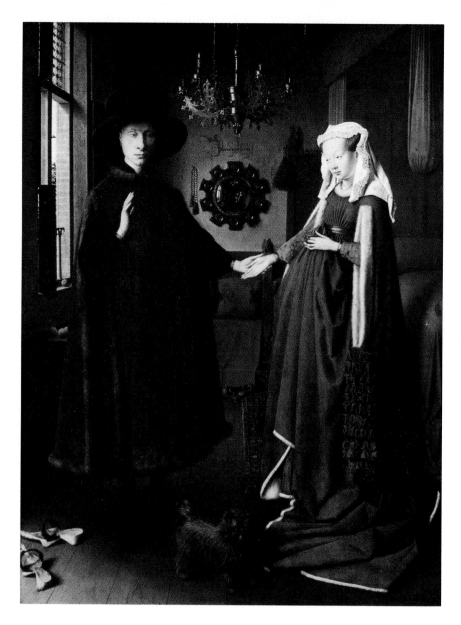

JAN VAN EYCK, GIOVANNI ARNOLFINI AND HIS BRIDE, 1434. *Arnolfini was a banker from Lucca, Italy, who worked in Bruges. This painting may have been intended to be sent to his hometown as a record of his marriage in the distant north. The solemn scene, together with witnesses, is reflected in the mirror (below).*

quest for realism by his utilization of a medium that had been known, but scarcely used, for at least a century: oil paint. With this medium, in which pigment is suspended in an oil vehicle, the painter can achieve a more dramatic range of lights and darks and deeper, more varied color than with the traditional medium of tempera. With oil, the artist could also meld one layer of pigment into another for greater subtlety and rework or correct his painting with relative ease. Van Eyck probably chose to use

oil paint because it allowed him to reproduce objects with greater fidelity than ever before.

Van Eyck's rendering of the structure and surface of things—the heavy clothes of the figures, the fur of the little dog, the brass of the chandelier, the brick of the window frame—is unprecedented. The colors in the painting are remarkable for their deep saturation and variety. But van Eyck's ability to reproduce, almost duplicate, the effects of light streaming in from the window is even more note-

worthy; never before in the history of art had light been painted with such realism.

The painting clearly is filled with objects that held specific symbolic meaning for the fifteenth-century viewer, although much of this meaning has been lost. Thus, exactly what is happening in this picture is unclear. It has been suggested by scholars that this is a pictorial record of the wedding of Giovanni Arnolfini and his bride, Jeanne. Many objects in the painting may serve a dual function. They help to describe the couple's room and give it a specific character, but the objects also carry symbolic messages that may gloss a wedding ceremony: the oranges ripening on the windowsill are symbols of fertility, the dog is an emblem of fidelity, the mirror stands for purity. Marriage was a sacrament that did not need to be (and, in fact, usually was not) performed in a church by a priest. Instead, marriages and the equally important act of betrothal were often solemnized at home, and it may be that the small figures reflected in the mirror are witnesses to the event.

Whatever the exact subject, this portrait is a landmark in the history of painting. The probing, analytical realism of the small room with its beautiful, lovingly painted appointments bathed in the steady light, while certainly based on the pictorial experiments of some of van Eyck's predecessors, including the Limbourg brothers, was new. Van Eyck has created an atmosphere of absolute stillness; the two figures stand motionless in the purity of the light that sanctifies all it touches. This is one of the earliest depictions of light diffused through atmosphere and reflected and absorbed by various objects. Although everything in *Giovanni Arnolfini and His Bride* seems almost preternaturally real, the picture is, paradoxically, pervaded by a deep sense of mystery. Jan Vermeer, the great seventeenth-century painter of luminous silence, is van Eyck's only rival in the depiction of such spiritual interiors.

It is no surprise that van Eyck's near obsession with the replication of things in paint led him to portraiture. His portraits, like his altarpieces, helped establish the parameters of the type for the next century. All of van Eyck's portraits [p. 119] have a veracity that is very different from contemporary Italian examples. No matter how close to the actual appearance of the sitter the Italian portraits came, there was always an abstraction and a style inter-

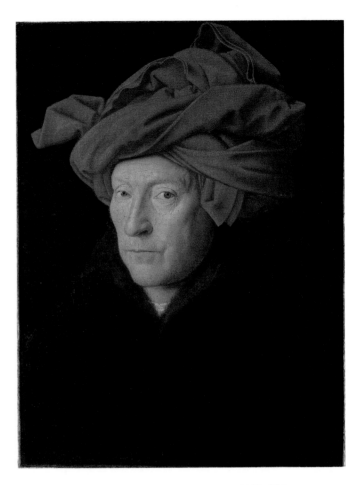

JAN VAN EYCK, MAN IN A RED TURBAN, 1433. *This painting, done in a mixture of oil and tempera paints, is thought by some scholars to be a self-portrait.*

posed between sitter and observer. Portraits by van Eyck, and Northern portraiture in general, get much nearer to the sitter; in them, the illusion prevails that art has not been interposed between sitter and viewer.

The faces that look out from the portraits by van Eyck and his Northern contemporaries are unidealized. In them one sees character formed by age and reflected in all the minutely reproduced wrinkles and sags of the human face. Yet there is much more to these portraits than the reproduction of reality. They are also wonderful works of art that strike a delicate and highly contrived balance between the particularization of the face and the patternlike abstraction of the hats, jackets, and dresses that surround them. But, ultimately, the faces are mysteries. These people, who seem so near, do not

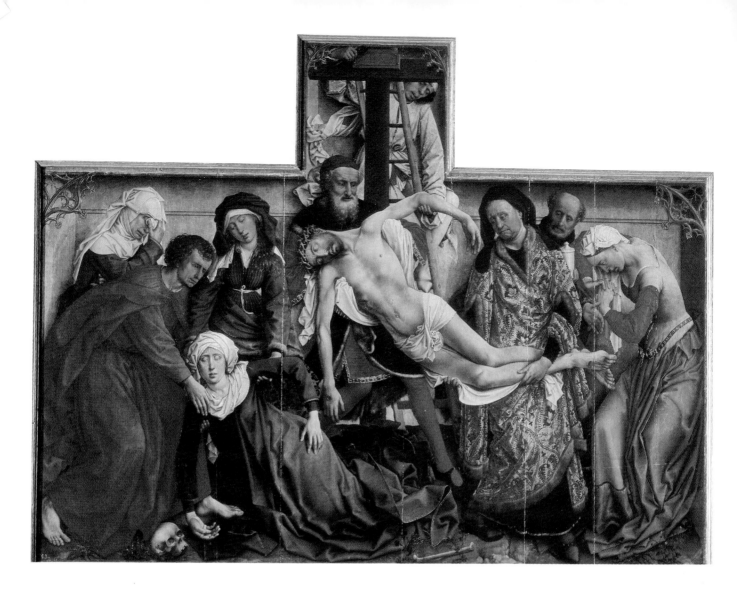

ROGIER VAN DER WEYDEN, DESCENT FROM THE CROSS,
c. 1435. *In this large panel painting (about 7 x 8') Rogier*
seems to have been influenced by contemporary carved
wooden altarpieces that presented their substantial figures
(sometimes life-size) against a blank background.

really communicate much about themselves; their
thoughts and feelings are hidden behind a mask of
heightened reality.

Northern artists of the fifteenth century also
produced masterpieces of devotional art. Van Eyck
himself painted a number of deeply felt altarpieces,
which had considerable influence on younger paint-
ers, including Rogier van der Weyden (1399/1400–
1464), his most brilliant follower. Rogier's master-
piece of c. 1435, *Descent from the Cross* [p. 120], is

an exceptional work in which the intense realism of
van Eyck has been used to create images taut with
pathos. Rogier has placed his figures against a wall
of shimmering, space-denying gold. In their shallow
niche they are hemmed in on all sides by the frame;
in fact, there is barely room for them to stand. The
claustrophobic, airless feeling perfectly expresses
the overwhelming grief of the small group of Christ's
followers. Bracketed by the bending bodies of John
the Evangelist and Mary Magdalene and knit to-
gether by the two great echoing diagonals of the
dead Christ and his unconscious mother, the scene
is a visual dirge.

But Rogier van der Weyden understood that the
subject required more than realism and thereby in-
jected a number of dramatic devices to bring out the

palette, both created and reflected the harrowing sadness of the event. Certain colors, such as the reds worn by the bracketing figures or the blue sash of the Madonna's robe, help delineate and bind the compact group of figures, each of the saturated hues reinforcing the central message of the altarpiece.

Rogier van der Weyden's *Entombment* [p. 121], about 1450, which he seems to have painted after a trip to Italy where he saw and was influenced by Florentine painting, is filled with the same sorrowful spirit as *Descent from the Cross,* although it is expressed more quietly, more meditatively. The altarpiece gives visual form to the central ritual of Catholic worship, the Mass. Christ, who died for mankind, and whose body and blood are miraculously reconstituted in the Host and in the wine, is presented to the communicant. The altar on which the *Entombment* would have stood was often called the tomb of Christ: the altarlike stone slab supporting the feet of the dead Christ and the tomb in the background of the *Entombment* would have helped the worshiper visualize the miracle of the Mass and reinforced the sacrificial nature of Christ's death. The commingling of reality and symbol, of restrained but deep emotion, makes this light-filled landscape a masterful work of considerable intellectual complexity.

An interesting exchange between the Northern tradition and the burgeoning art of Florence occurred when Tommaso Portinari commissioned Hugo van der Goes, one of the most important Northern artists of the second half of the fifteenth century, to paint a large triptych [pp. 122–23] (a three-paneled altarpiece) whose center panel was to be an Adoration of the Shepherds. Portinari, a Florentine, was an agent of the Medici bank in Bruges; like Giovanni Arnolfini, he was one of the many Italians working in the bustling financial and commercial centers of the North. The altarpiece, commissioned for the church of Sant'Egidio in Florence, would have been one of the largest panel paintings in the city at that time. Portinari obviously wanted to make an impression with an altarpiece remarkable not only for its size but for its foreign style and interpretation.

Hugo van der Goes was born about 1440 in Ghent, the hometown of Jan van Eyck, and like many subsequent Northern artists, Hugo fell under

ROGIER VAN DER WEYDEN, ENTOMBMENT, C. 1450.
Rogier's trip to Italy in 1450 must have taken him through Florence, where there was considerable interest in Northern painting; at least two works (still extant) by the artist were commissioned by the Medici family.

power of the story. The painting is made as unreal by these devices as it is real: the figures are shown in unnatural poses, which create a piquant contrast to their apparent realism. Tilted at angles, lifted to the picture plane, Rogier's distorted figures reveal their origins in the Northern sculptural tradition, not in the graceful, harmonious world of Italian painting; they are counterparts to the linear, space-denying, abstracted carvings of Gothic sculpture.

A talented colorist, Rogier, with his somber

TAPESTRIES
OF THE NORTH

Craftsmanship of many kinds
reached an exceedingly high level in Northern
Europe as well as in Italy, but the North,
most notably Flanders, was a pioneer in the

HUGO VAN DER GOES, PORTINARI ALTARPIECE, C. 1476. *The side wings of this triptych contain portraits of Tommaso Portinari, his wife, and children. These figures, almost life-size, are among the largest and most conspicuous in all of contemporary Florentine art.*

development of tapestry weaving. An ancient craft that can be traced back to the Egyptians, tapestry weaving gained royal patronage and began to flourish in the North during the era that the Dukes of Burgundy owned Flanders. The seven Franco-Flemish "Unicorn" tapestries of c. 1499–1514 reached a high point of tapestry weaving. Shown here is one panel depicting the hunt and capture of the mythical unicorn.

the spell of that great artist. The master and later dean of the painters' guild of Ghent, Hugo was an important figure in the art world there. The *Portinari Altarpiece* is his most famous work. In 1478, suffering from bouts of madness, he moved to a monastery, where he may have finished the altarpiece; according to one contemporary account he was convinced of his own impending damnation. He died in 1482 after a severe mental breakdown.

The center panel [p. 124] of the *Portinari Altarpiece* shows the sort of empirical space that was so different from the much more rationally planned one-point perspective system of the Florentines. The space seems to tilt up, and the figures appear loosely and randomly placed on the sloping ground. But within this inexact spatial world, there are passages of the utmost realism and accuracy: the faces of the eager, weather-beaten, and only half-comprehending shepherds; the brilliant portrayal of the angels' gold-encrusted robes; the splendid architectural detail; and, above all, the beautiful still life of the vases and flowers in the immediate foreground, unifying the spiritual and material realms. As Northern painting became more overtly realistic, everyday objects at the same time increasingly took on symbolic meanings. Thus the lilies in the still life symbolize the Virgin; the light passing through the glass represents her purity; and the sheaf of wheat represents the Eucharistic wafer, the body of Christ, whose infant form is presented to the communicant above the grain. Such symbolism is a particular characteristic of Northern painting.

The *Portinari Altarpiece* quickened the dialogue between the arts of the North and Italy. Florentine artists and their patrons stood in amazement before such complicated narrative and space, rendered with so much detail and clarity. They also were impressed by the artist's use of the oil medium, which was not yet popular in the Italian peninsula but, partially due to the influence of the *Portinari Altarpiece,* was to gain increasing favor there. Above all, the Florentines marveled at such an accurate and minute reproduction of the physical world; although they were fascinated with the problems of reality and materialism, they had not attempted to make the subject seem so real. In many ways, the mentality of the men who paid for the altarpieces and portraits—the merchants and bankers of Ghent, Bruges, and Florence—was the

HUGO VAN DER GOES, PORTINARI ALTARPIECE, CENTER PANEL, C. 1476. *This large altarpiece must have been an object of considerable interest to the painters who saw it in the Florentine church of Sant'Egidio, where it was installed about 1483.*

same. But the visual, concrete expression of the individualism, realism, and secularism that they felt was quite different. And these different modes of expression, as the strong effect of the *Portinari Altarpiece* on contemporary Florentine painters proves, influenced and strengthened each tradition and helped make both seminal forces in the art of the Western world.

Parallel to the development of the highly realistic altar paintings was the *Schnitzaltar,* an elaborately carved wooden altarpiece, often with many wings, which had fully round and relief images of saints and biblical scenes. Often polychromed, these altars were a union of sculpture, architecture, and ornamentation, combining elements from mystery plays, religious dogma, worship, and storytelling. For a society thirsting to make the intangible tangible, carved altarpieces were perhaps even more satisfactory than painting. On occasion such monuments of craftsmanship reached the level of high art.

One such masterpiece is the *Saint Wolfgang*

Altarpiece, made between 1471 and 1481 by Michael Pacher (c. 1435–1498) for the church of Saint Wolfgang on the Abersee in Austria [p. 125]. Carving in limewood, Pacher re-created the same holy ritual Filippo Lippi depicted in *Coronation of the Virgin*, but here only two human attendants are present: Saint Nicholas and Saint Wolfgang, each with requisite croziers and robes. Pacher's beautiful Virgin, with her cascading ringlets and high-domed forehead, kneels in adoration before the blessing Christ. The whole assembly is a virtuoso display of carving, demonstrating the remarkable potential of the hard, fine-grained limewood. Shaved down to nearly knife-blade thinness for the drapery, the wood is also cut and gouged to describe the complicated arrangement of robes and gowns. While the wood's brittle nature and its capacity to give sharp, clear edges were exploited for the drapery, its solidity and its response to the slightest, most subtle shaving were utilized to convey Mary's soft flesh, her slightly double chin, her delicate hands. The already intricate altar adds a labyrinthine complexity in the surmounting tracery, which interlocks in such multiple forms that the scene below seems simple by comparison.

What lifts this work above the level of mere technical mastery is Pacher's ability to give character and expression to his figures. From the gentle dignity of the Virgin to the more austere eloquence of the saints, Pacher's figures are animate and believable. Yet they have come no further than Sluter's sculptures, done more than half a century earlier. Pacher's altar is tangible, sumptuous, dazzling, but its characters are remote. Carved to impress, the altar first and foremost declares its separation from the mundane by the very ostentation and stateliness of its ritual and by the majesty of its characters. It is a palpable visualization of a mystery, but an equally powerful reminder of its remoteness from everyday reality.

Much the same attitude underlies another outstanding achievement of wood carving: Bernt Notke's *Saint George and the Dragon* of 1489 [p. 126]. When Notke (c. 1440–1509) was asked to make a funerary monument for Sten Sture, the Swedish regent, he produced a Gothic extravaganza. He carved a knight complete with armor, mounted on a horse, both life sized; they battle a spectacular dragon fitted out with bat wings, horns,

MICHAEL PACHER, SAINT WOLFGANG ALTARPIECE, 1471–81. *Various levels of illusionism were a favorite device of Northern artists, who mixed painting and sculpture in ways that anticipated seventeenth-century developments.*

and teeth. In this work, called a monument to Sture's victory over the Danes, again personality and individuality—in fact, humanity—are eschewed in favor of the older conventions of symbol, splendor, and technical mastery—so unlike the *Saint George* that Donatello had created more than fifty years earlier. A hero by virtue of his character, will, and personality, Donatello's Saint George was a human being first and a saint second. In Notke's hands, Saint George became an excuse to carve an elabo-

rate costume and a complex arrangement of figures, and to demonstrate his technical abilities.

The whole scene is a romantic medieval adventure. The armored knight, the beautiful princess, and the elaborate dragon all reenact a dream already waning when the Limbourg brothers painted their charmingly detailed scenes for Jean of Berry almost a hundred years earlier. By the end of the fifteenth century, bourgeois urban life, mercantilism, and humanism had helped supplant the feudal world that bound vassal to knight and knight to king. Romance, fairy tales, and knightly legends were embedded in fifteenth-century culture, and Bernt Notke's *Saint George* is not merely an equestrian monument and a tomb, it is also a gorgeous expression of a fading dream.

At the end of the fifteenth century technical virtuosity may have supplanted narrative concerns, as can be seen in Tilman Riemenschneider's works. This German sculptor, active about 1478–1531, often chose not to color his carvings so that the natural wood grain would be evident: the object was meant to be appreciated as a carving instead of a simulacrum. Not all Riemenschneider's patrons accepted his novel decision to leave his sculpture with a natural finish, but one of his most famous works, the *Altarpiece of the Assumption of Mary,* done between 1505 and 1515 for the Herrgottskirche, Creglingen, was left unpainted [p. 127].

Here Riemenschneider's accomplishments as a carver are immediately apparent, since they are not obscured by polychromy. Riemenschneider turned the scene of the Assumption into an essay on light and shadow. The flickering patterns of dark and light of the convex and concave surfaces of the wood lend a sense of agitation, movement, and energy to the scene. Using the inherent property of the wood to describe edges, Riemenschneider turned the Virgin's windswept mantle into a series of eddies and pools of fabric. Her face is impassive, her gesture traditional. She is weightless and graceful, despite her voluminous gown. The apostles bid her farewell with intense expressions, as though they were witnessing a vision instead of an actual event. The whole assembly takes on a pyramidal configuration that is gracefully echoed in the curved shape of the altar's top. This is surmounted by yet another arrangement of Gothic tracery, in which a smaller, more distant Madonna receives the crown of

BERNT NOTKE, <u>SAINT GEORGE AND THE DRAGON,</u> 1489. *Executed in the same year as Memlinc's little Gothic church, Notke's* Saint George *is a similar look at the past. Meant to commemorate the victory of the Swedish army under the regent Sten Sture over the Danes in 1471, it combines the equestrian statue with tomb sculpture.*

heaven. A sophisticated arrangement of large and small patterns, the whole image has the insubstantial quality of a mirage: bodies too thin to be real, faces with features too exaggerated and large, the setting far too shallow for so many figures. Hovering dramatically between materiality and illusion, Riemenschneider's altar signals the apogee of the *Schnitzaltar* before its rapid decline in the sixteenth century.

During the last decades of the fifteenth century,

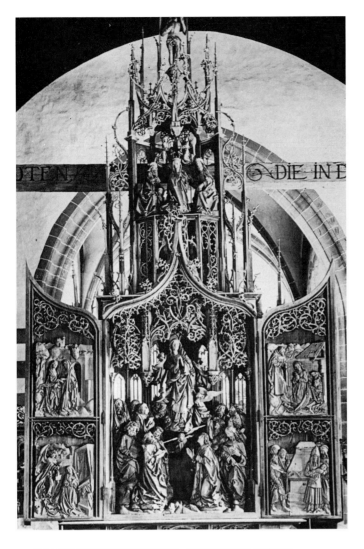

TILMAN RIEMENSCHNEIDER, ALTARPIECE OF THE ASSUMPTION OF MARY, C. 1505–15. *For centuries, Mary's bodily ascent into heaven, aided by angels, was celebrated as an annual church festival. The subject was often treated by artists in the Middle Ages and Renaissance. Riemenschneider's theme of Mary's assumption is surrounded by scenes from her earlier life.*

prints emerged as a new and important art form. One of the earliest masters of the print was Martin Schongauer (c. 1430–1491), who worked in a medium—engraving, in which a copper plate was incised with a burin, then inked and pressed on paper —that was as inexpensive as the *Schnitzaltar* was costly. Moreover, Schongauer and other printmakers worked for a wider and less aristocratic audience. Inexpensive engravings and woodcuts were sold at fairs, from workshops, and by booksellers.

The people who bought prints, like those who commissioned paintings, preferred religious subjects. One of Schongauer's most accomplished early works is his *Temptation of Saint Anthony*, engraved about 1480–90 [p. 128]. Showing an episode in the life of a hermit saint who was plagued by demons, Schongauer made the demons seem alive and yet fanciful. Though grotesque, they are not without humor as they poke, prod, and tug at the long-suffering Anthony; not only have they descended upon him like a horde of bizarre locusts, they have pulled poor Anthony into the sky. Impassive, Anthony is steadfast, and his torture is described in vivid detail through volume, light, texture, and gradations of tone extracted from the limited material of dark ink on white paper. In this engraving a mystical experience has become real.

Indeed, mysticism, and the desire to know the unknowable through the use of metaphor and imagery, inspired the transcendent realism of the fifteenth-century Northern artists. In a culture where tradition was powerful and the future was regarded with trepidation, the art of the North remained codified and ritualized; at the end of the century it looked to the past for protection and guidance, rather than to the future.

Nonetheless, humanism also flourished in the North, and was especially channeled into religious reforms. Erasmus of Rotterdam, Thomas More of England, and Martin Luther of Germany were the leaders of a movement based on humanistic training and a close reading of biblical texts to challenge the authority of the corrupt and secular papacy in Rome. In 1517, Martin Luther had nailed his ninety-five theses to the door of Wittenberg Cathedral, crystalizing the Reformation movement and setting the Reformers on a path that would ultimately rend the fabric of the unified church.

Germany was home at that time not only to the founder of the Lutheran faith but to a number of important artists, including the greatest engraver, draftsman, and painter of the late fifteenth and early sixteenth century, Albrecht Dürer. Born in Nuremberg in 1471, where he died in 1528, Dürer closed one era and opened another. He was deeply pious and remained a lifelong Catholic, yet he admired both Erasmus and Luther, the founders of the Reformation. The themes of Dürer's early work reflect the lingering mentality of the waning Middle Ages,

but his later work is an enlightened and original discourse on the Italian Renaissance. Dürer's meticulous craftsmanship and his obsession with detail place him squarely in the tradition of Jan van Eyck and his followers; but in his search for ideals of proportion, and for mathematical systems by which to structure his vision, and in his insatiable visual appetite, Dürer became the German counterpart to Leonardo da Vinci.

Like Leonardo, Dürer drew incessantly. His drawings, watercolors, and diary entries trace his many journeys to observe and record. Dürer's watercolor studies of clumps of grass, animals, and land-

MARTIN SCHONGAUER, TEMPTATION OF SAINT ANTHONY, CA. 1480–90. *An early Christian saint, Anthony (A.D. ?251–356) is often credited with founding the monastic movement. Anthony's legendary temptations during his ascetic desert life were subject to numerous pictorial interpretations throughout the Middle Ages and the Renaissance.*

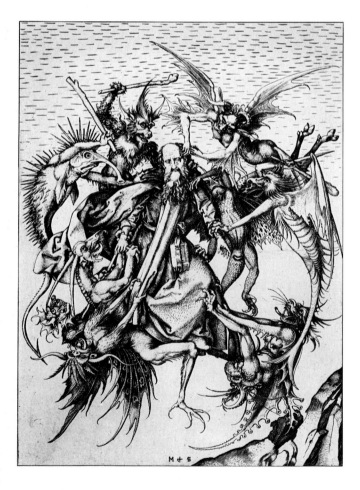

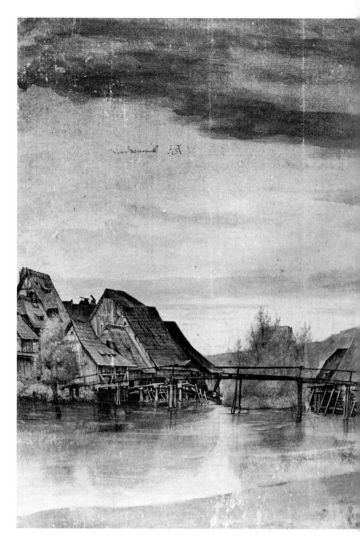

ALBRECHT DÜRER, WILLOW MILLS ON THE PEGNITZ, C. 1496–1500. *Using the portable materials paper, water, and powdered pigments such as tempera, Dürer probably recorded this landscape on the spot—a rare practice for artists in his day but increasingly prevalent in the seventeenth and later centuries.*

scapes are precociously scientific in their objective transcription and range of subjects, though latently medieval in their unquestioning acceptance of surface reality without any systematic attempt to penetrate to underlying principles.

The landscapes Dürer produced on his numerous travels are among the earliest independent treatments of the theme and anticipate the interest landscape would generate among Northern artists of the seventeenth century. His *Willow Mills on the*

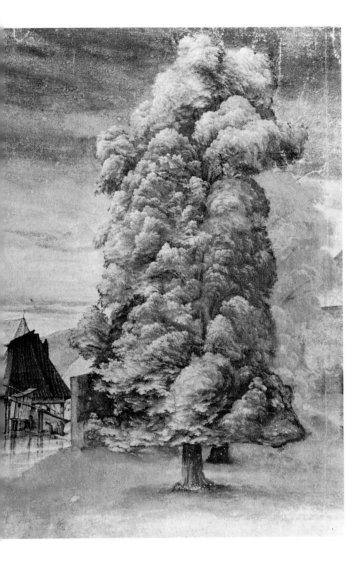

tions of Saint John had to say about an anticipated end. The result was fourteen full-page woodcuts that translate Saint John's written descriptions into compelling images.

The most famous of Dürer's *Apocalypse* scenes is the *Four Horsemen of the Apocalypse* [p. 129], who bring with them war, famine, death, and hell. Using the linear visual language that was his heritage, Dürer powerfully described the scene in vivid

ALBRECHT DÜRER, FOUR HORSEMEN OF THE APOCALYPSE, 1498. *Woodcuts, made by cutting away wood except for the lines upon which ink is to be rolled to register the image on paper, were a simple, inexpensive, and popular art form, affordable for far more people than painting was. A master of the woodcut, Dürer took pride not merely in describing but in embellishing and in adding twists, curls, and extravagances of all kinds to his lines to demonstrate his technical virtuosity.*

Pegnitz [pp. 128–29] may have been painted some time after he returned from his first trip to Venice, about 1496. For Dürer, the river that flowed on the outskirts of Nuremberg became the subject of a watercolor simply because he saw it as he walked about his city. Atmospheric effects, the local flora, including the wispy river willows, and the high-peaked houses, are masterfully described but also interpreted. Dürer's watercolor has transcended mere topographic description and has made nature into art.

Dürer's first great success as a printmaker was connected with Europe's obsession with the century's end: people were gripped by the fear that the year 1500 would bring the end of the world. Dürer responded to the moment by producing, in 1498, an illustrated *Apocalypse,* showing what the revela-

detail. The entire image explodes with movement as horses trample people underfoot. Anxiety emanates from every line and form. A bishop falls into a monster's open jaws, while God's destructive forces reclaim the earth and cleanse it of its evil, as the horsemen move forward, sparing no one. Intended for the general public, Dürer's *Apocalypse* was an immediate success, bringing him fame in Germany, Italy, and throughout Europe.

Dürer not only mastered the woodcut, he became an unparalleled engraver. His ability to make the copper plate yield diverse effects of line, light, shade, and texture is the union of infinite patience and brilliant technique. One of his most celebrated engravings is *Adam and Eve* [p. 130], done in 1504, the year that Michelangelo completed his famous *David.* Here Dürer joined the quest for the ideal beauty and proportions of the human figure that had inspired Italian masters of the time to look at surviving works of antiquity. Dürer's *Adam and Eve* reflects the antique *Apollo Belvedere* found in 1489–1490 and an antique Venus of the type exemplified by the *Medici Venus* in Florence. He placed these gods in the gloomy precincts of a dark German forest, surrounded by local as well as exotic fauna.

For Dürer, Adam and Eve provided the opportunity to describe the most perfect of God's creations, who, through their disobedience to Him, doomed their descendants to physical as well as spiritual imperfection. Thus these medieval symbols of human corruption stand before the viewer as embodiments of Renaissance ideals of flawless beauty and grace. Dürer's methodical burin has transcribed every wave of Eve's luxuriant tresses, and every hair of the cat's thick coat. Symbolically, the cat and all the other forest creatures explain the nature and consequences of the Fall: as the cat traps the mouse, Eve caught Adam, and their sin of disobedience brought into being the four temperaments, or humors—the phlegmatic, choleric, sanguine, and melancholic personalities.

Subject to fits of melancholy himself, Dürer endured its torments and regarded melancholy as the natural temperament of the artist. In this respect Dürer shared with his contemporaries in Italy a new understanding of the artist, as someone apart from and above the rest of society because of his creative spirit. One of Dürer's greatest engravings is a cautionary discourse on the nature of melancholy.

ALBRECHT DÜRER, ADAM AND EVE, 1504. *Engraving relies on ink being deposited in the small depressions carved into a copper plate by a burin. The results are more complex than woodcutting and the efforts more painstaking. No artist surpassed Dürer in his mastery of engraving.*

Produced in 1514, Dürer's *Melancholia I* [p. 131] anticipates the doubts and frustrations about the creative quest that later found expression in Italy. Slumped into tormented passivity, Melancholia stares into space. Implements of thought, measurement, and creation lie about, discarded and useless in the pursuit of artistic perfection. Obsessed with thought, Melancholia embodies its futility. Utilizing his unlimited technical abilities, Dürer, in his *Melancholia,* set about describing the nature of his own artistic limitations. To Dürer, technical mastery was achievable, but artistic endeavors often led the artist to the unknown and the unreachable. What the human mind pursues is ultimately elusive and mysterious; Dürer's portrayal of Melancholia was one of the earliest expressions of artistic frustration. His message was destined to be echoed

by many other voices over the centuries, by artists liberated from their role as pure craftsmen and confounded by their freedom.

Dürer stands alone in Northern art for the range of his subject matter, which includes not only traditional themes but, as in his *Melancholia*, new concepts. His great contemporary, Mathis Gothart Neithart, called Matthias Grünewald, was an equally remarkable painter, but his subject matter remained that of religious art. However, Grünewald looked at traditional subjects anew, interpreting them with great psychological insight and endowing them with a startling power of expression.

Born about 1475, Grünewald was probably an

ALBRECHT DÜRER, MELANCHOLIA I, 1514. *Produced ten years after his* Adam and Eve, *Dürer's* Melancholia I *is a dramatic departure from the confident and idealized vision in the earlier work. Though a single, comprehensive interpretation of the* Melancholia *has never been achieved, its fundamental meaning, of intellectual and creative despair, is self-evident.*

Dürer's fascination with measurement (reflected in both his *Adam and Eve* and his *Melancholia*), his refined technical precision, and his high level of craftsmanship were echoed in the many exquisite instruments produced in the North during the sixteenth century. One of the finest of these was the Astronomical Globe made by Gerhardt Emmoser for Emperor Rudolf II in 1579. Portraying a Celestial sphere on the back of the mythological winged horse Pegasus, this device was used to establish the position of stars and constellations.

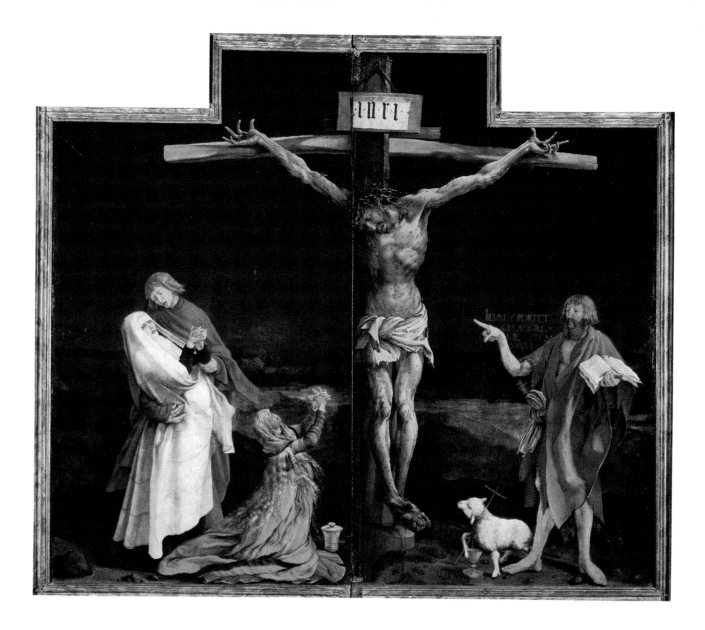

**MATTHIAS GRÜNEWALD, CRUCIFIXION, FROM THE
ISENHEIM ALTARPIECE (CLOSED), C. 1510–15.** *The*
Isenheim Altarpiece, *which was finished only about a decade
after Grünewald's first datable painting, is the artist's
masterpiece.*

architect and engineer as well as a painter. His sur-
viving works are few, and his fame arises principally
from one large altarpiece, now at the Unterlinden
Museum at Colmar, but originally commissioned
about 1510–15 for the Antonite Monastery at Isen-
heim. The *Isenheim Altarpiece* is a large, compli-
cated work incorporating several wings (painted on
both sides) and wooden sculpture done by another
artist. With the opening and closing of its parts in
various combinations, the imagery of the altarpiece
could be adjusted for different feast days; this sort
of complicated, transformable altar was found
throughout the North.

The central picture of the *Isenheim Altarpiece*
is the *Crucifixion* [p. 132], a compelling, powerful
work. In what appears to be a night scene, the
greenish, battered body of Christ hangs on a rude
cross. Twisted, broken, and covered with the punc-
tures of a hundred nails and thorns, and clothed
only in a frayed and dirty loincloth, Christ is a

MATTHIAS GRÜNEWALD, TEMPTATION OF SAINT ANTHONY, C. 1510–15. *Like much of the rest of the* Isenheim Altarpiece, *the* Temptation of Saint Anthony *(a saint frequently invoked against disease) is an obsessive depiction of human suffering.*

ghastly, shocking spectacle. He is simply, painfully, and horribly dead without any of the nobility and serenity that is so often an important part of a Crucifixion. On both sides of this apparition are arranged the small group of Mary, Mary Magdalene, Saint John the Evangelist, and Saint John the Baptist. The Baptist's presence is not historical (he pre-deceased Christ), but didactic: he points to Christ and says, in words written behind him, "He must increase, but I must decrease" (John 3:30).

This brutal Crucifixion, as John's words suggest, offers hope for salvation through Christ's sacrifice, but it also dwells on the mortal pain and physical degradation of the act of crucifixion. The members of the Antonite order would have been familiar with human suffering because they were active in the care of the diseased; Saint Anthony himself was invoked for protection against the dread, painful, and deadly Saint Anthony's fire, a widespread bacteriological illness. The sick were

**PIETER BRUEGHEL THE ELDER, MAGPIE ON THE
GALLOWS, 1568.** *A master of the bird's-eye view of landscape,
Brueghel used it to provide a sweeping panorama.
The scene may reflect the invasion of Brussels by the Spanish,
who between 1567 and 1569 slaughtered six to eighteen
thousand men, women, and children.*

brought to the *Isenheim Altarpiece,* where they
would have seen that their own sufferings were
matched by those of Christ and his followers. They
would also have known that Christ was able to tran-
scend his terrible earthly condition and that his sac-

rifice made it possible for them to eventually do the
same. The grisly and disturbing *Crucifixion* from the
Isenheim Altarpiece must have been a beacon of
hope for the afflicted who were brought to pray be-
fore it.

In other parts of the *Isenheim Altarpiece,*
Grünewald showed the dark world of demons. The
Temptation of Saint Anthony [p. 133], based on an
engraving by the printmaker and painter Martin
Schongauer, is a particularly graphic and horrifying
treatment of a traditional subject. Everything in the
painting, including the spectral Saint Anthony and

the weird landscape, is bizarre. These monsters from Grünewald's strange imagination are the natural inhabitants of the dead and threatening bewitched landscape in which they exist. One other horrifying note is sounded by the bloated man dressed only in a hood in the painting's lower left corner. Covered with huge, oozing sores, and writhing with pain, he must have been viewed with considerable sympathy and understanding by the Antonite brothers and their patients who prayed for healing before this powerful altarpiece.

Both Dürer and Grünewald explored the human condition. Their creative imaginations channeled that knowledge into images that both mirror and transcend their time. Shortly after Dürer and Grünewald had died, a painter was born who was destined to establish the theme of man and nature as one of Northern Europe's most important subjects. Pieter Brueghel the Elder was born c. 1525 in the Netherlands, around Brueghel or Breda. He, like Dürer and other Northern artists, made his way to Italy, where the trip through the mountains, forests, and valleys of Europe may have inspired his enthusiasm for nature. In contrast to the prevailing fashion of his day, Brueghel did not emulate Italian art but retained his own, indigenous approach. He was an insightful student of human nature and a lover of the natural environment.

Working in the aftermath of the Reformation, in a period that witnessed peasant revolts, wars of religion, persecutions, class struggle, and economic upheavals, Brueghel embedded in his images an understanding of human folly as well as an appreciation of human dignity and endurance. Brueghel's portrayals of the months of the year, produced about 1565, show both the scope of his vision and his sensitivity to nature. *Hunters in the Snow* [pp. 112–13] belongs to this series. Depicting Winter, it is singular in its concentration on human efforts within a broad natural setting. Filled with anecdotal details that balance the panoramic sweep of the scene, the work shows humanity as part of nature. Seasons, weather, the contour of the landscape and the vegetation that grows upon it, all affect the lives of the people who live and work in, and reap the bounty of, the natural world.

An astute observer of humanity, Brueghel understood life in its broadest sense. His *Magpie on the Gallows* [p. 134] is a haunting evocation of human suffering, mortality, and cruelty, set within the grander scheme of social order, human folly, and endurance. Peasants dance, sing, laugh, and carouse in the shadow of gallows that have temporarily become the roost for a harmless magpie. Like the bird, the peasants are greedy for life, and hardy and industrious even in the face of death. The gallows, an instrument of death made by humans for use against others of their kind, are a stark reminder of the violence of the age, while the dancing people are symbolic of human indifference as well as human survival.

Unlike his Italian counterparts, who made the human figure their subject and its perfection their challenge, Brueghel took as his subject the reality of human existence. Quotidian in its approach, anecdotal in its treatment, and epic in its sweep, Brueghel's art made both humanity as it really was and nature as it actually looked the central subjects for artists of the next century. The great landscape painters of Holland and Flanders, such as Ruisdael, Cuyp, and Koninck, all studied Brueghel, while such great students of human nature and peasant life as Brouwer, van Ostade, Hals, and Steen also have roots in his work. Through Brueghel's efforts, satire, humor, pathos, and the vast parade of peasant and village life had joined the mainstream of artistic expression.

Brueghel's forthright and honest portrayal of life was worlds away from the art of the Italian Renaissance. When Brueghel died in 1569, Titian was still active and Tintoretto had another quarter of a century of work ahead of him. While Brueghel knew, absorbed, and transformed Italian sources, the Italians ignored his contributions. The human figure of nearly mythic proportions was and remained for them the supreme subject. In Italy during the sixteenth century, the unvarnished reality that Brueghel championed was ignored in favor of a heroic interpretation of the human form. Whereas Brueghel examined humanity for all its internal and external flaws, the Italian masters of the sixteenth century stripped them away, and celebrated the human form as a paradigm of perfection and beauty such as would never be created again.

MICHELANGELO, SISTINE CHAPEL CEILING, 1508–12. *Before Michelangelo repainted it, the Sistine Chapel ceiling had been painted to resemble a blue sky dotted with stars. The original program called for a painting of the twelve apostles, but after Michelangelo developed his own scheme, he painted more than three hundred figures on the ceiling.*

[8]

THE AGE OF TITANS: ITALIAN ART OF THE SIXTEENTH CENTURY

The sixteenth century has been called the Age of Exploration and Expansion; the Age of Reformation; the Age of Scientific Rebirth; the Golden Age; and the Age of the High Renaissance. It was also an age of individual genius. By the year 1500, the collective mentality which still lingered in the early Renaissance had been decisively abandoned. Between 1492 and 1600 Christopher Columbus, Amerigo Vespucci, and Ferdinand Magellan charted new paths to the West. Martin Luther's religious convictions led him to challenge papal authority and found a new faith. Copernicus pursued astronomy—his observations in direct contradiction to Christian dogma. Combining wishful thinking with insightful observation, in 1517 Niccolò Machiavelli finished writing *The Prince*, now a classic treatise on how ambitious men can seize and gain power. Though Machiavelli's hopes for a Borgia dynasty in Italy were never fulfilled, others more successfully followed his advice. Charles V, who kept a copy of *The Prince* by his bed, became Holy Roman Emperor in 1519, rul-

LEONARDO DA VINCI, ADORATION OF THE MAGI, BEGUN 1481. *In this large, unfinished drawing, Leonardo began shaping his figures from the outset as structures of light and dark. Such a notion departed radically from the standard practice of artists at that time, who generally set out a large design based on outlines. To add volume and mass they then added areas of shading.*

ing the largest empire in the West. The papacy enjoyed a golden age between 1500 and 1527. Artists filled Roman churches and papal buildings with masterpieces, and the secular power of Popes Julius II, Leo X, and Clement VII rivaled that of kings. But Rome eventually was brought to her knees by Charles V and his army in the Sack of Rome in 1527, and the Reformation ended the unchallenged authority of the Catholic Church. Charles's victories ultimately ended in defeat as well. Having tried to unify Europe under his rule, he abandoned the struggle, abdicated in 1556, and retreated to a monastery. His weariness of spirit is symptomatic of the dramatic contrasts between optimism and pessimism that permeated the age.

Many of the West's most legendary artists—Leonardo da Vinci, Michelangelo, Raphael, Titian, Tintoretto, and Veronese—were active during this era. They changed not only the direction of Western art but established the modern concept of the artist. Giorgio Vasari (1511–1574), who valued these artists sufficiently to write the first biographies of them, continually referred to their "divinely inspired" talents. His accounts of Leonardo, Michelangelo, and Raphael reveal that they dared to regard themselves as equal to their aristocratic patrons by virtue of their genius, a view that seemed to be accepted by even the most wealthy and powerful members of their society. Michelangelo defied Julius II, who went to extraordinary lengths to persuade him to return to Rome. Raphael received the unheard-of honor of having the niece of a cardinal offered to him as his bride. Titian was made a Knight of the Golden Spur; his reputation was so great that it was said that Charles V stooped to pick up his brush. The tolerance granted to these artists also extended to their eccentricities (Leonardo's vegetarian diet; Michelangelo's misanthropy; Raphael's sensuality; and their collective melancholia), which were forgiven or explained by their exceptional talents.

Despite their highly individual temperaments and working methods, all the artists of this period were trained in traditional workshops. Apprenticed as youths to a master, they learned how to draw and to copy. Learning style and technique through imitation was a basic principle of Western art until the nineteenth century. Innovation was discouraged in favor of tradition in the workshops where the young Leonardo, Raphael, Michelangelo, and others learned their craft. Yet when they emerged from their training, these great artists channeled what they had learned into something wholly original, personal, and largely inimitable.

Much of their inspiration came from the growing interest in the art of antiquity. For instance, Lorenzo the Magnificent (Lorenzo de' Medici) had a marvelous collection in Florence of ancient marble sculpture that the young Michelangelo studied intensively. As more and more ancient works of art were found (the *Apollo Belvedere* was recovered in 1503, and the *Laocoön Group* in 1506), painters and sculptors flocked to see them and strove not merely to imitate but to rival them. These ancient celebrations of the human figure, together with the optimistic spirit of the early sixteenth century, fostered an unprecedented interest in the figure as art. As individuals rose to prominence in every sphere of

human endeavor, the idea that the figure was the true subject of art regained acceptance, though how artists interpreted the figure varied. It was through the human figure that the ideas and early ideals of the age were expressed. More grandiose in conception than early Renaissance art, and planned with a greater integration of the parts to the whole, the art of the early sixteenth century in Italy entered the period known as the High Renaissance.

Leonardo da Vinci (1452–1519) made the earliest decisive steps in a new direction. Born in the hamlet of Vinci, near Florence, he was the illegitimate son of a notary and a peasant woman. He spent his youth exploring the Tuscan hills, developing the interest in nature and animals that would last throughout his life. His drawing ability earned him an apprenticeship about 1466 with the leading Florentine painter Andrea del Verrocchio, and his precocious talent soon enabled him to surpass his master. According to Vasari, Leonardo's contribution of an angel to Verrocchio's *Baptism* convinced the master to give up painting. Even in these early years, Leonardo demonstrated his interest in nearly every intellectual discipline—mathematics, music, anatomy, botany, and engineering. It may have been that Leonardo's many interests kept him from completing commissions, and perhaps his reputation for not finishing work prevented him from gaining the kind of patronage that he might have had. In the five thousand pages of his notebooks, drawings, notes, diagrams, and sketches crowd each page, recording everything from the movement of water and the mechanics of flight to the study of light: "The air, as soon as there is light, is filled with innumerable images to which the eye serves as a magnet." Leonardo saw his creativity as a mirror of divine creation: "[The artist's mind is] a copy of the divine mind, since it operates freely in creating the many kinds of animals, plants, fruits, landscapes, countrysides, ruins and awe-inspiring places." The artist has ideas "first in his mind and then in his hands."

Leonardo's first major impact on Florentine art came with the painting *Adoration of the Magi* [p. 138], left unfinished when he went to Milan about 1482. In 1481 the monks of San Donato a Scopeto, outside Florence, had contracted with Leonardo to produce an Adoration of the Magi in twenty-four to thirty months. The subject was particularly popular

LEONARDO DA VINCI, LADY WITH THE ERMINE, c. 1485.
Here Leonardo's theories of portraiture were put into practice. He believed light should fall in front of the face, and that the face should be placed before a dark ground so it would acquire volume through contrast. He also noted that mist or haze endowed faces with softness and beauty.

in Florence, where the Medici supported a Compagnia de' Magi, which annually reenacted the Magi's visit. Leonardo's *Adoration of the Magi* is a significant departure from the conventions established for this theme. In contrast to the brightly lit, linear, decorative, and emotionally aloof portrayals of the Adoration by such masters as Botticelli, Leonardo's throng of figures is captured in a rush of movement, intense emotion, and deep shadow. The geometry of their groupings appears ready to dissolve at any moment. Their motion reflects an agitated state of mind, and the whole assembly is gathered in an environment that has none of the reassuring and prosaic references to contemporary Florence found

in so many paintings of the day. Instead, there are stairs that lead nowhere and horses that rush off into infinity. Though Leonardo's studies of light, anatomy, and nature have made his image lifelike, the feverish emotion, the refined beauty and perfection make it unreal—a mirage spun out of mists.

When Leonardo went to Milan, about 1482, he worked for Ludovico Sforza, only a year older than himself and also interested in engineering and mechanics, as well as in art. Perhaps Ludovico's interests and temperament suited Leonardo better than those of Lorenzo the Magnificent, who was more literary. In the seventeen years that Leonardo worked for Ludovico, he produced numerous inventions for his patron, including theatrical entertainments, spectacles, and music. Having recommended himself to Ludovico as a military engineer first and foremost, Leonardo spent a great deal of

his time designing and building military defenses. Despite these many occupations, the first of Leonardo's famous notebooks dates from these years. He also found time to paint portraits of Ludovico's mistresses.

One such portrait, *Lady with the Ermine* [p. 139], has been identified as Ludovico's mistress Cecilia Gallerani. Set against a dark ground and selectively lit, Leonardo's carefully staged portrait is, like his *Adoration of the Magi,* a wonderful fusion of contrivance and spontaneity. As an essay on beauty, a study of motion, and a description of character, it remains a revolutionary work. As Cecilia holds the ermine (a symbol of purity), she turns and her face registers sudden recognition as she prepares to greet someone. Her head is directed to the right, her body to the left; with this device Leonardo has animated his sitter and balanced the body with the vivacity of the face. Cecilia herself—graceful, sweet, and cultivated—is contrasted with the wild ermine, which is clearly based on precise studies from nature. Cecilia's refined hand calms the untamed creature clawing her sleeve and poised for flight. Her form and expression are perfectly self-contained, and civilizing adornments (headband, veil, cap) embellish her features. This and later por-

LEONARDO DA VINCI, LAST SUPPER, c. 1495–98. *The* Last Supper *is poised between the specific and the general. Leonardo's detailed observations of nature give this image believability, while his distillation from nature of its essence gives the painting its rare beauty. A master of contrast, Leonardo played off the strict geometry of the setting with the irregular configurations of the actors.*

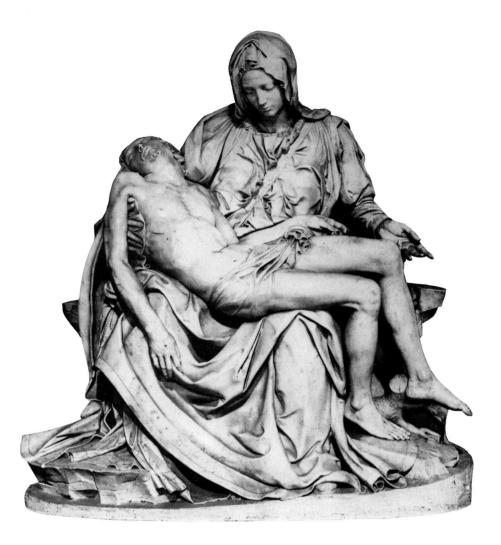

MICHELANGELO, PIETÀ, c. 1498–1500. *Until Michelangelo undertook this work for a cardinal's tomb in Saint Peter's, the theme of portraying in sculpture the dead Christ across Mary's lap had been limited to the art of Northern Europe. Vasari reports that it was the only work Michelangelo signed, so as to leave no doubt of its authorship.*

traits by Leonardo, such as the *Mona Lisa,* injected a great sense of personality and psychological complexity into portraiture. Leonardo's portraits of women are especially appealing for their mystery and ultimate elusiveness.

Leonardo's most famous painting in Milan, the *Last Supper* [p. 140], is today, tragically, in ruin. In the *Last Supper,* done about 1495–98 for the friars of Santa Maria delle Grazie, Leonardo used a novel technique, but the medium, an experimental variation of the fresco technique, soon deteriorated,

leaving the present work a shadow of the original masterpiece. Like Leonardo's *Adoration of the Magi,* the *Last Supper* is a traditional subject; it was a theme particularly popular for refectories, where monks gathered to take their meals and hear the scriptures read. Christ was always shown at the center of the table, with the apostles divided into groups on either side, except for Judas, who was traditionally isolated across the table.

Leonardo maintained the traditional format, yet his *Last Supper* is a fresh reconsideration of the story. Molded out of light and shadow, surrounded by an airy mist, Christ and his disciples exist in a realm raised above and beyond that of the viewer. Set off by an open window (itself a new device) behind him, Christ has just delivered his shocking news to his followers, "One of you will betray me," and they start in disbelief. Judas, who knows he will

be the betrayer, is cast in shadow, while the others express a subtle and complex range of emotions. In choosing this moment of high drama, Leonardo abandoned earlier conventions, which emphasized the Eucharistic meaning of the Last Supper by showing Christ raising the bread and admonishing his apostles to eat. Leonardo also supplanted the early conventions that treated the apostles as individual components; instead, he consolidated them into groups of three, thereby fusing the image and giving it greater cohesion. Each expression and gesture has been planned to bring meaning to the story, balance to the composition, and grace to the overall scene. Once again, a deeply complex mood is controlled by the most refined artifice. The whole image transcends reality, through its beauty, harmony, and perfect perspective.

Like his *Adoration of the Magi,* Leonardo's *Last Supper* was much studied by other artists. Prints, drawings, and painted copies proliferated and carried his work north as well as south. Raphael studied the *Last Supper* through prints, and it became the basis for his own grand essay of figures in architecture: *The*

MICHELANGELO, DAVID, 1504. *Records of the deliberations that took place in 1504 about where to place Michelangelo's* David *still survive. Opinion was divided between the church, the loggia beside the Palazzo Vecchio, and the front of the Palazzo Vecchio. In the end, the honored spot in front of the door of the Palazzo was chosen, and the* David *was moved out of the workshop of the Duomo on May 14, 1504. It took four days to move the giant, as he was known, to the Piazza, and installation lasted until June 8.*

School of Athens. Rubens and Rembrandt borrowed from it in the seventeenth century, Ingres in the nineteenth. All these artists recognized in Leonardo's work an extraordinary sense of beauty. Leonardo's art, though revolutionary, grew out of a long-standing love of grace and beauty that can be traced back to Simone Martini, Ghiberti, Fra Angelico, and Verrocchio. The style of his younger contemporary Michelangelo, on the other hand, grew out of the more monumental conception of the figure that traces back to Giotto, Masaccio, and Donatello.

Twenty-three years younger than Leonardo, Michelangelo Buonarroti (1475–1564) outlived him by forty-five years. Born in the town of Caprese near Arezzo, Michelangelo spent his childhood among stonemasons in Florence, causing him to joke later in life, "With my wet-nurse's milk, I sucked in the hammer and chisels I use for my statues." In 1488 he became an apprentice to Domenico Ghirlandaio, but Michelangelo's gifts soon brought him to the attention of Lorenzo the Magnificent, who invited the talented youth to study the ancient works in his sculpture garden. In these years Michelangelo was also reportedly granted the unusual privilege of studying anatomy by dissecting corpses in the cloisters of Santo Spirito, permitted by a prior in exchange for a crucifix carved by Michelangelo.

Michelangelo first gained fame by carving a sleeping cupid that proved he had learned his lessons from antiquity very well. The sculpture imitated the ancients so perfectly, it was said, that it could be confused with an authentic work of antique art. The sensation caused by the cupid inspired patrons in Rome to commission works from this precocious new artist. In Rome Michelangelo proved his merits with a beautiful *Bacchus* and his more famous *Pietà* [p. 141]. The *Pietà,* produced for a cardinal in Rome of c. 1498–1500, established Michelangelo instantly as the leading sculptor in marble of his time. Since the ancients, no master had been able to transform marble into such a complex arrangement of figures and draperies. Showing a youthful, beautiful Madonna (whose face has the oval-shaped perfection of an ancient Venus) holding the body of her son across her lap, the work is a technical and artistic marvel. Michelangelo's intensive study of the figure is evident in the details of musculature and anatomy. The *Pietà,* it was said, surpassed even the ancients through its virtuosity

and the beauty of its proportions. Yet, despite its physical perfection, the *Pietà* lacks the emotional depth of Michelangelo's mature work.

In 1501, Michelangelo found a new challenge for his skills: the directors of the Duomo (Florence cathedral) art works asked him to carve a David from a piece of marble that had lain discarded for nearly half a century. Completed in 1504, Michelangelo's *David* [p. 142] was an even more astonishing accomplishment than his *Pietà.* Carved from a block of marble that was tall, shallow, and flawed, the resulting figure triumphed over these obstacles. Moreover, this work possesses a characterization to match its technical mastery. Fourteen feet high, confident, aloof and determined, the human body here is transfigured into heroic proportions and attitude, not seen since ancient times. Whereas the figures of the *Pietà* seem soft and sensuous, *David* displays an aggressive muscularity, an assertive demeanor. Brilliantly conflating particularity, which allowed him to describe in detail each aspect of David's anatomy, with overall design so that all the parts fit together in perfect harmony, Michelangelo created a hero who was beautiful as well as psychologically inspiring. With *David,* the largest sculpture Italy had seen since antiquity, any doubt concerning the perfectibility of man had been banished. Youthful, optimistic, and powerful, this work exults in the human body. Florentine leaders immediately recognized its artistic and symbolic value and installed it in front of the Palazzo Vecchio (the town hall), instead of the Duomo, where it became an emblem for the entire city.

With this grand, larger-than-life figure, Michelangelo not only set a taste for colossi, which swept through Italy, but challenged other artists to meet or exceed his accomplishment. The nude male form now became the major subject for his rivals and followers, most notably Benveuto Cellini, and remained a principal sculptural theme for centuries.

When Pope Julius II summoned Michelangelo back to Rome in 1505, the artist was thirty and at the height of his creative powers. Tall, restless, and overbearing, Julius had a temper to match that of his new, young employee, and a tempestuous relationship between artist and patron began that ended only with Julius's death in 1513. Julius first commissioned Michelangelo to design and construct the largest and most magnificent papal tomb to date.

When Pope Julius II died in 1513, his tomb, which had been neglected so that Michelangelo could finish the Sistine Chapel, remained unfinished. Michelangelo took up and abandoned the project several more times before it was completed in 1547. Among the most celebrated sculptures for the tomb are the four *Prigionieri* or prisoners, designs begun around 1518 when the Pope's family had pressed Michelangelo for the tomb. Tall and massive and still largely unfinished, these figures provide remarkable insight into Michelangelo's working and thinking process. Intended to serve a load-bearing function, Michelangelo's "prisoners" or "captives" as they have come to be known, were eventually abandoned because of ceaseless demands on Michelangelo from subsequent popes.

Unfinished for more than thirty years, the tomb was the bane of Michelangelo's existence. Its final appearance and location in San Pietro in Vincoli in Rome was a departure from the patron's and the artist's original intentions, in part because of Julius's grandiose scheme for rebuilding Saint Peter's. After sending Michelangelo to Carrara to see about the marble for his tomb, Julius was suddenly caught up in the scheme to make Saint Peter's an appropriate setting for his burial place; lacking money and support to continue the tomb project, Michelangelo left Rome in disgust. In 1508 the pope persuaded Michelangelo to return but did not engage him to pursue the tomb as Michelangelo had hoped, insisting instead that the artist decorate the Sistine Chapel ceiling, a project of enormous dimensions.

Wrestling with nearly insurmountable obstacles, Michelangelo spent the next four years painting the ceiling. Forced to redesign his scaffolding to make it work, and firing his assistants for incompetence, Michelangelo also scrapped the pope's original pictorial program, gaining permission to design his own program and paint the work himself. Barring even the pope from entering, Michelangelo labored over the project for such prolonged periods that his head and neck were in danger of becoming permanently dislocated; for some time, he could read letters only with his head bent backward. Stiflingly hot in summer, bitterly cold in winter, the Sistine Chapel tested Michelangelo's endurance as well as his talents. Paint perpetually dripped onto his face, the plaster irritated his skin, and the pope continually plagued him to finish the project. When the work was finally finished, on October 31, 1512, the pope celebrated Mass; according to Vasari, "When the work was thrown open, the whole world came running to see what Michelangelo had done; and certainly it was such to make everyone speechless with astonishment" [pp. 136–37]. Above the viewers, on the ten thousand square feet of vaulted ceiling, over three hundred figures, some three to four times larger than life size, painted from every conceivable vantage point, reenacted scenes from Genesis. Painted in brilliant colors (as recent cleaning now shows), the ceiling was the most grandiose and ambitious pictorial decoration anyone had ever seen, presenting on a colossal scale a nearly overpowering vision.

The nine scenes from Genesis, the twelve

SISTINE CHAPEL CEILING (DETAIL)—<u>CREATION OF ADAM</u>

prophets and sibyls, and the numerous nudes who link the whole design are part of an intricate pictorial program, most likely developed with the aid of theologians. On the narrative level, the nine Genesis scenes foretell the coming of Christ and are accompanied by the prophets and sybils, who underscore the prophetic nature of the scheme. On an artistic level, the ceiling is essentially an unmatched series of figure studies. Organized by the simulated architecture that divides one area from another, the figures embody both grand and simple ideas, acting in some areas as merely decorative devices and in others as the actors in a great biblical drama. The prophets and sibyls, for example, express their serious purpose through their dynamic, monumental presence and vivid expressions. Whether seated or standing, Michelangelo's figures are bursting with energy and movement. Seemingly carved out of paint, they command the space around them and render the style and conception of the fifteenth-century frescoes on the chapel walls below them obsolete.

Though tracing the Fall of Man from Genesis, the ceiling in fact celebrates the rise of man, whose beauty and perfection are gifts of God. That idea is best expressed in the *Creation of Adam,* [p. 146], where the figure representing God recalls the great Daedalus of antiquity. Two beings—one divine, the other human—exist in parallel realms of perfection, the Creator having created man in his image; Adam gained form and life, as well as a divine spark. Michelangelo was the heir of Florentine Neoplatonism and its belief in the inherent dignity of man. The godlike beings of the Sistine ceiling established standards for the figure for centuries to come; artists borrowed the figure types and poses until well into the nineteenth century. But the underlying attitude, the belief in the perfectibility of man that inspired Michelangelo, did not survive even the artist's own lifetime. Always deeply spiritual, Michelangelo in later life rejected his early ambitions and ideas about the perfection of man. One of his last works as a painter shows his vision had changed profoundly.

Michelangelo's *Last Judgment* [p. 147], was painted between 1534 and 1541, when he was in his sixties. Covering the altar wall of the Sistine Chapel, it shows an entirely different, more pessimistic view of humanity. Though Christ and his heavenly host are cast in the heroic mold of the Sistine ceiling, the human souls are not. Here their mortality and their

MICHELANGELO, LAST JUDGMENT, 1534–41. *Three frescoes by Perugino and two by Michelangelo had to be removed to make way for this vast painting, which became the largest fresco in Rome.*

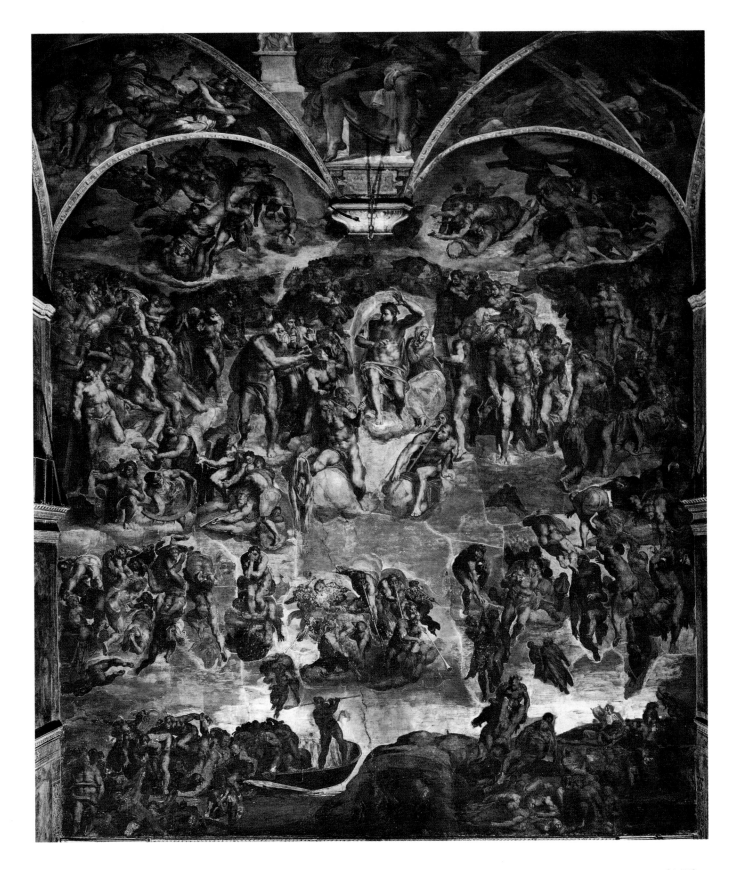

spiritual flaws weigh their heavy, earthbound bodies down. They are helped upward not by self-will but by the efforts of angels, who, though described as figures, are now more heroic than the mortals. When Michelangelo painted the *Last Judgment,* Rome had been sacked, Europe was at war, and papal authority had diminished, all in the name of religion. Michelangelo's deepened spiritualism is the subject of his poetry:

> My course of life already has attained,
> Through stormy seas, and in a flimsy vessel,
> The common port, at which we land to tell
> All conduct's cause and warrant, good or bad,
> So that the passionate fantasy, which made
> Of art a monarch for me and an idol,
> Was laden down with sin, now I know well. . . .

Raphael Santi (1483–1520), though younger than Michelangelo, had died more than twenty years before these lines of poetry were written; nevertheless, his fame rivaled that of Michelangelo and Leonardo. His father, Giovanni Santi, was a court painter of minimal talent in Urbino, the city benevolently ruled by Federigo da Montefeltro. The young Raphael joined the large workshop of Perugino, an Umbrian painter of gentle Madonnas and sun-filled landscapes of considerable beauty.

Although it may seem paradoxical, no Renaissance artist demonstrated more respect for the past nor was more inventive than Raphael. Raphael's work would not have been possible without Perugino, Leonardo, and, especially, Michelangelo, but what Raphael borrowed was transformed through much thought and reworking it until he had made it

RAPHAEL, DEPOSITION OF CHRIST, 1507. *This altarpiece was commissioned for the church of San Francesco al Prato at Perugia by Atalanta Baglioni, a member of one of the leading families of the city. It was painted by Raphael while he was working in Florence and is the masterpiece of his Florentine period.*

RAPHAEL, SCHOOL OF ATHENS, C. 1511. *In 1509 the young Raphael was already in Rome, working on the papal apartments in the Vatican. The Stanza della Segnatura (named after a tribunal whose decisions required a papal signature, segnatura), was painted between 1509 and 1511.*

his own. This process of creative borrowing was characteristic of great artists from Raphael through Rembrandt (one of the most omnivorous of all borrowers), right down to Picasso.

Raphael's attitude toward the work of other artists is apparent in his *Deposition of Christ* of 1507 [p. 148]. Although this work was painted for a church in Perugia, it was commissioned while the artist was in Florence, where he had moved to find employment. There he came into close and prolonged contact with works by Leonardo, Michelangelo, and a number of other painters who were

working in a style quite different from and more monumental than the idiom he had learned from his master, Perugino. Raphael learned with alacrity, and by the time he was ready to leave Florence for Rome, he was already an important painter.

Raphael was also one of the finest draftsmen in the entire history of Western art. An early preparatory sketch for his *Deposition* springs from a painting of the *Lamentation over Christ* by Perugino. But as he worked on, thinking, rethinking, and developing his own ideas about it, the subject changed from a Lamentation to a Deposition, a subject with much more potential for the sort of physical movement that interested Raphael at the time. A series of brilliant drawings document how the artist thought through the new subject, adopting several motifs and figures from both Leonardo and Michelangelo.

DONATO BRAMANTE, TEMPIETTO (SAN PIETRO IN MONTORIO), 1502–11. *Bramante was the architect chosen by Pope Julius II to rebuild the early Christian basilica of Old Saint Peter's in Rome. The foundation stone for Saint Peter's was laid only four years after the Tempietto was finished.*

The perfection of Raphael's talents can be seen in the frescoes the twenty-six-year-old artist painted in the papal apartments of the Vatican, especially in the *School of Athens* of c. 1511 [p. 149], which depicts a group of Greek philosophers engaged in vigorous discussion before a large structure resembling one of the Roman baths that Raphael, who was keenly interested in antiquity, had seen in Rome. Framed by the opening of the central arch

are the two towering figures of Plato and Aristotle; Euclid, Pythagoras, and Socrates appear elsewhere. The philosophical discussion in the *School of Athens* was contrasted with the divine argument found in the facing fresco, the *Disputa*. There God the Father, Christ, and the Holy Spirit preside over a lively debate by eminent theologians from all times about the nature of the Eucharist. It appears that the Stanza della Segnatura, the room that these frescoes decorate, was part of the papal library; consequently, the themes of learning, knowledge, debate, and wisdom expressed in the paintings are highly appropriate. The paintings also reflect the thinking of the humanistic scholars and clerics of the sixteenth century, whose admiration of antiquity impelled them to reconcile the pagan past with the Christian present.

The *School of Athens* is a masterpiece of planning in which balance, order, clarity, and harmony prevail. The composition reflects the essence of the subject and by so doing shows a synthesis of form and content that can only be termed classic. Along with Michelangelo's adjacent Sistine ceiling (which Raphael probably saw before it was completed) the *School of Athens* provided a new and quintessential Renaissance vision of the heroic potential of rational man surrounded by the glory of his own accomplishments.

It has been suggested that Donato Bramante (1444–1514), Raphael's fellow artist from Urbino, helped design the architecture in the *School of Athens*. Bramante began as a painter, but he is now best known for his architecture. One of his most influential works, the Tempietto (little temple) [p. 150] in Rome, is in many respects conceived with the same synthesizing and monumental spirit that informs Raphael's fresco. The Tempietto, which is almost exactly contemporary with the *School of Athens*, was built for Christopher Columbus's patrons Ferdinand and Isabella of Spain to commemorate the spot on which Saint Peter, the first pope, was believed to have been martyred. Bramante, like Raphael, was deeply interested in antiquity; it was from the early Christian martyrium—a small, centrally planned structure built to commemorate a martyrdom or some other important religious event —that he derived the inspiration for his plan. Bramante probably realized that the martyrium was itself indebted to pagan Roman types and that it, like

his Tempietto, was not a church but a simple memorial to an important event.

The Tempietto, which has Doric columns and other antique forms in the service of a Christian building in much the same way that Raphael contrasted the pagan philosophers with the Christian theologians, is simply but deftly planned. A row of columns set on a circular base surrounds the dome-covered sanctuary enshrining the spot where Saint Peter was martyred. Originally Bramante had planned to set the whole ensemble in a circular courtyard. The arrangement of the architectural elements and the monumentality and balance of column, window, base, and dome create a harmony that is close in spirit to that in the *School of Athens* and the Sistine ceiling frescoes.

Reverberations of works by Raphael, Michelangelo, Leonardo, and Bramante were clearly felt in Venice, the rich and powerful mercantile empire to the northeast. But these, like all the other outside influences reaching the city, were absorbed into the particular intellectual and emotional spirit that set the city apart from the rest of Europe. From Giovanni Bellini (1430–1516) to Paolo Veronese (1528–1588), Venetian artists endowed traditional types and subjects with new meaning while redefining and expanding the nature and scope of painting itself.

Among the many talented Venetian painters there was one, however, of such consummate genius that his contribution to the history of Western art is unparalleled. Tiziano Vecellio, known as Titian, was born in Pieve di Cadore in the Dolomite Mountains to the northwest of Venice about 1485. When he died in Venice in 1576, the first truly international career in the history of art ended. The nonagenarian Titian had revolutionized European painting and delineated the boundaries of both form and subject within which artists were to work for the next several centuries. His life was so long and his work so prolific that they encompassed the length and breadth of those of two or three other artists. His many patrons, which included an emperor, a pope, a king, dukes, and other notables, were all anxious to obtain his works. Made a noble by Emperor Charles V, Titian was one of the first artists to rise above the level of craftsman to become a wealthy and famous *artist*.

Titian's extraordinary career began with an ap-

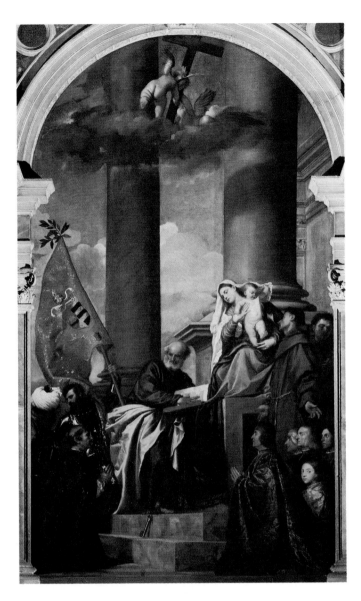

TITIAN, PESARO ALTARPIECE, 1519–26. *This is Titian's second great altarpiece for the Church of the Frari in Venice. The first, the* Assumption of Mary, *is the major altarpiece of the church. In the* Pesaro Altarpiece *Titian daringly reoriented the figures along a diagonal axis.*

prenticeship to Giovanni Bellini, himself an artist of superior invention and talent, and was followed by study and collaboration with Giorgione (c. 1478–1510), a revolutionary and brilliant painter. Although Titian's first independent paintings date from about 1510, it was not until the end of the century's second decade, after the death of Bellini and Giorgione, that he began to receive the critical

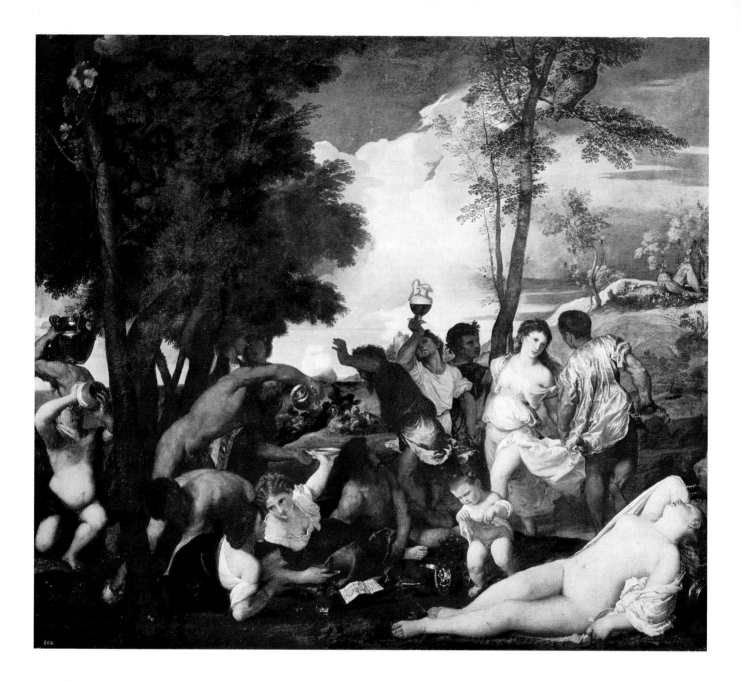

TITIAN, BACCHANALIA AT ANDROS, C. 1522–23. *This
painting and three others, two by Titian and one by Giovanni
Bellini, were commissioned by Alfonso d'Este, duke of Ferrara.
For centuries, Titian's three canvases served as an important
source of figural and landscape inspiration for Western art.*

attention and fame that would characterize the rest
of his life.

The *Pesaro Altarpiece* [p. 151], a work begun
in 1519 but not finished until several years later,

reveals the full range of Titian's first maturity. In this
painting, done for the church of Santa Maria Glo-
riosa dei Frari in Venice, Titian depicted Bishop
Jacopo Pesaro, victor over the Turks in the Battle of
Santa Maura of 1502, kneeling before Saint Peter
and the Virgin Mary. Behind Pesaro a warrior saint
guards the bishop's infidel captives while, to the
right, other members of the Pesaro family, accom-
panied by Saints Francis and Anthony, kneel in ad-
oration. The importance of this painting is in its

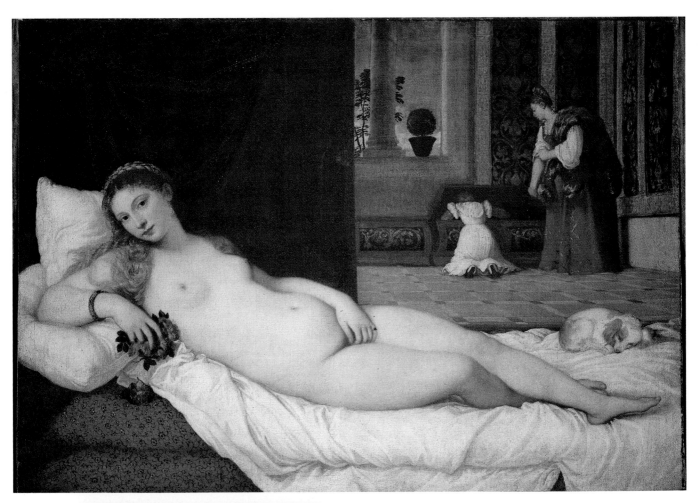

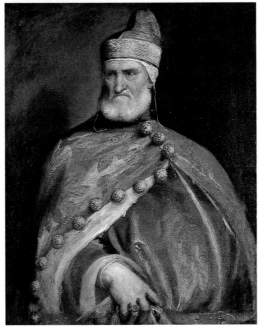

TITIAN, VENUS OF URBINO, 1538. *The first owner of this painting, Guidobaldo II della Rovere of Urbino, referred to it simply as "the nude woman." The title may have been an attempt to give the painting a gloss of antiquity and thus a measure of respectability.*

TITIAN, DOGE ANDREA GRITTI, C. 1540. *Doge Andrea Gritti (1455–1538) was a famous military commander. He began his career as a merchant, but became one of Venice's most expert soldiers and authorities on strategic defense.*

Francis I (1494–1547), King of France from 1515, was the chief political and cultural rival of Charles V, the Holy Roman Emperor. Both rulers spread the influence of Italian art throughout Europe during their reigns. While Charles maintained close contact with Titian (who painted his portrait), Francis invited Benvenuto Cellini to work for him. His numerous chateaux set new standards for French architecture and decoration. Their embellishments included innumerable treasures of which perhaps the most famous is Cellini's *Salt Cellar* completed in 1543.

orientation. In traditional altarpieces of the Madonna and Child with saints, all the figures squarely faced the viewer, but Titian shifted the scene: the Virgin, saints, and donors are seen at a diagonal, and the viewer's glance rushes into space along the stairs, the Madonna's throne, and the huge columns. This dynamic spatial movement combines with the upward motion of the columns towering above the clouds to imply a vast extension of space. Also, Titian welded the forms together with a single light source, which creates broad areas of highlight and shadow. The *Pesaro Altarpiece*, and many of Titian's other works with the same sense of spatial and compositional drama, lighting, and grandeur, were to be studied by the artists of the early seventeenth century, who found in them the inspiration for a new style called the Baroque.

Titian also reinvented the portrait. In paintings like the portrait of Doge Andrea Gritti from c. 1540 [p. 153], he painted not only the face but also captured the sitter's will, his inner strength and majesty. Gritti's massive upper body fills the canvas, and the dynamic, quick turn of his head toward the left creates a drama of action. The doge has gathered his robe in his powerful right hand and, within seconds, will depart to go about his important duties of state.

This type of unsurpassable portrait of authority earned Titian many commissions and was to serve as a seminal model for the depiction of rulers and authority in the West.

Titian and his Venetian contemporaries also created a new pictorial realm of mythology and sensuousness. The world of ancient myths had been explored and even painted in the 1400s, but it was only in sixteenth-century Venice that its full dramatic, poetic, and sensual potential was realized. Titian's *Bacchanalia at Andros* of 1522–23 [p. 152] depicts a dream of untrammeled pleasure: dappled by the rays of a late afternoon sun, the charmed inhabitants of the island of Andros, where the rivers run red with wine, relax, chat, sleep, and dance with an abandon hitherto unseen in painting. The expansive skyscape with its billowing clouds set against the feathery trees provides the perfect setting for this dream from which the Venetians derived so much pleasure.

The realm of myth also produced another subject newly found in Titian's Venice: the Venus. The many depictions of recumbent, full-bodied women are probably idealized portraits of Venetian courtesans whose fame had spread throughout Europe by the sixteenth century. Titian's so-called *Venus of*

FRANCIS I BY JEAN CLOUET

CHARLES V BY LEONE LEONI

Urbino of 1538 [p. 153] is the finest example of the sensuousness and eroticism that captivated Venetians of the time. This voluptuous woman fixes the viewer with a steady, self-assured gaze. Rendered in oil paint, a medium that allows for subtle nuances in surface texture, tonality, and color, her soft, yielding skin breathes with the new-found carnality that characterizes Titian's paintings of every subject.

Several generations of important Venetian painters founded their art on Titian; these men, like Titian, were to strongly influence the course of much subsequent Western art. One of these artists, Jacopo Robusti, called Tintoretto (1518–1594), was nearly as inventive as Titian himself. A prolific painter of large-scale canvases, he worked best when painting life-size or larger than life-size figures. He often rejected traditional types and interpretations. In their stead, as in the *Removal of the Body of Saint Mark* of 1562 [p. 156], he created paintings of striking originality.

The *Removal of the Body of Saint Mark* depicts Venetians stealing their patron saint's remains from Alexandria, an act of which they were extremely proud. Tintoretto has turned this scene into high drama by setting it in a tunnel of swiftly receding space surrounded by architecture. A further diago-

nal is created by Mark's body, carried by a small group of men struggling in the windstorm that scatters and topples the picture's other figures. The ominous sky is filled with lightning and vaporous forms of spirits appear at the sides. Dynamic and powerful, this whirlwind of a picture, while strongly indebted to Titian for many fundamental elements of its style, is an extremely personal creation. The artists of the next generation were to be much influenced by this and many other paintings by Tintoretto, whose work was to help shape the emerging Baroque style.

The paintings of Tintoretto's eminent contemporary Paolo Veronese (1528–1588) were also to have considerable influence on subsequent European art. Although born and trained, as his name indicates, in Verona, the substance of Veronese's art is Venetian. His interest in the depiction of texture, atmosphere, and color is particularly Venetian, as is his love of opulence and display. The work of Veronese and his Venetian contemporaries, unlike the paintings of the artists of Florence and Rome, was always concerned with the senses, with the particular look, feel, and shape of things both divine and mundane.

Allegorical painting—the visualization of

TINTORETTO, REMOVAL OF THE BODY OF SAINT MARK, 1562. *This picture was part of the pictorial decoration of the Scuola Grande di San Marco, a powerful Venetian confraternity. Tintoretto's canvas was commissioned by Tommaso Rangone, the Grand Guardian of the Scuola, to complete the decoration which had been begun by the same artist in 1548.*

PAOLO VERONESE, APOTHEOSIS OF VENICE, c. 1585. *Veronese's painting is part of a large and complex scheme of paintings that was developed over several centuries to glorify the Venetian state and those who ruled it. Such decoration, although on a lesser scale, was a part of palaces and town halls of the many Italian city-states.*

concepts and states of being—was perfected in sixteenth-century Venice by Veronese and his fellow artists; such painting was soon to become an important part of Western art. In Veronese's ceiling painting in the Ducal Palace of Venice, the huge *Apotheosis of Venice* of c. 1585 [p. 157], the allegorical figure of Venice, seen as a beautiful, richly dressed woman crowned by Victory, ascends to heaven on a cloud bank surrounded by the Virtues and adored by her worshipful subjects. Here the concept of the majesty and power of the state is given the sort of concrete, palpable form prized by the earthy Venetians. Such splendid and abundant imagery, which is often quite incomprehensible to twentieth-century minds, struck a responsive chord and was soon to grace the ceilings and walls of the centers of power from Rome to London.

As the sixteenth century drew to a close, the Roman Church was using art to reaffirm the validity of Catholicism. The well-known subjects of the Counter-Reformation—the conversions, the visions, and the martyrdoms—gradually narrowed and focused the language of art. Though aimed at believers, such subjects seldom depicted them as donors or as participants within the image itself. Humanity was not the subject of these images; faith was. In Venice alone, art remained a more direct reflection of human experience. Donors were still portrayed within the context of religious subjects, and humanity remained both the subject and object of the many secular topics that Venetian artists examined, but when Tintoretto, the last of the great sixteenth-century Venetians, died in 1594, an age of genius came to an end.

The new century that opened six years later also produced outstanding artists. Some, like Rubens, achieved a status almost equal to the aristocracy; however, it was not their art but their image and manners that raised them to such levels. In the sacred and secular courts of the seventeenth century, art, like the humanity it reflected, abandoned the heroic, sober, and transcending idealism that so inspired much of the previous century. Idealism and the belief in the heroic potential of the individual had often been replaced by grandeur, pomp, and propaganda.

GIANLORENZO BERNINI, SAINT PETER'S PIAZZA, BEGUN 1656. *The facade of Saint Peter's, designed in the early seventeenth century, was criticized for being too wide for its height, and Bernini's giant freestanding colonnades were planned to partially mask this deficiency.*

[9]

ART FOR POPES AND PRINCES

During the first half of the seventeenth century, Rome and Madrid dominated Europe politically and culturally. Italian and Spanish were the languages of diplomats and intellectuals, Catholicism the faith of most rulers. Inspired by great saints (Ignatius of Loyola and Carlo Borromeo, for example), guided by strong popes, and promoted through the creative energy of artists, the Catholic faith regained much of its former vigor. Rome was once more the hub of a thriving religious empire. Madrid, fueled by gold from its American conquests and its power expanded by a complicated system of succession, was the capital of a vast Spanish kingdom that included the Netherlands as well as Naples and dominated European affairs until the middle of the century.

Both Rome and Madrid were part of an international cultural network to which the rulers of most European countries belonged. Philip IV of Spain, Charles I of England, Marie de' Medici, Louis XIV, and Pope Urban VIII patronized many of the same artists, spoke the same languages, and shared many of the same aspirations. Foremost in their minds was the consolidation of their power. The artists who worked for them were expected to use their talents to express the grandeur of the Church, the supremacy of faith, or the majesty and absolute, God-given power of the monarch. Architecture, sculpture, and painting were the means by which the greater glory of religion and monarchy could be made visible.

In the seventeenth century the elevated idea of man found in the art of Michelangelo and Raphael was transformed into the celebration of a particular man—the king, the ruler, the pope, or the noble. The seventeenth century became the age of the royal portrait. On horseback, standing, or seated, kings, queens, princes, and nobles saw themselves made more magnificent, more graceful, more exalted than ordinary mortals. The seventeenth century was also the age of the pictorial allegory. Ceilings, walls, whole rooms and buildings were dedicated to celebrating the power, majesty, accomplishments, and erudition of various popes, princes, and kings. Catholicism, having recovered from the Protestant challenge of the sixteenth century, reaffirmed the mysteries of faith by commissioning countless images of conversions and martyrdoms, thereby inspiring the last great age of altarpieces. Designed to affect the emotions, to inspire faith, not logic, these altarpieces, like the allegories and portraits, used realism to engage the viewer and theater to divert him. Though doomed to be eclipsed in the rationalist spirit born in this very century, faith was given one final glorious outburst of creative expression, exceeding in sheer energy and daring anything that had preceded it.

Popes, kings, clerics, and aristocrats had at their disposal artists of great virtuosity and intelligence. Some, such as Rubens, Van Dyck, and Bernini, became nearly the intellectual and social equals of their clients; others, such as Caravaggio and Velázquez, achieved social elevation belatedly. All these artists sought to make visible the interests and aspirations of their patrons. Each major sculptor or painter had, by the seventeenth century, acquired diverse techniques with which he could faithfully replicate or manipulate reality. That each successfully fused fact with fiction was the key to his success. That they all achieved their goals through quite independent and original styles is a mark of their greatness. Ranging from the highly controlled surfaces of Caravaggio to the fluid, vivacious brush marks of Rubens or the virtuoso handling of marble by Bernini, artists poured their talent and energy into astounding accomplishments.

Artists shared with thinkers and scientists the quest to understand reality that characterized the era. Certainly the exploration of reality by scientists and philosophers was the greatest intellectual endeavor of the age. Keppler, Galileo, and Newton discovered the principles of planetary motion and gravity; they discredited forever the geocentric theory prevalent in Western thought since the late Roman empire. Descartes's philosophic assertion "I think, therefore I am" established humanity as the prism through which the rest of the world could be understood. Toward the end of the century, the philosopher Leibnitz deduced that this is the best of all possible worlds, fixing humanity firmly in its material context. Thinkers, writers, and artists throughout the century examined the nature of reality and the nature of man. As a consequence, human thought departed forever from the certainty of faith and entered the questioning age of science.

The often paradoxical results can be seen in the trial of Galileo and in the career of Pascal. Galileo's scientific discoveries were initially applauded and his scientific apparatuses borrowed and copied throughout Italy by such conservative groups as the Jesuits. But when he published his *Dialogue Concerning the Two Chief World Systems* in 1632, the Church felt his assertion that the sun does not revolve around the earth challenged its doctrine, and the famous trial of 1632 ensued. Galileo was condemned to the rather mild punishment of house arrest, and the Church managed to separate the world of science from that of faith. Pascal—scientist, mathematician, and thinker—struggled to resolve this split. Stating in one breath "Take holy water and be stupid" and then in another, "The heart has its reasons that the mind cannot know," Pascal affirmed that human reality existed on several planes, the external and the internal, the real and the imaginary, the subjective and the objective, the emotional and the rational.

The medieval notion of the duality of man that contrasted the spiritual with the material now reasserted itself in a new paradox: reason as opposed to faith. The effect on art was profound. The artists working for rulers and popes more often than not distorted reality and exploited human emotion, subjectivity, and imagination to sustain faith and myth. Their empirical knowledge of reality became the basis for a convincing illusionism. Space, time, light, and substance were evoked or suspended with a newfound ease and sophistication. The extremes between reality and unreality were never

CARAVAGGIO, THE CALLING OF SAINT MATTHEW, CONTARELLI CHAPEL, SAN LUIGI DEI FRANCESI, 1599–1600. *The powerful patron Cardinal del Monte probably helped Caravaggio obtain the commission for the Contarelli Chapel. Del Monte, who represented Florentine interests in Rome, was one of Caravaggio's earliest collectors.*

stronger or more evident within a single work.

Having embarked on a quest to understand humanity and the human condition, artists made man, not God, the subject of the arts. Faith was made comprehensible through the mystical visions, conversions, or martyrdoms of the men and women who became saints. Popes, kings, and princes were men elevated by divine right, ennobled by rank and birth; the arts were used to inflate their importance as never before, perhaps because their fragile humanity was never more evident. "What a piece of work is man! how noble in reason! how infinite in faculties! . . . And yet to me what is this quintessence of dust? Man delights not me." These

thoughts of Shakespeare's Hamlet echoed throughout the age.

Rome, seat of the papacy and home to innumerable distinguished diplomats, courtiers, and clerics, did not view man as a "wretched earthworm," as Pascal had proclaimed. The popes all came from the leading Italian families (Aldobrandini, Borghese, Barberini, and Chigi), whose culture, education, sophistication, and ambition transformed Rome into a glorious reflection of a Church triumphant over doubt. For them, man was at heart a creature of irrationality, whom the artist was to inspire with engaging images of holy visions to restore and affirm faith.

For painters Rome was a mecca: Michelangelo and Raphael had worked there; the greatest masterpieces of antiquity, the *Laocoön Group* and the *Apollo Belvedere,* were unearthed there; and the richest patrons of the day lived there. Painters flocked to Rome from all over Europe, attracted by the art and the potential for commissions. About 1592, the young painter Michelangelo Merisi da Caravaggio from northern Italy arrived in Rome to seek his fortune. He was just over twenty, talented, temperamental, and violent. He fled Rome in 1606 after killing a man in a brawl. In 1610, trying to make his way back to Rome, he died of a fever brought on by knife wounds. Though Caravaggio worked for only about twelve years, he revolutionized Western painting.

The bulk of Caravaggio's work was religious, painted for the leading cardinals and families of

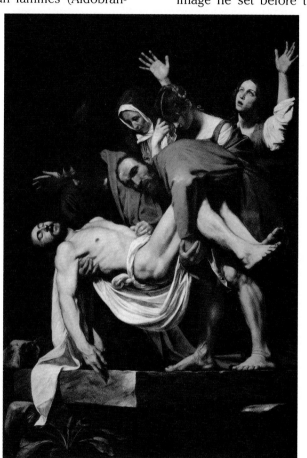

CARAVAGGIO, ENTOMBMENT, PINACOTECA VATICANA,
1603–4. *In creating this altarpiece for Santa Maria in Vallicella (also known as the Chiesa Nuova) in Rome, Caravaggio borrowed motifs from two famous works in Rome: Michelangelo's* Pietà *and Raphael's* Entombment. *Caravaggio's* Entombment *became his most celebrated Roman work.*

Rome. His earliest commission for a Roman church established him as a radical. Between 1599 and 1600 he painted both *The Calling of Saint Matthew* and *The Martyrdom of Saint Matthew* for the Contarelli Chapel of San Luigi dei Francesi. In *The Calling* [p. 161] Caravaggio broke with convention. The image he set before the viewer is one of prosaic reality: gathered around a table in a dimly lit space, the tax collector Matthew and his four assistants count money. They are shown in dress borrowed in part from contemporary fashion, and they are described with attention to the minutest detail of appearance. Caravaggio presented an everyday reality last witnessed in portraits of the fifteenth century. Ordinary people, not refined or beautified in any way, have become the characters of a holy drama. Christ and Saint Peter have entered the room and Christ says to Matthew, "Follow me." Matthew looks up and points to himself questioningly, his face registering mild surprise. A quiet but momentous occasion is taking place before the viewer's eyes: a sinner is about to move toward sainthood. The scene is so immediate and direct, and the characters so specifically portrayed, that it must be based on models posing in Caravaggio's studio. These models were not chosen for their beauty or for the nobility of their features, as was the practice of past artists, but because they reflected common reality. How better to engage viewers than by showing them their own world. With Caravaggio, "The antique lost all authority, as did Raphael, because it was so easy to obtain models

and paint heads from nature," the seventeenth-century Italian biographer and critic Bellori complained. Ordinary persons entered pictures not as donors but as models for extraordinary characters. This departure from convention shocked many patrons, disturbed critics like Bellori, but inspired other artists.

Yet Caravaggio did more than simply emulate nature. Like the great Venetian artists of the sixteenth century from whom he took much of his inspiration, he altered nature to suit his purposes. Despite the verisimilitude of his actors, the setting of *The Calling* remains devoid of any detail except window and table. The darkness of the space is pierced only by the strong shaft of light that beams over Christ's head, illuminating his hand and shining on the face of Matthew. Thus the effects of light have been both accurately described and used to great dramatic effect. The divine hand (last seen in the *Creation of Adam* by Michelangelo) bathed in light transforms reality into a miracle. All the characters lean toward the light and the messenger; the moment of conversion is at hand.

Caravaggio's message is that miracles transform the commonplace. To him, the great events of the Bible happened to average people. His models were the people he found in the streets of Rome, but in each of his great canvases, Caravaggio placed them into extraordinary situations filled with the highest drama. Caravaggio's paintings have the vivid artifice of theater; his models are actors set on carefully planned stages and illuminated by subtly manipulated lighting. In pushing both realism and artifice to their extremes, he made his images both startling and gripping. Centuries have passed since the newness of his art shocked viewers, yet the tension there between stillness and movement, darkness and light, silence and sound, continues to engage us.

Between 1603 and 1604 Caravaggio painted what is probably his most powerful work, the *Entombment of Christ* [p.162], done for the

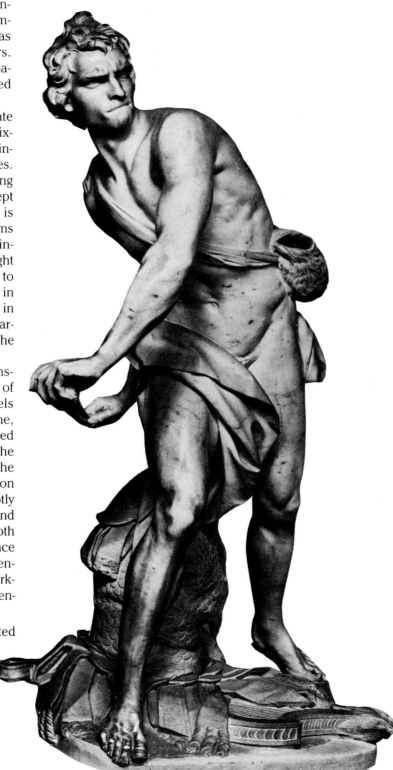

GIANLORENZO BERNINI, DAVID, 1623. *Bernini's David is a departure from earlier works of the same subject, not only because of its virtuoso handling of material and its departure from the tradition of remote and self-contained statuary, but also because it is the first to choose as its subject the moment of the actual encounter between David and Goliath.*

Vittrici Chapel in the Chiesa Nuova in Rome. Attended by a crescendo of figures—the three Marys, Joseph of Arimathea, and Nicodemus—Christ's body is lowered into a tomb that exists beyond or below the space of the picture. Indeed, the body is about to descend into the space occupied by the viewer; the chapel in which the viewer stands becomes, in effect, the very tomb into which Christ's body is being lowered. The limits of the picture plane are being crossed and the viewer and image are engaged in a very different manner. Renaissance art allowed the viewer to enter the world of the image; now the image is entering the world of the viewer.

In his monumental *Entombment,* Caravaggio's range of talents and paradoxical vision are given full rein. Giving the effect of an indivisible whole, the *Entombment* is composed of individual characters, each with distinctive gestures and emotions. Though shabby in dress and coarse or humble in feature, the characters embody the most noble emotions, expressing their grief and the awesome tragedy of Christ's death with sincerity and dignity. For all their realism, the figures are, like the characters in the *Conversion,* placed in a completely unreal setting. Darkness envelops them; it outlines their grief and lifts it from the level of ordinary experience to the highest drama.

Caravaggio's placing of commonplace people into carefully staged settings, gives his works a particular power that influenced much of seventeenth-century art. Other artists were inspired by Caravaggio to emphasize verisimilitude by transcribing the features of ordinary people in their images, thus breaking from the conventions that had guided the production of sacred art for centuries. Caravaggio's followers manipulated reality to affect the emotions of the viewer, but the dramatic contrasts of light and dark, ordinary settings and characters, and violent themes trace their origins to Caravaggio, whose influence was sufficiently broad as to earn the name Caravaggism.

Caravaggio's counterpart in sculpture was Gianlorenzo Bernini. Born in 1598, Bernini was a child prodigy; with his sculptor father, he went to Rome about 1604. Whereas Caravaggio's impact had been immediate, Bernini's was slower but longer lasting. During his long career, Bernini became the leading artist of Rome, serving every pope

during that time and many of the prominent families. His fame was international, and he set the style of sculpture for most of the rest of Europe. Bernini has been called the last of the universal geniuses who made Italy the cultural center of Europe.

Bernini's ability to manipulate marble has no equal in the history of art. His sculpture is the ultimate illusion. He made marble seem to have the pliability of wax or clay. Using fictive "clay," Bernini created illusions of living, moving, yielding flesh in states of such transience that a single instant seems forever frozen in time. Not since the sculptor of the *Victory of Samothrace* captured the sense of flight had motion had a greater interpreter. But Bernini's double illusion, of marble that becomes clay and clay that becomes flesh, is unprecedented.

One of Bernini's earliest triumphs was his *David* of 1623 [p. 163]. Working for the pope's nephew Scipione Borghese, Bernini presented his

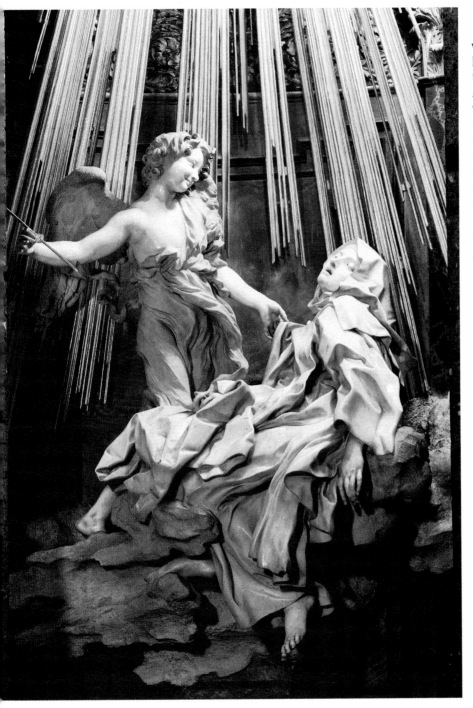

GIANLORENZO BERNINI, ECSTASY OF SAINT TERESA, CORNARO CHAPEL, SANTA MARIA DELLA VITTORIA, 1645–52. *Bernini was profoundly devout, and his sculpture, which follows the text of Teresa's own account of her vision quite literally, was an attempt to inspire spirituality. Though she was canonized in an age that valued her mystical encounters, the historical Saint Teresa was, in fact, a practical and influential figure, who founded seventeen convents and, besides spiritual guides for her Carmelites, penned an autobiography as well as an account of her work with the convents.*

version of ancient Hellenism, just as Michelangelo's *David* had been an interpretation of ancient classicism. Adapting a pose from a Hellenistic work, Bernini presented David at the split second before he releases the stone from his sling. His body a series of spiraling curves, his face a study in concentration, *David* crystalizes movement, transition, and confrontation, just as Michelangelo's *David* and Donatello's *David* embodied stasis and contemplation. As Bernini's *David* winds up for the throw, the spectator becomes Goliath, the target. With this ingenious rethinking of the relationship between the viewer and object, Bernini changed sculpture from a self-contained, isolated form to one that engages the surrounding space and viewers. This, like Caravaggio's *Entombment* and much contemporary architecture, exemplifies the style called the Baroque, where levels of reality are challenged, divisions between materials are breached, and the viewer is engaged with the object.

In making his *David* engrossed in a specific motion and moment, Bernini bound him to the spectator's time and place. Biographers of the time tell us that Maffeo Barberini held a mirror for Bernini to copy his own features for *David*'s face. As a consequence, Bernini's *David*, like Caravaggio's biblical characters, does not embody the heroic, idealized concepts that had animated Michelangelo's and Raphael's work. Though grand and sweeping, Bernini's fleet and taut *David* is ultimately anecdotal and temporal, instead of epic. He is theater, not meditation.

Bernini's theatricality is best seen in the *Ecstasy of Saint Teresa* [pp. 164–65], done between 1645 and 1652 for the Cornaro Chapel in Santa Maria della Vittoria, Rome. Here Bernini turned the entire chapel into a

theater. The altar is a stage and the sides of the chapel have box seats from which the carved effigies of the Cornaro family discuss Teresa's mystical vision. A Spanish mystic and founder of the discalced (barefoot) Carmelites, Teresa died in 1582 and was canonized in 1622. Particular emphasis was placed on her "transverberation"—the piercing of her heart by divine love. Teresa's description of this vision guided Bernini as he set about re-creating the event.

A broken pediment and pairs of pilasters frame a dazzling vision. Bathed in light, the white, churning form of Teresa lies in a swoon, having received the exquisite pain of the fiery divine arrow. As the angel prepares to pierce her heart once more, Teresa is transported into ecstasy. Hard white marble has gained the lightness of air and the softness of flesh. The *Ecstasy* is like a mirage that could disappear at any moment. It is conjured up by the members of the Cornaro family, who discuss the miracle among themselves, and it hovers before the entrant to the chapel like a momentary apparition, at once real and at the same time artificial. The sculpture is set into the "stage" in a way that makes it seem like a painting. The light that illuminates Teresa is both real and contrived. Shafts of fictive light, carved from wood and gilded, add a note of drama and a layer of unreality to an already distorted sense of reality. Where is Teresa and when is this scene happening? Flaring before us in a blaze of glorious light is a suspended instant. The conventional boundaries of painting, sculpture, architecture, portraiture, time, and place have been crossed to fabricate an encompassing illusion. The effect is illogical but totally convincing, transporting the viewer momentarily to the emotional state not of the Cornaro family but of the saint herself. Subjectivity, emotionality,

and irrationality are all achieved by Bernini in the most rational manner. The artist, who in fact was also a theater designer, used his knowledge as well as his imagination to fully control and manipulate the viewer's experience.

Bernini's ability with marble and his skills at verisimilitude as well as illusion made him one of the greatest portrait sculptors of all time. In fact, he set new directions for the portrait bust, which, since the fifteenth century, had followed the sober and static conventions of republican Rome. Bernini's most famous royal portrait is that of Louis XIV, produced in 1665 while Bernini was in Paris at the invitation of the French king. Bernini's trip to France was itself a historic occasion. All along the way people turned out to see the famous sculptor, and Bernini commented that he was a rare sight indeed, like an elephant. When he arrived in Paris, Bernini set about making sketches of the king as he went about his normal activities. Bernini's aim was to

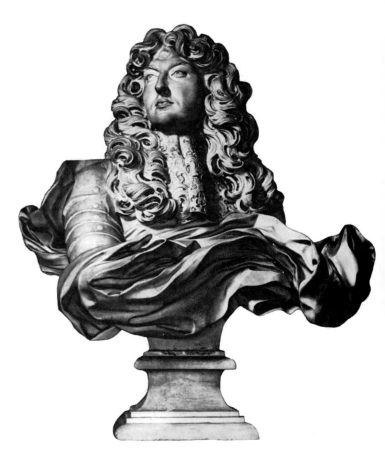

GIANLORENZO BERNINI, LOUIS XIV, VERSAILLES, 1665.
Records of Bernini's work on this bust are remarkably detailed. Bernini chose the marble block on June 21, 1665, and three days later he began a series of models in clay to get his ideas down. He worked on these until the 12th of July and in the meantime studied suits of armor from the royal armory to incorporate into his portrait. On July 14 he began carving the marble block and worked on it intermittently for forty days. Louis XIV sat for Bernini thirteen times, each time for about an hour; the sculpture was completed during the last sitting and later transported to the Louvre, but when the king made Versailles his home, he took the bust with him.

catch the king at the moment just before or after he spoke, or as he moved about. He used every opportunity to observe the monarch closely; but what he reached for and achieved transcended reality [p. 166]. Bernini provided no simple simulacrum of Louis's features but adapted them, ennobled them, and gave them the majesty of the king's quasi-divine state. "My king will last longer than yours," he replied to courtiers who questioned this departure from reality.

Swathed in animated drapery and enveloped by waves of curling hair, Louis appears calm, regal, and self-possessed. His authority is unquestionable, his dignity supreme. Like Rubens and Van Dyck (with whom he shared both elevated social status and patrons), Bernini understood that state portraiture needed to fuse the sitter with his position and to endow him with the nobility of his status, rather than to provide the reality of appearance.

Bernini's portrait of Louis is the only remaining relic of this trip to France; he had gone for architectural purposes, but his plans for the Louvre were not accepted. His architectural accomplishments in Rome, however, rank him among the foremost architects of his time. Despite his fame as an architect, Bernini considered his designs for palazzos and churches as almost a sideline. For him, as for Michelangelo a hundred years before, the great genre was sculpture, for it dealt with that preoccupation of art since the early sixteenth century, the human body. But Bernini was a remarkable architect precisely because his buildings have a dynamism that speaks not only a language of formal beauty but also one of human drama and emotion.

This drama is seen in monumental form in the tabernacle baldachino Bernini designed for Saint Peter's in Rome in 1624–33 [p. 167]. Under the patronage of Urban VIII (Maffeo Barberini), he received a commission for a tabernacle to be placed in the transept of the church above the tomb of Saint Peter, the first pope. The size of the tabernacle had to be colossal (it is over one hundred feet high, as tall as an eight-story building) to fit into the gigantic space of the church without being lost. Throughout the process of the baldachino's design, Bernini had to continually strive to make a structure that would, by size and design, assert itself in the vast space of Saint Peter's. This he did with his usual brilliance and ease.

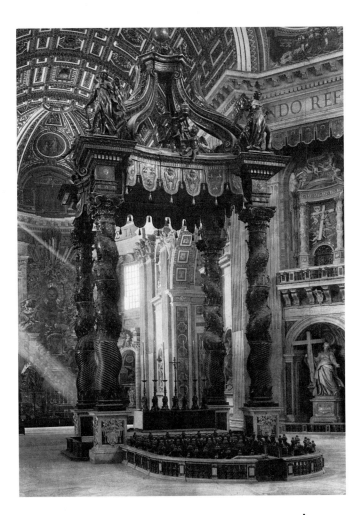

GIANLORENZO BERNINI, BALDACHINO, SAINT PETER'S, ROME, 1624–33. *A baldachino traditionally functioned as a canopy to cover and mark a sacred spot. Placed over the tomb site of Saint Peter, Bernini's baldachino, with its twisting columns and its numerous bronze bees alluding to the Barberini (Pope Urban VIII's family), served not only as a religious monument but also as a papal advertisement.*

The huge columns that writhe with internal energy are made of bronze, some of which was stripped from the revetment on the inside of the portico of the Pantheon. (Such despoliation led to the famous line "What the barbarians didn't do was done by the Barberinis.") Alive with the spiraling movement of the columns, the swinging volutes of the dome, and the relief incrustation (including several huge bronze bees, the Barberini symbol), and capped by round bronze figures, the tabernacle is a giant synthesis of architecture and sculpture.

It is also a moment of symbolic importance, for it proclaims the wealth, power, and glory of the

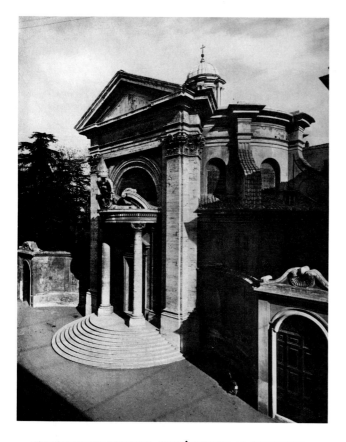

GIANLORENZO BERNINI, SANT'ANDREA AL QUIRINALE,
1658–70. *As an older man, Bernini used to sit in Sant'Andrea*
admiring this, his favorite church.

newly resurgent Church triumphant over the chal-
lenges of the Reformation. At the very heart of the
Catholic faith in the transept of Saint Peter's, its size,
material grandeur, and aggressive power all pro-
claim not only victory but unbounded confidence in
the faith. Bernini's baldachino was also a major
landmark in the history of art, for it was one of the
first and most seminal monuments of the Baroque
style, which was to sweep throughout Europe dur-
ing the rest of the seventeenth century.

Bernini designed whole buildings with the
same grandeur and dynamism seen in the balda-
chino. His favorite church was the diminutive
Sant'Andrea al Quirinale [p. 168], built for the Je-
suits, an order that was an important agent of the
Counter-Reformation. Sant'Andrea was begun in
1658 during the reign of Pope Alexander VIII, when
Bernini was about seventy and at the peak of his
artistic powers. The church is oval, a shape favored
by the seventeenth century, with the altar placed

dramatically opposite the entrance. Although a
great admirer of Renaissance architecture, Bernini
broke with its sober decorum and balance to create
much more expansive and encompassing build-
ings. In Sant'Andrea the oval of the church and the
semicircle of its porch and steps are dazzlingly
countered by the walls, which sweep outward,
drawing the advancing worshiper into their em-
brace. The enclosing walls, the cascading stairs,
and the vigorous oval body of the church itself com-
bine to produce high drama.

The expression of Sant'Andrea is found on a
grander scale in Bernini's remodeling of the piazza
in front of Saint Peter's [p. 158]. This vast space was
often filled with crowds seeking a papal blessing,
especially the Easter benediction. Bernini's task
was to give the space fitting form. This he did by the
use of freestanding colonnades—he may have
known these from Roman buildings—which shape
the space nearest Saint Peter's into a trapezoid and
then expand to enfold the rest of the piazza in a
manner reminiscent of the much smaller walls of
Sant'Andrea al Quirinale. Bernini likened the arms
of the colonnade to the arms of the Church welcom-
ing the faithful, and, in fact, one does feel both
enclosed and drawn to the church by these monu-
mental colonnades with their simple Tuscan order.
The vastness and power of the colonnades of the
piazza of Saint Peter's make an extraordinary
impression upon the visitor, who is simultaneously
awed and humbled by Bernini's remarkable shaped
space. Bernini had planned, but did not execute,
another freestanding colonnade opposite the
church that would have closed the piazza. This co-
lonnade would have masked the facade from the
principal approaches, creating a sense of surprise
and wonder for the pilgrim who walked through it
into the huge expansive oval of the piazza. As in
Sant'Andrea al Quirinale, Bernini took architectural
form and infused it and the space that it contains
with a new drama and energy. But for Saint Peter's
he also constructed a highly functional frame for
the principal church of the faith, a faith in which he
believed unquestioningly and which he helped to
sustain and glorify.

While Rome could pride itself on a multitude
of artists and a matchless extravagance of build-
ings, fountains, sculptures, and paintings, other Eu-
ropean cities also supplied geniuses who helped

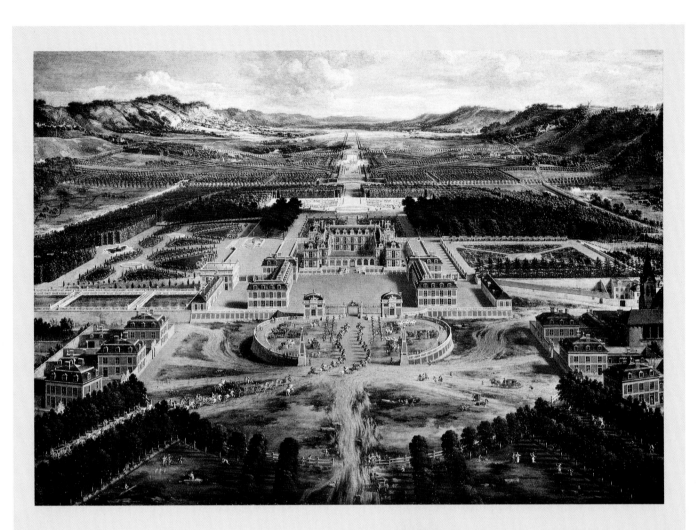

VERSAILLES

Started as a small chateau by Louis XIII, Versailles was built and enlarged between 1669 and 1685 under the direction of Louis XIV and served as his principal home outside Paris. It soon became the largest royal residence in the world and the envy of rulers everywhere. Its rigorous classicizing language was seen as an expression of Louis' absolute rule.

sustain the myth of power among the nobles. Antwerp was home to the two most renowned painters north of the Alps. These men, Peter Paul Rubens and Anthony Van Dyck, had much in common. They both built their styles on a common Northern heritage, they were influenced by the art of Italy—that of the sixteenth century and of their own times—and they were highly sophisticated courtier-painters who were at ease with the most powerful figures of their time.

Rubens was the older of the two. Born in 1577, one year after the death of his great hero, Titian, he, like Van Dyck after him, found early success in Antwerp. In 1600 he went to Italy, where he spent eight years painting for noble patrons and assiduously studying the works of the Italian artists of the sixteenth century, especially Michelangelo and Titian. In Italy, Rubens also immersed himself in a study of Roman art, which he was to use as a source throughout his life.

Rubens's success with princely patrons did not come through his art alone. Fluent in several languages, a scholar of classical antiquity, extensively traveled, charming, and urbane, he was not out of place among those whom he served both as a famous artist and a skilled diplomat. He was a new sort of artist, one whose talents, both intellectual and social, made him welcome at the courts of Europe for which he executed important commissions.

One was the cycle of twenty-one oil paintings for the Queen Mother of France, Marie de' Medici, a member of the wealthy and famous Florentine family. These giant canvases were to be paired with another set, which unfortunately was never executed by Rubens, depicting the life of Marie's deceased husband, Henry IV. Rubens's completed paintings are a glorification of Marie's life and reign, which, in reality, had been quite unexceptional. Glorification was Rubens's particular talent, and he attacked the project with his usual gusto and with a large workshop filled with talented pupils, among them Van Dyck.

That Rubens, like Caravaggio, could raise the ordinary to the exceptional and infuse it with a drama equal to that of Bernini is evident from every brilliant painting in the Marie de' Medici cycle, which Rubens endowed with the flamelike energy and opulence that characterize all his finest works.

For example, in the *Presentation of the Portrait of Marie de' Medici to Henry IV* [p. 171], a historical event is elevated to the level of mythology as the ecstatic king is transported by the sight of his future bride. (This canvas documents the important role played by the painted portrait before the invention of the photograph.) The portrait is presented by Hymen and Cupid, who have been dispatched by Jupiter and Juno, reclining on the cloud bank above. As France looks on, the smitten Henry admires Marie's picture while two amoretti carry away his armor, a sure sign of the peace that the marriage will promote. These allegorical figures, direct descendants of Veronese's, are foreign to the modern mind and perhaps a bit overblown, but the seventeenth century thought in terms of personifications that conveyed for the contemporary viewer a realism. Nevertheless, with the fluid strokes of his brush, Rubens was able to impart such a strong sense of pulsating life into all these monumental and fleshy creatures that they still command considerable admiration.

Rubens was a painter of dynamism and sensuousness. The large areas of glowing, pink skin, the billowing, shimmering drapery, the towering clouds over the landscape are held in a composition made up of strong diagonal and expansive, open movements. The dazzling palette, with its clear reds, golds, pinks, and greens, balances and complements the narrative. Rubens's superb draftsmanship and his study and total comprehension of Titian, Raphael, and Michelangelo are apparent in the magnificent figures of Jupiter and Juno, each composed with wondrous facility.

Rubens's skill as a painter of images of resplendent majesty found him many commissions, not only from Marie de' Medici but also from other monarchs. While in London in 1629 in the role of diplomat to negotiate a peace treaty between Spain and England, he began discussions with Charles I (who later knighted him) for a large series of ceiling paintings for the Banqueting House in Whitehall, a

PETER PAUL RUBENS, PRESENTATION OF THE PORTRAIT OF MARIE DE' MEDICI TO HENRY IV, 1633. *The marriage by proxy of Marie de' Medici to King Henry IV was performed in the cathedral of Florence on October 5, 1600, and celebrated by a colossal feast where each dish was an allegory of the splendid qualities of the illustrious bride and groom.*

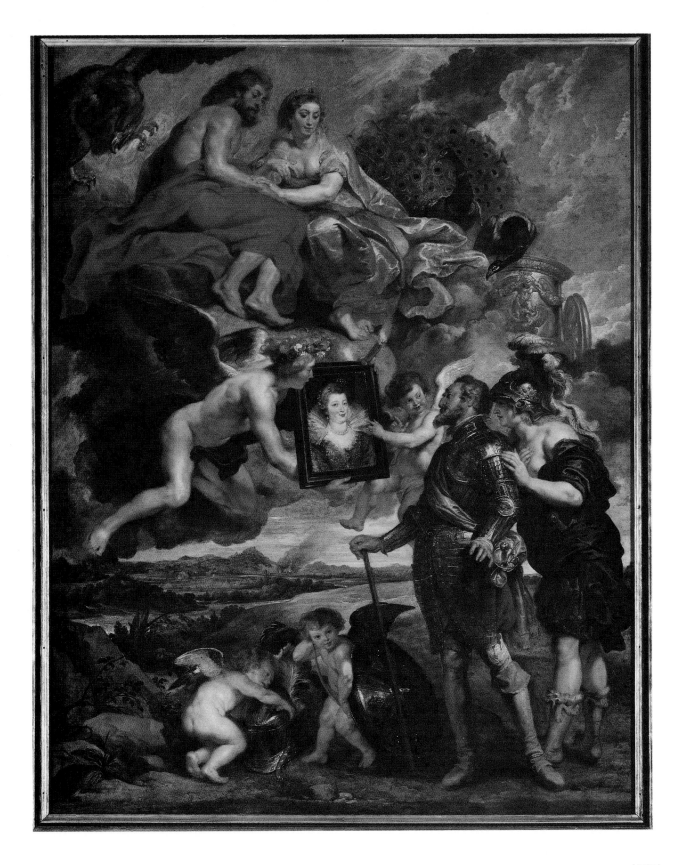

PETER PAUL RUBENS, THOMAS HOWARD, EARL OF ARUNDEL, C. 1629. *Thomas Howard, Earl of Arundel, was a discerning and learned collector and patron who sat for portraits by both Rubens and Van Dyck.*

found an artist supremely capable of capturing the essence of that gilded aristocracy teetering on the brink of regicide and disastrous civil war.

Following an earlier brief visit, Van Dyck arrived in England in 1632, where he remained until his death nine years later. In July of 1632 he was knighted and made Principal Painter in Ordinary to the king and queen. The next year, he finished his *Charles I on Horseback* [p. 172], one of the grandest visions of royalty ever painted. The king rides toward the spectator through a triumphal arch hung with drapery and decorated with the royal arms placed against the column base. Astride a spirited stallion, Charles, who was an accomplished horse-

ANTHONY VAN DYCK, CHARLES I ON HORSEBACK, 1633. *In 1638 a visitor to London in the suite of Marie de' Medici commented that Van Dyck had "so skillfully brought him [Charles I] to life with his brush" that he would boldly assert that the king was alive in this portrait, so vivid its appearance.*

building of great sobriety and dignity, designed by the talented English architect, artist, and designer of courtly masques Inigo Jones. Charles was a patron and collector of exceptional perception and taste whose reign saw the establishment of art in England on an international level. The ceiling paintings in the Banqueting House commissioned to honor James I, Charles's father, were a pictorial manifesto of the divine right and authority of kings. It is therefore ironic and tragic that Charles was beheaded outside the Banqueting House, thus bringing to an end one of the most effulgent episodes in the history of art and art collecting.

Charles and his circle, including the great collector and patron Lord Arundel [p. 172], whose vigorous likeness by Rubens is one of the landmarks of seventeenth-century portraiture, were always on the lookout for talented young artists capable of rendering idealized images of aristocrats in stone or paint. In Rubens's pupil Anthony Van Dyck they

man, rides with commanding ease as his riding master and equerry, the Seigneur de Saint-Antoine, strides by his side carrying the king's helmet and looking at his master with devotion and admiration.

All the ingredients of the royal equestrian portrait—horse, armor, coat of arms, dramatic sky, and servant—which can be traced back to their first definitive post-Roman form in Titian's work, are combined by Van Dyck with a newfound grace and theatricality and are put to the service of monarchy, just as Bernini's striking new works served and glorified the papacy. *Charles I on Horseback* was originally flanked by portraits of Roman emperors and hung at the end of a long gallery, where it must have seemed that the commanding image of the king was just then riding through the arch at the other end toward the viewer. This suave, self-confident image is painted with astounding fluidity and ease; Van Dyck, like his fellow glorifiers of power Bernini, Rubens, and Velázquez, was a virtuoso, making the difficult task of the representation of power and presence look easy. The exceptional adroitness of these artists was much valued at court, where elegance and grace were highly prized in all aspects of life.

These characteristics were given their definitive statement by Van Dyck in another magnificent portrait of the king, where Charles is shown dismounted, posing with easy grandeur in the hunting field, his horse held by a groom. The feathery trees, cloud-filled sky, and panoramic landscape are subservient to the urbanity and hauteur of the king, who, even without the trappings of royalty, as in *Charles I on Horseback*, is clearly sovereign by divine will and royal presence.

The image of the royal courtier, the natural aristocrat of Van Dyck's paintings, had a major impact on the history of English art. Van Dyck and Rubens brought a new and much needed level of talent and sophistication, and their works, especially Van Dyck's portraits of the aristocracy at ease, were to serve as models of patrician power and privilege down to the nineteenth century.

Like London and Rome, seventeenth-century Madrid was the hub of great power, under Philip IV, great-grandson of Charles V. Although a mediocre king, Philip was a great patron of the arts. His finest accomplishment was to hire Diego Velázquez as court painter in 1623. Velázquez thereafter lived at

DIEGO VELÁZQUEZ, PHILIP IV ON HORSEBACK, 1634–35. *Painted for the Hall of Realms of the Buen Retiro palace, one of the chief royal residences, this portrait was part of a complex of images designed to celebrate and commemorate Spanish royal authority and conquests.*

court and worked almost exclusively for the king. He recorded virtually every member of the royal family and helped decorate the palaces with suitable narratives and histories.

Velázquez was trained by Spanish masters who favored the emulation of nature. They also taught Velázquez to paint in a broad, direct manner, an approach that would become looser, composed of easily readable brush marks that coalesce to form the image. Velázquez's style and many of his subjects deeply influenced later artists, particularly Manet and Picasso. His earliest subjects were the poor and humble inhabitants of Spanish streets. When he began to work for the king, he adapted his realism to suit the purposes of his pictures. His portrait of Philip IV [p. 173] unsparingly reveals Philip's physical shortcomings—the enormous

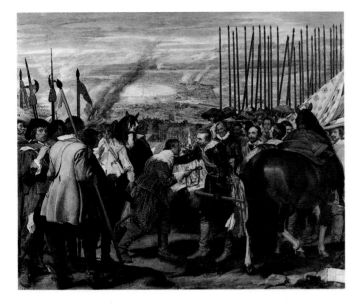

DIEGO VELÁZQUEZ, SURRENDER OF BREDA, C. 1630S.
*Painted about 1635–36 to commemorate the Spanish victory
over the Dutch in 1625, this scene portrays an event Velázquez
never witnessed. He relied on various prints and written
descriptions of the event to create a scene so vivid it appears as
though the artist were present at the surrender.*

Hapsburg lip and jaw, for example. But this truthful-
ness is placed within an idealizing context. *Philip
IV on Horseback* is one of many portrayals Veláz-
quez produced of his royal patron in their long as-
sociation. Painted in 1634–35 for the Hall of
Realms, in the Buen Retiro palace, it shows an or-
dinary man assuming with seriousness and delib-
eration the role of king. Mounted on a rearing
charger, he is the epitome of authority. Though Ve-
lázquez did not cast over Philip a veil of refinement
and grace like those awarded Charles I and Louis
XIV by Van Dyck and Bernini, he made him a living
emblem of power. With a vigorous brush and an eye
for the truth as well as for symbol, Velázquez delib-
erately maintained a tension between the real figure
and the role he played. In fusing such extremes he
was thinking like Caravaggio, whose altarpieces
also stretched the image into two directions. But the
effect here is not shocking emotionalism or grand
theater, but startling sobriety. The symbol gains cre-
dence by being fleshed out with palpable humanity,
and the human gains stature by being linked with
the authoritative symbol of the equestrian portrait.

For the same room, Velázquez also painted a
scene of Spanish victory, the *Surrender of Breda* [p.

174], which shows the Dutch rebels of Breda, sur-
rendering to Philip's commander, Ambrogio di Spi-
nola, on June 5, 1625. But this seemingly factual
depiction incorporates a substantial amount of fic-
tion. The picture was painted to please the Spanish
king, and its purpose was to underscore the benev-
olence and generosity of the Spanish. Thus Spinola
is shown graciously clasping Nassau's shoulder,
preventing him from kneeling in surrender. Though
Spanish surrender terms were historically generous,
it is doubtful that Spinola treated Nassau as an
equal; it is more likely that Spinola accepted Bre-
da's surrender from horseback, as was the conven-
tion of the time. Presenting a guise of factual
reportage, Velázquez adopted the grandiose lan-
guage of history painting, as it had been established
by Raphael in the Vatican Stanze some hundred
years before. Rubens, who had visited Madrid as a
diplomat in 1628, convinced Velázquez to visit Italy,
and by the time Velázquez had painted the Breda
episode, in 1635–36, he had already been to Italy
once. Velázquez's scene of the homage of the van-
quished and the nobility of the victor did not record
the actual event but simply adapted it to make per-
haps the greatest military picture ever painted.

Late in his life, in 1656, Velázquez painted what
is his acknowledged masterpiece, *Las Meninas,* or
The Maids of Honor [p. 175]. Here he provided his
own original essay on the nature of reality by fusing
several subjects. The group portrait, the "genre"
(scenes of daily life) theme, the self-portrait, the
artist in his studio, and the interior as it had been
developed by such Dutch masters as Pieter de
Hooch, have all come together in a new and distinc-
tive form.

The Maids of Honor is, in fact, a series of por-
traits within portraits. It is first a portrait of a room:
the artist's studio. That studio had been the bed-
room of the deceased prince Balthasar Carlos.
Thus, in painting his studio, Velázquez may have
been alluding to a regenerative spirit in the wake of
death. Gathered in the room are the Infanta Doña
Margarita (born in 1651 to Philip IV and his niece,
Mariana of Austria, whom he married in 1649), a
pair of attendants, and two dwarfs. Margarita looks
out of the picture winsomely, ignoring the tray of
refreshments and the artist to her right, as well as
the attendants to her left. Even the young dwarf, who
angrily kicks the family dog, has not diverted her

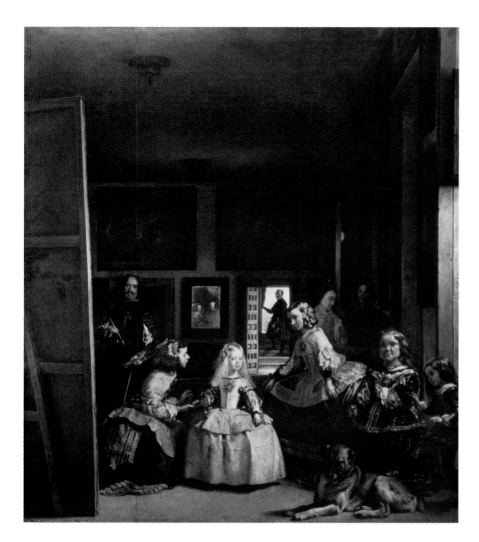

DIEGO VELÁZQUEZ, LAS MENINAS, 1656.
Considered Velázquez's greatest work, Las Meninas *interpreted
the past and anticipated the future. The device of showing
actual figures in lifelike rooms traces back to Van Eyck, as does
the device of the mirror reflecting an otherwise unseen
presence. The theme of the artist portraying himself at work and
showing the space in which his work takes place reflects the
autobiographical interests of the seventeenth century.*

in his studio has been woven into the scene.

Las Meninas hung in Philip's private office, a sure indication that it was special to him. Here, in a single image, much that was important to Philip was ingeniously brought together. His family, his retainers, his newly knighted painter, and, above all, his beautiful daughter are gathered in the room that belonged to his dead son and heir.

In an image both charming and melancholy, Velázquez has captured the waning years of the Spanish Hapsburgs. Velázquez died only four years later, and Philip died in 1666. During the years of Philip's reign Spain was in decline, and after his death France became the leading power of Europe. Philip's eldest daughter, Maria Teresa, became the wife of Louis XIV, whom Bernini had so artfully ennobled. But when she went to France, Maria Teresa was never again portrayed by an artist of Velázquez's brilliance. Louis outlived Maria by twenty-two years and saw Europe transformed by French manners and styles. During the reign of Louis XIV, refinement, delicacy, and fantasy replaced the vigorous and energetic illusionism of the seventeenth century. Italy lost its supremacy as the leading artistic power to France, and Spain and Holland also succumbed to the French style.

But before Holland ceded to France, it had become the center of an artistic development that handed to succeeding generations both the style and the subjects that were to become the backbone of artistic production for centuries to come. Long after royalty, nobility, and the clergy ceased to be important patrons of art, and the portraits, allegories, and altarpieces they had supported were no longer part of a broad cultural expression, the ordinary reality the artists of seventeenth-century Holland had transformed into art lived on.

attention. A group portrait has seldom been shown with greater spontaneity or informality. Whom the Infanta looks at has been the subject of much debate. It is possible she is looking at her parents, whose faces are reflected in the mirror behind her head. Logic dictates their presence in the viewer's space. They, in fact, may be the subject of a double portrait being painted on the canvas upon which Velázquez shows himself working—the artist

PIETER JANSZ. SAENREDAM, OLD TOWN HALL OF AMSTERDAM, 1657. *Saenredam traveled extensively in Holland, making meticulous drawings of important sites, particularly churches. In 1641 he had made a drawing of Amsterdam's old town hall, which burned down in 1651. This painting was commissioned by the city of Amsterdam to commemorate its old seat of government.*

[10]

A GOLDEN AGE: DUTCH ART OF THE SEVENTEENTH CENTURY

While artists working in the capitals and courts of Europe served kings and popes, there were artists in the small region of the Netherlands who worked for nearly everyone. A general art market developed in Holland not only for inexpensive prints, as had been the case earlier, but also for paintings. Holland's largely Protestant mercantile class continued to support painting, as it had since the early Renaissance, but now it was joined by craftsmen and laborers such as blacksmiths, cobblers, tailors, and bakers, who bought pictures that portrayed aspects of their own lives. For this land of burghers, the elevated rhetoric of aristocratic art had no meaning, and there was no need for the artistic accouterments of Catholic worship. But interest in portrayals of ordinary reality and the peculiar set of cultural circumstances that existed in seventeenth-century Holland produced an unprecedented pictorial examination of everyday life. The neat, orderly Dutch cities with their sturdy, clean houses; the dunes, woods, rivers, canals, and beaches that made up the countryside around them; the objects people owned; the amusements they enjoyed and the soci-

eties that they joined; the stories they loved; and the people themselves were portrayed with a remarkable mixture of honesty, insight, and artistry. The Dutch confronted themselves frankly, recognized their weaknesses, and valued their strengths. Hardworking, inventive, and adventuresome, they possessed a fascinating mixture of worldliness and domesticity.

Hundreds of painters worked in Holland between 1600 and 1700, driving the prices of art down and the competition among artists up. Few became rich, and many went bankrupt or turned to other livelihoods, but the quality of the resulting production was often extremely high. During this Golden Age of Dutch painting, as the seventeenth century has come to be known, a number of outstanding masters—Rembrandt, Hals, Vermeer, and Ruisdael —and countless lesser artists specialized in the various categories of easel painting that were eagerly collected. Portraits, landscapes, still lifes, interiors, town views, seascapes, and the scenes of daily life known as genre pictures were introduced into the artistic lexicon by these Dutch masters and remained an integral part of the subject matter of Western painting until the twentieth century.

Although inspired by the realist orientation inaugurated by Jan van Eyck and his contemporaries more than two hundred years earlier, Dutch artists of the seventeenth century no longer painted altarpieces, though stories from the Bible were still highly favored. Guided by a deeply moral spirit, the Dutch attached significance to every aspect of their material world and viewed life and humanity critically but sympathetically. Much of what was painted retained the admonitory symbolism of the past; while not directly religious, it reminded the viewer of people's vanity, the brevity of life, and human frailty. Yet the symbolism was imbedded in images that valued and reflected ordinary life.

Just why, during the seventeenth century, Holland witnessed such an outpouring of painting talent remains a mystery. Certainly there was a long tradition of painting in the North, and the economic growth Holland enjoyed in the seventeenth century supported artistic activity. Both deeply spiritual and unabashedly materialistic, the Dutch found satisfying expression in the production of paintings that showed the material world viewed through a moralizing looking glass.

In addition, the long struggle of the United Provinces to establish their freedom from Spanish rule, officially accomplished with the Treaty of Münster in 1648, at the end of the Thirty Years War, may have provided some inspiration for painters. In Holland, as had been the case in Renaissance Florence, the notion of independence was an ideal that was sustained in popular myth and expressed in the visual arts. The struggle for freedom, rooted in the religious differences between the Catholic Spaniards and the Protestant Dutch, had a significant impact on Dutch art, affecting the subject matter, which generally avoided both Catholic themes and aristocratic imagery. Holland was essentially Protestant, and the teachings of John Calvin were deeply embedded in the Dutch mentality. Calvin had emphasized austerity, honest labor, and frugality as acts of homage to God. The Dutch not only valued work and thrift, they appreciated well-made things and had a fascination for the world around them. It was the Dutch who, in 1650, completed the first world map, a marriage of utility and worldly interests. Moreover, the Dutch were particularly visual in their orientation. Dutch technology developed the most refined telescopes, which expanded the visual horizons to include the planets. The Dutch interest in seeing, or having portrayed for them all that was visible, also found expression in their collecting habits.

Enthusiastic collectors, the Dutch prized a variety of objects such as shells, insects, and exotic animals and objects. They traded in Venetian glass, Chinese porcelain, pewter, and Oriental carpets, all of which made Dutch interiors increasingly lavish during the second half of the century. But nothing could compare to the Dutch passion for flowers. Tulips, introduced from Turkey in the sixteenth century, were the subject of a tulip rage from 1630 to 1637. Until the market crashed, entire fortunes were made and lost on a single rare bulb. Not surprisingly, flowers as the subject of paintings were introduced by the Dutch, who generally paid more for a flower piece than for any other kind of picture. Paintings themselves were collected and traded; styles as well as subjects went in and out of fashion. Reflecting the interests and values of a large spectrum of Dutch society, paintings of this era provide a clearer picture of Dutch life than we have from any previous period.

PIETER JANSZ. SAENREDAM, INTERIOR OF THE CHURCH OF SAINT ODULPHUS, ASSENDELFT, 1649. *Assendelft, a small village near Haarlem, was Saenredam's birthplace. The old Romanesque church there was stripped of its altarpieces and decorations during the Reformation. Its tombs remained, and Saenredam faithfully transcribed the tomb slab (in the foreground) that holds his father's remains, as well as the large tomb that is the burial place of the lords of the city.*

With the onset of interest in the material world seemingly devoid of any justification but its existence, many new subjects emerged for painters. One striking new theme was the town view. Foreshadowed by the portrayals of actual towns in many early religious scenes, independent images of town views and studies of individual buildings and churches developed early in the century and became popular after about 1650. No artist left a more beautiful picture of the buildings among which he lived than Pieter Jansz. Saenredam (1597–1665). A hunchback and recluse, Saenredam made the buildings and squares of cities like Haarlem, Utrecht, and Ghent his subject. One of his finest

works, the *Old Town Hall of Amsterdam* [pp. 176–177], was painted in 1657 to record how the town hall had looked before it was destroyed in the fire of 1651. Using a drawing made ten years earlier as his source, Saenredam retained a feeling of freshness and immediacy through his obsessive attention to detail. Silent and motionless, his view of the old town hall is as reserved as it is explicit. It endows its subject with a melancholy dignity.

Saenredam's interests included church interiors. Traveling considerable distances to study them, he recorded churches in Utrecht and Amsterdam, as well as in his native Haarlem. His *Interior of the Church of Saint Odulphus, Assendelft* [p. 179] of 1649 is typical of his preference for architecture over people as subject matter. The church dwarfs the worshipers and appears remarkably empty despite their presence. The spare interior of this Dutch Protestant church is transcribed with such clarity and sureness that it becomes a meditation on the Puritan ethic. Stark, plain, and pure, this church allows nothing to detract from the sanctity of its

space, delivering a silent sermon to the onlooker about the divine order. Church interiors like this one were a particularly Dutch subject and, unlike town views, remained almost exclusively Dutch. Saenredam was the first to record actual church interiors, and his impact was especially strong in Delft, where a number of painters explored the theme of interiors both sacred and secular.

For Jan Vermeer (1632–1675), domestic interiors took on the quiet, meditative quality that Saenredam showed in his paintings of churches. Both in a biographical and artistic sense, Vermeer remains a mystery. He sold very few paintings during his lifetime, and it was not until the late nineteenth century that his work was rediscovered and reappraised. Like the Renaissance artist Piero della Francesca, whose paintings were rediscovered at about the same time, Vermeer soon became one of the most admired figures in the history of Western art.

Many of Vermeer's most beguiling paintings show people and objects in simple interiors. Serene and cut off from the outside world, his domestic images demonstrate the profound attachment of the Dutch to their homes. But there is more to Vermeer's paintings. His *Young Woman with a Water Jug* of about 1665 [p. 181] portrays a single figure standing before a window and next to a table that holds a pitcher and a bowl. Vermeer takes this common dross and spins it into gold. As window and map allude to the outside world, the room becomes an image of refuge and sanctity. The scene is motionless, the figure and objects suspended in time. The shape and position of the wall map, the table, and the window, and the linkage of all these units through the figure of the young woman, whose headdress and gown are themselves important and independent pictorial elements, create formal pattern and stability. Vermeer, like van Eyck and Saenredam, equated order and light with holiness, and the steady, purifying light streaming through the partially open window confers a transcendental quality to the objects in this simple Dutch interior, elevating the mundane and turning one's contemplation of it into a deeply felt religious experience.

Unlike Saenredam, who emphasized architecture, Vermeer created environments for the contemplative actions of people. Other painters of domestic life placed different emphasis on the everyday, celebrating the appurtenances of material existence while evoking themes that are as subtle as their portrayal is explicit. Pieter de Hooch (c. 1629–after 1677), Vermeer's older contemporary, found the structure and materials of rooms as interesting as the people within them. De Hooch spent some years working in Delft, before settling in Amsterdam. His scenes provide an intimate glimpse into Dutch houses, taking the viewer through doorways and hallways, where women and children go about their chores. Famous for the diverse spaces he could portray within a single frame, de Hooch used these as a means to express the values of cleanliness, orderliness, and rectitude.

One of de Hooch's most beautiful paintings is *Courtyard of a House in Delft* of 1658 [p. 182], where he leads the eye from the courtyard behind a house through its hallway and out to the street and houses beyond; unlike Vermeer, who concentrated on interiors cut off from the outside world, de Hooch alludes to the urban context of the home. Stepping from the grape arbor, a Dutch woman and her child walk over neatly arranged bricks toward a bucket and broom. Using shifts in scale and light, and sensitively describing the texture, mood, and pace of domestic life, de Hooch has condensed a complex setting into a single, well-ordered and memorable frame faithfully mirroring reality.

Many Dutch artists, particularly those active outside Delft, exploited images of domestic life for their strong narrative potential. People placed in rooms offered endless possibilities for storytelling; themes with either salacious or moralizing overtones were equally popular. Scores of lovesick maidens, bawdy soldiers, merrymakers, and lovers acted in pictorial dramas. One of the most notable masters of the domestic "drama" was Gerard Ter Borch (1617–1681). His images, though they survey a wide spectrum of Dutch society, often portrayed the life of the wealthy upper class. Ter Borch's *Musical Company* [p. 182], painted about 1665, shows his technical virtuosity as well as his narrative skills.

JAN VERMEER, YOUNG WOMAN WITH A WATER JUG, c. 1665. *Only about forty works by Vermeer have been identified, and few of these are signed or dated. Based on the mature handling of paint and the composition, this picture has been dated to roughly 1665, the highpoint of Dutch seventeenth-century painting.*

GERARD TER BORCH, MUSICAL COMPANY, C. 1665.
Interiors painted in the second half of the seventeenth century became more lavish and people's costumes more magnificent, indicating the higher standard of living enjoyed by the Dutch after the Peace of Westphalia of 1648, which established Holland as one of Europe's leading political and commercial powers.

PIETER DE HOOCH, COURTYARD OF A HOUSE IN DELFT, 1658. *The unusually high value the Dutch placed on home, marriage, order, and cleanliness is reflected in De Hooch's portrayals of domestic life, which include direct and oblique references to the moral overtones of cleanliness as well as to the importance of teaching children these values.*

As a wealthy young lady, dressed in satin, furs, and brocade, plays a theorbo (a double-necked lute), a young gentleman leans across the carpeted table, perhaps accompanying her in song. His companion looks on, and all seem absorbed in the music. Yet their absorption seems to allude to other meanings. The open door, the dog, the candle, and the bed all have sexual connotations, while music in Dutch images is often associated with love. Ter Borch created an illusion that in miniature reflects, but also amplifies, the material world. He has selectively emphasized certain elements, such as the satin dress, and obscured other details. His meticulous manner of painting reflects a style called "fine painting" that was popular with the Dutch the entire century, while his subtle narrative manner was unsurpassed. Ter Borch delighted in creating layers of reality, building his story out of innuendoes. To

the Dutch, the boundaries between love and lust, between morality and immorality, between respectable materialism and wanton greed were delicate and changeable. Ter Borch was a student of life and human nature, expressing these ideas with grace, restraint, and understanding.

What was gently and soberly implied by Ter Borch was quite raucously stated by Jan Steen (1626–1679), born in Leiden. Steen made his artistic career by exposing, with good-humored fun, human frailties. Acting as moralist, epigrammatist, and enthusiastic storyteller, Steen created unforgettable pictures of family life, such as *The Way You Hear It Is the Way You Sing It* [p. 183]. A mingling of themes, it shows a family gathered to celebrate Twelfth Night, on which the grandfather is crowned king and merrily waits for his drink. The grandmother reads an old Dutch rhyme, "The way you

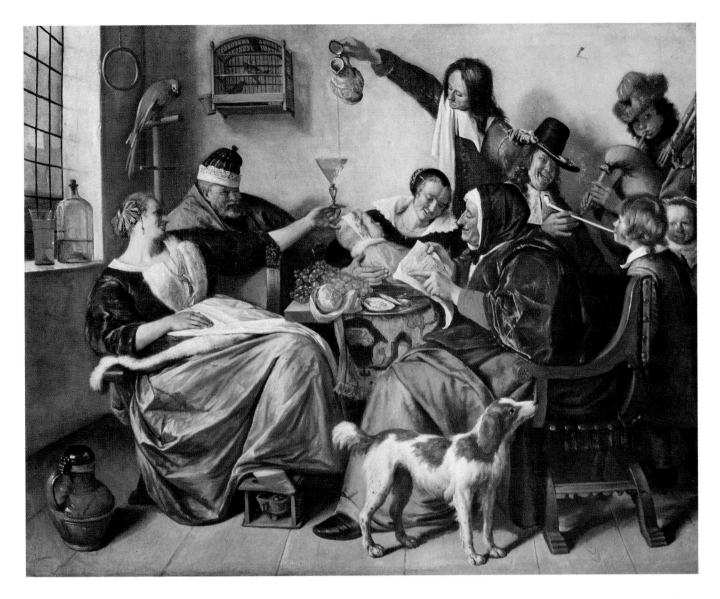

JAN STEEN, THE WAY YOU HEAR IT IS THE WAY YOU SING IT, C. 1665. *One of Steen's favorite subjects was family life. He usually included three generations pursuing pleasure in cluttered surroundings. Steen's images were intended to admonish viewers about the results of intemperance and the effects of adult behavior on children. Steen frequently used himself as a model, and here he is probably the figure offering his pipe to his son.*

hear it is the way you sing it," alluding to the tendency of children to imitate their elders. In this gathering, a moral tale unfolds, enriched by the depicted objects. The parrot, like the children, is a mimic. This theme is also reflected by the elder who shows the young boy how to smoke a pipe. Adding

a note of licentiousness with this vignette on smoking, Steen makes references to the various meanings of the word *pijpen* (pipe), which has sexual overtones, by showing a young man vigorously playing a bagpipe. Like Ter Borch's drama, Steen's domestic scene strikes more than one note— suspicious of the very pleasures it portrays, his picture creates a moral tone with wit and insight.

In seventeenth-century Holland, the still life, in which various objects are assembled and portrayed, underwent significant development. Beginning with simple portrayals of food and other objects, still lifes, like other kinds of subjects, could also convey hidden meanings. Vanitas themes—portraying emblems of vanity and the momentariness of this world

—developed. Flowers became the specialty of a particularly well-paid group of painters. By the second half of the century, the *Pronk* still life, which portrayed magnificent and expensive imported objects such as Chinese porcelain and Venetian glass, gained popularity.

Reflecting a new sumptuousness, the Pronk still life reached its apogee in the art of Willem Kalf (1619–1693). Born in Rotterdam, Kalf spent most of his career in Amsterdam. Though still-life painting had a low reputation among most artists—figure painting in Holland, as in Italy, was considered the chief occupation of the artist—Kalf was one of the few still-life painters widely admired in his own day. His sensitivity to light, as it transforms and is transformed in turn by material objects, was unrivaled. In this regard, his vision comes closest to such Delft masters as Vermeer. His *Still Life* [p. 185] assembles costly objects such as Venetian glass, Oriental rugs, and Chinese porcelain, which had replaced the humbler pewter and damask that graced still lifes by earlier masters. In Kalf's hands, these objects have been suspended in time, expressing an eternal, quiet beauty that shares the spirit of Vermeer's meditative interiors. Giving off a shimmering light, which gently reveals the objects even as they are enveloped by a velvety darkness, they become more beautiful and noble than they are in reality. Kalf, like Ter Borch, emulated reality to create an unreality—a selected, exquisite truth based on art, not on life alone.

Kalf endowed a relatively limited range of objects with mystery and drama; landscape painters of the age attempted to encapsulate the vast and complex information found in nature and then organize it into art. The result of their efforts is the richest, most diverse, and influential landscape painting produced in the West and destined to have a particular impact on the great nineteenth-century interpreters of landscape, including Constable and Turner.

No other artist of the period could rival Jacob van Ruisdael's profound and epic interpretation of the elemental aspects of nature. Ruisdael (c. 1628–1682) was born in Haarlem, the son of a painter turned art dealer and the nephew of the fine but lesser landscape painter Salomon van Ruysdael. As a young man, Ruisdael traveled along the Rhine River to the border of Germany; later he went to

The art of drawing was particularly useful for Dutch artists. Besides being used to copy old masters, and to make the model studies by which artists trained their hands and eyes, drawings became for the seventeenth-century Dutch a vital means to capture the rich texture of everyday experience, which was the basis for so much of their artistic expression. No Dutch artist drew more incessantly or with greater mastery than Rembrandt. More than five hundred of his drawings survive, though many more have been lost over time. Using chalk or, more often, pen and ink on paper, Rembrandt

drew whatever interested him. Beggars, fishwives, gossiping housewives, and itinerant vendors, as well as scenes of execution all caught his eye. His imagination was also stimulated by the Bible, and he drew countless biblical episodes.

Rembrandt's portrayals of women with children and scenes of intimate family life became more frequent after his marriage to Saskia van Ulyenburgh in 1633. Until her death in 1642, Saskia was his principal model and the subject of numerous drawings. The most poignant and moving of these are Rembrandt's portrayals of her prolonged and ultimately futile convalescence, which capture the extent of Saskia's sufferings with only a few insightful strokes of the pen.

WILLEM KALF, STILL LIFE, 1663. *Kalf repeated many of the same objects in a number of his still lifes. Objects were assembled to inspire reflection on the material as well as the spiritual values of life. Kalf interpreted his objects so poetically that Goethe was moved to comment on a still life by him.*

Scandinavia. Both trips, as well as the scenery around Haarlem, inspired him. Ruisdael's finest works include distant views of his native Haarlem, where his sensitivity to atmosphere, light, sky, and clouds is particularly evident. Earth and sky in Ruisdael's paintings are unmatched for their scope, and for their imaginative fusion of reality and art. By Ruisdael's time the panorama—the long, distant vista—had become an established type of landscape painting. Ruisdael's *Distant View of Haarlem* [p. 186], painted in the early 1670s, is a cosmic view of nature and mankind's place within it. In the foreground, orderly rows of linens have been laid out in the bleaching fields. The city of Haarlem is visible in the distance, its church spires and windmills picked out against the horizon, marking the union between earth and sky. Moisture-laden clouds loom over the city, bringing showers and casting their

JACOB VAN RUISDAEL, DISTANT VIEW OF HAARLEM, EARLY 1670s. *Though painted on a small scale, Ruisdael's view of Haarlem is grand and sweeping. Haarlem can be identified by Saint Bavo's, which still dominates the skyline.*

shadows over the earth below. The atmosphere that binds sky and earth has never been more effectively portrayed in paint, nor has nature's grand sweep, its mutability, and its inherent energy been more effectively examined.

Animated landscape—the vitality in the configurations made by sloping hills, winding paths, and billowing clouds—is the subject of Ruisdael's most fundamental vision, his *Wheatfields* [p. 187], painted about 1670. A road that leads straight into the painting seems to stretch to infinity. Blond fields of wheat ripen under the dampened sky. Dwarfed yet accommodated by the natural environment, people go about their business, walking among the fruits of their efforts and nature's bounty; like all Dutch art, landscapes were an extension of human life, and even in this solitary and epic painting, people and the evidence of their labor are woven into the scene. The change of seasons, alterations in weather, and figures in motion are the themes Ruisdael explored in this painting. Perpetually chang-

ing, the land is also perpetually the same, nurturing and renewing. As in the paintings of Brueghel, life is placed in its most elemental context, though the emphasis here is on nature first and then humanity. Ruisdael's principal focus was the damp, variable Dutch weather, with its shifting patterns of light and its continual supply of clouds. His ability to describe these effects in paint remains unsurpassed.

Ruisdael was highly influential, inspiring numerous artists in his own day; he became particularly important for the romantic landscape painters of the nineteenth century. Yet he was not nearly as popular in the Holland of his day as the "Italianate" landscape painters. These masters of Italian landscape, who often crossed the Alps to view Italy, brought back not only exotic scenery but a particularly Italian light, golden, warm, and captivating. One of these painters was Aelbert Cuyp (1620–1691), perhaps the most gifted painter of the blond, sunny, late-afternoon scenes that were so popular with Dutch collectors seeking portrayals of a light not found north of the Alps. Cuyp lived and worked in Dordrecht, where he was a prominent citizen and where he turned out countless scenes like his *View of Nijmegen* of c. 1665 [p. 187], which, with its peaceful cows, people at ease, and warm light, imbues the viewer with a sense of quiet repose.

Paintings of objects, of the land, of ships, of towns, and of civic monuments were the backbone of artistic activity in seventeenth-century Holland. But no painting outranked the portrait in importance. Though produced by many painters, it rose to the level of great art in the hands of only a few. Foremost among these was Frans Hals (c. 1580–1666). Born in Antwerp, Hals lived and worked in Haarlem all his life. His *Banquet of the Officers of the Saint George Militia Company, Haarlem* of 1616 [pp. 188–89] displays his talent at portraying spontaneous individual action and integrating it within a large, complex, yet cohesive composition. Each of the men is distinctively portrayed and each is woven into the fabric of the composition by his sash, ruffs, and other accouterments, which become decorative devices that can be emphasized and ordered.

Hals's best-known individual portrait is *Laughing Cavalier* [p. 188], which, with its free and energetic brush marks, anticipates the loose and painterly quality of the oil medium later rendered by Velázquez and Rembrandt. In the *Laughing Cava-*

JACOB VAN RUISDAEL, WHEATFIELDS, C. 1670. *Throughout his life, Ruisdael sought to express the grandeur of nature, its epic expanse and its constant mutability. Paintings such as this one profoundly influenced nineteenth-century English painters, including Constable and Turner.*

AELBERT CUYP, VIEW OF NIJMEGEN, C. 1665. *Nijmegen, located on the Waal River, was quite far from Cuyp's native Dordrecht. Cuyp most likely took riverboats to the many picturesque sites he recorded, making detailed drawings that he translated into paintings in his studio.*

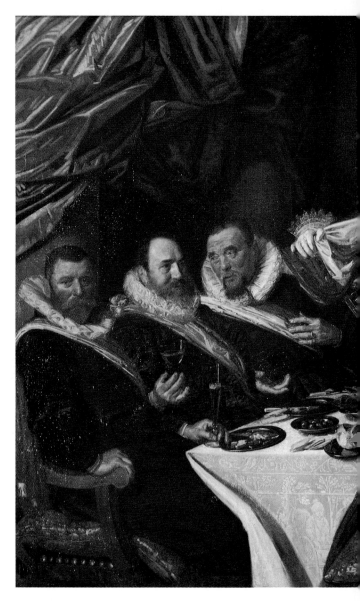

FRANS HALS, LAUGHING CAVALIER, 1624. *Despite the apparent spontaneity with which this masterpiece was painted, the complex embroidery on the cavalier's sleeve is highly detailed. The symbols in the embroidery were probably emblems of love that had significance to the sitter.*

FRANS HALS, BANQUET OF THE OFFICERS OF THE SAINT GEORGE MILITIA COMPANY, HAARLEM, 1616. *Founded to help defend Haarlem against the Spanish, the Saint George company, by 1616, had become what amounted to a social club for the leading young men of Haarlem.*

lier, Hals has frozen the moment in which a dashing cavalier turns toward the viewer, his energy, confidence, and arrogance forever immortalized. Hals spent his life studying human faces and searching for the character that lay beneath the surface. Toward the end of his long life—about eighty, impoverished, his style passé but not yielding to fashion —he produced a distillation of experience and understanding that marks him as an undiminished genius in his old age. His painting the *Regentesses of the Old Men's Almshouse, Haarlem* of c. 1664 [p. 190], his last important commission, interprets time

and humanity in a new way. Hals here portrays the effects of time on the face and on human character. These regentesses are alternately compassionate, stubborn, patient, modest, or proud. Quiet and undramatic, they are gathered around a plain table, their faces and their stiff white collars contrasted against the somber tones of the room and their dresses. Hals has depicted here practical women, who dispense meager funds to the poor. In so doing, he provides a poignant reminder of the benefits as well as the shortcomings of all human institutions, inspired as they are by imperfect motives

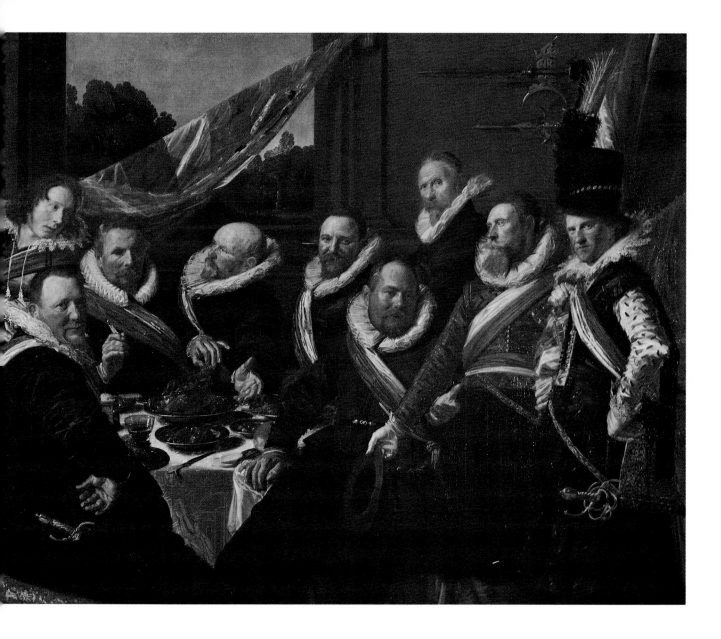

and governed by imperfect creatures. His tolerance and understanding echo through this silent gathering, as does his perception of the human condition.

Of all Dutch artists, none rose to the heights achieved by Rembrandt van Rijn (1606–1669). A prodigy in his youth, Rembrandt lived a long and fruitful life—enjoying wealth, enduring poverty, and gaining great insight into art and life. To Rembrandt, such categories as still life, landscape, and history painting, one or another of which most painters followed, became meaningless in the conventional sense of the terms. Rembrandt's earliest artistic

training took place in Leiden, where he was born, but by about 1632 he had moved to the thriving metropolis of Amsterdam, where he was to work for the rest of his life.

Only the mundane facts of Rembrandt's life are known, but he left a series of about fifty self-portraits, which, better than any document or manuscript, furnish an unmatched record of a supreme artist's thoughts. The self-portrait at that time was a fairly recent invention, becoming popular in Italy only in the sixteenth century. Not previously considered a worthy subject, the development of the

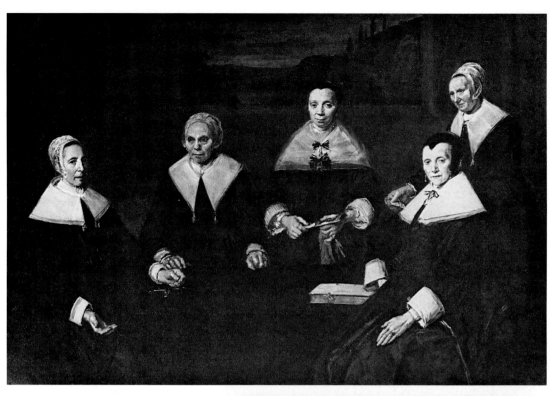

FRANS HALS, REGENTESSES OF THE OLD MEN'S ALMSHOUSE, HAARLEM, C. 1664. *Ten years before this picture was painted, a local baker seized Hals's belongings for an unpaid bill. Hals's financial hardships continued to the end of his life, though in 1664 he was granted a modest annual pension by the town councilors of Haarlem and he was awarded the commission to portray the Regentesses as well as the Regents of the Old Men's Almshouse.*

self-portrait documents the increasing importance of the artist and his new-found persona. The earliest of Rembrandt's self-portraits, done while he was still in Leiden, were theatrical poses, which were soon replaced by a much more insightful reading of character and station. In his 1640 self-portrait [p. 191], dressed in fur and velvet, he appears as the successful Amsterdam artist he had become. As Rembrandt's art matured, the works of the great Italian Renaissance artists played an increasingly important role for him; in fact, he based his 1640 self-portrait on portraits by Raphael and Titian that were then in Amsterdam. Rembrandt was an admirer and collector of other artists' work, from which he often borrowed. In his self-portrait he transformed the dashing, urbane faces of his Renaissance models into something very personal and revealing, an un-idealized face. The puffy jowls, the scraggly mustache, and, above all, the bulbous nose, only par-

REMBRANDT, CHRIST AND THE WOMAN TAKEN IN ADULTERY, 1644. *Rembrandt settled in Amsterdam about 1631 and quickly gained clients among the wealthy burghers. His painting* Christ and the Woman Taken in Adultery *reportedly belonged to Willem Six, the senior alderman of Amsterdam. His relative Jan Six also collected Rembrandt's work and later, when Rembrandt fell on hard times, lent him money.*

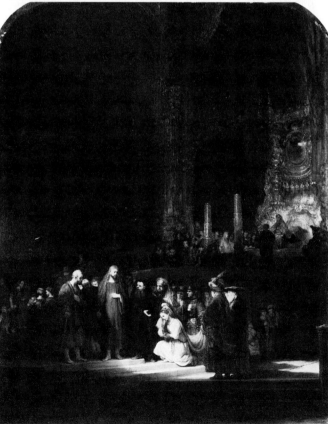

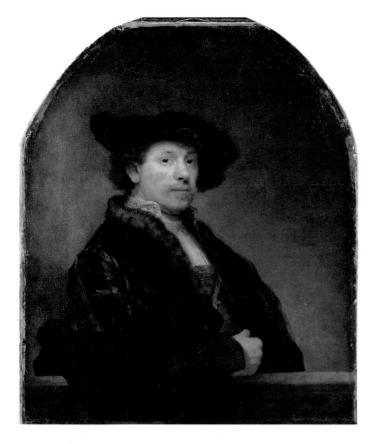

REMBRANDT, SELF-PORTRAIT, 1640. *In this self-portrait Rembrandt seems to have been most influenced by an early portrait, which he saw in Amsterdam, by Titian, the* Man with the Blue Sleeve, *an impressive work depicting a haughty young man.*

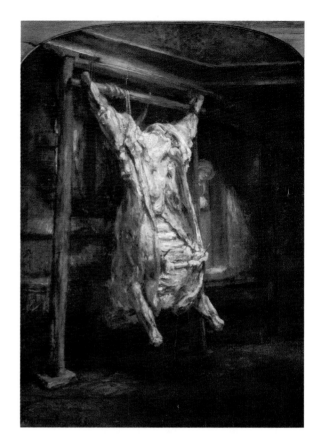

REMBRANDT, SLAUGHTERED OX, SIGNED AND DATED 1655. *Rembrandt rarely devoted whole paintings to animals, including them instead in his larger narratives. His portrayal of a slaughtered ox interprets the theme with a profound sense of tragedy and sacrifice.*

tially disguised by shadow, reveal an unblinking vision of great clarity, which was to become the major characteristic of Rembrandt's art. One feels that the artist is already uncomfortably aware of his own pretensions, and that the pose and the fancy, expensive clothes somehow do not match the plain, honest face.

Rembrandt's earliest narrative painting was strongly influenced by the work of Caravaggio and his numerous Northern followers. Dramatic, spotlighted works such as *Christ and the Woman Taken in Adultery* of 1644 [p. 190] are often set within a vast, theatrical architectural space. But Rembrandt always went beyond the merely dramatic to elucidate the deepest human feelings. Standing in a pool of light surrounded by the glowing architecture of the giant, dark buildings behind, Christ looks with compassion on the poor woman accused by the encircling elders. Amidst the scores of figures, the

huge buildings, and the peripheral activity, the small human drama assumes major importance.

As Rembrandt grew older, his work became much less theatrical and increasingly concerned with fundamental human emotions and relationships. He found material for his study of the human condition in the Old Testament, a text he knew well, and in the daily life that swirled around him in the bustling, commercial city of Amsterdam. In his *Slaughtered Ox* of 1655 [p. 191] he elevated a scene familiar to every citizen of Amsterdam to a new level of meaning. The massive carcass of the butchered animal emerges from the dimly lit shop to confront the viewer with questions about his own mortality. Shorn of hooves and head, split open and eviscerated, the animal's glowing body is rendered with a flurry of masterfully placed brushstrokes of red and yellow. Dignified and powerful even in its mutilation, the dead animal is an affirmation of the sacra-

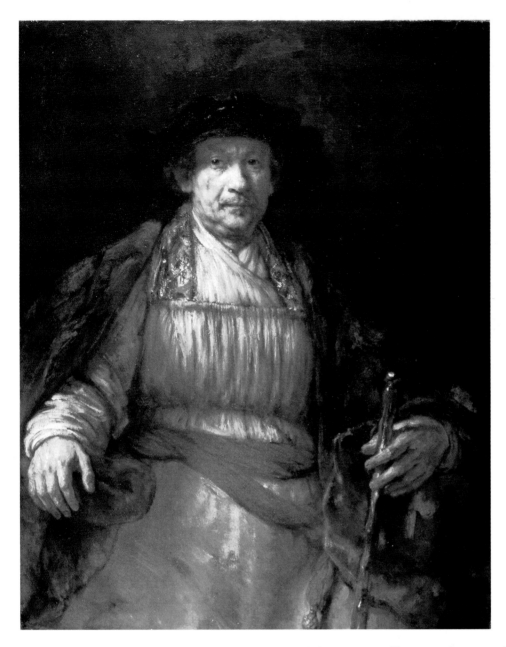

REMBRANDT, <u>SELF-PORTRAIT</u>, SIGNED AND DATED 1658.
Painted in the year that Rembrandt was forced to sell his possessions to pay his creditors, this self-portrait reflects the artist's detachment and calm as well as his recognition of his power as an artist.

the result of his reflection and questioning was, as in the splendid self-portrait of 1658 [p. 192], a work of extreme psychological complexity and profundity. In this painting, probably based on a Venetian model, Rembrandt sits facing the viewer. Clothed once again in fur and expensive fabric, his body dominates the space, and his head is the focal point of the picture. He sits, in fact, like a king, his painter's maulstick his scepter, his soft beret his crown. But the face is no longer wary or haughty. The flesh has sagged and creased, the nose has become more prominent, and the eyes are filled with experience, understanding, and a vague sadness.

Rembrandt's skill with oil paint had been preceded only by Titian's. In Rembrandt's hands oil paint could magically become anything: cloth, gold, or even atmosphere and light, while retaining the physical nature of paint. This can be seen in the 1658 self-portrait: the aged hands, the knobby wooden maulstick, and the gold threads of the collar are, at one and the same time, magnificent illusion and the unmistakable physical marks of Rembrandt's loaded brush.

Near the end of his long life, filled with considerable success but also much personal tragedy, Rembrandt's complete mastery of his medium, the profundity of his vision, and his compassion for humanity resulted in a series of masterpieces, including the poignant *Return of the Prodigal Son* of c. 1668 [p. 193], a story that fascinated Rembrandt. The joy of the Prodigal Son's father, who gathers his

mental nature of all life and is regarded as such by the dwarfed woman looking through the door in the back of the shop.

Meditations on mortality were also very much a part of the aging Rembrandt's self-portraits. Often

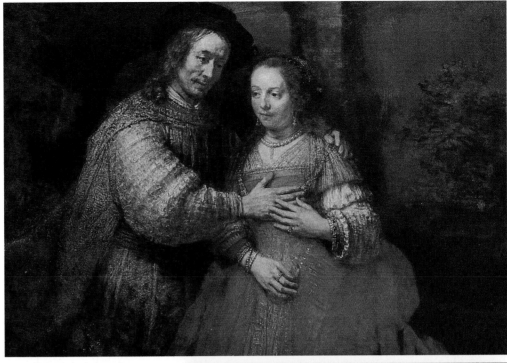

REMBRANDT, JEWISH BRIDE, c. 1665. *Though the exact nature of its subject remains in question, this painting's true theme—the transcendent quality of human love—is clearly evident.*

wayward, repentant son in his arms, is a visual metaphor for the sanctity of human forgiveness and love. Presented with breathtaking simplicity—only five figures, perfectly related to one another—and a palette of glowing reds, yellows, and browns, the *Return of the Prodigal Son* enlarges and deepens one's understanding of compassion.

In the painting called (probably mistakenly) the *Jewish Bride* of c. 1665 [p. 193], the actual subject is of minimal importance. Instead, it is the tender and protective relationship of the couple, formed by the triangular unification of their bodies and the isolation of their setting, which is the real message of this painting of human love.

Rembrandt's late paintings were not fully understood by his contemporaries: they were outside current convention and highly personal in both form and interpretation of subject. Yet he is the master of the Dutch Golden Age. The humanity that reverberates through his work, the great themes of compassion, love, and reconciliation on which he meditated are a high point in the history of Western art.

REMBRANDT, RETURN OF THE PRODIGAL SON, c. 1668. *Engrossed in themes of reconciliation and compassion, Rembrandt portrayed the story of the Prodigal Son several times, but no version is as moving as this last example, probably done in the 1660s.*

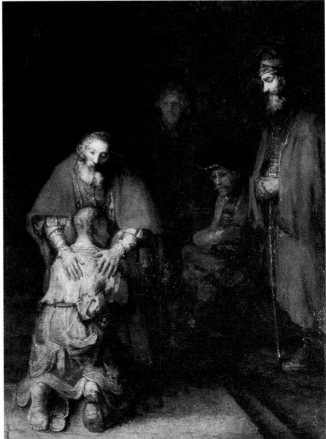

ANTOINE WATTEAU, PILGRIMS LEAVING THE ISLAND OF CYTHERA, 1717. *This painting was given by Watteau to the Royal Academy in 1717, five years after he had been made an associate of that institution.*

[11]

FROM FANTASY TO REVOLUTION: THE ART OF THE EIGHTEENTH CENTURY

As the seventeenth century drew to a close, the discoveries of science steadily increased human understanding, as well as control of the natural world, and affirmed the primacy of human reason. The human intellect eclipsed faith as the guiding force of civilization. The unifying culture of Christianity was supplanted by the fractious and specialized disciplines of science, philosophy, history, and literature. The impact of this change on art was subtle but significant. Although eighteenth-century artists served the same types of clients as their forebears, the images they created changed. By turns logical, intuitive, polemical, impulsive, brilliant, or pedestrian, the art of the eighteenth century built on and exaggerated the tendencies of earlier periods. It became more refined, more delicate, more sensuous, more intellectual, more emotional, and more secular.

Eighteenth-century art reflected an era that alternately promoted and questioned the notions of civilization, knowledge, education, and the pursuit of pleasure. This was the age of encyclopedists,

scientific experimenters, inventors, archaeologists, and classifiers. As Denis Diderot was assembling the first great encyclopedia (intended to contain all the world's knowledge), Benjamin Franklin was experimenting with electricity, and Carolus Linnaeus was laying down his vast system to classify nature. Excavations at Pompeii and Herculaneum in 1738 and 1748 established the discipline of archaeology and inspired a classical revival that eventually affected everything from fashion to furniture styles.

Social and political problems began to weaken the political structure of Europe. While the nobility and the aristocracy maintained their claim to rule by inherited right, their power was challenged and their authority was eroded by an increasingly educated populace. The spirit of rebellion that beheaded Charles I in the previous century exploded

ANTOINE WATTEAU, PIERROT, C. 1715–21. *Watteau's only known life-size figure, this portrayal of an Italian comic actor may have been used as a shop sign for a café in Paris. Italian comedy troupes were particularly popular in France in the eighteenth century.*

into revolution. In 1776 the American colonies revolted against British domination, and in 1789 the French rose up against their king. France, the cultural capital of eighteenth-century Europe, witnessed during these years the last great flowering of art for the aristocracy. which, in its determination to maintain the status quo, increased the demands for change.

In many respects the art of the eighteenth century is the art of France. As the Bourbons rose to power after 1650, the language, manners, customs, and styles of France increasingly shaped those of the rest of Europe. Led by Louis XIV, who remodeled Paris into the grandest European capital, successive French kings lent their names to the decorative arts that spanned the century, and French artists set the styles that the rest of Europe followed.

France was transformed during the eighteenth century. Civilization was seen as an intellectual ideal, manifested through taste and erudition. Styles of one kind or another were viewed as expressions of taste. Classicism, valued by the academies born in the seventeenth century, was rejected by early eighteenth-century artists searching for an art of nuance and grace, of spontaneous, energetic, natural forms. Thus the art of the Rococo —the frothy antithesis of the sober precepts of the classicists— was born. However, the rigorous forms of classical art regained favor at the century's end.

Ideologies concerning art were particularly important to the French Royal Academy, an institution established in the previous century. In 1737 the Academy, which held history painting—grand pictures of historical, biblical, or mythological narratives—in the highest esteem, began to stage annual Salons, or exhibitions, open to the public. These Salons spawned the careers of professional art critics, who offered opinions, evaluations, and interpretations for the art-going public. In this era, the first public museums were established throughout Europe, institutions that democratized art and made it part of the cultural purview of a growing leisured middle class.

It was through the Salons that one of France's most gifted masters entered the art world of Paris. Jean-Antoine Watteau (1684–1721) was born in Valenciennes, a small town on the Flemish border. Watteau was poor and obscure when he arrived in

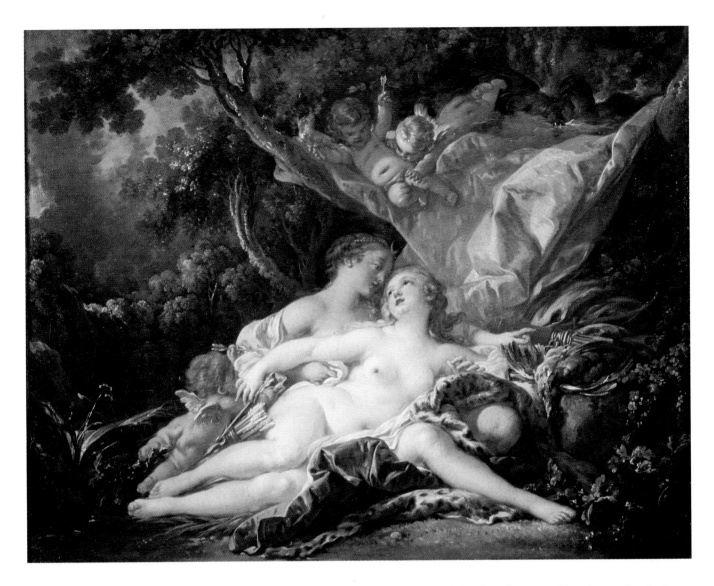

**FRANÇOIS BOUCHER, JUPITER IN THE GUISE OF DIANA
SEDUCING CALLISTO, 1759.** *The Jupiter and Callisto theme
comes from the ancient poet Ovid; it was first popularized by
the Venetians of the sixteenth century.*

Paris. To gain membership into the French Academy, he submitted in 1717 what is one of his finest
works, *Pilgrims Leaving the Island of Cythera* [pp.
194–95]. This scene of gilded lovers in a landscape
shows the mingling of intellectual, emotional, and
carnal content that distinguishes Watteau as the exemplar of his age. The painting depicts mythological subjects in modern dress; the protagonists are
wealthy, beautiful, and elegant, and the mood is
sophisticated, transient, and tinged with sadness.
Like the works of many of Watteau's contemporaries, it is indebted to the sort of luscious oil painting
best exemplified by the great Venetians of the sixteenth century and by Rubens and Van Dyck. Yet its
dreamy vision, its emotional delicacy, and its subtle
mingling of philosophical and sensual ideas mark
this work as a product of its own time.

The exact subject of Watteau's painting has
been the source of debate: it has been called both
Pilgrims Leaving for the Island of Cythera and *Pilgrims Leaving the Island of Cythera.* This is an important point, because each of the episodes
involves a different set of emotions. Cythera, an island off the southern coast of the Peloponnesus,
was sacred to Aphrodite (Venus) and the location
of her cult and shrine. Pilgrims embarking for the
island would be filled with a keen sense of antici-

pation, while those leaving it would be abandoning a paradise of love and pleasure. The melancholy mood of Watteau's beautiful picture surely suggests that the wistful protagonists are preparing to leave this island of pleasure for the harshness of the real world. There is a fragile delicacy, an almost autumnal feeling about the painting, which dwells on the fleeting nature of love and life. A lush and welcoming landscape surrounds these exquisite but pensive figures, who move with a rustle of satin and silk as they reluctantly prepare to board the waiting boat. But, as in so much of eighteenth-century painting, the true subject is love and its captivating power over men and women of all times and stations. Watteau's placement of contemporary protagonists in an imaginary setting makes both the reality and the limitations of this fantasy apparent and compelling.

Watteau's short but brilliant career was filled with pictures of similarly delicate, complex, and fleeting sensibilities. Most of his paintings deal with mythology, allegory, or scenes from contemporary life, especially that of the stage. Shortly before his death, Watteau painted *Pierrot* [p. 196], a disturbing and enigmatic work. Made as a placard for a theatrical troupe, the image represents Giles, or Pierrot, a traditional figure of popular Italian comedy. An ignorant and simple clown, he was a stock figure, but Watteau transformed him into a subject of subtle complexity. Isolated from his worldly, chattering companions and clad in his traditional ill-fitting costume of white silk, with his arms dangling awkwardly at his sides, he stares at the viewer with a mixture of incomprehension, innocence, and vulnerability. Pierrot is an avatar of human feeling and sympathy—a sensitive, simple, and trusting man who becomes an object of ridicule; Watteau's imagination

has changed him into a shimmering specter of purity and innocence.

Watteau's style and interpretation of subject had a considerable influence on French painting. His follower François Boucher (1703–1770) gained great success, counting among his patrons Louis XV's mistress Madame Pompadour. Boucher's work epitomizes the content and form of the luxuriant and worldly art of the French aristocracy before the cataclysm of the Revolution. He produced a stunning series of portraits, landscapes, and mythologies, painted with a fluidity and energy partially derived from the great Venetians and Rubens, artists much admired by the eighteenth century.

Boucher's *Jupiter in the Guise of Diana Seduc-*

JEAN-HONORÉ FRAGONARD, THE SWING, 1766. *The Baron de Saint-Julien first tried to commission this picture from another painter, who refused to paint the subject, especially since the baron wanted a bishop to be painted in the place now occupied by the rather obscured husband (at the right).*

JEAN-BAPTISTE CHARDIN, STILL LIFE, 1763. *Many of the objects in Chardin's still lifes appear repeatedly; some of the more costly of them, such as a silver goblet and a gaming table, seem to appear in inventories of the painter's household.*

ing Callisto of 1759 [p. 197] is exactly the sort of erotic story that Boucher painted so deftly and that appealed to the refined appetites of his clients. Jupiter, in the form of Diana, the chaste goddess whom Callisto served, is about to seduce the innocent nymph, whose yielding and extremely fleshy form is the real subject of the painting. Boucher's lush hues enrich the nature of the subject. The voluptuous feeling of soft skin is marvelously conveyed by the modulation of whites and pinks, while various greens, blues, and browns add palpable sensuousness.

Boucher's pupil Jean-Honoré Fragonard (1732–1806) in many respects surpassed his teacher, becoming, as the notable French historians and critics the Goncourt brothers said, "the master of a dream world." Fragonard, however, lived through the French Revolution and witnessed with dismay the destruction of the formal and contextual bases of the luxurious and erotic art that had characterized French painting since Watteau. The character of this prerevolutionary art is magnificently presented in Fragonard's *The Swing* [p. 198], commissioned by the Baron de Saint-Julien in 1766. This painting, in which adults abandon themselves to the playful games of children, depicts the baron's mistress being swung by her assenting husband as the baron, lolling on the ground, admires her exposed legs. The long diagonals of the composition, the pastel palette, the billowing arrangement of trees, and the moisture-filled sky set the stage for this rather overt display of the charms of the young and beautiful mistress, sumptuously adorned in a dress that looks like it is painted in pink cake icing. Here Fragonard created a world of pleasure, fashion, elegant manners, and polite eroticism that shut out the increasingly menacing political, economic, and social realities.

One painter working under the Old Regime, however, often did record, with refinement and intelligence, the plainer aspects of life. Jean-Baptiste-Siméon Chardin (1699–1779) painted a brilliant succession of still lifes and game pieces, ordering them with the rigor of a mathematician and describing the objects with both respect and understanding. Chardin's interest in the rituals and objects of

daily life resulted in masterpieces of observation and nuance.

Much of his current reputation rests on his still lifes [p. 199]. Common objects—fruits, bottles, knives, coffee cups—are shown in a new light; in Chardin's world, these objects often take on monumental formal properties. Their realness was a healthy antidote to the dreamy ephemera of Boucher and Fragonard. Chardin was a master at conveying the tactility of objects—their hardness or softness, temperature, and weight. He shared this ability with his great Northern predecessors Jan van Eyck and Jan Vermeer.

The fantasy and effervescence that marked much of eighteenth-century French painting is also characteristic of the architecture and interior decoration of the time. The large town houses then being constructed in Paris were decorated with elaborate and costly interiors, often carried out by artists of superior invention and skill. One such house is the Hôtel de Soubise, built for the Prince de Soubise. The somber and formal exterior of this large mansion gives little hint of the lightness and elegance of its famous rooms.

The Salon of the Princess [p. 200], built and decorated by Gabriel-Germain Boffrand (1667–1745), with its movement, light, and color, evokes the world of such paintings as Watteau's *Pilgrims Leaving the Island of Cythera*. Illuminated by large arched windows, the oval room is animated by stuccowork, gilding, glittering chandeliers, and paintings; there is a special emphasis on exquisite craftsmanship and the ostentatious use of costly materials. The gilded, undulating furniture that decorates this room is deliberately bereft of sharp edges or angles, endowing the entire space with a grace that is sensual and extraordinarily refined.

The architectural and decorative exuberance seen in the interior of the Hôtel de Soubise also characterizes some of the finest ecclesiastical architecture of eighteenth-century Europe. Still heavily influenced by the dynamic Baroque innovations of the previous century, especially those of Bernini, church design, like the domestic environment of the period, showed a remarkable integration between architecture, sculpture, and painting.

One of the greatest examples of such a structure is the German pilgrimage church of Vierzehnheiligen (the Fourteen Saints) [p. 201] in Oberfranken, first built in 1743 where a shepherd had seen a vision of fourteen saints who told him they wished their chapel erected there. The simple chapel soon became a major pilgrimage site. It was replaced in 1772 by a large church designed by Balthasar Neumann (1687–1753), one of the most distinguished German architects of the time. Set on a site visible from a considerable distance, Vierzehnheiligen, with its two towers, recalls the powerful weight of pilgrimage churches from the twelfth and thirteenth centuries, although its elaborate, highly decorative, and somewhat fussy design clearly belongs to the eighteenth century. Inside, however, is a jubilant chorus of blazing light, color, and opulent, dynamic decoration. Pinks, whites, and the glitter of omnipresent gold interweave with skillfully designed forms to turn the church into a great, sumptuous, and invigorating whole, the ecclesiastical counterpart of the Salon of the Hôtel de Soubise.

GABRIEL-GERMAIN BOFFRAND, SALON OF THE PRINCESS, HÔTEL DE SOUBISE, PARIS, C. 1735. *The room's paintings, by Charles-Joseph Natoire (1700–1777), narrate the love story of Cupid and Psyche.*

BALTHASAR NEUMANN, VIERZEHNHEILIGEN, IN OBERFRANKEN, GERMANY, 1743–72. *Neumann, one of the principal German architects of the eighteenth century, also designed the Residenz at Würzburg, where Tiepolo painted a fresco masterpiece.*

Though France led the way in fashion, styles, manners, language, and much of art, Italy, Germany, and England all produced artists of originality and importance. England, which had imported so many of its artists in the previous century, saw its native artists gain a significant place in the history of eighteenth-century art. Of all the illustrators of contemporary manners and customs who supplied the seemingly endless demand for such themes throughout Europe, none mirrored and transcended his time better than William Hogarth (1697–1764). A brilliant student of human nature, working in a tradition that traced its origins back to Northern art of the fifteenth century, Hogarth helped popularize the serial narrative. Painted as well as engraved, his satirical interpretations of humanity are reminiscent of Jan Steen's rowdy portrayals. Hogarth made the crowds of London his subject—injecting comedy,

history, and morality into his stories of the fortunes and misfortunes of a harlot, a rake, or a sadist. The sale of prints from his series *Rake's Progress* gained him fame and profit in 1735.

Filled with anecdotal details, humor, satire, and pathos, Hogarth's *Rake's Progress* takes the single images of domestic life made popular in the seventeenth century and expands them to many scenes. Hogarth lets his story unfold in a series of vignettes that incorporate themes of greed, betrayal, knavery, devotion, and stupidity. In the first scene of *Rake's Progress,* called "Rakewell Takes Possession" [p. 201], a profligate young rake, just come into a fortune, is buying off with a handful of coins the mother of a poor young woman he has seduced by promising marriage. All around him assistants recover the wealth hoarded by his miserly father as he is measured for a new suit of clothes. As the first scene hints, Rakewell comes to no good. His fortune is lost to gambling and he is forced into a marriage of convenience with a wealthy old crone. That fortune is lost as well, and Rakewell ends his days in Bedlam asylum, tended by the foolish but loyal Sarah Young.

WILLIAM HOGARTH, "RAKEWELL TAKES POSSESSION," FROM THE SERIES THE RAKE'S PROGRESS, 1735. *A series of eight engravings traces the decline of Rakewell, a weak, self-indulgent wastrel from a good family. Having seduced Sarah, he ignores the promises he made to her and embarks on a life of pleasure. The mirror Hogarth held up to his society reflected the foolishness and weakness of human nature.*

Like his contemporaries, Hogarth invoked the viewer's moral judgment, portraying characters who incur censure much more than pity. Like other artists of this period, he addressed the mind, emphasizing the importance of will, discipline, and common sense in conducting one's life and affairs. Hogarth was the champion and critic of the common man. His rich narratives, built on Dutch and French models, earned him international fame.

In the field of portraiture in eighteenth-century England, one of the greatest painters was Sir Joshua Reynolds (1723–1792). After an obscure beginning, Reynolds established himself in the London intelligentsia; among his close friends were Dr. Samuel Johnson and Oliver Goldsmith. When the Royal Academy was founded by George III in 1768, Reynolds was made its president and was knighted by the king. An acute student of art and a discerning collector of drawings, Reynolds was also a perceptive writer on art. A true son of his age, he hoped to ally scholarship with art in order to elevate the latter.

Influenced by the portrait tradition Van Dyck had created in England, Reynolds soon found further, and lasting, inspiration from the great Venetians of the sixteenth century. Although Reynolds clearly was influenced by Michelangelo and Raphael as well, he continually returned to the Venetians' lush and free handling of paint and their feeling for atmosphere and color.

These various strands of influence are intermingled in the painting that Reynolds considered his masterpiece, *Sarah Siddons as the Tragic Muse* of 1784 [p. 203], in which the famous actress is shown as the muse of tragedy, surrounded by various figures and attributes, such as Pity and Terror, which comment on and amplify the theme of tragedy. Portraiture in the guise of personification, a portrait type that derived from the previous century, was popular in the eighteenth century, since it permitted the viewer to exercise the mind as well as the eye. Suspended between the real and the imaginary, Siddons is ennobled by the mythical setting and its symbols. Her pose recalls Michelangelo's great sibyls and prophets on the Sistine ceiling, whereas the rich painterly and atmospheric quality derives from an intensive study of Rembrandt and the Venetians; thus Reynolds has fused a grand manner of painting with a grand subject.

Sarah Siddons as the Tragic Muse and other portraits by Reynolds and his English contemporaries are perhaps the brightest reflections of the privileged, elegant, and intellectually stimulating environment of the remarkable social and intellectual world of London in the eighteenth century, so well chronicled by James Boswell, Edward Gibbon, and their peers. Reynolds's patrons, the cultivated and monied nobility and gentry, considered a tour of the European continent a necessary part of every gentleman's education. The Grand Tour inevitably encompassed Italy, and Italy's art, both contemporary and ancient, became a passion for Europe in general but for the English in particular. Venice in the eighteenth century was the Italian artistic center. Fabled for its courtesans, its carnival, its endless gaiety, Venice offered visitors entertainment, pleasure, and erotic adventures. This was the city where Casanova began his career, where Goldoni wrote his comedies, and where Vivaldi composed his glorious music. Venice was also home to scores of painters, most of whom served the foreign clientele —the tourists who were attracted to its many sights and amusements.

Antonio Canal (1697–1768), called Canaletto, specialized in painting the town view, a subject Dutch artists had made popular in the previous century. Canaletto's views are the means by which eighteenth-century Venice is now best known. Painting primarily for English tourists, Canaletto became so popular with them that he worked intermittently in England for ten years (between 1746 and 1755) before returning to Venice. Canaletto began his career painting theater designs but soon turned to the scenes of Venetian festivals, holidays, and landmarks that were much in demand and became his specialty. *The Bucintoro at the Molo on Ascension Day* of 1732–35 [p. 205], like the event it records, was done for tourists. Factual and detailed, Canaletto's painting satisfied the public craving for accurate reportage and exotic subject matter. Insistently clear, sunny, and rational, Canaletto's view of the doge's barge *(The Bucintoro)*, returning to the palace after the Ascension Day festival, sets forth the action casually. The barge comes into view as though the onlooker is seated in a gondola making its way down the Grand Canal.

Canaletto worked on relatively small, portable canvases that could easily be carried back to En-

SIR JOSHUA REYNOLDS, SARAH SIDDONS AS THE TRAGIC MUSE, 1784. *Reynolds was, above all, a portrait painter, and his many elegant portraits form a gallery of the most notable men and women of his time.*

In an era that championed rationality and eagerly pursued scientific knowledge, Venice became a principal attraction because of its many diversions and the escape it offered from reality. Carnival there lasted for six months of the year. People wearing masks were free to gamble in the Ridotto, court their mistresses in gondolas, and devote themselves to pleasure with complete anonymity. Something of the flavor of carnival and fantasy is captured in the drawings of Domenico Tiepolo (1727–1804), the finest of which are his portrayals of Punchinello, a comic theater character much favored as a mask by carnival revelers. Tiepolo took Punchinello from youth to old age, and

showed him enjoying a vast array of amusements. Thus, as Venice underwent decline, resulting in her subjugation by Napoleon in 1797, Tiepolo captured the last glimpse into that mixture of fantasy and reality that had charmed Europe for centuries.

CANALETTO, THE BUCINTORO AT THE MOLO ON ASCENSION DAY, 1732–35. *Canaletto shows here the doge's barge on its way back from the Lido, where the doge has thrown a gold ring into the Adriatic to celebrate the marriage of Venice and the sea, a part of the annual Ascension Day festival.*

gland, where so many of his pictures found their way. By contrast, his younger contemporary Giovanni Battista Tiepolo (1696–1770) spent his career covering vast expanses of palace walls and ceilings with the allegories and histories so beloved by the aristocracy. He suspended mythical and allegorical figures in an airy empyrean, bathed in light and gorgeous colors. Tiepolo's most celebrated ceilings are those he produced for the Residenz of the prince-bishop Carl Philipp von Greiffenklau of Würzburg in 1752–53. Dedicated to celebrating the ancestry of the prince-bishop, the ceiling of the Kaisersaal (imperial chamber) shows Apollo bringing Beatrice of Burgundy as the bride of Carl Philipp's great ancestor Frederick Barbarossa [p. 206]. No attempt at historical accuracy was made or deemed necessary in this fanciful illusion of infinite space. Galloping across peach-colored clouds,

Apollo's steeds, bearing a curiously Venetian-looking beauty, are accompanied by swarms of winged putti, who reveal pudgy bottoms and chubby toes to the viewer below. Myth, legend, and history coalesce with humor, fantasy, and sensuality. As a nereid fondles the ancient river god Main, a winged, high-breasted genius stands above as her chaste double. Sexuality is overt yet innocent, the characters sincere yet gay, the mood both light and serious. The sweep, energy, and sense of movement of the scene perfectly complement the curving, ebullient forms of the interior decor. Tiepolo was unmatched in making his fanciful concoctions seem real and uncontrived. In contrast to Boucher and Fragonard, Tiepolo's art was less overtly erotic and covered a broader range of emotions, ideas, and subjects. But, like Fragonard, Tiepolo lived to see his style of painting grow outmoded. He spent his last years working in Madrid for the Spanish king, painting royal allegories similar to the Würzburg frescoes, but the grand-scale decorations Tiepolo had perfected were becoming old-fashioned. In their place, the art of antiquity was being championed once more.

One of Tiepolo's townsmen and probable stu-

GIOVANNI BATTISTA TIEPOLO, APOLLO BRINGING THE BRIDE, CEILING OF THE KAISERSAAL, RESIDENZ, WÜRZBURG, 1752–53. *A minor principality, Würzburg had ties with Venice through trade and commerce. When Carl Philipp von Greiffenklau succeeded as prince-bishop in 1749, he inherited a palace that rivaled Versailles in magnificence, and he quite naturally turned to Venice for an artist to decorate it.*

dents, Giovanni Battista Piranesi (1720–1778), was a great enthusiast of ancient Roman art. Having studied architecture and etching in Venice before traveling to Rome, Piranesi dedicated his career to recording and interpreting antiquity. Working exclusively as an etcher, he produced an enormous body of work, including the chief sights of Rome illustrated in his *Vedute di Roma,* a project that occupied him from 1748 until his death. His largest study of antiquities is the four-volume *Antichità romane,*

completed in 1756, which earned him honorary membership in the London Society of Antiquaries and the friendship of the eminent Scottish architect Robert Adam. One of Piranesi's most famous images from the *Vedute* is his view of the Colosseum [p. 207]. Inspired by the magnificence of the grand structure, he combined reportage with artistic license. Studying the Colosseum by moonlight to emphasize the contrasting dark and light forms of the building, Piranesi rendered it so that it looms out of the picture and blots out the sky. Though the Colosseum is impressive, its actual appearance is far from Piranesi's grandiose artistic interpretation.

Piranesi's fascination with and love of ancient Rome were part of a larger antiquarian spirit, which had grown with the rediscovery of Pompeii and Herculaneum. Johann J. Winckelmann, whose excavations at those famous sites helped found the

modern discipline of archaeology, was active in the same era as Gibbon, who wrote the long, exhaustive, and brilliant *Decline and Fall of the Roman Empire.* To these artists and scholars, antiquity held clues to artistic, technical, historical, and political ideas that were worth examining and reinterpreting once more. In France, the Neoclassical style emerged with particular power in the hands of Jacques-Louis David (1748–1825).

David's *Oath of the Horatii* [p. 208], painted in 1784, brilliantly portrays the late eighteenth-century revival of interest in the antique. Illustrating an episode of ancient Roman history recounted by both Livy and Plutarch, David's painting shows the three sons of Horatius swearing on their swords, held by their father, that they will sacrifice their lives in defense of Rome against Alba; in contrast, their wives and sisters, one of whom is betrothed to a man of the rival Alban clan, are overcome by grief about the inevitable tragedy. Extolling patriotism, courage, and self-sacrifice, David's *Oath* is the antithesis of the sensuous fantasies in the art of the early part of the century.

Here the masculine world reigns. Ideology supplants emotion. The weeping women, with limp, slumping forms, are portrayed as the weak, ineffectual counterparts to the straight, vigorous, and determined figures of the Horatii father and sons. Strung across the shallow surface of the picture— as in an ancient relief—the unbending shapes of the three sons and the father are placed in a suitably stony courtyard and set within arched forms, underscoring the moment of their resolution. The only strong color note—red, the color of blood—is reserved for the men, alluding to the forthcoming battle. Commissioned by Louis XVI, David's painting, after it was displayed in the Salon of 1785, was acclaimed as the most beautiful of the century. Its

GIOVANNI BATTISTA PIRANESI, "THE COLOSSEUM," FROM THE VEDUTE DI ROMA, 1757. *Begun in 1748, the* Vedute *contained 137 views of Rome. Piranesi originally intended his* Vedute *to illustrate guidebooks as well as to be sold as individual scenes. The* Vedute *were reprinted numerous times, spreading Piranesi's fame throughout Europe and providing him with a comfortable income.*

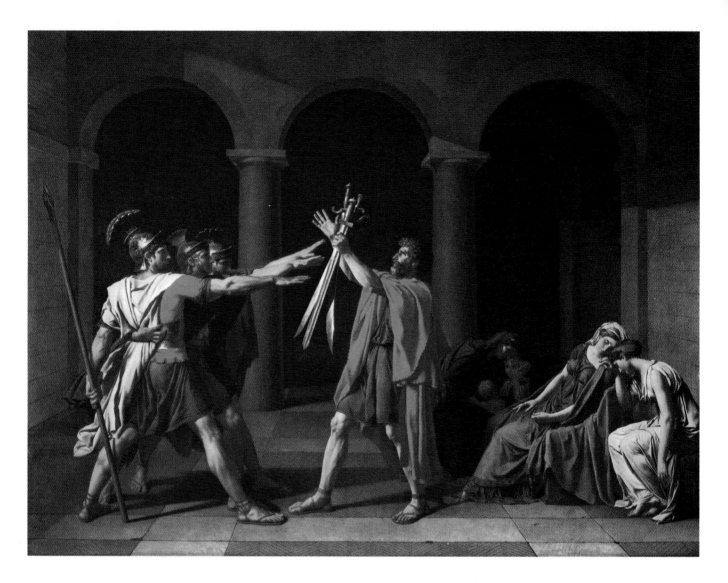

JACQUES-LOUIS DAVID, OATH OF THE HORATII, 1784.
*This painting illustrates one of the legends about ancient Rome,
made popular in eighteenth-century France by the French
dramatist Pierre Corneille, whose ballet* Les Horaces *inspired
David.*

enthusiastic reception signaled a change that was
not only aesthetic but political, ironically ending the
reign of the patron who commissioned the work and
ultimately changing Europe.

This was the age of revolution. In 1793, less
than ten years after David painted the *Oath*, both the
king and queen of France were dead, victims of the
guillotine that would soon take the heads of many
more during the Reign of Terror in the French Rev-
olution. The theme of sacrifice and honor that the
king had admired in art did not inspire valor among

his political supporters or among his detractors. In-
stead, the idealistic militaristic theme of David's
painting was an ironic antithesis to the violence and
anarchy to which France succumbed, that which
David himself not only witnessed but also recorded.

In 1793, Jean-Paul Marat, a hero of the French
Revolution, was murdered in his bath by the aristo-
crat Charlotte Corday. David commemorated the
event in his famous *Death of Marat* of the same year
[p. 209], which shows Marat holding the now blood-
stained letter by which Corday gained her entry. A
modern-day Christ, Marat lies in a watery tomb. In
contrast to the *Oath of the Horatii*, where ancient
history was his starting point, in the *Death of Marat*
David was responding to an event that happened in
his own lifetime to a friend. David made the actual

scene of Marat in his bath both more pathetic and more heroic than it was in life; simple, austere, and tragic, the picture remains true to Marat the man but also translates him into Marat the martyr. The allusions are not classical but overtly Christian; David's inspiration for this painting was not ancient models but Titian's pietàs and Caravaggio's realistic portrayals of martyrdoms. Thus, this famous icon of the Revolution and Neoclassicism reflects a tradition that had become suspect among David's contemporaries.

One of these was the internationally known Italian Neoclassical sculptor Antonio Canova (1757–1822). After training as a stonemason and working briefly in Venice, Canova, like David and Piranesi, went to Rome, where he too studied the art of antiquity. He was particularly inspired by the Greco-Roman antiquities newly found in the excavations of Pompeii and Herculaneum.

One of Canova's more outstanding reinterpretations of antique themes and forms is a marble sculpture of 1783–93 depicting Cupid and Psyche [p. 210]. Showing the two young lovers linked in a tender embrace, Canova's work is designed to be seen in the round, a virtuoso performance of carving. The delicacy of the marble, as translucent as alabaster, beautifully expresses the chaste yet sensuous nature of his theme. The look of ancient marble sculptures, stripped of their original colors and bleached white by time, was adopted by Canova as a positive aesthetic, evoking a pure and great past. His *Cupid and Psyche* is cool, distant, and impersonal in the uniformity of its whiteness. In this image of adolescent love, the human body has declined as

a subject. The limp, unmuscled forms are an indication that in the late eighteenth century, David's *Oath* excepted, the nude human form had lost heroic, dynamic meaning; eighteenth-century Neoclassicism valued the intellectual over the physical.

Both David and Canova lived on into the next century and worked during the reign of Napoleon. The classical style they favored was passed on to the masters of academic art, who became the leaders of the artistic conservatism that followed.

Architecture, like painting and sculpture, looked to antiquity during the closing years of the eighteenth century. The elegance and buoyancy of

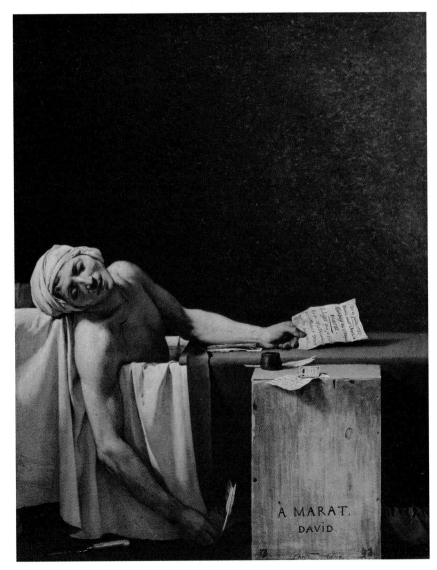

JACQUES-LOUIS DAVID, DEATH OF MARAT, 1793. *David often portrayed the political events of the day, including the assassination of the revolutionary Jean-Paul Marat by Charlotte Corday. David was arrested and imprisoned for treason after the downfall of Robespierre, but his fortunes were restored and he became court painter to Napoleon.*

ANTONIO CANOVA, CUPID AND PSYCHE, 1783–93. *The theme of Cupid falling in love with the beautiful maiden Psyche was particularly popular in the eighteenth century, which admired the "chaste fondness" contained in the story.*

republic was a period especially favored by the late eighteenth century; the republic, it was widely believed, was a model to be emulated for its uncomplicated, vigorous egalitarianism. This concept was given visual form in the unadorned Doric order in the Brandenburg Gate and, in the United States, in the simple elegance of Monticello of 1796 [p. 211], the home that Thomas Jefferson designed for himself just outside Charlottesville, Virginia. Jefferson had traveled widely and was inspired by a diversity of architectural styles, from Roman to Renaissance. He was especially influenced by Andrea Palladio (1508–1580), an architect whose books and buildings had been restudied earlier in the eighteenth century, especially in England. The seriousness and dignity of early Roman architecture echo throughout Jefferson's plan for Monticello, though he built it not of marble but of local brick and wood.

The seventeenth century examined physical reality, while the eighteenth century examined the mind. Fantasies, reveries, ideas, and ideals of all kinds are imbedded in the diverse images of this period. Guided by the intellect, art throughout most of the century is characterized by an artifice that marks it and its creators as urbane, sophisticated, and educated. But the journey into the human psyche eventually ferreted out darker, more uncontrollable emotions, which the Revolution affirmed were hidden beneath the thinnest veneer of civilization. Even Neoclassicism, which revived the ordered and rational forms of antique art, can be viewed as embodying powerful emotions. As the age of Romanticism dawned, life, death, and human experience of all kinds became a matter of feelings, not logic.

the Hôtel de Soubise and of the Vierzehnheiligen were, at the end of the eighteenth century, a contrast to new buildings with very different ideological premises. Structures such as Berlin's Brandenburg Gate of 1788–91 [p. 211], by Karl Langhans, were sometimes directly inspired by famous buildings of the ancient world, in this case the Propylaea on the Athenian Acropolis. Behind the choice of the ancient style were the same beliefs and aspirations evident in the paintings of David and many of his contemporaries. These artists and their patrons, who surprisingly included a number of aristocrats of prerevolutionary France, saw in their rediscovery of the weight and severity of classical architecture a mirror of their own dreams of the future. The Roman

**KARL LANGHANS,
BRANDENBURG GATE,
BERLIN, 1788–91.** *The
forerunner of many similar
structures in the nineteenth
century, the Brandenburg Gate
has become a symbol of Berlin
itself.*

**THOMAS JEFFERSON,
MONTICELLO,
CHARLOTTESVILLE,
VIRGINIA, 1796.** *Jefferson's
architectural plans for
Monticello, the University of
Virginia, and other buildings
had a considerable influence
on the architecture of the new
American republic.*

THÉODORE GÉRICAULT, THE RAFT OF THE MEDUSA, 1819. *After its less than enthusiastic reception in Paris, Géricault took this huge canvas (about 16 x 23 feet) to London where it met with considerable success in exhibitions.*

ART AS EMOTION: THE FIRST HALF OF THE NINETEENTH CENTURY

As Europe entered the nineteenth century, those forces that would shape her political and cultural destiny were already in place. From 1799 to 1815 the most powerful figure in Europe was Napoleon Bonaparte (1769–1821). During his meteoric rise and fall France was at war with the rest of Europe, and after his defeat Europe's political structure was changed forever. Despite Napoleon's dictatorship, he exported the ideals of the French Revolution to the countries he occupied. Thus Holland, Italy, Germany, and Austria adopted the goal of self-determination, which had been at the root of the revolution. During the rest of the nineteenth century that ideal affected not only nations but also individuals.

England, which had defeated Napoleon at Waterloo, was rapidly becoming industrialized in the late eighteenth and early nineteenth century. Factories operated by the power of coal and steam transformed the country's largely agrarian economy into a mechanized one. The modern technology of steel manufacture, centered in Sheffield, supported the new railway system and influenced the production of a whole new range of buildings, from train sheds to exhibition halls. This dramatic metamorphosis was echoed in the rest of Europe later in the nine-

FRANCISCO GOYA, CONJURATION, 1797–98. *Goya worked at the corrupt court of the Spanish king Charles IV. The French poet Baudelaire admired Goya's work for "giving monstrosity the ring of truth."*

teenth century as the industrial revolution spread.

Toward the end of the eighteenth century, heightened sensibility became a convention in literature, while intensified feeling became characteristic of the visual and musical arts. This tendency toward images of impassioned or poignant feeling, which lasted to about the middle of the century, cut across all national boundaries, finding expression among artists in France, Spain, and Germany, as well as England. *Romanticism,* though a loose and imprecise term, reflects the movement of writers, musicians, painters, and sculptors away from rationalism toward the more subjective side of human experience. Feeling became both the subject and object of art.

Love, for instance, was seen as an overpowering emotion, beyond the control of reason and capable of inflicting death on its victims. Goethe's tale of Werther, who committed suicide for love, intoxicated Europe when it was published in 1774. *The Sorrows of Young Werther* became a powerful symbol of the era, with its portrayal of a highly sensitive, self-indulgent, passionate youth. Love had become a form of madness, and madness in its many manifestations became one of the central themes of Romantic art.

A Spanish artist, Francisco José de Goya y Lucientes (1746–1828), known as Goya, was one of the earliest artists to see beneath the facade of rationality and expose the mind as the seat of irrationality. Active in Spain and employed for much of his career by the Spanish court, Goya rejected the lighthearted fantasies of his great predecessor at court, Giovanni Battista Tiepolo (who had died working for the king of Spain when Goya was twenty-four). Instead, Goya looked penetratingly at the characters of the decaying monarchy who employed him, experienced the brutality of Napoleon's forces on the Spanish people, and distilled from these and other events a view of humanity as often bestial.

Goya was one of the first artists to make human madness a major theme in his work. His *Conjuration* of 1797–98 [p. 214] portrays the diabolical world of witchcraft and demons that tortures and confuses the mind. Dark and hideous, the conjurers loom over their victim. Are they a frightening hallucination, part of that midnight of the soul to which humankind is vulnerable, or are they real? For Goya, the two realities were the same: the deranged mind could victimize the body that it inhabited as easily as real witches could. Many of Goya's paintings and etchings depict madness, and even his portraits often emphasized the neurotic and decadent nature of his subjects.

Man as victim was another of Goya's great themes. He was in Madrid when Napoleon's troops occupied the city, and he may have witnessed the execution of Spanish loyalists on May 3, 1808. Six years later, in 1814, Goya commemorated the episode, which had taken place just outside the royal palace. *The Third of May, 1808* [p. 215] is both specific and elemental. French troops are shown lined up at the right, efficiently and remorselessly dispatching their prisoners. Goya exposed these vic-

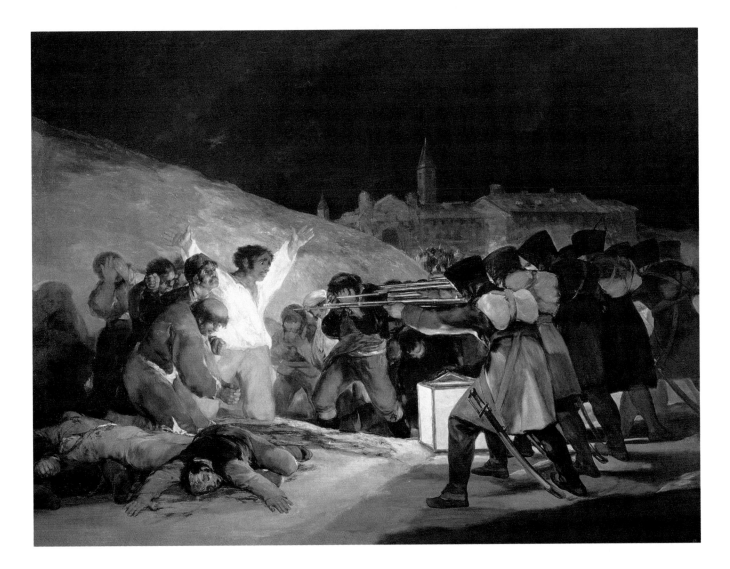

FRANCISCO GOYA, THE THIRD OF MAY, 1808, 1814. *In 1814, when Ferdinand VII resumed the Spanish throne, Goya painted two pictures to commemorate Spanish resistance to French occupation. The first, entitled* The Second of May, 1808, *portrays the Spanish uprising against Napoleon's cavalry; the second and more famous* Third of May, 1808 *depicts the French reprisals.*

tims' hideous plight, illuminating their desperation, fear, and helplessness by the lamplight needed in the early dawn for the soldiers to hit their marks. Despite its origins in a historic event, Goya's painting goes beyond the specific references and is a stark portrayal of man's inhumanity to man.

Goya's understanding of human limitations extended across all boundaries of class and national-ity. He exposed the evils of ignorance, stupidity, arrogance, and sadism. More than once he turned to the concept of sleep as a metaphor for the abandonment of reason. Struck deaf in 1793 after an illness, he became increasingly pessimistic in his later years. In 1819 he bought a house that he decorated with his "black paintings," which concentrated on themes of death, destruction, and cruelty, and included his horrifying depiction of the god Saturn devouring his own children. In Goya's world, the illumination of the Enlightenment had been dimmed by the atrocities of his age. When the liberal Spanish government he supported was overthrown in 1823, he sought refuge in France, settling in Bordeaux in 1824. His last years were spent in isolation and anguish, and he poured his torment

THÉODORE GÉRICAULT, DECAPITATED HEADS, C. 1818.
Géricault's love of horror and shock are nowhere better depicted than in these grisly studies.

into his work. Goya deeply influenced later artists, including a number of French Romantics, particularly Géricault and Delacroix.

Théodore Géricault (1791–1824) grew up in the turbulent years of the French Revolution and Napoleon's reign. He studied with several fashionable artists, but the strongest impact on his work, besides Goya, came from the influence of Baron Jean-Antoine Gros (1771–1835), a painter who had studied with David and who was a fundamental link between David and the new generation of French painters of the early nineteenth century. From Gros's canvases, especially those which make Napoleon the center of an emotional, almost mystical, glorification, Géricault drew much inspiration both for Romantic interpretation and for style.

Géricault, like Gros, Goya, and other artists, was interested in painting contemporary, topical events, not only as a depiction of that particular event but also as an exploration of the passionate emotions and truths that underlay it. Often Géricault's searches yielded dark and previously unknown images. Fascinated by violence and horror, he made a series of bloodcurdling paintings of the decapitated heads of criminals [p. 216]. These he studied not in the scientific manner of a Leonardo da Vinci eager to learn the secrets of the human

form, but for the awful nature of suffering and violent death, something he himself courted by riding dangerous horses and by a failed attempt at suicide.

That Géricault found the irrational compelling is confirmed by another disturbing series, this time of mad men and women. Whereas Goya had portrayed the hallucinations to which a madman might be prone, Géricault intensively studied the faces of those who were actually insane. The fact that these disturbed and frightening creatures were now considered, like the severed heads, worthy subjects for painting demonstrates a fundamental shift in the concept of what art was supposed to depict. It is impossible to conceive of David, the great Neoclassicist, painting such gruesome and, in the traditional view, such uninspiring and degrading subjects. Among the most remarkable paintings of Géricault's short and tempestuous life, these images explore various forms of madness. Beautifully painted, some of them reminiscent of the insightful portraits by the mature Rembrandt, the likenesses are both terrifying and pathetic. The portrait of a child murderer [p. 217] is especially horrible, for the viewer is made aware of both the woman's suffering and her still-murderous potential in a restrained, almost detached observation. These are memorable likenesses—painted with a sober, tempered palette and a spontaneous, free, heavily loaded brush—which have never been surpassed for their incisive exploration of the madness that Géricault thought of not as a sort of extraneous invasion of the soul but as something intrinsic to the human mind.

Géricault's famous *Raft of the Medusa* of 1819 [pp. 212–13] revealed his abilities to plan out and complete a vast and ambitious history painting. The story of the raft was, once again, a topical subject and thus something that would have been disdained by many earlier painters. The *Raft of the Medusa* depicted the helpless passengers and crew of the French ship *Medusa*. When the ship was wrecked near Senegal in July 1816, they were placed aboard a raft and cut adrift by the captain. At the time of their rescue only 15 of the 149 passengers and crew members were still alive. A notorious event, involving political corruption and scandal, since the incompetent captain owed his job to his allegiance to the French monarchy, it was the sort of horrific subject that interested Géricault and his contemporar-

THÉODORE GÉRICAULT, PORTRAIT OF A CHILD MURDERER, 1822–23. *Géricault studied and drew the insane from 1822 to 1833. His other studies of mad people are equally controlled and frightening. Géricault's friend Dr. Georget was a pioneer in the clinical study of insanity.*

ies. Moreover, the ordeal of the victims involved a titanic struggle against the forces of nature, brilliantly shown in the painting by the immense, stormy sea and the powerless occupants of the raft. The unequal struggle of man against nature was a theme that fascinated many of the best painters of the first half of the nineteenth century.

It was Géricault's concept to make this sordid contemporary tragedy into something monumental and heroic. He made an intensive study of the disaster—he depicted the occupants of the raft just as they sighted the rescue ship on the horizon—which included acts of cannibalism and mutiny. Géricault even interviewed some of the survivors and had the carpenter of the *Medusa* build a model of the raft and set it up in his studio. He then made numerous studies and an oil sketch before beginning the actual painting. For the composition and for the poses of the men and women on the raft, Géricault ran-

sacked the art of the past, from Raphael and Michelangelo—whose influence is extremely strong in the figure types and gestures—to the work of his immediate forerunners. The result of all this study was grand in both scale and conception. The large canvas (c. 16 by 23 feet), with its twisting figures and tilting diagonals, was shown at the Academy in 1819. Though it was titled simply *Shipwreck,* all the visitors knew its real subject. Critics either condemned or praised it depending on their political rather than their artistic leanings. Disappointed by the lack of artistic appreciation, Géricault lapsed into depression. But in 1820 he exhibited the painting in England, where it was immensely popular.

Géricault's early death, caused by a fall from a horse, ended a brilliant and original career. Fortunately, his influence was felt and absorbed by his talented friend Eugène Delacroix (1798–1863), who became the principal exponent of the French Romantic school of painting and the principal rival of his contemporary Ingres, whose stylistic orientation was classical and academic. Delacroix studied briefly with the academic painter Pierre-Narcisse Guérin, who had also taught Géricault, but Delacroix had little sympathy with the systematic method and classicizing subjects Guérin propounded. Delacroix was keenly interested in the new directions taken by Goya, Gros, and Géricault. Largely self-taught from looking at the works of Michelangelo, Rubens, and Titian in the Louvre, Delacroix made many acute observations about his art in his journal, a highly valuable document that remains compelling reading.

Delacroix, like Géricault, was fascinated by the exotic, both of the past and of the present. His *Death of Sardanapalus* of 1827 [p. 218] gave him a chance to depict in a remote place and time the sort of physical and emotional violence that so fascinated many painters of the age. Sardanapalus, an Assyrian ruler of the seventh century B.C., held out against his besieging enemies for two years before his palace fell. Delacroix depicted the last moments of Sardanapalus, who watches as all his treasures, horses, and concubines are brought together to be burned with him in a defiant act of self-immolation.

Painting under the influence of Rubens, Delacroix created a wild scene of writhing struggle and death. The strong crescendo of expansive forms, reminiscent of the *Raft of the Medusa,* gives the

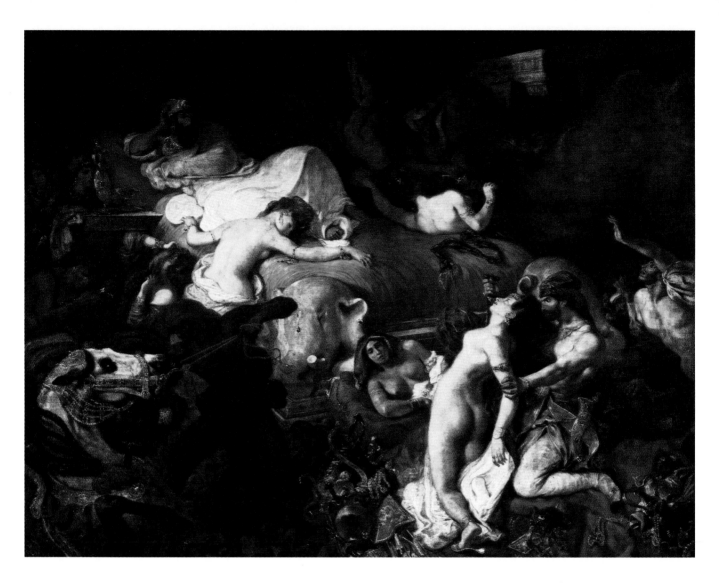

EUGÈNE DELACROIX, DEATH OF SARDANAPALUS, 1827.
*Delacroix seems to have derived his inspiration for this picture
from a poetic drama,* Sardanapalus, *by Lord Byron, written in
Ravenna and published in 1821.*

picture visual excitement and power. Delacroix
dwelled on the various episodes of cruelty per-
formed in this exotic Levantine palace, especially
the murdered women, whose bodies reveal Dela-
croix's remarkable ability to paint glowing, lambent
flesh. The opulent color animates the painting and
helps create the action-filled drama. Deep reds,
golds, and the ubiquitous flesh colors are spread
over the surface of the canvas in masterful inter-
relationships. The smoke of the battle, the smolder-

ing colors, and the expansive bodies seem to swirl
around the brooding Sardanapalus, who watches
the final manifestation of his will from his couch.

Though the *Death of Sardanapalus* was con-
sidered excessive when it was displayed in the
Salon of 1827, Delacroix regained official favor
shortly thereafter. In 1831 he was awarded the Le-
gion of Honor by the king and, after numerous rejec-
tions, membership in the French Academy in 1857.
In the early 1830s he had accompanied a French
delegation to North Africa, where he made numer-
ous sketches that were to serve as inspirations for
later paintings of this then-exotic part of the world.
One of the best known of these is the *Women of
Algiers* [p. 219] of 1834, depicting concubines in a
harem, a subject of considerable sexual titillation

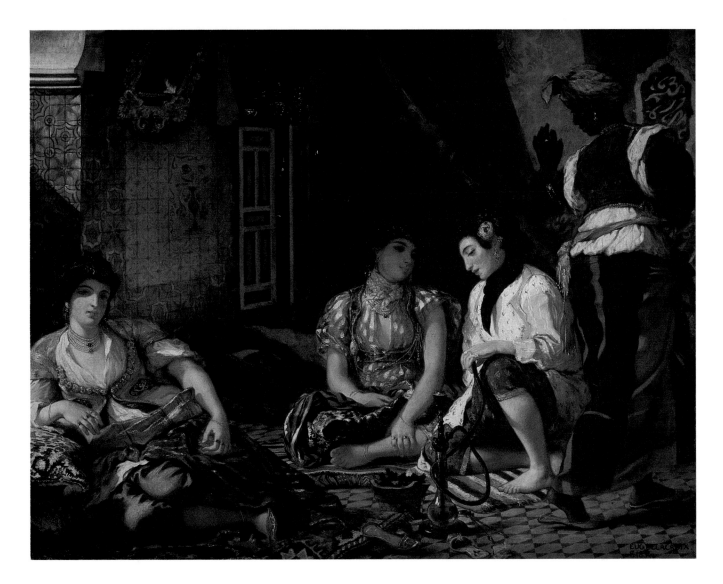

EUGÈNE DELACROIX, WOMEN OF ALGIERS, 1834.
Delacroix's 1832 trip to Morocco, in the company of the French diplomat Count de Mornay, was one of the painter's most important experiences. The images he saw and the drawings he made on this trip were used by him for the rest of his life.

for the nineteenth century. Notable for its light and large areas of interrelated color as well as for its alien subject, the picture was to have great influence on the Impressionists, who found, especially in its palette and its depiction of textures, a source of inspiration.

An opposite sensibility to Goya, Géricault, and Delacroix, more academic and controlled, is exemplified by the great French painter Jean-Auguste-Dominique Ingres (1780–1867). Born in Montauban, Ingres studied at the art academy in Toulouse before joining the studio of Jacques-Louis David in Paris. Ingres, who was David's best student, began his career in obscurity. Though he personally disliked the Academy and avoided the Salon, Ingres has come to be identified with its goals and viewed as an artistic conservative. But, despite his allegiance to clear and precise form, balanced compositions, and idealized beauty, he shared much of the same interest in exotic and erotic subject matter that had attracted the Romantics.

This is readily apparent in one of Ingres's early works, *Napoleon I on the Imperial Throne* [p. 220], painted in 1806, when Ingres was twenty-six. Like David and his contemporaries, Ingres was en-

thralled by the magnetic presence of Napoleon, who had been proclaimed emperor in 1804, an event memorialized by one of David's most famous paintings. Ingres's portrait of Napoleon is a beatification in paint. Enthroned, swathed in imperial robes, holding scepters of authority, and framed by a halo of carved decoration, the youthful Napoleon is presented like a Roman emperor. Throughout his life, Ingres was an assiduous student of the history of art, and even in this early stage of his career he turned to the past for information and inspiration. To help with the creation of his *Napoleon*, he studied Roman art, Byzantine ivories depicting emperors, and perhaps medieval manuscripts. He used these images of authority to create the starkly frontal, immobile figure of the emperor, who engages the viewer with his hypnotic stare and pose.

Ingres was a sensitive and painstaking draftsman. For him, drawing was the very heart of painting, and he drew and redrew whatever he was to paint until he understood all its elements and their subtlest interrelations. Though he valued history painting above all else, he also often produced portraits, some of the best of which are drawings. Having been awarded the Prix de Rome by the Academy, which included a stay in Rome, Ingres decided to remain there after his stipend ended in 1810. He helped support himself by making portrait drawings of visitors to Rome [p. 221]. These drawings are skillful, concise masterpieces, presenting form and character with an absolute minimum of line and with a brilliant use of the white of the paper, which becomes space, atmosphere, and light around the figure. Ingres's outstanding evocation of place, light, and character in these seemingly casual portrait drawings establishes him as one of the most revered draftsmen in art history.

Unlike the quick poses sufficient for drawings, sittings for painted portraits were often arduous experiences, as Ingres worked through the numerous transformations necessary to refine reality into his particular vision. One of the most renowned portraits by Ingres, that of Madame Moitessier [p. 221], was begun in 1844 and finished only in 1856. In the intervening twelve years the determined artist and his patient sitter struggled toward the magnificent final result. Ingres presented Madame Moitessier as a monumental figure whose great form dominates the space of the painting. Her pose was derived

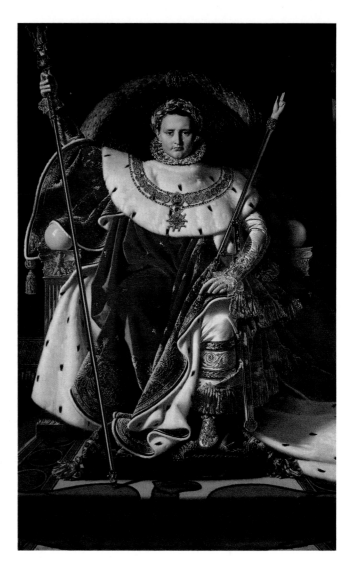

JEAN-AUGUSTE-DOMINIQUE INGRES, NAPOLEON I ON THE IMPERIAL THRONE, 1806. *For centuries the frontal, enthroned figure had been a symbol of both divinity and authority. Ingres used this tradition to make Napoleon into a living icon.*

from a painting of a goddess that had been unearthed from the ruins of Herculaneum, but for this portrait Ingres also carefully studied the works of Raphael and his contemporaries. With its enamel-like surface and fastidious drawing, *Madame Moitessier* does recall a Renaissance portrait. Yet, in its exquisite refinement of form and the careful, almost obsessive adjustment of shape to shape, the painting fulfills Ingres's own vision. It exudes a disturbing airless feeling, as though the atmosphere had been sucked out of the room, revealing the

JEAN-AUGUSTE-DOMINIQUE INGRES, CHARLES-FRANÇOIS MALLET, ROME, 1809. *The subject of this portrait drawing was a famous French engineer. The various Roman monuments in the background are an allusion to his role as road and bridge builder.*

JEAN-AUGUSTE-DOMINIQUE INGRES, MADAME MOITESSIER, 1844–56. *Ingres was commissioned to paint Madame Moitessier in 1844, but it was not until twelve years later that this painting was finished.*

sitter and the surrounding objects with a preternatural sharpness. In this claustrophobic environment, personality has been distilled away and sensuality has become magnified. Madame Moitessier's long, snakelike arms and tentacle-like fingers, her perfected, idealized features, and her rounded form give her the appearance of a Greek sculpture come to life. Surrounded by her expensive things, dressed in a costly gown of white flowered silk, Madame Moitessier is both exotic and erotic. Even in his portraits Ingres exhibited a sensual feeling that was more often expressed in the nudes that preoccupied him in his old age.

While Ingres and Delacroix expressed their romantic tendencies through the figure, artists in Germany and England utilized the landscape. A pantheistic conception of God had deeply affected the thinking of English and German poets and painters. Spurred by a thirst for spiritualism in this secular and mechanistic era, they found in nature a manifestation of divinity. Thus landscape emerged as the single greatest subject in Western European art in the nineteenth century. The allusions to nature in the works of Wordsworth, Gray, Goethe, and Beethoven, for example, are proof of the powerful inspiration nature provided.

The German Romantic painter Caspar David Friedrich (1774–1840) devoted his entire career to expressing a spiritual presence in landscape. Born in Greifswald, he settled in Dresden in 1798. An ardent patriot, Friedrich was also devout, introspective, and prone to melancholy. His mother died when he was seven, and six years later his brother died as he was saving Friedrich from drowning.

These experiences deeply affected an already sensitive nature and endowed him with a lifelong obsession with death, God, and nature. In the solitary beauty of the landscape, Friedrich found comfort and inspiration. His travels to the Baltic coast, to the Riesengebirge (the Giant Mountains), and to the Harz Mountains provided him with subject matter. During these excursions, Friedrich made drawings of certain motifs—such as rainbows, old oaks, and fir trees—that had archetypal significance for him. Remarkably gifted as an observer and interpreter of landscape, he was particularly adept at expressing the nuances of light, texture, and color. He also saw nature through the eyes of a pious believer. "The divine is everywhere, even in a grain of sand," he wrote. Friedrich's fusion of observation with piety resulted in pictures of extraordinarily expressive power and spiritualism.

In 1809–10, Friedrich painted his *Abbey Under Oak Trees* [p. 223], an image infused with the theme of death. The scene is the graveyard of a ruined church where a burial takes place. As a procession of monks carries a coffin across the wintry churchyard (which underscores the funerary content of the scene), they are dwarfed by the ancient oaks and decayed abbey. Silhouetted against the leaden sky, the trees and the abbey seem ghostly inhabitants of a desolate place, yet the image is also permeated with a mystical spirit. Cold and insistent, the clean, pure light that illuminates the sky invokes a sense of the dematerialization of life, transformed into the spiritual essence that is light. Instilling awe, Friedrich's picture conveys a deeply religious message. Despite or because of its disintegration, the abbey is the embodiment of the Christian faith. Transformed by the forces of nature, which are God's most elemental signs, the abbey is bound to those forces and purified by them.

Friedrich made a habit of walking to his favorite natural spots, a practice that was prevalent in Germany and England—walking to picturesque places became a welcome pastime for wanderers eager to meditate on the beauty of nature. Friedrich's *Man and Woman Gazing at the Moon* of 1830–35 portrays two such wanderers [p. 223]. Fixed in time and place, the man and the woman confront the infinite and eternal manifestations of God. The evergreens and the waxing moon are both symbols of Christ, but they are also part of the vast expanse of nature. Stripped to an essence, Friedrich's paintings are hypnotic and memorable, evoking powerful longing, as though deep memories, dreams, and yearnings have been revived and ache to be fulfilled. The product of a singularly pious and sensitive personality, Friedrich's landscapes joined the writings of Goethe and Schiller and the music of Beethoven as a particularly profound expression of German Romanticism.

In England, two artists born within one year of each other also responded to nature and made landscape their principal subject, which they interpreted in less specifically Christian but no less evocative ways. Joseph Mallord William Turner (1775–1851) infused landscape with passion, energy, and power, interpreting his subject on its most epic and elemental levels, while his contemporary John Constable looked closely at the properties of shifting light and the movements of clouds, creating paeans to actual places and times of day. Both men were products of their times, but Turner's work, with its strident emotionalism, can be called the culmination of the Romantic landscape, while Constable, with his interest in visible reality, anticipated the concerns of the Impressionists.

Their careers were remarkably different. Turner was precocious, brilliant, and successful. By the age of thirty he had become a member of the Royal Academy. Despite his success, he was a recluse—secretive, short (in both stature and speech), and uninterested in society. Rumpled in dress, Turner was also irascible and mean with money. He never married, though he had a lifelong mistress and a passionate nature. The erotic imagery Turner produced was burned after his death by his admirer, the eminent critic John Ruskin.

Turner's life was devoted to painting, as evidenced by a vast body of work, consisting of over twenty thousand paintings, drawings, and watercolors. Turner was particularly fascinated by subjects that lent themselves to dramatic effect. Like Caspar David Friedrich, he loved Gothic cathedrals, and he painted numerous watercolors of them early in his career. Traveling through mountains, he recorded the chasms and waterfalls that were both beautiful and dangerous. He had a lifelong passion for the sea and for rivers. It is not surprising that his favorite foreign city was Venice, the ultimate fusion of water and civilization, where he made countless

CASPAR DAVID FRIEDRICH, <u>ABBEY UNDER OAK TREES</u>, 1809–10. *Obsessed with themes of death, Friedrich developed images that, through their silence, sadness, and symbolism, provide meditations on mortality.*

CASPAR DAVID FRIEDRICH, <u>MAN AND WOMAN GAZING AT THE MOON</u>, 1830–35. *Figures shown from the back gazing into infinity became a particularly useful device of Friedrich to express human yearning for infinity. A quiet, meditative melancholy and the object of the couple's gaze— the moon—became popular themes not only in painting but in the poetry and music of the period. In particular, Schubert and Goethe have connections with Friedrich's painting.*

THE
ART OF
NAPOLEON

A general who became emperor, Napoleon not only had an instinct for military strategy but also for art, through which he brilliantly promoted his myth. From the first, he befriended artists who helped to build his image. The Baron Jean-Antoine Gros accompanied Napoleon on his Italian campaign, drawing and painting him many times. After Napoleon crowned himself emperor in 1804, images associating him with imperial tradition proliferated. David painted the coronation, Ingres portrayed Napoleon on his throne, Canova turned him into a latter-day Caesar Augustus, and Gros continued to glorify Napoleon's military conquests. Myth was grafted onto and supplanted reality. Goya, who commemorated Spanish resistance so forcefully with his *Third of May, 1808*, is another artist who responded pictorially to Napoleon's impact on the world. Turner, who portrayed the battleship *Temeraire*, of the Battle of Trafalgar, 1805, in which French forces were defeated, was sufficiently inspired by Napoleon's history that he also painted a haunting image of the ruler in exile. A hero for both the Neoclassicists and the Romantics, Napoleon had an impact on the visual arts that was less enduring but no less important than his effect on Europe's political structure.

JOSEPH MALLORD WILLIAM TURNER, THE FIGHTING TEMERAIRE, 1839. *Popular from the first day it was exhibited, Turner's painting of the* Temeraire *satisfied the public's taste for drama and emotion. The* Temeraire *was famous for having avenged the death of Admiral Nelson in the Battle of Trafalgar, 1805. When Nelson was killed by a bullet fired from the French ship* Redoutable, *the* Temeraire *retaliated by blowing up the French ship; won by the British, the Battle of Trafalgar saved Britain from invasion by Napoleon.*

sketches and watercolors on his visits in 1819 and again in 1828. During the 1830s and 1840s Turner developed his mature vision, in which the forces of nature and history were given grandiose expression.

In 1838 Turner was aboard a steamer making its way along the Thames River when he saw the battleship *Temeraire* being towed to a wrecker's yard. He turned this event into a painting of operatic drama [p. 225]. Set against a molten sunset, the white and gold hull of the *Temeraire*, hero of the Battle of Trafalgar, gleams iridescently against the dark, grimy tug that pulls her to her ignoble destiny. A simple, relatively prosaic event from real life has become an epic vision describing the forces of good and evil, war and peace, life and death, heroism and destiny. Perhaps ironic to those who witnessed it, the episode became in the hands of Turner a moment of grand emotion, with patriotic and historic overtones.

The image coalesces almost magically out of dabs of paint, alternately so thin as to be a mere wash and so thick that it forms crusts on the surface. Turner's handling of paint was intuitive, organic, and effusive; paint as well as subject are the vehicles of emotion. The feelings evoked by this

JOSEPH MALLORD WILLIAM TURNER, RAIN, STEAM AND SPEED—THE GREAT WESTERN RAILWAY, 1844. *Legend has it that Turner prepared himself for painting this vision of the steam engine by sticking his head out of a train window for ten minutes during a storm.*

JOHN CONSTABLE, STUDY OF CLOUDS AT HAMPSTEAD, 1821. *(opposite) His wife's tuberculosis first brought Constable to Hampstead in 1819. It was an ideal place for him to study the cloud formations and weather conditions that had become such an important part of his work, and he made cloud studies such as this one regularly there. These sketches, considered among the most original aspects of his work, gained favor with collectors only after the French painters of the Barbizon school and the Impressionists helped establish a taste for free, loose, and spontaneous ways of working.*

picture and several others that deal with the eclipse of a hero had particular meaning for Turner, who, viewing himself as a great artist, identified closely with the notion of greatness and destiny. Regardless of Turner's personal reasons for painting the scene, *The Fighting Temeraire* received an enthusiastic re-

that also inspired his *Rain, Steam and Speed—The Great Western Railway* of 1844 [p. 226]. Here paint was used to translate the exhilarating and novel experience of speed. Rushing out of a vaporous mixture of steam and rain, the black engine will soon race past. The very nature of flux, motion, and velocity is given form through paint. A diagonal cuts deeply into the picture's space and plows ahead with dynamic energy. The train that surges along its straight path, the steam, the rain, and the landscape become blurred. Turner understood and appreciated the impact of such technological advances as the steam engine. Employing the visual devices of the past, particularly the exaggerated perspective of Tintoretto and the scumbled, molten paint surface developed by Titian, he looked toward the future, describing the pulse and energy of the twentieth century. Paralleling the forces of nature and those of machines, Turner evoked their power and their potential.

His handling of paint by 1844 had become purely personal and intuitive. Scraped, brushed, and smeared, its purpose was to create sweeping movements and general atmospheres; to imply, rather than describe, both setting and details. Specific forms occasionally loom out of the organic, pulsing stretches of paint, giving context and reference points to the overall blots of color. As he matured, Turner's approach to painting became increasingly idiosyncratic. Though John Ruskin, the great English theorist, championed him, Turner's late works were often ridiculed. To modern eyes,

ception at the Royal Academy in 1839, being compared to a performance of "God Save the Queen" in its effect on the audience.

The contrast between the smoke-belching tug and the stately sailing ship in Turner's *Temeraire* exemplified the developing industrial era, a theme

however, looking back over the last hundred years, when painters removed all subject except the paint, Turner's work is not only great but also prescient.

In 1799, when Turner was already a member of the Royal Academy, John Constable (1776–1837) entered its school as a student. Unlike Turner, Constable painted landscape with an eye to verisimilitude. His more prosaic views of nature, following the traditions of such Dutch masters as Ruisdael and Cuyp, were unfashionable. Constable was thirty-nine before he sold a picture, and in his fifties before he was invited to join the Royal Academy.

Constable's career was spent creating poetic expressions of his native Stour Valley. During the summers he would work in the village of East Bergholt, where he was born. This region of Suffolk and the Stour Valley came to be known as Constable country. There he made sketches, both painted and drawn. These "notes" would become the basis for the large and ambitious canvases that he would prepare in London for the annual exhibition at the Royal Academy. Constable's sketches of skies [p. 227] and sites such as *Dedham Lock and Mill* of c. 1820 [p. 229] are regarded today as important works that capture the spirit and feeling of the countryside, possible to attain only when the artist is working directly from nature. One of the earliest Western European artists to study changing light and atmospheric conditions so closely, Constable kept notes and diaries recording weather conditions and times of day. Keenly sensitive to all aspects of nature, he especially loved every detail of the Stour Valley. "I love every stile and stump, and every lane in the village, so deeply rooted are early impressions," he noted. In working out-of-doors, Constable was anticipating the direction that the Impressionists would later take with such conviction. But for him, producing large canvases outside was impractical: his "six-footers," designed to catch the attention of Royal Academy visitors, were painted in his studio, as was common practice until the Impressionists decided to do more than sketch outside.

The painting for which Constable has become best known is *The Hay Wain,* painted in London during the winter of 1820–21 [p. 229]. The subject of the picture is the Stour Valley, in particular the fording place between Flatford Mill and Willie Lot's Cottage, where an empty hay wagon (wain) makes its way to the haymakers in the distance. Constable had spent a summer making innumerable pencil and oil sketches of the haymakers, and in his large picture he made this episode of simple farming life into a celebration of a particular summer day, with billowing clouds and a bright sun shimmering over the glossy foliage of magnificent trees.

Constable, who made nature his subject, was dedicated to understanding and developing new ways to describe its mutability. The sky especially engrossed him. "The sky is the source of light in nature and governs everything," he remarked, and his obsession yielded the largest body of sky and cloud studies produced in Western art. He also experimented with different techniques, such as stippling the canvas with white flecks to capture the effect of wet leaves and dew, or incorporating dots of red that would make the green of the vegetation stand out and register more prominently. These attempts, like his outdoor studies, were an important inspiration to the later Impressionists.

The death of his beloved wife, Mary, in 1828 affected Constable profoundly. His work became darker and more brooding, infused directly or indirectly with a sense of mourning. In 1829, Constable painted his large version of *Hadleigh Castle* [p. 230]. Hadleigh, a thirteenth-century ruin perched on a hill overlooking the Thames, was painted largely from imagination. Constable had visited it in 1814 during his long and difficult courtship of Mary. He wrote her about the "melancholy grandeur" of the place, and he may have been inspired by his memories to paint this grand ode to ruins. Set against a cloud-streaked sky (in a manner reminiscent of Friedrich's churchyard), the old stump that remains of Hadleigh tower gives way to a view of the silvery Thames in the distance. Here a "morning after a stormy night" (as he titled the work) is shown, when the forces of nature, though now abated, have had and will continue to have their effect. They have transformed the fortress into a pasture. Humanity is diminished by nature's power, yet endures. Only human feelings can match nature's forces, and, to Constable, nature is a mirror of human emotions. The past, present, and future are bound up in this image, as are reality and fantasy, emotion and reason.

Constable, though interested in the real appearance of things, was not a dispassionate ob-

JOHN CONSTABLE, THE HAY WAIN, 1820–21. *Constable's view of the empty hay wagon crossing the River Stour took him five months to paint. Though it was not popular in England, it was bought by a French dealer and exhibited in the Paris Salon of 1824 where it aroused excitement, causing one French critic to comment, "Look at these English pictures —the very dew is on the ground."*

JOHN CONSTABLE, DEDHAM LOCK AND MILL, C. 1820. *Constable's father owned and worked the Dedham mill, and Constable knew it well, making numerous oil sketches of it. His treatment of water, reflections, atmosphere, and light shows his strong affinity with the great Dutch masters of the seventeenth century.*

JOHN CONSTABLE, <u>HADLEIGH CASTLE</u>, 1829. *Painted the year after his wife's death, the picture was exhibited with the lines from James Thomson's "Summer," from* The Seasons, *which allude to wild melancholy, glittering ruins, and a view from a hill which have much in common both with the spirit and the subject of the painting.*

server. His subjects had, as they did for all Romantic artists, strong personal meanings and ties; his attachment to nature was emotional as well as intellectual. An acquaintance of Wordsworth, Constable shared his belief in the beautiful, evocative aspects of nature and in the value of the humble. He also felt a strong affinity for poetry, occasionally exhibiting his works with lines of noted poems.

Constable's exhibition of *Hadleigh Castle* earned him his long-awaited election as a member of the Royal Academy. But if recognition came

slowly in England, Constable had gained renown more rapidly in France. His *Hay Wain* was seen by Géricault in London at the Royal Academy exhibition of 1821. Géricault was so impressed with the work that, at his behest, it was bought by a French dealer and exhibited in the Paris Salon of 1824, where it won a gold medal. French artists such as Géricault and Delacroix admired Constable's freedom of brushwork and the freshness of his subject matter. He was a fundamental inspiration to the French Romantics and also to the French painters of landscape.

During the years that Constable and Turner were changing the direction of English painting, England's engineers and builders were altering her industrial and social fabric. By the 1820s England's cotton industry had matched that of the whole of Europe, and her iron and steel mills were unsur-

passed. The steam engine and railway lines aided the fast and efficient transport of materials, and grand new structures such as the Crystal Palace of 1850–51 celebrated progress. England led the rest of Europe in taking control of and altering the physical environment as never before. Yet these vast, overpowering structures diminished individuals, who were dwarfed by their scale. The textile mills, forges, and massive industries that raised the standard of living for many soon choked cities in clouds of soot, displaced thousands of craftsmen such as weavers, and chained people to the machine so that the quality of life was lowered as well as raised by the progress that technology seemed to provide. Artists not only portrayed the new world that technology wrought but often turned nostalgically to the era passing from view.

SIR CHARLES BARRY AND A.W.N. PUGIN, THE HOUSES OF PARLIAMENT, LONDON, 1840–60. *Pugin, one of the major nineteenth-century proponents of the Gothic style in England, was not pleased with the structural regularity of Barry's plan for the Parliament. He is reputed to have said of the plan, "All Grecian, Sir: Tudor details on a classic body."*

Conscious of being propelled into the future, Europe began to take a long and wistful look at the past and embarked on a series of revivals. Classicism, which had gone in and out of style at regular intervals, was joined with revivals of Gothic art, Egyptian art, and the art of the Renaissance. These revivals were particularly important for architecture, which became robustly eclectic. Unlike earlier periods, which had often used a single style from the past to make certain moral or formal statements, the nineteenth century frequently combined many architectural idioms from different ages and periods to produce a host of associations and emotions. England in particular favored architectural revivals.

One of the most important commissions of nineteenth-century England was for the new Houses of Parliament [p. 231], made necessary after a fire in 1834 destroyed much of the old Palace of Westminster (an event portrayed by Turner). The rules for the competition stipulated that the style had to be either Tudor or Gothic, the only two styles considered English enough. The prize was given to Sir Charles Barry, who, with the assistance of A. W. N. Pugin, an important theorist of the neo-Gothic style,

built the famous pile that today is the very embodiment of the British government. A huge and complex structure erected between 1840 and 1860, it is an amalgam of various Gothic and pseudo-Gothic structures on a plan that owes much to Barry's study of ancient as well as contemporary Neoclassic architecture. Part cathedral, part castle, it is a wonderfully evocative building whose huge, variegated silhouette and many eccentrically beautiful details create a unique atmosphere and mood. Wrapped in a mantle of Gothic splendor, it is steeped in romance and historical grandeur.

The rapidly industrializing society of the nineteenth century, with its new commercial and social requirements, challenged architects and engineers. Some of the resulting structures, such as the Albert Buildings of 1871 [p. 232] on Queen Victoria Street in London, are fantasies of historical style assembled in a bold and striking shape. Irregular in silhouette and volumetric in the handling of the various structural elements, these buildings have a sense of character and association with the past. They are buildings with real, distinctive personalities, which bespeak the optimism and confidence of the period, and the high level of craftsmanship prevailing, especially in England.

As rail travel expanded, new types of structures, particularly enormous new train stations, were required. In these buildings, such as Saint Pancras Station of 1863–65 [p. 233], in London, architecture takes second place to engineering. Although the outside of the stations may be Gothic or Renaissance, the huge iron or steel girders and glass roofs spanning the train sheds are purely modern in their stark functionalism. These were new structures without historical association, and as

F. J. WARD, ALBERT BUILDINGS, LONDON, 1871. *The Albert Buildings, designed in the so-called Gothic arcaded mode, were the most modern commercial structures of their time, with shops on the ground level and offices above. Built on cleared slums, they are an early example of urban renewal.*

SAINT PANCRAS STATION (INTERIOR), LONDON, LATE 1865–67. *The dimensions of Saint Pancras are still impressive: it is 698 feet long and 100 feet high, with a roof span of 243 feet. When built, it was one of the largest structures in Europe.*

such they needed no decoration to mask the considerable engineering and structural skills of their designers. Train sheds, greenhouses, temporary exhibition buildings, bridges, docks, warehouses, and other new types of structures displayed an unabashed functionalism, which was to change the direction of the subsequent history of architecture until the very recent past.

By the mid-nineteenth century, much of Europe had become industrialized, and the generation of architects and artists who had inaugurated the Romantic movement were dead. But much of the Romantic spirit lived on. In their emphasis on individual genius and subjective experience, artists of the Romantic era handed future generations the basis for their own development and provided a point of view that colored their understanding of the past. Without the contributions of Goya, Géricault, Delacroix, and Turner, the works of later nineteenth-century artists like Munch, Klimt, Gauguin, and van Gogh would have been impossible. Furthermore, present-day interpretations of great artists active before 1800 are still inescapably filtered through the Romantic interpretations of the nineteenth century. Romanticism, which still survives in various permutations, yielded in the second half of the century to different and occasionally more dispassionate examinations of reality as the pendulum between emotion and reason continued to swing.

VINCENT VAN GOGH, CORNFIELD WITH CROWS, 1890.
*This is one of the most agitated and powerful of Van Gogh's
views of cornfields, all executed with great speed in the last
days of his life.*

[13]

TOWARD A NEW REALITY: 1850–1900

During the second half of the nineteenth century, the ideal of self-determination fostered by the French Revolution and spread by Napoleon helped spawn a revolutionary spirit across much of Europe. In 1848, the year in which Marx and Engels published the *Communist Manifesto,* revolutions broke out in Paris, Vienna, Berlin, Venice, Milan, Parma, and Rome. Though inspired by different circumstances, these revolts shared a common ideology centered on a growing belief in democracy, a sense of individual freedom, and an emerging social awareness. The revolutions of 1848, particularly in Paris, crystallized questions of class and pressed on the public consciousness the miseries as well as the power of the laboring masses. Called the last outburst of the idealism of the eighteenth century, these revolutions, despite limited degrees of success, gave rise to the socialist ideology that would increasingly affect Western political, social, and cultural history.

The spirit of rebellion also infected artists of the period. Between roughly 1850 and 1900, the radical position of the separation of art from function gained many supporters. Commonplace today, the notion of art for its own sake was revolutionary when it was declared that art objects that were useful ceased to be beautiful. Artists also challenged

the philosophy and the aesthetic principles of the academies, looking outside these conservative institutions for their training, subject matter, style, and purpose. Of the notable artists active between 1850 and 1900 fewer were trained in the academies, and fewer used the Salons and official exhibitions to gain exposure for their work.

Art became a hotly debated topic in print and in cultural circles. Many artists and critics promoted the status quo, supporting established values, conventions, and norms. Others sought change, seeing validity in the new themes and the new approaches. To many artists, the histories and mythologies still promoted by the academies offered no inspiration, and so they turned elsewhere for their subject matter: some to nature, others to daily life, and still others to themes of the worker, the poor, and the oppressed.

As they sought alternatives, many artists gathered in groups based on common interests. Sometimes exhibiting together, at other times still seeking exposure through the annual Salons, these artists were generally not bound by academic standards or practices. Outside the established mainstream of their own time, the members of these groups broadened the horizons of Western art and expanded participation to include, for the first time in history, a significant number of women. The Pre-Raphaelites, the Barbizon school, the Realists, the Impressionists, the Post-Impressionists, to name the best-known groups, not only reflected the various aesthetic ideologies that proved to be the most important for the development of subsequent Western art but counted among their members women whose artistic stature and accomplishments matched or exceeded those of men.

While the artists outside the established institutions were revolutionizing art, the Academy continued to function as a bastion of traditional standards and values. Recognition in the annual Salon remained the most effective means for an artist to establish himself. Thousands of pictures were submitted each year, and many, which failed to meet the academic standards, were rejected. Those that were admitted were candidates for a host of distinctions. In 1890, when a group of prominent French artists debated who would, a century later, be regarded as the greatest painters of the second half of the nineteenth century, they predicted that

this distinction would fall on Adolphe-William Bouguereau (1825–1905) and J.-L.-E. Meissonier (1815–1891), the most celebrated exhibitors in the Salons and both laden with honors. Though not as famous in the 1980s as predicted, these masters and numerous other academicians are now undergoing a revival of interest and a reevaluation. No longer seen merely as the enemies of change, they are now better appreciated for their technical and narrative skills. While, to modern tastes, Bouguereau's soft-bodied women and Meissonier's polished military reportage still fail to match the accomplishments of Manet or Courbet, contemporary critics have begun to reappreciate the traditions that such academic artists represent.

About 1848, one of the earliest groups of French artists to work outside the Academy was forming. Théodore Rousseau and Jean-François Millet, among others, abandoned the upheavals of revolutionary Paris for the serenity of the Forest of Fontainebleau near the village of Barbizon. Inspired by Constable, who had led the way in making landscape painting a faithful rendering of nature, the Barbizon painters sought to paint nature directly.

Théodore Rousseau (1812–1867), the leading representative of the Barbizon school, was one of the first artists attracted to the region. After traveling through the French provinces in the 1820s making sketches out-of-doors, he settled in Fontainebleau about 1837. From 1836 to 1847 he was excluded from the Salon, but such views of the Fontainebleau region as *Under the Birches* of 1842–43 [p. 237] earned him a reputation as an important landscape painter among such distinguished patrons as Delacroix and George Sand. A mingling of observation and artifice, Rousseau's picture presents a "portrait" of a place, a record of the individual characteristics of each tree. The sense of time and place, as mundane as it is specific, anticipates the preoccupations of the Impressionists, who became active from the 1860s on. The underlying structure, utilizing the horizontals and verticals established by the picture's shape, brings this record of a place into the realm of art.

In 1849 Rousseau began to participate regularly in the Salons. Though Salon-goers disliked his clots of paint, his unelevated subjects, and his presentation of what he saw instead of what was known, he eventually gained much recognition through the

THÉODORE ROUSSEAU, <u>UNDER THE BIRCHES</u>, 1842–43.
Rousseau, a member of the Barbizon school, painted in the Forest of Fontainebleau, roughly forty miles from Paris and famous for its natural scenery. Numerous painters, including Corot, Daubigny, and Millet, painted there as well.

Academy. Besides a gold medal earned in the Salon of 1849, Rousseau was later awarded the cross of the Legion of Honor, an exceptional distinction. As he gained financial success, he appealed to officials to preserve the Forest of Fontainebleau as a natural sanctuary and to save it from industrialization. Rousseau's interest in portraying nature was shared by a number of other important painters of the Barbizon school, including François Daugbigny (1817–1878) and Camille Corot (1796–1875). Other Barbizon painters, notably Millet, turned to themes of humanity's relation to nature.

Jean-François Millet (1814–1875), who settled in Barbizon late in 1849, was born into a farming family. Trained with an academic painter in Paris, Millet devoted his early work to portraits and erotic nudes. He was sensitive to the changes brought about by the increasing urbanization and industrialization of France, and he was particularly inspired by the social issues raised by the Revolution of 1848. Thereafter he turned to scenes of peasants laboring, endowing them with heroic form adapted from the art of the past.

Unprecedented in French art, such works by Millet as the *Sower* [p. 238] of 1850 were particularly controversial in the political climate of the time. Powerful and monumental, Millet's sower strides across a newly plowed field with energy and resolution, scattering the seeds for a new crop; he serves as an emblem of regeneration and of the elemental relationship between man and nature. Crude in appearance, the work provoked commentary not only on its subject matter but also on its style and unorthodox technique. Théophile Gautier, a famous nineteenth-century critic working for a government newspaper, noted that Millet "trowels on top of his dishcloth of a canvas, without oil or turpentine, vast masonries of colored paint so dry

JEAN-FRANÇOIS MILLET, SOWER, 1850. Sower *was exhibited in the Salon of 1850–51, as was Courbet's* Stonebreakers; *both works were inspired by an interest in turning away from the myths and allegories favored by the Academy and exploring the social realities of the time.*

Millet's contemporary Gustave Courbet (1819–1877), a self-declared Realist, rejected the inherent sentimentality of Millet's work along with that of earlier Romantics, with whom Millet's work still has an affinity. Courbet's interest in portraying things as they really appear, together with his nonacademic orientation, place him in the front rank of the quest for realism that was the premise for much of the artistic activity during the second half of the nineteenth century. Abandoning the study of law for art, Courbet arrived in Paris from his native Ornans in 1840. Essentially self-taught, he learned the rudiments of his profession from studying the works of Caravaggio in the Louvre. In 1847 Courbet made a trip to Holland, which strengthened his belief that painters should work from the life around them, as Rembrandt, Hals, and the other Dutch masters had done.

Courbet, like Millet, was affected by the events of 1848. Courbet himself later asserted that from 1848 on, he concentrated on "realistic" subjects. His efforts were more consciously designed to arouse controversy than Millet's had been. Courbet's *Stonebreakers* [p. 239] scandalized the Salongoers of 1850. Inspired by the "complete expression of human misery" in an encounter with an old road worker in tattered clothes and his young assistant, Courbet asked them to pose for him in his studio. Painting the road workers life size on a large canvas, Courbet showed them absorbed in their task, faceless and anonymous, dulled by the relentless, numbingly repetitive task of breaking stone to build a road. Unflaggingly honest, Courbet, much like Caravaggio in the seventeenth century, violated rules of artistic propriety by setting every detail of his lowborn workers' wretched state before the viewer.

Exhibiting the *Stonebreakers* in the Salon of 1850–51, together with a portrayal of a family funeral at Ornans and a scene of peasants returning from a fair, Courbet achieved the notoriety he so desired. He openly declared his socialist ideals but also affirmed that his subject matter had as much to do with his interest in "real and existing things" as with politics. Criticized for deliberately adopting a cult of ugliness and for attacking the established social standards, he was also praised by such social reformers as his friend the social theorist Pierre-Joseph Proudhon, who saw in the *Stonebreakers* a

that no varnish could quench its thirst." Political conservatives, who viewed the peasants as a potentially disruptive social element, attacked Millet, while liberals praised his ennoblement of rural life.

A nostalgia for an existence that was a dying phenomenon eventually made Millet's works, and the *Sower* in particular, some of the most famous images of their day. His paintings were exhibited widely, and he was revered on both sides of the Atlantic. Millet is buried at Barbizon next to Théodore Rousseau.

Rousseau, Millet, and other painters of the Barbizon school helped establish landscape and themes of country life as vital subjects for French artists. The Barbizon school also fostered an interest in visible reality, which was to become increasingly important to the Realists as well as to the Impressionists.

GUSTAVE COURBET, STONEBREAKERS, 1849. *Courbet coined the term* realism *to define his interest in the actual circumstances of his day. Despite his realism, however, Courbet controlled his images, underscoring the dramatic and symbolic nature of his subjects so that his paintings had an intellectual as well as a visual component.*

visual condemnation of capitalism and its potential for greed. When Courbet's work was rejected for the Paris International Exhibition in 1855, he took the novel approach of opening his own pavilion. Still at the center of political activity in the 1870s, he was arrested and imprisoned in 1871 when the Commune he supported fell. The following year he was released, and he moved to Switzerland, spending the remainder of his life in exile and painting the rough Swiss terrain in new, experimental ways. Courbet, together with Millet and Rousseau, had turned to nature and images of laborers with a realism that increasingly attracted artists who chafed under the restrictive conventions of academic art.

In 1859, a young Parisian painter named Edouard Manet (1832–1883) submitted his first pic-ture to the Salon, but his *Absinthe Drinker,* portraying a drunken bum, was rejected for its seamy subject and uncompromising realism. Manet shared with Courbet a lifelong devotion to a new vision. Highly independent, and extraordinarily original in both his unconventional portrayals of modern life and his spontaneous brushwork, he struggled for academic acceptance throughout his life. Though his official success was limited, Manet has come to be viewed as one of the founders of modern art, as easy to appreciate as he is difficult to categorize.

Born the eldest son of a high official in the French ministry, Manet became a painter against his father's advice, joining the studio of the respected academic painter Thomas Couture in 1850. Though he remained with Couture for six years, Manet gained his real knowledge of art much as Courbet had done. A trip to Italy in 1853 and a trip to Holland in 1856 exposed Manet to the same masters who had so profoundly interpreted realism in the past: Titian and Velázquez. Frans Hals, the master of the momentary, also made a lasting impression on the young painter.

EDOUARD MANET, OLYMPIA, 1863. *Monet, in writing to the French minister of education in 1890, said of Olympia: "It seems incredible to us that his [Manet's] work should not have its place in our national collections. . . . Furthermore, we view with alarm . . . the competition of the American market and the departure—so easy to foresee—of so many of our great and glorious works of art for another continent." Olympia was accepted for the Luxembourg Museum in 1890 and transferred to the Louvre in 1907 only after Monet intervened once more.*

In 1863 Manet participated in the famous Salon des Refusés, an exhibition consisting of works rejected by the official Salon, and he came to be viewed as the hero of the nonconformists. Though Manet regarded himself as working in the tradition of the great masters, his approach was to rethink established themes in modern terms. Perhaps it was the singular juxtaposition of well-known conventions and a contemporary context that so offended Salon visitors and critics alike. Manet succeeded in shocking his audience on a number of occasions,

but no work he produced created more furor than his *Olympia* [p. 240], painted in 1863 and exhibited in the Salon of 1865, which represents his interpretation of the traditional theme of the nude.

The response to Manet's painting was outrage against an image that was sexually explicit, socially provocative, and stylistically antithetical to accepted standards of modeling and composition. Manet's picture, which is a reinterpretation of Titian's *Venus of Urbino,* substitutes a prostitute (Olympia was a name commonly used by Parisian prostitutes of the time) for a goddess. Titian's Venus was probably a portrayal of a sixteenth-century courtesan presented as a goddess, but Manet's painting leaves no doubt as to the profession of his model. Completely at ease and proud of her naked body, Olympia exudes a frank sensuality. Her flower, neck band, bracelet, and shoes underscore her nudity. Olympia calmly gazes out at the viewer, who is engaged with the painting in a manner reminiscent of

Caravaggio. By implying that the viewer may take the part of the admirer who has proffered the bouquet Olympia's maidservant holds, Manet has not only affirmed the enduring power of Caravaggio's art but has given his picture a heightened sense of immediacy and spontaneity. Critics found Manet's interpretation unacceptable. Théophile Gautier complained that "Manet has the distinction of being a danger. *Olympia* can be understood from no point of view. . . . Here there is nothing . . . but the desire to attract attention at any price."

Despite the realism of Manet's subject, even Courbet attacked Manet's style, saying that *Olympia* looked like "a Queen of Spades getting out of the bath," referring to the lack of modeling in the figure. Having observed how light really falls on the human form, Manet did away with the half-tones that Courbet, like most figure painters, used; he described instead less subtle but much more truthful relationships between light and form.

Olympia eventually earned Manet admirers, including the writer Emile Zola, who praised Manet's

ALEXANDRE CABANEL, <u>BIRTH OF VENUS</u>, 1863. *Venus and other mildly erotic themes were especially favored by academic painters and Salon visitors during the second half of the nineteenth century, when paintings of women bathing, harem scenes, and slave markets attracted vast crowds, entertained and titillated by what they saw.*

truthfulness and noted that Manet had introduced the Parisians to a woman of their own times. By 1890 the furor over Manet's *Olympia* had died down, and his friend Claude Monet raised a subscription in order to donate the work to the Louvre. But in 1865, visitors to the Salon had different expectations.

What the Parisian Salon-goers expected to see were nudes such as the *Birth of Venus* [p. 241] of 1863 by Alexandre Cabanel (1823–1889), which provocatively yet demurely interprets this subject. Based on such earlier versions of the theme as Botticelli's *Birth of Venus*, Cabanel's picture has all the refined eroticism displayed by the works of Canova or Ingres. Idealized and devoid of any blemish or body hair, Cabanel's Venus is sexually passive,

characterless, and more perfect than is possible. Surrounded by masses of luxuriant hair, she is the ultimate male fantasy, voluptuous yet chaste, as well as accommodating. Her form, a brilliant performance of draftsmanship and careful, systematic modeling, is the nineteenth century's version of ancient and Renaissance styles. It should come as no surprise to learn that Cabanel's *Venus* was purchased by Napoleon III. Zola, who so admired Manet's *Olympia,* observed that she would have been more acceptable if Manet had borrowed Cabanel's rice powder puff for her cheeks and breasts. Despite Cabanel's tamer and more conventional approach, there is no denying the brilliance of his technique or the mastery of his draftsmanship.

The outrage provoked by Manet's *Olympia* may have caused him to abandon the nude for less controversial subjects. He did not paint another nude for nearly ten years. Instead, during the 1870s, Manet turned to the street and café life that appealed to modernist artists of the time. In his summary style, learned in part from studying the work of Frans Hals, and with a sympathetic eye, Manet depicted the humor, pathos, comfort, and pain that characterize ordinary life. His most famous interpretation of café life was painted the year before he died, of a debilitating circulatory disease.

His *Bar at the Folies-Bergère* [p. 243] of 1882 is a nearly life-size portrayal of a fleeting encounter with the barmaid at the popular Parisian nightclub. Using an actual barmaid, named Suzon, as his model, Manet made her the focus of a glittering scene. Her weary, distracted demeanor suggests the many customers whom she has served. The mirror behind her reflects not only her particular client of the moment, but it sets before the viewer the entire world in which Suzon exists. In this scene Manet has presented a full spectrum of colors, made more vibrant by his unerring use of black, and has described the effects of lighted chandeliers on marble, mirrors, glasses, and people. The figure of Suzon divides the picture vertically, her large and stable form becoming the axis around which the social activity swirls. Manet has portrayed her with the immediacy of a quick sketch but also with the permanence of a carefully planned composition.

Manet's *Bar at the Folies-Bergère* demonstrates his unique gifts. Not only sensitive to nuances of mood and spirit, he was a gifted interpreter of complex visual information. With its quick brushstrokes and its description of the various effects of light, Manet's painting reveals his response to the Impressionists, who all knew him and who had learned much from his realism.

The Impressionists, a closely knit group of artists that included Camille Pissarro (1830–1903), Gustave Caillebotte (1848–1894), Mary Cassatt (1845–1926), Berthe Morisot (1841–1895), Pierre-Auguste Renoir (1841–1919), Jean-Frédéric Bazille (1841–1870), Claude Monet (1840–1926), and occasionally Edgar Degas (1834–1917), met regularly at small restaurants such as the Café Guerbois, where they discussed painting and stressed the need for recording momentary sensations on the canvas and the importance of spontaneity. Manet's refreshingly direct look at life and his spontaneous yet monumental translation of what he saw into paint earned him the position as their unofficial leader. Though he never regarded himself as an Impressionist and never exhibited with them, Manet strongly supported their choice of subject matter.

Everywhere that people gathered, especially for amusement and pleasure, became a place that the Impressionists painted: streets and cabarets; views down boulevards and across rivers; people at work or at leisure. The Impressionists also looked at landscape, painting whole paintings, not merely sketches, directly out-of-doors. They wanted to record how the eye really sees, depicting figures cut off or caught in spontaneous movement and seen from unusual vantage points. Above all, they wanted to paint in such a way that the brush marks captured not only the movement of light on the surface but also the constant motion of all life. Encouraged by the writer and critic Charles Baudelaire, who in 1861 urged artists to "be of their own time," to be modern by looking to "transitoriness, the fugitive, the accidental" as their subjects, Manet and many of the Impressionists painted what they saw around them. At their disposal was a new tool, the photograph. Developed in the early nineteenth century, the photograph was particularly valued by some Impressionists as a means to judge reality, to capture unusual views, and to study figures in action. Photography aided them in their determination not merely to imitate nature but to capture some of its effects, such as light, motion, or expression, in paint.

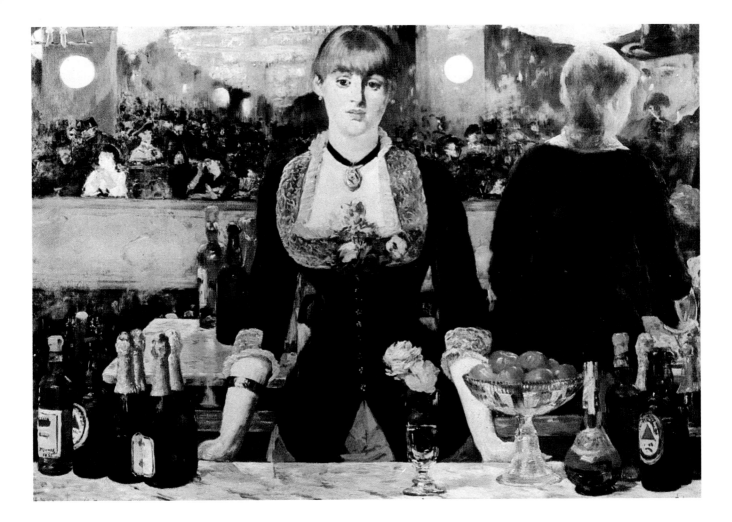

EDOUARD MANET, BAR AT THE FOLIES-BERGÈRE, 1882.
Like Degas, Manet used bars and restaurants as his subjects. The Folies-Bergère, located on the Rue Richier in Paris, was immensely popular—half theater, half café, it featured vaudevilles, operettas, and farces.

In the 1870s, while Manet was painting café society and other scenes of Parisian life, his friend Claude Monet (1840–1926) had settled in Argenteuil, so he could paint along the banks of the Seine River. Monet had a lifelong love of water, and he once joked that he would like to be buried in a buoy. Monet had spent his childhood in the port town of Le Havre and had taken his early painting lessons there from the painter Eugène Boudin (1824–1898). Boudin, who specialized in scenes of people strolling on beaches, worked up sketches out-of-doors and encouraged Monet to do the same. Monet was soon converted. "Suddenly a veil was

torn away. . . . My destiny as a painter opened out to me," he later said. His destiny was to paint out-of-doors and to paint the effects of light on water more often than any other Impressionist.

Monet went to Paris in 1859, where he met and befriended Pissarro and Manet, and also briefly studied with the successful academic painter Charles Gleyre. Monet married in 1870, and in 1871 he settled in Argenteuil, where he fixed up a boat with an easel and painted his way up and down the Seine, searching for the means to capture his impressions of the interplay of light, water, and atmosphere. Monet was joined there by Manet (who painted Monet aboard his boat), Renoir, Alfred Sisley (1839–1899), and Caillebotte, who were all painting similar subjects.

In 1874 the Impressionists (except for Manet) banded together as the "Société anonyme des artistes peintres, sculpteurs, graveurs." Just before the

CLAUDE MONET, IMPRESSION: SUNRISE, 1872—73. (above left) *Monet reportedly stated that he wished he had been born blind and then gained his sight so he could truly paint what he saw instead of what he knew. His early attempts to paint what he saw included this view of Le Havre. Its title earned the Impressionists their name.*

CLAUDE MONET, FIELD OF POPPIES, 1873. *Argenteuil, where Monet settled in 1871, offered him a chance to portray the surrounding countryside at his leisure. One of his favorite subjects was the meadows full of wild poppies.*

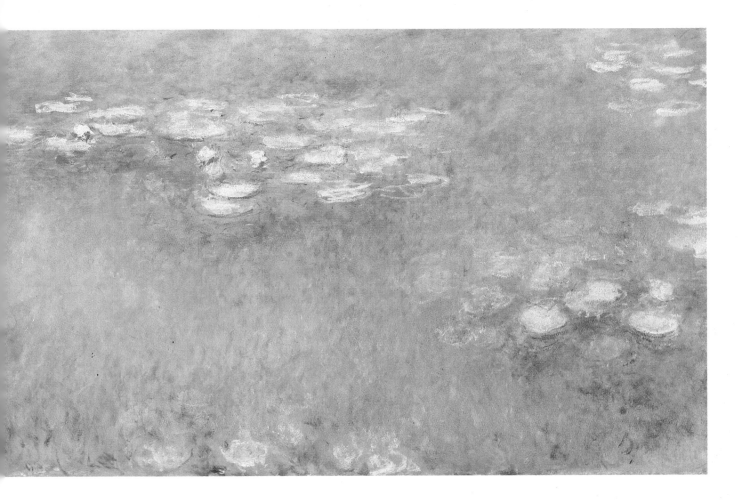

CLAUDE MONET, WATER LILIES, 1916–26. *Monet's garden at Giverny became his principal subject during the 1890s, the years in which he began to develop his water garden. Though he had planted his water lilies purely for pleasure, they became essentially his only theme during the last twenty years of his life.*

annual Salon of 1874, they gave a public exhibition of their work in the Paris studio of the photographer Nadar, who was sympathetic to their ideas. Monet exhibited a view of a sunrise at Le Havre as seen from a window. Entitled *Impression: Sunrise* [p. 244], it is dated 1872 but was probably painted in 1873. It demonstrates his method of working. With the most sparing palette and brush marks, he fixed the movement of light and water between the morning sun, dulled by fog, and the small dark skiff in the foreground. Jotting as though taking notes, he set down essentials, not details, yet his skill at translating vision into paint managed to register a complex reality: distance, atmosphere, light, time of day, place are all convincingly portrayed. This is a moment of transition, which in a few minutes would disappear.

Monet's painting gave the group its name, coined in derision by the critic Louis Leroy shortly after the exhibit. The Impressionists, he fumed, applied paint like "tongue lickings" and generally disregarded the conventions for rendering visible reality. Despite the financial failure of their first exhibition, the Impressionists continued to exhibit together until 1886; Monet slowly achieved recognition in the years after the Impressionists disbanded. Throughout his career he remained fascinated by the transitoriness of light.

His *Field of Poppies* [p. 244] of 1873, probably another of the twelve paintings Monet showed in the first Impressionist exhibition, demonstrates just how important light was to him. Though his wife and son are shown wandering through a poppy field near Argenteuil, they are incidental details, transformed into blots of paint that register the effects of

Edgar Degas

Claude Monet

sunlight on their forms. Establishing both a psychological and physical distance from his figures, Monet lets them become vehicles for his true interest. Light and shadow are created by juxtaposing different colors, not by introducing gradations of tone, as the academicians had done. Monet, like his fellow Impressionists, learned from experience that shadows could look blue, or dark green, or any number of colors, depending on conditions of light. By the late 1870s he had begun to experiment with series of pictures that allowed him to capture the changes from one time of day to another. Famous for painting outside even in the most inclement weather, he devoted his entire life to the single-minded pursuit of capturing the flux of nature. From his views of trains arriving in the Gare Saint-Lazare to his later series of haystacks, poplars, and water

lilies, the changing conditions of light—affected by atmosphere, time of day, and season—remained his theme. Painted after he moved to Giverny in 1883, Monet's water lilies [p. 245] are the culmination of a lifetime in which the out-of-doors had become his studio.

Painting the lilies in the pond of his garden hundreds of times between 1900 and 1926, Monet used them to explore the inherent property of oil paint. His increasingly personal experiments with layering strokes of paint, with the relationships between colors, and his amorphous forms, evolved, as Turner's works had done, into images where paint alone became the subject. Like the other Impressionists, Monet was dedicated first and foremost to the medium in which he worked, letting his eye and the material dictate the form. In that respect

Pierre-Auguste Renoir

Edouard Manet

he fundamentally opposed the approach of the academicians, where intellect and method guided and controlled observation.

By detaching himself psychologically from his subject and by refusing to give his images any single primary focus, Monet insisted on the significance of the relationships among forms and underplayed the importance of the human figure. His ideal subject was landscape, though other Impressionists retained an interest in the figure. Monet's lifelong friend Pierre-Auguste Renoir (1841–1919) visited him often at Argenteuil and there began to intensify his experiments with the Impressionist technique applied to human subjects. Renoir remained something of a society painter, making scores of portraits of well-to-do clients. Renoir's *Luncheon of the Boating Party* [p. 248] of 1881 fuses his interest in por-

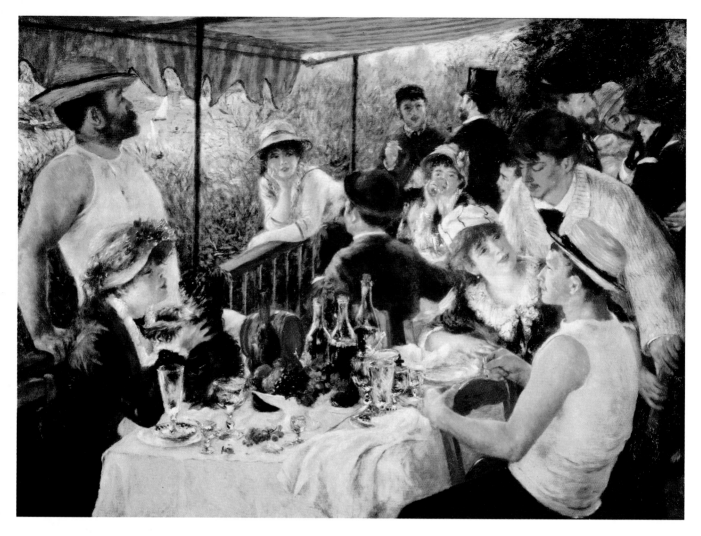

PIERRE-AUGUSTE RENOIR, LUNCHEON OF THE BOATING PARTY, 1881. *Renoir set his scene at an open-air restaurant on the island of Chatou and portrayed his friends amusing themselves. Renoir reveled in images of the happy side of human life. "For me a picture must be an amiable thing, joyous and pretty—yes, pretty! There are enough troublesome things in life without inventing others." Renoir's optimistic spirit sustained him through his final years, when, crippled by rheumatism, he painted by having the brush tied to his wrist.*

traiture with his love of scenes from everyday life. As he captured the relaxed atmosphere of a party gathered on the terrace of the Restaurant Fournaise on the Seine River, Renoir created indelible characterizations of his friends. At the right, wearing a boatman's hat, is the Impressionist painter Gustave Caillebotte, who chats with the actress Ellen Andrée. The man who gathered this group together,

Baron Barbier, is shown in the background wearing a top hat. Renoir's model Angèle sits drinking, while his future wife, Aline Charigot, plays with a dog in the foreground.

As thoroughly absorbed in their intimate circle of friends, their conversations, and their pleasures as Courbet's *Stonebreakers* are engaged in their work, Renoir's party reflects his own memories of those years: "Life was a perpetual holiday. The world knew how to laugh in those days." The casual air, with a seemingly random gathering of figures, has all the spontaneity of Monet's or Manet's work, but a close study of this picture reveals how carefully Renoir orchestrated his scene, creating the pairings and groupings that order and structure the painting.

Renoir's devotion to the figure was shared by several other important Impressionists, particularly

EDGAR DEGAS, LA RÉPÉTITION, 1877. *From the time he was twenty, Degas regularly attended the ballet and was a frequent visitor to rehearsals where he studied the dancers in training, his major theme during the late 1870s.*

Degas. If Renoir had the most optimistic outlook and sunniest disposition, then Edgar Degas (1834–1917) was his exact opposite. Introverted and shy, he socialized infrequently with the other Impressionists. Though he participated in the historic Impressionist exhibition of 1874, he detested the label "Impressionist," regarding himself as a Realist. Degas, like Renoir, practiced portraiture and believed in the importance of the figure in art, but Degas concentrated on people at work instead of at play. Degas's interest in the figure may have developed with his academic training with Louis Lamothe, a pupil of Ingres. In the 1850s Degas traveled to Italy, where the Renaissance masterpieces had a

great impact on him, although Ingres himself remained a lifelong idol. Yet like his associates, Degas believed in contemporary subject matter—turning, for example, to racetracks and circuses for his images. But for more than forty years, his overriding interests were the dance and opera, and his portrayals of dancers in oil or pastels—frequently capturing a sense of the arduous work that preceded each public performance—are often regarded as his best paintings.

Degas's *La Répétition* of 1877 [p. 249], which places equal emphasis on the ballet studio and on the ballerinas, is one of his finest works. Without a central focus, dancers are shown in the midst of a rehearsal, moving around the room or resting unselfconsciously—some practicing their movements as a dancing master beats out instruction, others having their costumes adjusted. A spiral staircase partly obstructs the view, giving the scene the feeling of a passing encounter, as it might have been seen by

any visitor stepping undetected into a ballet studio with the dancers hard at work. Degas's pictures make us look down, up, or into a scene from many angles, with any number of elements blocked or cut off from view. Adopting the arbitrary cropping afforded by photography (which he soon took up) and inspired by old masters, Degas in particular among the Impressionists continued a long and vigorous dialogue with the past; he produced images that were the result of much labor in the studio instead of being spontaneously created out-of-doors.

In his later years Degas began to lose his sight, and he turned to sculpture as a substitute for painting. He became increasingly bitter and isolated; his prickly character irritated many. The notorious Dreyfus case of the 1890s (in which a Jewish army officer was falsely convicted of espionage) brought out Degas's anti-Semitism, causing a break with Pissarro and other artists. Yet, when he died, Degas was deeply mourned. His lifelong friend and fellow painter Mary Cassatt, herself in ill health and also with failing eyesight, wrote that she had lost her best, her only friend.

Mary Cassatt (1845–1926) left her native Philadelphia in 1866 and settled permanently in Paris. Between 1872 and 1874, while the Impressionists were beginning to gather as a group, Cassatt was accepted into the Salon. Degas noticed her work, commenting, "I will not admit that a woman can draw so well." Ten years her senior, he played the role of mentor. Although many friends believed they were lovers, their relationship was most likely platonic. In 1879 Degas invited Cassatt to exhibit with the Impressionists, and she continued to exhibit with them and support their work until her death.

Cassatt's subjects grew out of the Impressionist interest in contemporary life, but in her case there was a particular emphasis on women and children. One of her finest paintings is *Woman in Black at the Opera,* painted in 1880 [p. 250]. Silhouetted against the wide circle of box seats at an opera hall, a stylishly dressed woman looks through her opera glasses, unaware that she has become the object of someone else's interest. Inspired by Degas and recently imported Japanese prints, where gaudily colored images created designs on a flat surface, Cassatt juxtaposed near and far, dark and light, large and small. Her clear and sophisticated manipulation of space followed none of the established

MARY CASSATT, WOMAN IN BLACK AT THE OPERA, 1880.
Cassatt's admiration for Degas first developed over his picture of a dance rehearsal that she bought in 1873, and a lifelong friendship ensued. Cassatt shared Degas's interest in the opera, but she concentrated on the audience instead of the performers.

conventions of perspective but relied on scale, contrast, and color.

Cassatt was one of several Americans who responded to the daring innovations of the Impressionists. James Abbott McNeill Whistler (1834–1903), born in Massachusetts, left for France at the age of twenty-one, arriving in late 1855 just before the Exposition Universelle closed. There he had the opportunity to see Courbet's own pavilion and the battle of styles between classicism and Romanticism that still occupied public attention. In Paris, Whistler studied with Gleyre, the academic painter who had taught a number of the Impressionists. Whistler also befriended Courbet, emulating his bo-

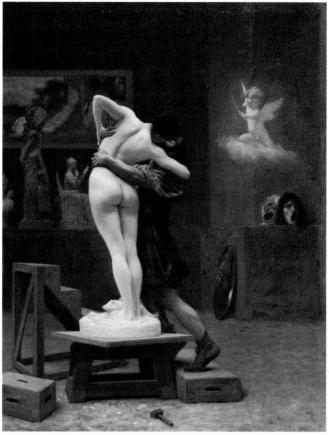

JAMES ABBOT MCNEILL WHISTLER, NOCTURNE IN BLACK AND GOLD: THE FALLING ROCKET, C. 1874. *Whistler worked on a series of scenes he called "moonlights" during the 1870s, but his patron Frederick Leyland, who was an enthusiast of piano music, suggested the title "nocturne," connected with the works of Chopin. Whistler's libel trial against Ruskin in 1878 centered on these nocturnes. Though Whistler won, earning him a single farthing in damages, legal costs ruined him financially.*

JEAN-LÉON GÉRÔME, PYGMALION AND GALATEA, AFTER 1881. *In the ancient Greek myth retold by Ovid, Pygmalion carved a statue that came to life. For Gérôme it became an opportunity to portray a lightly erotic subject in a historic setting, the kind of scene particularly popular with Salon-goers in the late nineteenth century.*

hemian life-style. In 1859 Whistler moved to London, dividing his time between Paris and London thereafter. Somewhat of a dandy, Whistler signed his works with a butterfly. He was greatly admired by Cassatt, who ensured that his work, like that of the other Impressionists, was acquired by her wealthy American friends.

Japanese art and Impressionist ideas in general contributed to Whistler's treatment of landscapes. His most compelling are his *Nocturnes*, which include *Nocturne in Black and Gold: The Falling Rocket* of c. 1874 [p. 251]. Within a limited palette of grays, blacks, and earth tones that seem at once murky and insubstantial, Whistler has suggested a

dark night, illuminated only by sparkling fireworks that define the sky and clouds and pick out the riverbank. Vague at first glance, the *Nocturne* hovers between pure abstraction and effective description. Its absence of definition resulted in the famous slander trial between Whistler and the English art critic and writer John Ruskin, who greatly admired Turner, though Turner himself was not a painter of literal reality. Whistler's more subtle image was an affront to Ruskin, who declared that Whistler had flung a pot of paint in the public's face. A trial ensued; Whistler was asked how long it had taken to make the work, and he proclaimed it was the experience of a lifetime. In the trial, which Whistler won

but which bankrupted him, he not only championed the new aesthetic of Impressionism (which supported the intuitive and spontaneous approach to nature that he pursued) but he also challenged the notion of the work ethic as it had been applied to painting. His enemies were the scores of academic artists who charged for the time it took them to paint a picture.

The academicians, such as Jean-Léon Gérôme (1824–1904) and Adolphe-William Bouguereau (1825–1905) in France, worked in a laborious technique that translated into very high prices. Bouguereau was so highly paid for his work that he claimed, "I lose five francs every time I piss." He and Gérôme catered to the hundreds of thousands of visitors who attended the Salons: the average-size crowd in the 1880s was forty thousand. That audience thrived on the escapist and historical fantasies that Bouguereau and Gérôme painted with superb skill and wonderful imagination.

Gérôme made a good living painting scenes like *Pygmalion and Galatea* [p. 251] (painted sometime around 1881), which fuses mythology, history, fantasy, eroticism, and sentimentality. Gérôme accepted and brilliantly fulfilled the standards of finish, detail, and polish established by the Academy, an approach that had found favor from the Middle Ages on. Gérôme gave his audience what it wanted, and he scorned those who took artistic shortcuts. In turn, he and the academicians of his generation were lavishly rewarded with more prizes and awards than any other generation of French artists.

Gérôme counted among his pupils Thomas Eakins (1844–1916), who ranks among the greatest American painters of his day. Eakins was in Paris from 1866 to 1869, where he saw the works of Manet, Courbet, and other Realists. He also had a chance to study Manet's and Courbet's heroes—Velázquez, Rembrandt, and Ribera—and he developed a rigorous and brilliant understanding of the human figure. When he returned to Philadelphia, Eakins's devotion to artistic tradition and to the figure brought him into conflict with authority. Active in the Pennsylvania Academy of the Fine Arts from 1873 to 1886, he resigned over opposition to his use of nude models. Drawing from the nude had been standard practice for centuries, but the Victorian sensibilities of conservative Philadelphia were offended.

THOMAS EAKINS, THE GROSS CLINIC, 1875. *A famous surgeon, Dr. Gross is shown wearing street clothes, as was the custom before sterile environments were introduced in the practice of surgery. According to the laws of the time, a relative of the patient had to be present during the operation; here he is the cringing figure at the far left.*

Eakins embraced an earnest and sober verisimilitude that endowed his portraits and narrative scenes with a haunting truthfulness, worlds away from the charmingly polished visions of Gérôme. Eakins also used history to give contemporary events context and power. For the Philadelphia Centennial, for example, he painted his most famous masterpiece, *The Gross Clinic* [p. 252] of 1875, which is based on Rembrandt's *Anatomy Lesson of Dr. Tulp*. Portraying a triumph of modern science—surgery performed on an anesthetized patient—Eakins combined scientific precision with artistic license. His lighting is selective, focusing on Dr. Gross and the patient, emphasizing the intelligence, concern, and dedication of the one and the complete vulnerability of the other. The jurors of the centennial exhibition rejected Eakins's picture for

the art display, and the work was shown instead in the medical section. Eakins's work is a perfect example of how diverse the interpretations of the figure were during the last decades of the nineteenth century: the potential for color and form established by the Impressionists, as well as the challenges of reality, inspired artists to move in many different directions.

Sculpture of this period was as diverse as painting. In 1886, the French people donated to America the Statue of Liberty, as the work has come to be known. Made by the famous sculptor Frédéric-Auguste Bartholdi (1834–1904), the statute embodies the ideals for the figure that were nascent some two thousand years earlier among the Periclean Greeks. To Bartholdi, those canons were still viable and particularly valid for a national symbol.

The most notable sculptor during this period, however, was Auguste Rodin (1840–1917), who was destined to abolish those canons and find new means to interpret the human figure. Having studied at the Academy, Rodin continued to live and work in Paris. Inspired by the work of Donatello and Michelangelo, Rodin was one of the last great champions of the heroically conceived figure in the history of Western art, but his means to achieve that heroic effect completely abandoned the classical tradition. Though he suffered numerous rejections from the Salons in the 1860s and early 1870s, Rodin persevered, and in the 1880s he was on his way to becoming the most internationally celebrated sculptor of his day.

One of Rodin's most controversial but today highly acclaimed works is his monument to the French novelist Honoré de Balzac [p. 253], commissioned by the Société des Gens des Lettres on the recommendation of Emile Zola in about 1891 and completed six years later as a plaster work ready for casting. Rodin submerged himself in the task of commemorating the novelist (who had died in 1850), by reading his novels, studying photographs of him, and visiting his home. What Rodin produced has none of the literal verisimilitude of a portrait, however, nor does it follow the established canons for figure sculpture. Though he experimented with a nude Balzac, Rodin abandoned many old—and to him worn-out—conventions, finding the means to express the genius of the writer through a new, more intuitive and summary approach. Much like

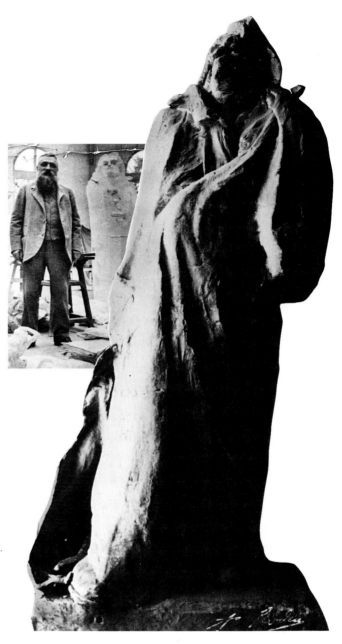

AUGUSTE RODIN, BALZAC, PLASTER MODEL, 1895. *This photograph of the plaster model for Rodin's* Balzac *was taken in 1895, before the work left Rodin's studio. Shown in the 1898 Salon, the plaster was vilified by critics, but Rodin predicted that the work would survive. In 1939, eighteen years after Rodin had died, the bronze version of the sculpture was erected in Paris.*

Turner and the Impressionists, who also relied on their medium to carry the subject, Rodin exaggerated some forms, eliminated others, and finally created a work that is both epic and informal, amiable

and slightly grotesque, just as the writer himself actually was.

A plaster cast of Rodin's *Balzac* was shown in the Salon of 1898, and the critics were relentless. "Never has anyone had the idea of excising a man's brains in this way and smearing them on his face," one carped. Another declared that the Balzac sculpture was proof of the "degree of mental aberration we have reached at the end of this century." Younger sculptors, however, admired the work for its distillation of power, its sense of emerging form, and the intuitive interpretation of the surface, which makes character and spirit spring to life. Rodin himself declared, "If truth is imperishable, I predict that my statue will make its own way. . . . This work . . . is the result of my whole life."

As Rodin was changing the direction of sculpture, a number of seminal painters working in the 1880s and 1890s changed the appearance and meaning of painting. Responding to and rejecting some of the notions of Impressionism, the Post-Impressionists are today considered the harbingers of modern art.

The term *Post-Impressionism,* which arose from a famous exhibition held in London in 1910, is, like most other "isms" in art, a nebulous one. In its broadest sense it can be used to describe the work of a number of painters who, often working independently from one another, evolved a style that originated, in part, from their reaction against the Impressionists. Although several of these artists began their careers exhibiting with the Impressionists, they soon developed a style of painting that was much more concerned with structure and form. Less interested in the transitory effects of light and motion than the Impressionists, they often turned instead to different subjects, which they painted with a greater emphasis on formal discipline. In a sense, these heirs of the Impressionists were returning, knowingly or unknowingly, to some of the traditional principles of painting that were so brilliantly exemplified by David and Ingres in the first half of the nineteenth century.

The most important of the Post-Impressionists was Paul Cézanne (1839–1906). The son of a well-to-do banker in the southern French city of Aix-en-Provence, he first studied law but abandoned it in favor of painting. He joined Zola, his closest boyhood friend, in Paris in 1863. There Cézanne came

PAUL CÉZANNE, WOMAN WITH COFFEE POT, 1890–92. *As with Ingres, Cézanne's sittings for portraits were laborious experiences as the artist constantly searched for the right way to transform his visual experience into art.*

under the influence of the Impressionists and exhibited with them in their first show in 1874. His works in this exhibition drew particular scorn, because of their seemingly harsh and ugly colors and the rough paint surface, worked extensively with a palette knife.

As Cézanne matured as an artist, he moved away from Impressionism, saying that he wished "to make of Impressionism something solid and durable, like the art of the museums." In 1877 he returned to Provence and began his search to express visually the basic structure of the world. For example, in a remarkable painting of 1890–92, *Woman with Coffeepot* [p. 254], the central object, the figure, is presented with the same dispassionate, meticulous, exploring eye as the coffeepot. Cézanne

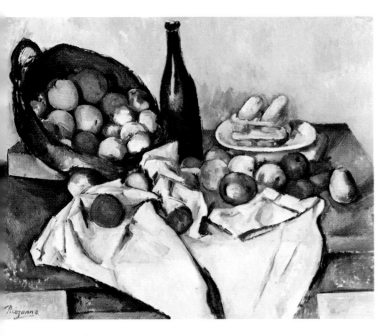

PAUL CÉZANNE, STILL LIFE WITH BASKET OF APPLES, **1890–94.** *Cézanne's interest in abstract forms and their interrelations is evident here in the pastries, which are tipped up and stacked like logs in an architectural arrangement.*

discerned and described the basic shape of all the forms and then showed their interrelationships. The woman achieves monumentality through the abstraction and reduction of the various parts of her body—the arms are cylinders, the lower part of the dress is a triangle—the human form is at one with the cylinder of the coffeepot and the rectangles of the door panels. "There are two things in the painter: the eye and the mind. Each of them should aid the other," wrote Cézanne.

Cézanne was also a searching colorist, whose hues do not attempt to duplicate surface reality but seek to amplify structure. To his contemporaries the patches of color that he used to model form (perhaps "carve" is the better word) may have seemed puzzling. Yet, throughout his painting, color applied in a multitude of small, calculated areas is a unifying and form-creating element, in perfect harmony with the empirical nature of the painter's vision. Cézanne's probing eye saw all form like this, whether a mountainlike woman or the mountain itself.

Cézanne's analysis of structure is especially evident in his still lifes [p. 255], which are revolutionary in their departure from previous examples of the

type. In them there is little attempt at verisimilitude in the usual sense. Instead, Cézanne relentlessly examined the structure, texture, and colors of bottles, fruits (he used waxed fruits because real ones spoiled as he painted, studied, and then repainted them), and tablecloths, often the most alive element in his still lifes. Traditional conventions of spatial representation, perspective, and color have been abandoned and the still life has become a visual analysis translated into paint. To Cézanne it really did not matter whether he was painting an apple or a man—the search for the underlying structure of form and color was the same.

The same sort of intense intellectual analysis of form and exploration of basic structure characterized Cézanne's contemporary Georges Seurat (1859–1891). Twenty years younger than Cézanne, Seurat began his tragically short career with study at the Ecole des Beaux-Arts in Paris, where he worked with Lehmann, a former pupil of Ingres. Strongly influenced by the Impressionists and Delacroix, Seurat was also intensely interested in theories of vision and color, which he knew from several books, including Chevreul's well-known work on the theory of color, first published in 1839. Out of his study and experience Seurat devised a system of painting called pointillism or divisionism, in which dots of pure primary colors set side by side were supposed to optically mix in the viewer's eye. This scientifically erroneous theory, which was intended to improve upon the less scientific use of color by the Impressionists, underlies but does not dominate much of Seurat's landscape and figure work.

The pointillist method is evident in Seurat's masterpiece *A Sunday Afternoon on the Island of La Grande Jatte* of 1884–86 [p. 256], in which he depicted the citizens of Paris at their ease on a summer day. Here thousands of tiny dots form areas of pattern and interpose a colored cloud between the viewer and the objects represented. The color is a complement to the highly rigorous structure of Seurat's carefully planned composition, which has a stability and permanence lacking in the work of the Impressionists but found in many of Cézanne's paintings. Each of the figures and trees in Seurat's painting seems forever frozen in a composition of perfect stasis. The interrelated, carefully balanced horizontals, verticals, and diagonals of the shapes, which have been flattened by the use of color and

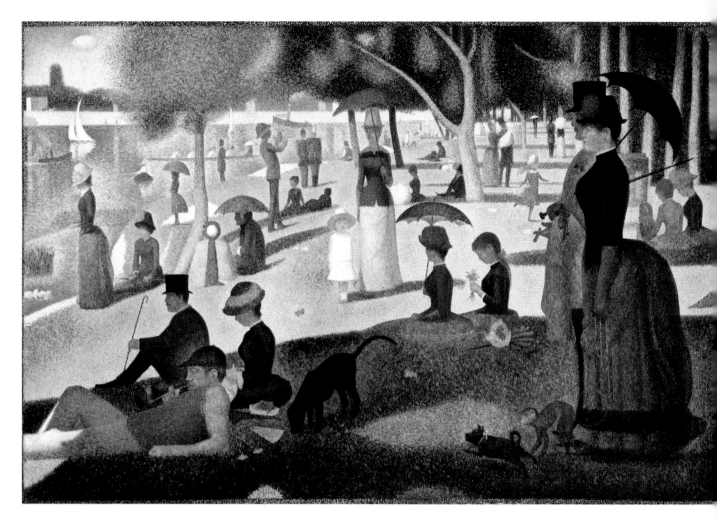

GEORGES SEURAT, A SUNDAY AFTERNOON ON THE ISLAND OF LA GRANDE JATTE, 1884–86. *This is one of only seven large pictures executed by Seurat during his short life. He said of modern life that he wanted to decipher it with the feeling of the frieze of the Parthenon, and some of the classical quality of that sculpture is embodied in Seurat's portrayals of the life around him.*

sharp outline, are turned into patterns set against the luminous grass and shimmering water of the park.

Seurat's almost exact contemporary was Vincent van Gogh (1853–1890), whose tragic and tempestuous life and lack of recognition during his own lifetime have now become the stuff of legend. The son of a Dutch pastor, van Gogh was a schoolteacher in England and a missionary to the desperately poor coal miners of Belgium before he taught himself to paint. In many ways, including the fact that he served no apprenticeship, sold no paintings,

and labored in almost total isolation, poverty, and obscurity, van Gogh is the prototype of the popular idea of the modern artist who sees art as both a calling and a catharsis, and not as a profession, as it still was considered by many artists in the second half of the nineteenth century. It is apparent from van Gogh's letters that for him art was a source of spiritual experience and inspiration. Aside from his Dutch heritage, he was especially influenced by Degas, Seurat, Henri de Toulouse-Lautrec (1864–1901), and Paul Gauguin. But although he partially built his style on these artists, he evolved an idiom expressive of his own passionate, open mind and heart. Trusting, innocent, and sometimes naively credulous, van Gogh was also a highly sophisticated artist with great formal skill.

Certainly the greatest period of van Gogh's short but highly productive career came at the end of his life, when he moved to the south of France,

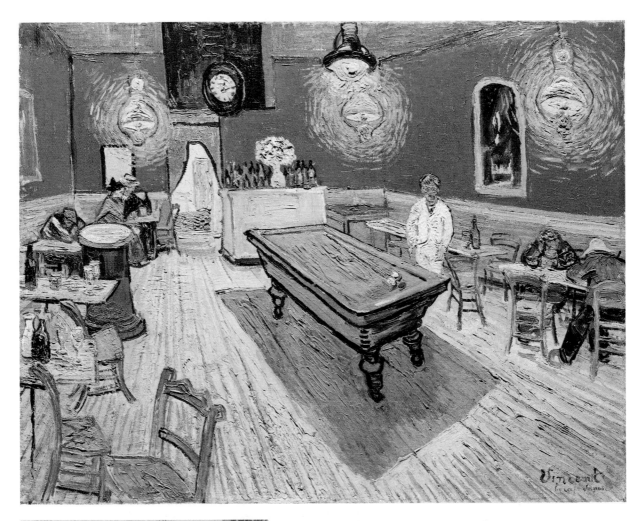

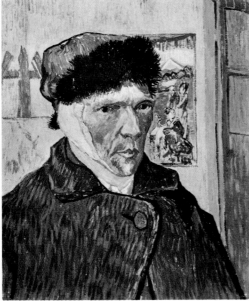

VINCENT VAN GOGH, <u>NIGHT CAFÉ</u>, 1888. *In 1888, van Gogh wrote that for three nights in a row he had sat up to paint—"I often think that the night is more alive and more richly colored than the day."*

VINCENT VAN GOGH, <u>SELF-PORTRAIT WITH BANDAGED HEAD</u>, 1889. *In December 1888, a month before this portrait was painted, van Gogh severed part of his ear during a fit of madness and gave it to a prostitute. During this period Gauguin was working with van Gogh in Arles.*

where, amidst bouts of serious mental illness, he produced a series of fervid paintings. His *Night Café* [p. 257] of 1888, which, in his words, was painted to express "the most terrible passion of humanity by means of red and green" and was done in "blood red," is a deeply disturbing picture. The abrupt, tipped-up view of the red room with its dazzling lights and hot colors is both strange and menacing, a vision of latent evil. Using much of what he had

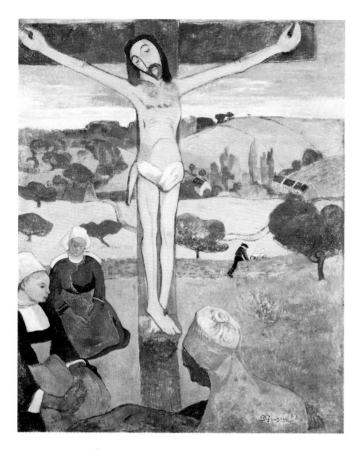

PAUL GAUGUIN, THE YELLOW CHRIST, 1889. *Modeled on a wooden crucifix Gauguin saw during his stay in Brittany, this painting depicts a group of Breton peasant women mourning a yellowish Christ crucified in a landscape populated by flat orange trees and ribbonlike streams. The conscious breaking of representational and historical conventions was part of Gauguin's attempt to return to a simpler, more primitive world of visual expression and meaning.*

learned about form and color from the Impressionists, but in a more expressive, personal way, van Gogh created summary forms with a heavily loaded brush. It is common to attempt connections between van Gogh's mental breakdowns and his style, but such simple linkages seem quite out of place with the *Night Café,* a picture of emotional turbulence conceived and executed with care and rationality.

The intensity of the *Night Café* is seen again in the great self-portrait of January 1889, with the artist's head still bandaged from the recent self-mutilation of his ear [p. 257]. In this painting, the forms have been carefully constructed and defined by hundreds of brushstrokes of pure color, which give

the coat, face, and hat a bursting energy, even though there are very few colors in this painting— the blue of the coat, the black of the fur hat, the flesh colors, and the background. Above all, it is the haunting face with its deeply troubled eyes that rivets one's attention and sympathy and serves as the focus.

During the last days of his life, van Gogh painted a series of landscapes about which he wrote, "They are vast stretches of corn under troubled skies, and I did not need to go out of my way to try to express sadness and the extreme of loneliness." Yet these canvases [pp. 234–35] are filled with joy and optimism: brilliant fields of crops waving in the wind, roads snaking through the corn, and a blazing noonday sky. They are affirmations of the renewing, triumphant power of nature. About these last landscapes he said, "I almost think that these canvases will tell you what I cannot say in words, the health and fortifying power that I see in the country."

Paul Gauguin (1848–1903), van Gogh's sometime friend and idol, was born during the 1848 revolution. He was a stockbroker with five children when, at thirty-five, he turned to art. He first exhibited with the Impressionists, but later denounced their style as superficial and affected. Like van Gogh, he was largely self-taught, but he had a much more pessimistic and cynical view of modern civilization. In 1885 Gauguin abandoned his family, going first to paint in the rustic villages of Brittany and then, in 1891, to Tahiti. His restless pursuit of paradise took him back and forth from Brittany to Tahiti and finally to the Marquesas Islands, where he died. Although he took little from the art of his places of refuge, Gauguin was deeply interested in medieval, Japanese, and other non-Western, and presumably less decadent, arts. Like van Gogh, he lived in poverty and isolation and painted with little commercial success or acclaim.

Gauguin, like van Gogh and Cézanne, moved painting further away from its traditional representational foundations. He rejected the naturalistic conventions that had been part of Western painting since the Renaissance, and substituted a simplification of form and color aimed at creating a newer and, according to him, purer and more personal vision of the world. Even subjects such as the Crucifixion [p. 258], which had become standardized

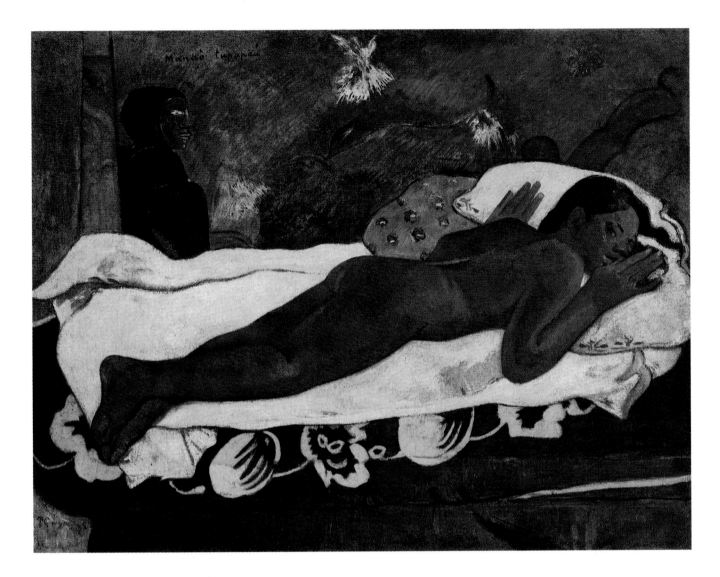

PAUL GAUGUIN, SPIRIT OF THE DEAD WATCHING, 1892.
Although Gauguin's exotic location, flat forms, and colors were new, the recumbent nude had been a prominent motif in Western painting since Titian's Venus of Urbino.

over centuries of representation, were rethought by Gauguin.

Large fields of flat color—often florid and idiosyncratic pinks, greens, and yellows—describing simplified, abstract forms are characteristic of many of Gauguin's paintings. Both shape and color make the image more immediate and more intense. Es-

pecially compelling are his mystical portraits of the Tahitians [p. 259], who were already threatened by the modern world. These fascinating paintings are the work of a sophisticated artist striving for, and almost achieving, a sort of neo-primitivism, which includes personal symbolism and exotic motifs and colors. Gauguin, a visionary and a rebel, whose interests centered on an internal rather than an external reality, was particularly important to the next generation of artists—especially the haunting visions of Edvard Munch, Gustav Klimt, and Egon Schiele.

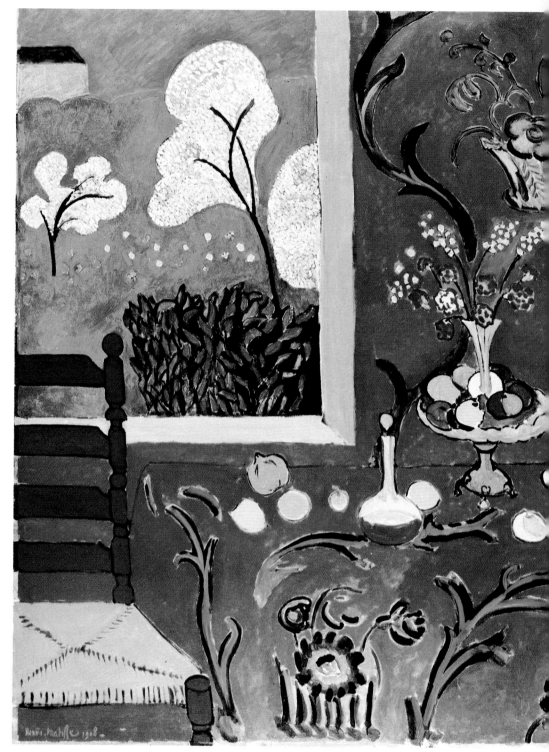

HENRI MATISSE, RED ROOM, 1908–9. *As much a portrait of the color red as it is the portrayal of a room, this painting fulfills Matisse's stated ambition: "What I want is an art of equilibrium, of purity and tranquility, free from unsettling or disturbing subjects, so that all those who work with their brains, and this includes businessmen as well as artists and writers, will look on it as something soothing, a kind of cerebral sedative as relaxing in its way as a comfortable armchair."*

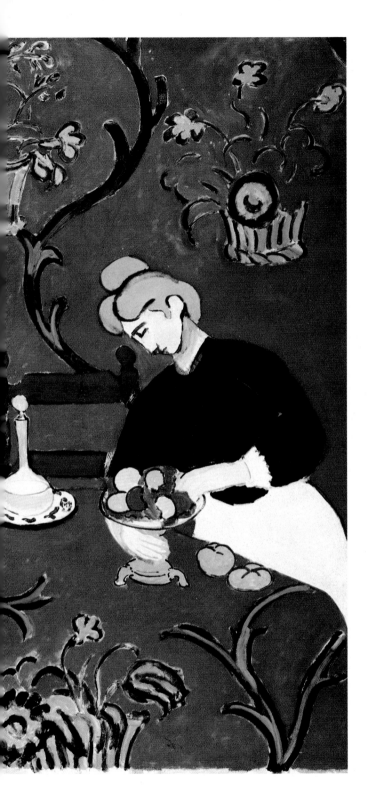

[14]

A BREAK WITH THE PAST: THE ART OF THE EARLY TWENTIETH CENTURY

In 1886, the eighth and last Impressionist exhibition was held in Paris. While many of the original Impressionists had taken their art in different directions, a new generation of artists was emerging. The young Pablo Picasso was growing up in Barcelona, Henri Matisse was a student in Paris, and Georges Braque had celebrated his fourth birthday in Le Havre. They were among the artists destined to make Western art radically depart from the past during the first years of the twentieth century. As they grew up, Europe and America were undergoing vast changes.

In 1889, the Austrian crown prince Rudolf purportedly committed suicide, Adolf Hitler was born, and Benjamin Harrison was inaugurated as the twenty-third president of the United States. The following year van Gogh died, and in 1891 Gauguin settled in Tahiti. The Impressionist painter Gustave Caillebotte's important collection of Impressionist works was rejected by the Musée Luxembourg in Paris in 1894 (though it became part of the national French museums in 1897); 1894 also saw Monet complete his series of the Rouen Cathedral viewed in different light conditions, and Claude Debussy

compose *Prelude to the Afternoon of a Faun;* in 1896 the Olympic games were revived in Athens. There was a heightened awareness that humanity was entering a new and different era. By 1914, when World War I cut its great swath across history, life had been transformed by science and technology.

Telephones and motorcars were in their infancy; the phonograph, the motion picture camera, the radio, and rocket propulsion had been invented. In 1903 Wilbur and Orville Wright successfully flew their airplane; two years later, Albert Einstein formulated his Special Theory of Relativity, and Sigmund Freud published his theories on human sexuality. By 1913, Henry Ford had sent the first motorcars off his assembly line, and the skylines of Chicago and New York had been transformed by the earliest skyscrapers.

The early years of the twentieth century also brought the first challenge to the primacy of the human figure in art since the collapse of the Roman empire more than a thousand years before. The motivations for departing from the figure were not religious, as they had been in the past, but philosophical and aesthetic. In searching for the meaning and purpose of art, artists steadily stripped art of its traditional subjects, finding form, color, and shape—at times divorced from any meaning except themselves—sufficient justification for art. For other artists, machines, motion, speed, and flight supplanted humanity as worthwhile subjects for representation.

The human figure and the human condition did remain vital concerns for many artists, but in the waning years of the nineteenth century and the opening years of the twentieth, artists responded with diverse and often pessimistic interpretations. In Vienna and Berlin, where such artists as Gustav Klimt, Egon Schiele, and Edvard Munch had gathered, life was viewed with anxiety, pessimism, and despair. Death seemed to obsess these artists. Their paintings are filled with images of anguished people, tortured from without and within. For these painters, the city was the breeder of sin and the corrupter of the human spirit.

Vienna in particular suffered from a failure of nerve. Known for its elegance and aristocracy, Vienna had more suicides than most other cities at that time, and despair was brought on not by material but by spiritual crisis. "We live in a slow, rotten

GUSTAV KLIMT, JUDITH, 1901. *Klimt transformed a local Viennese beauty into Judith, a symbol of death mingled with eroticism. By juxtaposing the almost portraitlike appearance of his subject with the purely decorative elements of gold design, Klimt was challenging the traditional separation between decorative and fine arts.*

time," Crown Prince Rudolf had declared the year before his death. The self-destructive urge upon which Rudolf seems to have acted was commented on by the newspapers. "Nervousness is the modern sickness," stated the Vienna *Tageblatt* in response to his death in 1889. The event prompted Sigmund Freud to use the word *subconscious* for the first time in print as he examined the psychological implications of suicide. Influenced by Freud's development of psychoanalysis, Viennese artists began to explore the deeper recesses of the psyche.

In 1897, Gustav Klimt (1862–1918) became the president of the Vienna Secession, an organization of younger artists who had broken away from the established Academy and were dedicated to elevating the level of Austrian art to that of other leading artistic communities. Like Gauguin and some Impressionists, such as Cassatt, Klimt was inspired by the potential for design and composition when the three-dimensionality of a figure is denied and it becomes part of a flat, well-wrought arrangement composed on the picture plane. Klimt's *Judith* of 1901 [p. 262] is made more erotic and exotic by the patterns and colors surrounding the protagonist's form, which is brought close to the picture surface and cropped. *Judith* represents a subject made popular in the Renaissance, but Klimt's forms had their origins in the art of the Middle Ages. Klimt, whose travels to Italy took him to Ravenna, was particularly inspired by the ninth-century mosaics there. These mosaics, which reduced the human form to flat bits of color, offered Klimt, with his anti-naturalistic vision, the perfect device to free art from the constraints of emulating reality. For him the adoption of flat, decorative pattern was a dramatic move in the direction of modernism, developed from pictorial models that had been ignored by artists from the Renaissance to the mid-nineteenth century.

Klimt's powerful forms, his symbolic content, and his sexual themes deeply affected Egon Schiele (1890–1918), who met Klimt in 1907. Schiele's brief career (he died in the influenza epidemic of 1918, which also killed Klimt) involved a personal and raw look at humanity, seemingly diminished and tortured by its sexuality. Schiele exposed his own private world, fraught with psychic tension; drawings such as *Standing Female Nude with Crossed Arms* of 1910 [p. 263] portray humanity as vulnerable and haunted. This emaciated figure, whose skin

EGON SCHIELE, STANDING FEMALE NUDE WITH CROSSED ARMS, 1910. *Schiele's loneliness found artistic expression in drawings of provocatively nude women. Often explicitly erotic, these drawings earned him three weeks in prison in 1912 for obscenity.*

is raw and red where it is most often exposed to the elements, emanates anxiety. Ignoring the conventions for portraying external reality, both Klimt and Schiele probed the subconscious reality of the human mind, mixing elegance and sophistication with highly charged, intimate, and often disturbing subject matter. While Klimt's works sometimes explored the larger cycles of love, death, and regen-

eration, Schiele's images portray human beings as alone, vulnerable, and strangely tormented.

That sense of isolation and suffering also underlies the work of their older contemporary, the Norwegian artist Edvard Munch (1863–1944), who responded to personal tragedies by creating images of loneliness and despair. His pictures have become visual paradigms for humanity in crisis. In France from 1889 to 1892, Munch absorbed the style and vision of the French Impressionists, as well as that of van Gogh and Gauguin; but Munch's own troubled view of the world, affected in part by the death of both his mother and his sister from tuberculosis, gained new maturity and power in Berlin, where he exhibited his work in 1892. It was in Berlin that he embarked on his series of images devoted to stages of life. Love, suffering, death, jealousy, and isolation were facets through which Munch viewed existence, and his powerful treatment of such themes as adolescence in the painting *Puberty* of 1894 [p. 264] shares with Gauguin the bold, flat, and simplified use of forms and color, to which he added a deeply brooding, melancholy spirit. Munch's *Cry* [p. 265] of 1893 is an almost existential portrayal of isolation. Hands covering ears, his figure screams in anguish. The approaching people, the bridge, and the blood-streaked sky, echoing the person's cry, are the visualization of a nightmare. Danger, fear, alienation, and despair are delineated as clearly here as space was mapped out in a Florentine Renaissance painting, but the means are far less objective than the Renaissance artists' mathematical perspective. Munch's artistic device is his own haunted imagination. His daringly personal paintings of the dark and vulnerable side of humanity inspired young local artists to split away from the existing society and form the Berliner Secession, which became a point of departure for the later generation of artists soon to be known as the German Expressionists.

While Munch, Schiele, and Klimt were working in Vienna and Berlin, artists in Paris were producing equally revolutionary, if less pessimistic, visions. Experimentation and innovation in art, already evident in the work of the Impressionists and Post-Impressionists, continued with Matisse, Derain, Picasso, and Braque. Building on the works of van Gogh and Gauguin, these artists saw new potential for color, form, shape, and subject, which separated

EDVARD MUNCH, PUBERTY, C. 1894. *Here Munch interprets adolescence as the beginning of loneliness, vulnerability, and anxiousness.*

art from reality and emphasized the beauty inherent in abstract ideas. Even those artists who retained the figure often departed from conventional means of portrayal.

In 1905 an exhibition took place in Paris that is now regarded as one of the inaugurating moments of the art of the twentieth century. At the Salon d'Automne (Autumn Salon), a loosely affiliated group of young painters including Matisse, Derain, and Vlaminck displayed paintings of such intense colors, vivid form, and nonillusionistic imagery that they quickly came to be called Les Fauves (the Wild Beasts).

Henri Matisse (1869-1954), the most gifted of these painters, had studied briefly with the visionary

EDVARD MUNCH, THE CRY, 1893. *Munch, who spent several months in a sanatorium being treated for depression, once said, "One cannot forever paint women knitting and men reading....I want to represent people who breathe, feel, love and suffer."*

painter Gustave Moreau (1826–1898). But more important to Matisse in 1905 were the paintings of van Gogh and Gauguin, whose highly keyed color and flat forms guided his development of a different kind of painting. His *Portrait with Green Stripe* [p. 266] was roundly criticized in 1905, but Matisse, asserting his independence from representation in making art, claimed, "Above all, I did not create a woman, I made a painting." Here the woman's face becomes an excuse to present a strong array of hues, all the more startling because they convinc-

ingly describe a human form, but not as it would be experienced in daily life. The shadow modeling her form is green, her hair is black and purple, and her face is described from a broad range of hues. For Matisse, color and shape had their own life in art.

In *The Red Room* [pp. 260–61] of 1908–9, Matisse's belief that "no point is more important than any other" in a picture is clearly evident. This idea that emerged with the Impressionists' avoidance of a central focus in their pictures led Matisse to make the background and the space around objects and

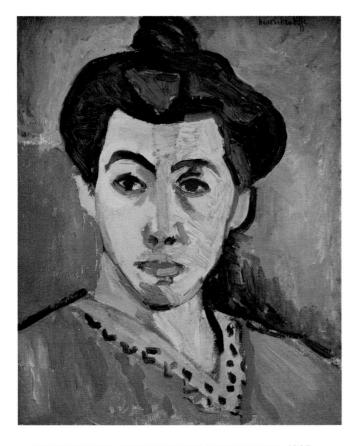

HENRI MATISSE, PORTRAIT WITH GREEN STRIPE, 1905.
*This portrait is part of a series of paintings Matisse produced in
1905 in which colors, particularly reds and greens, were
employed in a deliberate departure from the natural palette of
the Impressionists.*

figure as important as the objects themselves. The
pattern of the tablecloth and wall is equal to and
nearly overpowers the woman placing a tray of fruit
on the table. The chair (derived from van Gogh) and
window define spaces that the table and wall deny.
And yet this deliberately ambiguous world exists
naturally and beautifully within the logic of Ma-
tisse's canvas.

Matisse, whom Picasso once described as hav-
ing "sun in his belly," spent his lifetime discovering
the pleasures of glorious shapes, uplifting colors,
and appealing subjects. His life-affirming art can be
detected in his titles—*The Joy of Life, The Dance*—
drawn from the comfortable, sustaining existence
of middle-class life. Matisse transcended any partic-

ular movement and period and produced a body of
work in which the sun perpetually shone on the
human spirit. For him, art enriched and ennobled
life. His sophisticated achievements with line
(which often pay homage to Ingres), color, and form
did much to lay the groundwork for future artists,
who learned from Matisse how to develop the po-
tential dialogue among picture plane, flat color, and
shape.

Matisse's compatriot André Derain (1880–
1954) was attracted to the tenets of Fauvism while
he was a student in Paris between 1899 and 1904.
His friendship with Matisse taught him to appreciate
color, and his exposure to African art, which he
avidly collected, inspired him to search for equally
vibrant forms in his own art. In 1905 the avant-garde
Paris art dealer Ambrose Vollard gave Derain a con-
tract to travel to London and execute a series of
views of the Thames River in the hope that Derain's
work would repeat Monet's recent success with a
Thames River series. Derain's results, which include
Effects of Sunlight on Water of 1905 [p. 267] reveal
how well he accomplished his goals and reflect the
sources from which Fauve ideas were derived.
Echoes of van Gogh and Seurat can be detected in
Derain's dots of intense colors and bold shapes. His
strong design breaks down the relationship between
foreground and background, giving equal emphasis
to all parts of his portrayal of sunlight and clouds
above the banks of the Thames. This quest for un-
focused images, begun by the Impressionists and
continued by the Fauves, was to become an impor-
tant aesthetic idea in much subsequent modern
painting.

Perhaps the most revolutionary modernist,
Pablo Ruiz y Picasso (1881–1973) began his career
in his native Barcelona, where at a very young age
he already showed the artistic virtuosity that was to
be a hallmark of his long and productive career.
Influenced early by the Impressionists and Munch,
in 1900 he made his first trip to Paris. Here he set-
tled in 1904 and began to work in a wide variety of
styles and interpretations, something he continued
to do for the rest of his long life.

One of the strongest influences on the young
Picasso came from Cézanne, many of whose works
were exhibited in a retrospective held in Paris in
1906 after Cézanne's death. Cézanne's search for a
new structure for painting was reflected in his use

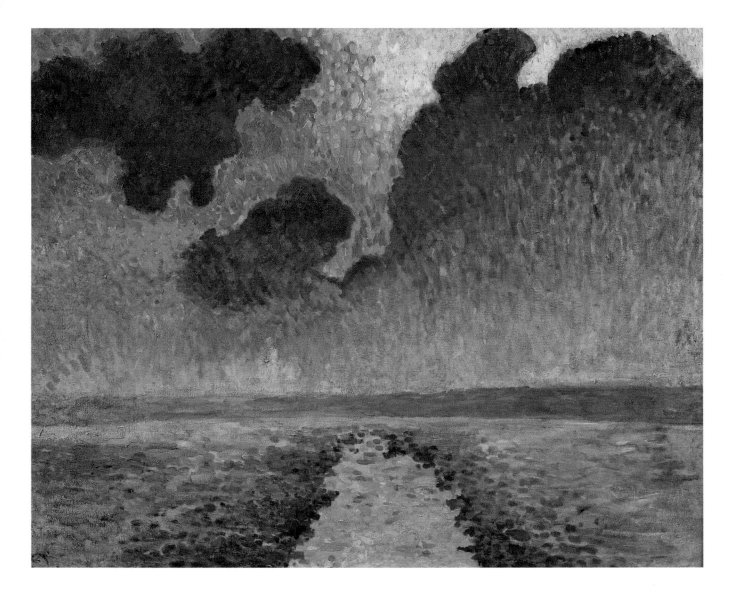

ANDRÉ DERAIN, EFFECTS OF SUNLIGHT ON WATER, 1905. *Derain followed in Monet's footsteps by painting views of the Thames, but his formal inspiration came from van Gogh and the Post-Impressionists. "Van Gogh was the god of my adolescence," Derain later declared.*

of geometric forms. Picasso was also empirical and sought, through his changing styles, nothing less than a new pictorial vision of the world.

The beginning of this search is seen in his self-portrait of 1907 [p. 268], in which Picasso reinvented his own face. Simplified, reduced to its barest essentials, it is constructed with carefully analyzed planes of color and bounded by thick black lines. Yet, as in all of Picasso's major paintings, form and color are ultimately the catalysts of a profound expression of the human spirit. It is, in fact, his unceasing concern with the exploration of humanity that makes Picasso one of the great artists of the Western tradition.

Picasso took the rearrangement of form yet an-

other step further in *Les Demoiselles d'Avignon* [p. 269] (or *The Brothel of Avignon*, as he preferred to call it) of 1907. For this depiction of a brothel, located in Picasso's old neighborhood on the Carrera d'Avinyó (Avignon Street) in Barcelona, he was inspired by the pre-Roman Iberian stone heads of his native Spain and by the African masks that were just then being collected in Paris; these highly schematic representations of the face, with their large

staring eyes and expressionistic features, influenced not only Picasso's *Self-Portrait* of 1907 but also the heads of the two flanking figures and the face of the squatting woman in *Les Demoiselles d'Avignon*.

In this painting Picasso took a subject often treated in the nineteenth century and divested it of all its former associations of time, place, and character, for which he substituted his own angular, schematic, and brutal conception of the world. Figure and space have been exploded and rearranged, and traditional ideas of beauty, form, and atmosphere have been replaced by a rigorous intellectual structure. With this work and its vast influence, traditional conventions of painting were shattered, and the unbroken chain that had led from the Renaissance to the late nineteenth century severed. Under Picasso's influence, painters found it increasingly impossible to return to the concept of painting as it had existed before 1907.

During the next several years Picasso himself moved with amazing speed along some of the directions suggested in *Les Demoiselles d'Avignon*. The *Girl with Mandolin (Portrait of Fanny Teller)* of 1910 [p. 270] is composed of various planes that define, in an elemental form, a woman strumming a mandolin. The large planes of *Les Demoiselles d'Avignon* have been reduced in size and made more numerous, but, as in that seminal picture, the traditional conventions of perspective, space, and the construction of the figure have been consciously abandoned. The palette of *Girl with Mandolin* has become much more monochromatic, with subtle tones of brown, gray, and white.

The concepts of *Les Demoiselles d'Avignon* and the *Girl with Mandolin* were ridiculed by the critics, and the term *Cubism*, derived from the cube-like arrangement of small planes, was a derisive one. Yet, within just a few years Cubism was to become one of the dominating forces in modern art.

In 1905, the same year the Fauves were exhibiting in Paris, a group of artists in Germany—including Ernst Ludwig Kirchner (1880–1938), Paula Modersohn-Becker (1876–1907), and Erich Heckel (1883–1970)—formed a group called Die Brücke (the Bridge) in Dresden. Kirchner, who helped establish their goals, wrote, "He who renders his inner convictions as he knows he must, and does so with spontaneity and sincerity, is one of us." For the

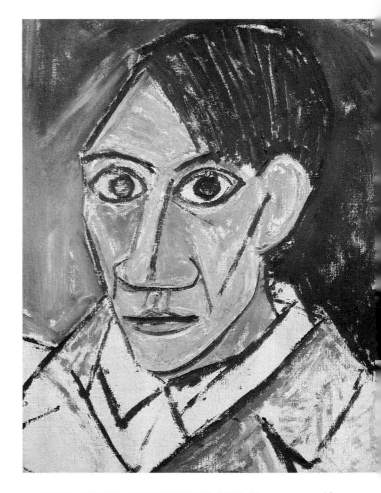

PABLO PICASSO, SELF-PORTRAIT, 1907. *Picasso once said, "Whether he likes it or not, man is the instrument of nature; it forces on him its character and appearance."*

members of Die Brücke, who were the early German Expressionists, the human condition conveyed through evocative and emotional themes was the artist's principal subject. Humanity was viewed with much the same anxiety and pessimism with which Munch, Klimt, and Schiele had seen it. Like the Cubists, the Expressionists shattered and fragmented the figure, but for emotional and not purely intellectual reasons. Society's critics and watchdogs, the Expressionists saw danger to the human spirit in the corruption of contemporary urban life.

Kirchner's *Berlin Street Scene* of 1913 [p. 270] portrays the jostling crowd on a Berlin street as a kind of demimonde of prostitutes and pimps. Kirchner deployed jagged edges and angular forms

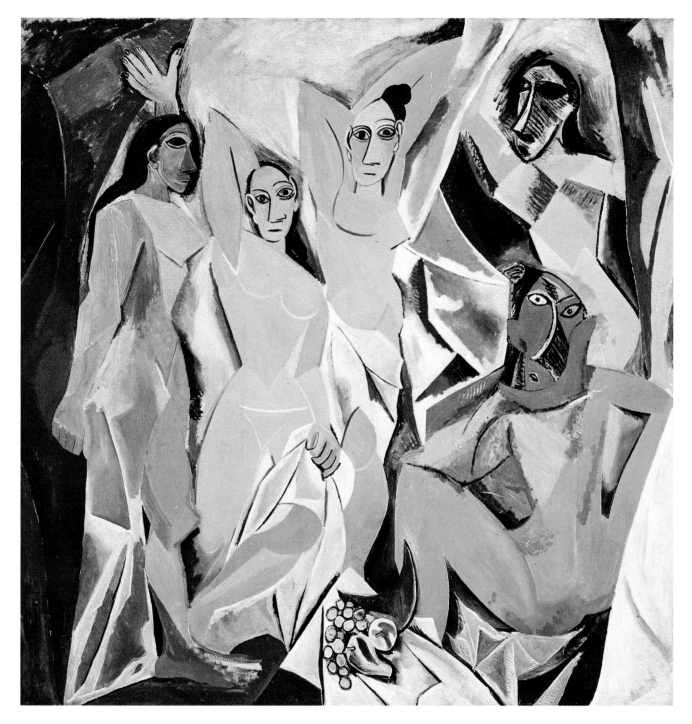

PABLO PICASSO, <u>LES DEMOISELLES D'AVIGNON</u>, 1907.
One of the most influential paintings of the twentieth century,
Les Demoiselles d'Avignon *was already legendary by the early*
twenties. It has been called the first cubist painting.

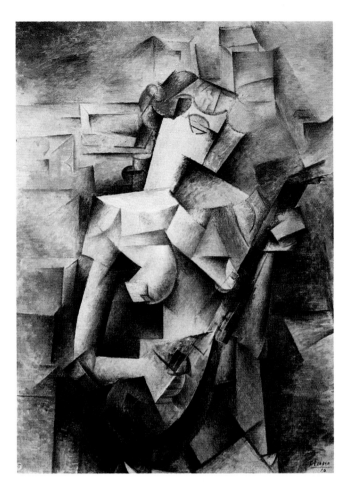

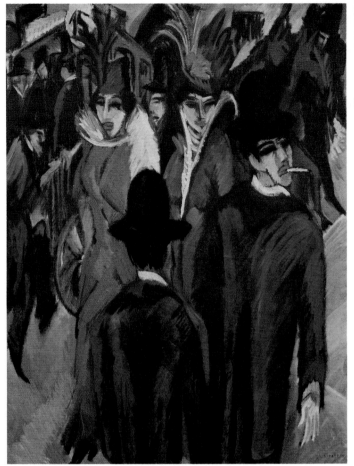

PICASSO, GIRL WITH MANDOLIN, 1910. *Although the forms in this painting have been reduced to geometric shapes, the woman and her mandolin are still recognizable. Picasso's love for the figure seldom allowed him to disintegrate it by complete abstraction.*

ERNEST LUDWIG KIRCHNER, BERLIN STREET SCENE, 1913. *Described in the late nineteenth century as "the German Chicago," Berlin was then the newest and most modern city in Europe. In the early twentieth century, Berlin was in her heyday —home to Marlene Dietrich, Josephine Baker, Albert Einstein, the Bauhaus school of designers, the German Expressionists, and writers such as W. H. Auden, Christopher Isherwood, and Vladimir Nabokov. Besides having the most uninhibited nightclubs in Europe, Berlin had grandiose theaters and three opera houses running simultaneously.*

to define a grotesque exterior for damaged spirits. To Kirchner these forms more spontaneously and sincerely portrayed reality than any simple attempt at surface verisimilitude. The connection between Kirchner's painting and the ungainly, diminished humanity of Gislebertus's *Last Judgment* tympanum is not accidental.

In 1906 another gifted young German painter joined Die Brücke: Emil Nolde (1867–1956), who took his name from his city of birth, Nolde. He studied in Karlsruhe, Munich, and Paris, where he worked as an Impressionist until roughly 1904. In Paris he encountered African art and was particularly impressed with the African mask, stating that "its absolute primitiveness, its intense, often gro-

tesque expression of strength and life in the very simplest form" inspired him. He soon depicted masks himself, as in *Masks* of 1911 [p. 271], which portrays a series of grotesque masks hanging by strings. Concentrating on forms intended to alter reality, Nolde gave the masks evil and sinister power; they became animate, ghoulish echoes of the human soul. With their garish colors and crude forms, Nolde's masks share with the Fauves a devotion to the picture surface, but in their overt pes-

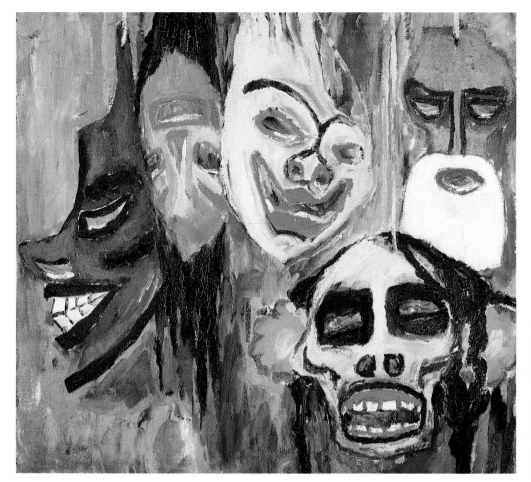

EMIL NOLDE, MASKS, 1911.
Nolde's belief in cultural renewal through primitivism inspired his interest in African masks and prompted an extended trip to the South Seas in 1913 and 1914. Although an early member of the Nazi party, Nolde was by 1937 forbidden to paint his "degenerate" work, secretly producing 1,300 watercolors during the war years.

simism, Nolde's images belong to the world of Klimt and the German Expressionists.

It was in this charged artistic climate of Europe that artists moved toward the notion of pure abstraction, imagery without reference to any visible reality. While the Fauves and members of Die Brücke had as their focus the human figure and as their subject the human condition, another group, more loosely affiliated, was Der Blaue Reiter (the Blue Rider), active in Munich between roughly 1912 and 1916. The group's most important artist was Wassily Kandinsky (1866–1944). Born in Moscow, he studied law, but abandoned it for art. Kandinsky moved to Munich in 1896, gaining access to the advanced works of the Post-Impressionists, Gauguin and van Gogh in particular. Also impressed by the reductive simplicity and materials of folk art, Kandinsky began to experiment with technique as well as with subject matter.

Kandinsky's turn to nonrepresentational im-agery was spiritual in orientation and was summed up in his influential book *On the Spiritual in Art*, published in 1912. He argued that in order to speak directly to the soul and avoid materialistic distractions, it was preferable to use an art based solely on the language of color. Free from references to a specific reality, color could become like music, beautiful for its interrelationships of tones and intensities. Throughout his life, Kandinsky was stimulated by music, particularly by that of the Austrian composer Arnold Schoenberg (1874–1951).

Kandinsky's series of forty or more improvisations done between 1911 and 1913 consists of prophetic abstract images. They were followed by more fully evolved compositions [p. 272]. To Kandinsky these works expressed pure feeling removed from any physical context. In their spontaneity and in their concern with emotional expression, his paintings anticipate the American Abstract Expressionists.

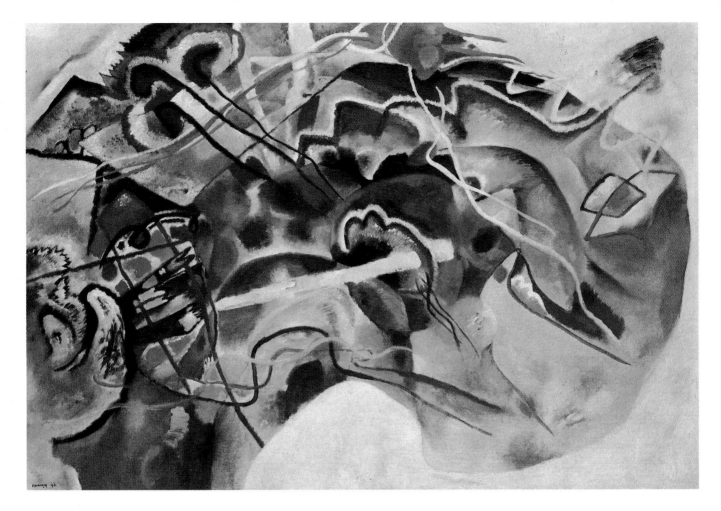

**WASSILY KANDINSKY, <u>COMPOSITION VII (NO. 2)</u>,
1913.** *"To send light into the darkness of men's hearts—such is
the obligation of the artist," said the composer Robert
Schumann. Kandinsky used this quotation in his essay
"Concerning the Spiritual in Art," in which he articulates the
aims of his paintings.*

To Kandinsky, the abstract forms and the color
relationships he created liberated art from the re-
strictions of representation. Like a number of others
developing at roughly the same time, his was a pos-
itive artistic ideology. In Milan, the Italian poet-
editor Filippo Tommaso Marinetti (1876–1944)
developed the Futurist manifesto. Declaring that
nostalgia for the past amounted to a failure of nerve,
the Futurists looked forward to the modern era with
confidence and optimism. They felt art should re-
flect the improved and changing social conditions
offered by technology, which promised new poten-
tials for speed and harnessed energy. Umberto Boc-
cioni (1882–1916) and Giacomo Balla (1871–1958)

were among the most important artists who re-
sponded to the Futurist manifestoes.

Boccioni, a painter and a sculptor, was partic-
ularly inspired by Marinetti's *Manifesto of Futurist
Painters*, published in 1909, which declared that "a
roaring motorcar, which looks as though it runs on
shrapnel, is more beautiful than the *Victory of
Samothrace.*" Boccioni searched for forms that
would reflect the positive potential of man and ma-
chine. He found new forms to adapt to his vision in
the work of the Cubists, whose fragmentation of the
components that make up a figure or object charged
each facet with energy and thrust. Boccioni's most
celebrated sculpture, *Unique Forms of Continuity in
Space* of 1913 [p. 273], is his interpretation of the
Victory of Samothrace, fragmented into Cubist forms
and disintegrating as well as coalescing into the
parts of a human form in motion. Motion is both the
subject and the form: each of the many planes that
shape this striding figure is aerodynamic, describ-

ing the interaction between atmosphere and form.

In contrast, Balla's painting *Dog on a Leash* [p. 273] is one of the most amusing portrayals of movement. Adopting an unconventional viewpoint first introduced by the Impressionists, Balla registered each movement of the dachshund's legs, feet, and head, as well as his owner's feet. In doing so, Balla made a visual portrayal of motion that is both convincing and whimsical. Balla neatly summed up in painting what the English photographer Eadweard Muybridge's (1830–1904) multiple exposed photographs showed: the progressive placement of limbs when a body is in motion.

The Futurists' utopian vision of a humanity invigorated by technological progress made motion one of their chief subjects. They inspired a number of followers, but none was as important as Marcel Duchamp (1887–1968), whose influence on modern art has been as long-lived as Picasso's. Born in the Normandy region of France, Duchamp moved to Paris in 1904, where Picasso, Matisse, and Braque were transforming the language of art. He quickly took in the lessons of Cézanne, the Symbolists (such as Odilon Redon [1840–1916]), the Cubists, and the Futurists. His most famous essay on the human figure in motion is *Nude Descending a Staircase No. 2* of 1912 [p. 274], which shows both a Cubist and Futurist understanding of form. As in the work of the Futurists, Duchamp's *Nude* has been made to appear like a machine. He has reduced the human figure to elements of form—the planes,

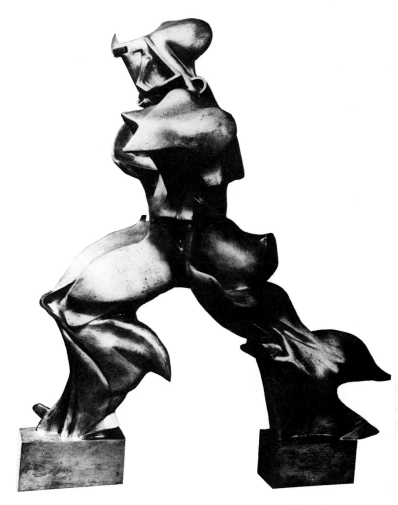

UMBERTO BOCCIONI, UNIQUE FORMS OF CONTINUITY IN SPACE, 1913. *Boccioni began exploring dynamic movement in sculpture in 1912, an experiment that culminated in this masterpiece of visualized action. Boccioni, who often spoke of "physical transcendentalism," shows here a figure that seems to lift itself from the material into the spiritual.*

GIACOMO BALLA, DOG ON A LEASH, 1912. *While visiting Tuscany, Balla painted his first futurist work, a dachshund belonging to his pupil Countess Narazzini. Using photographs taken from a very low viewpoint, he reduced the dog and its mistress to their propulsion, creating an image both humorous and accurate in its representation of movement.*

cones, and linear intersections that are necessary to understand the figure—on a purely intellectual, not emotional, level. Like the Futurists and Kandinsky, Duchamp crossed over to pure abstraction on a number of occasions, finding it the most satisfying means to express his ideas when not constrained to conventions such as the figure.

Between 1911 and 1914 a number of other artists forged their own interpretations of Cubism and Futurism. Perhaps the most intellectual of these was Piet Mondrian (1872–1944). Considered one of the greatest pioneers of abstract art, Mondrian was born in Amersfoort, Holland, the son of a schoolteacher. His early development followed the manner of Dutch painting, including van Gogh. Late in 1911, inspired by the works of the Fauves and the Cubists, Mondrian moved to Paris, where he remained until the outbreak of World War I. By 1913 he had surpassed the original Cubists in the direction their art had taken in "developing abstraction towards its ultimate goal." Using the figure or landscape as his point of departure, Mondrian in such works as *Composition VII* of 1913 [p. 275] stripped his images of subject both in title and in treatment. His search for higher, simpler, and more elemental truths led him at that time toward a subdued palette, in a composition that is made up of a tapestry of horizontal and vertical elements, punctuated here and there by curvilinear forms.

By 1913 European art had developed decisively new and modern directions. Fascinated by European modernism, a group of American artists arranged to bring examples of this art to New York. Arthur B. Davies (1862–1928), an avowed modernist, led the organization of the Armory Show of 1913. Staged in the Armory of the 69th Regiment of New York, it brought European art to the American side of the Atlantic. Leaning heavily toward French art (there were

MARCEL DUCHAMP, NUDE DESCENDING A STAIRCASE NO. 2, 1912. *"I completely gave up the naturalistic appearance of the nude, retaining only the abstract lines of some twenty different static positions in the successive descending movement,"* Duchamp noted about his painting. This simple idea had profound repercussions. After the display of Nude Descending a Staircase *in the Armory Show of 1913, where it was a sensation, Duchamp was, with Napoleon and Sarah Bernhardt, the best-known Frenchman of the day.*

PIET MONDRIAN, COMPOSITION VII, 1913. *Works like this* Composition *were part of Mondrian's lifelong search for a "universal pictorial language," which ultimately led to his classical abstractions of the 1920s and 1930s, with their interlocking grids of black rectangles and their primary colors of red, yellow, and blue.*

few German Expressionist or Austrian works, for example), the Armory Show included art from Ingres to Cézanne, as well as the more contemporary developments of Cubism and Fauvism. The exhibition introduced Americans to Matisse, Picasso, Brancusi, Rodin, Kandinsky, Kirchner, Redon, Gauguin, van Gogh, and other artists. Marcel Duchamp's *Nude Descending a Staircase No. 2* created a sensation. Crowds gathered around it daily; it was popularly described as an explosion in a shingle

factory, and the Cubist room was known as "the chamber of horrors." Yet, the exhibition gained many converts to European modernism. The Metropolitan Museum of Art in New York bought its first Cézanne painting from the exhibition, and 75,000 people are thought to have attended the month-long display. The show moved on to the Art Institute of Chicago, where nearly 200,000 people crowded in. The Armory Show was the first step in the internationalization of American art; Americans either championed the modernist tendencies or derided them, but no one ignored the exhibition's implications.

The years around the turn of the twentieth century were also a period of intense architectural reevaluation. Far-reaching developments, both in aesthetics and in technical aspects, occurred in America, where buildings and building types began to assume the international importance they still maintain.

New structural types such as the train shed and the office building, which were developed to accommodate the changing needs of the first half of the nineteenth century, had employed new materials and technologies in novel ways. For example, train shed construction, with its exposed iron arches spanning huge spaces covered by glass roofs, jettisoned as unnecessary and incongruous traditional ideas of architectural style and decoration. This new type of building was the art of the engineer, not the architect. The facade of the station hotel, though probably built with construction methods as modern as those used for the train shed, might be a hodgepodge of pseudo-Gothic or Renaissance styles, but the train shed itself would be starkly functional, without decoration, and not at all like any previous architecture.

This conflict between engineering and traditional architectural shape and decoration, inherent in the clash of the train shed and station hotel, was to preoccupy the finest architectural minds of the second half of the nineteenth century and the beginning of the twentieth. This was especially true in the United States, where, in cities such as Chicago, much new wealth and the need for many new buildings created a favorable climate for architectural development and innovation.

Devastated by the great fire of 1871, the booming city of Chicago was rapidly rebuilding at the end of the century. This midwestern giant was a relatively new city, free of older structures and traditions that could have acted as inhibiting forces on its architects. Moreover, Chicago was in a hurry to prove itself great, and it was intensely proud of its architects.

One of the most influential of these was Louis Henry Sullivan (1856–1924). Born in Boston, Sullivan studied in Paris, then moved to Chicago in 1873, where in 1879 he began working with the firm of Denkmar Adler, an accomplished architect and engineer.

One of Sullivan's most notable buildings, which illustrates well the conflict between the decoration and ornamentation of a building and its construction and function, is the Wainwright Building in Saint Louis of 1890–91 [p. 278]. An office building, it required a rational plan of many rooms (all of which could be modified by movable partitions to suit the needs of various clients), which was achieved by the use of a gridlike iron skeleton ten stories high. In the major cities of the United States land values had soared, making it necessary to build up rather than outward, a solution made possible by the invention of the elevator. These new, taller buildings were the first skyscrapers, and Sullivan was instrumental in charting their early construction and development.

However, the iron grids of Sullivan's skyscrapers were partially masked by the system of traditional decoration that the architect felt compelled to use. The Wainwright Building is, in fact, divided into a classical tripartite facade with a base; the building's shaft, which partly reveals the grid of its modern construction; and a large cornice under which runs an ornamental band of red terra-cotta, one of Sullivan's favorite materials. The facade of the Wainwright Building is thus really a sort of window dressing over what is a very austere, functional, and modern system of building.

Sullivan partially resolved this conflict between structure and decoration in the famous department store he built for the Schlesinger and Mayer Company, now the Carson Pirie Scott and Company store [p. 278], which was erected between 1899 and 1904 in several stages. This is a very large building, intelligently tied together and given focus by a corner tower, which contains the store's main entrance. Much light was needed for the display of merchan-

PABLO PICASSO. <u>CELESTINE</u>, 1903.

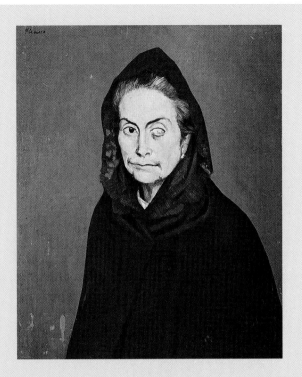

The career of Pablo Picasso, the most legendary artist of the twentieth century, spanned vast changes in his own work and in the world around him. When Picasso arrived in Paris at nineteen, he was a poor and unknown figure—his suffering reflected in the work of his "Blue Period." The sensitive and evocative figures of that time were followed by scenes of acrobats and clowns in his "Pink Period." From there Picasso moved toward his Cubist experiments, which fundamentally revolutionized art. The women in Picasso's life, his political ideas, and his obsession with the art of the past all nurtured his creative

energies. He transformed every material—clay, metal, paint, whatever was handy—into art. Picasso's prints, his ceramics, his sculpture, his drawings, his collages, as well as his paintings show his prodigious talent. "Art is a lie that tells the truth," he once said. A masterful manipulator of his own fame, Picasso indulged his eccentricities—keeping a goat in his house, for instance—and his passions, which helped sustain and build his myth. Yet that myth is centered in unquestionable artistic genius, which spawned the notion of modernism at the century's beginning and remained a unique affirmation of conservatism toward its end.

But the functionalism of the grid of the building is denied by its first two stories, which serve as a base for the structure's shaft. This lower part of the store is covered with lush cast-iron ornamentation designed under Sullivan's supervision. The profusion of twisting, interlaced tendrils, which seem to be growing around the building and wrapping around its main entrance, is Sullivan's admission that decoration and ornamentation, of either a historical or organic nature, was necessary to give a severe and functional structure relief and a certain benevolence.

Many of Sullivan's ideas were brought to fruition by a midwesterner destined to become one of this century's most innovative architects, Frank Lloyd Wright (1869–1959). Wright began his career as a temperamental young draftsman with the firm of Adler and Sullivan in Chicago. Much of his most brilliant early work centered on domestic architec-

LOUIS SULLIVAN, WAINWRIGHT BUILDING, SAINT LOUIS, 1890–91. *Designed in 1890 and finished one year later, the Wainwright Building represented all the latest technology of the day, including reinforced concrete footing and an all-metal framework.*

dise, and Sullivan provided this by designing a steel frame that allowed large areas of rectangular fenestration. The upper part of the building is uncompromisingly severe and geometric, but Sullivan gave the store a much more horizontal emphasis than is found in the Wainwright Building and several of his taller structures. Faced with smooth, white terracotta tile, the shaft of the Carson Pirie Scott building anticipated much of the functional architecture of the twentieth century and was a radical departure from the eclectic style of nineteenth-century commercial buildings. In its stark geometry and lack of historical or figurative association, it also heralded some of the major developments in modern painting and sculpture.

LOUIS SULLIVAN, CARSON PIRIE SCOTT AND COMPANY STORE, CHICAGO, 1899–1904. *The Carson Pirie Scott and Company store was Sullivan's first department store, with a revolutionary, and influential, design for what was then a new type of building.*

WALTER GROPIUS,
FAGUS FACTORY,
ALFELD-AN-DER-LEINE,
GERMANY, 1911–14.
*A pioneer in modern
industrial design and
planning, Gropius said,
"The sensibility of the artist
must be combined with the
knowledge of the
technician to create new
forms in architecture and
design."*

ture. Although the young Wright was influenced by current fashions in domestic architecture, especially in his first houses, he eventually rejected the traditional European historical style and evolved a house that was both modern and American. These substantial houses, many of them built for wealthy patrons, were revolutionary in their plan, construction, and decoration.

Known as prairie houses [p. 281] because their long, ground-straddling articulation seemed to spread out much like the American prairie, these houses had an entirely new shape and look. Often built of long, horizontal bricks and arranged around a massive stone fireplace—Wright said that it was comforting to think of a fire burning deep within the masonry of the home—which anchors the structure to the earth and serves as the hearth around which the family can gather, these structures are uncompromisingly geometric with their long unadorned lines, overhanging hip roofs, and severe planes of brick and stone.

The revolutionary plan was also apparent inside. Radiating from the great hearth, the rooms flowed into one another in an organic fashion. Separated by angles instead of doors, these rooms were part of the unified whole of the prairie house.

Wright's numerous innovations include cathedral ceilings, built-in furniture (much of it designed by Wright himself), built-in lighting fixtures, and casement windows that open out. Wright also built some of his houses on concrete slabs and invented the car port. All these concepts are, of course, part of present-day suburban architecture, which in its style, plan, and detail is still heavily indebted to Wright's work before the First World War. Wright, it may be said, reinvented that quintessential feature of modern America, the suburb.

Wright's new ideas in commercial architecture rivaled those found in his domestic structures. In the Larkin Company administration building in Buffalo of 1904 [p. 280], now unfortunately destroyed, Wright gave a dazzling display of the independence of his architectural genius. Massive, cubic, authoritative, and almost without any ornamentation, this building was the logical conclusion of the tendencies of late nineteenth-century architecture exemplified by Sullivan and his engineer forerunners. The Larkin Building was an expression of the tremendous power of pure architectural shape and mass disassociated from any historical style or decoration. Freed from the fetters of the past, this mighty building must have seemed the embodiment of the

spirit of the young and optimistic American republic. Wright's design for the interior of the building (which was the first commercial structure built with air conditioning) was as dramatic as its exterior. A series of galleries ran around a four-story shaft covered by a large glass skylight. Wright, who was meticulous about every detail of his buildings (which he wanted to be his totally), designed the furniture, lighting, and other office equipment for the Larkin Building, all in his unmistakable, modern idiom.

Wright's work had considerable influence in Europe when some drawings and plans of his buildings were published in Berlin in 1911. European architects were fascinated by his novel ideas, especially the Germans, who had themselves already embarked on many new structural and stylistic directions. Foremost among these young German architects was Walter Gropius (1883–1969), whose Fagus factory [p. 279] at Alfeld, Germany, of 1911–1914, is one of the most prophetic buildings of the twentieth century. Commercial structures—factories, office buildings, and the like—offered almost unlimited opportunity for inventive design. These buildings were not supposed to be examples of art, such as opera houses or palaces were, but rather architectural machines built to get a particular job done efficiently. Consequently, modernity and innovation were valued, and historical style and ornament were often thought to be signs of an unwanted and outmoded tradition.

The Fagus factory looks as if it could have been made by a machine. An unornamented steel box with non-load-bearing walls of windows, it is a no-nonsense structure. There are several new aspects to the building: exterior and interior space appear to merge through the large amount of glass, and the corners of the factory are without visible means of support, a daring and untraditional feature that helps open the box to the outside.

The rigid angles and patterns of steel, glass, and masonry exclude the familiar organic forms of earlier buildings and the evidence of the human hand at work, but they point to the future of architecture. The following generations were to be dominated by the ideas of Gropius and several of his contemporaries. Much of the spread of Gropius's ideas came through an extremely important and influential school in Germany, which he directed first at Weimar and then at Dessau. Begun as the School

FRANK LLOYD WRIGHT, LARKIN COMPANY ADMINISTRATION BUILDING, BUFFALO, 1904 (DESTROYED). *The cubic mass of this daring building and its dramatic interior were among the finest and most original examples of American commercial architecture of the time. In 1949, the building was destroyed and its material sold for salvage.*

of Arts and Crafts and then, after its move to Dessau in 1925, called the Bauhaus (House of Building), the school served as the training ground for many of the architects and designers who would play critical roles in the history of architecture and the other arts in the twentieth century. Until the ascension of the Nazis, who equated stylistic modernity with decadence, and the closing of the school, the instructors and students of the Bauhaus (many of whom were to flee to the United States) turned their attention to the redesign and modernization of everything from office buildings and apartments to ceramics and furniture. There was a strong idealistic strain among the members of the Bauhaus that impelled them to create high-quality, unadorned designs that could be mass-produced using modules made of modern materials; by this means it was hoped that the school would bring the standards of good functional design to the greatest number of people. And, in fact, many Bauhaus ideas, both in architecture

and the decorative arts, were absorbed into the mainstream of modern design after World War I.

Architecture, like painting and sculpture, in the early decades of the twentieth century had begun to challenge some of the most basic concepts by which art had been created since the Renaissance. The impact of these revolutionary ideas was to be felt throughout the period between the world wars.

FRANK LLOYD WRIGHT, ROBIE HOUSE, CHICAGO, 1909.
This is one of the finest examples of Wright's prairie houses which were designed to blend with the natural environment in which they are set. The various long planes of the structure combine to provide a sense of sweeping horizontal movement.

FRANZ MARC, THE FATE OF THE ANIMALS, 1913. *Marc used the fragmented vision of the Cubists to create an awesome metaphor for the disintegration of nature caused by the machinery of war.*

[15]

ART BETWEEN THE WORLD WARS: 1918–1941

In 1914, much of Europe went to war. It was to be the "war to end all wars," brief and decisive. But in 1918, when peace was finally achieved, the losses were staggering: more than ten million people had been killed or maimed. On the occasion of the German surrender Churchill said the victory had been "bought so dear as to be almost indistinguishable from defeat." Lives had been irreparably shattered, and the optimistic spirit at the war's beginning had been profoundly altered by chaos and destruction.

Postwar Europe faced crushing social, financial, and political problems. Fascism, fueled by rampant inflation, was a growing political menace. Europe's financial problems soon spread to America, leading to the stock market crash of October 1929. In 1933, Hitler was appointed chancellor of Germany, and an estimated sixty thousand writers, artists, musicians, architects, and actors began an exodus from Europe. In 1936, the Spanish civil war erupted and Hitler and Mussolini proclaimed the "Rome-Berlin axis." Germany invaded Poland in 1939, and just two decades after the "Great War" had ended, an even greater conflict began. Six years later the first atomic weapons were used against an enemy, thus bringing World War II to an end. The nuclear age had dawned in the aftermath of a grotesque holocaust. The war dead were estimated at

thirty-five million, in addition to the ten million more who died in concentration camps. Western civilization, which had espoused the value of human life, individual dignity, and liberty, had seen abuses of these ideals on an incomprehensible scale.

Many of Europe's finest writers and artists were lost during the First World War. Those who survived were often physically or psychologically scarred. Searching for meaning to the madness that had produced such devastation, artists began to question the values of Western civilization and its culture. Yet, the postwar period became one of the most fertile in Western art. Between the two world wars some of the pioneering artists of the early twentieth century matured: Mondrian developed his most elegant abstractions in the 1920s and 1930s; Matisse continued to engage the viewer with his exploration of shape and form, figure and ground; Picasso evolved his expressive pictorial language. And the large emigration of European artists to America in the thirties and forties ultimately helped make the United States the new artistic center of the West. Ranging from those who embraced the modernism of the Armory Show of 1913 to those who created regional impressions of America, American artists entered the mainstream of contemporary culture.

For the generation of European artists that included survivors of the catastrophes at Verdun and the Somme, World War I, the "Great War," had been a lie. The painter Franz Marc (1880–1916), who died at Verdun, had been a member of the German Expressionist Blaue Reiter (Blue Rider) group, lasting from 1911 to 1914 in Berlin. Inspired by the Futurists, Marc eventually settled in Reid, Germany. One of his final works, *The Fate of the Animals* (1913) [pp. 282–83], painted just before he was called into service, portrays the destruction of nature by artillery—Marc's anticipation of the catastrophe of the war.

By 1915, artist refugees from the war had gathered in Zurich, Berlin, and New York. Poets, theorists, painters, and sculptors conducted poetry readings accompanied by a cacophony of bells, drums, banging on tabletops, screams, sobs, and whistles. Revolted by the insanity of life, they created anti-art. They called themselves "Dada," a name that is as paradoxical as the movement. In Russian the word means "yes, yes"; in French,

GEORGE GROSZ, DEDICATION TO OSKAR PANIZZA, 1917–18. *Oskar Panizza (1853–1921), a psychiatrist and writer whose satires brought him into court twice, was greatly admired by the German Expressionists in Berlin. In dedicating this work to Panizza, Grosz exclaimed in a letter of 1917, "I am unshaken in my view that this epoch is sailing down to its destruction."*

"rocking horse"; in German, it is simply idiotic babble. Like this multilayered name, the meaning of Dada shifted. One declaration stated it meant nothing. Other manifestoes decried the limits of Expressionism as a means to present the anxiety and dangers of the present and championed Dada; the 1918 Berlin Dada Manifesto proclaimed that "Dada is the international expression of our times, the great rebellion of artistic movements." Spreading to Hannover, Paris, and Cologne, Dada artists produced montages of sounds and images taken from the everyday world—the newspapers, the noises, and the advertisements that crowded in on the senses everywhere. Some artists saw Dada as a continuation of the Expressionist style; for others, it

became an opportunity to rethink the relationship between artist and object. A number of artists took found objects, manufactured or naturally occurring, and transformed them into art. For them, it was the artist's mind, not his hand, that mattered.

George Grosz (1893–1959) was the founder of Dada in Berlin. Grosz had studied in Dresden and Berlin and had spent time in Paris as well, but the First World War and its aftermath were the experiences that most shaped his art. Grosz served two years on the front (1914–16) and eventually ended up in an asylum. He resettled in Berlin in 1918, where he was swept up in the struggles between leftists and Fascists. German artists, active as social critics through the early Expressionist movements, readily formed new groups. Grosz, whose artistic vision had been formed among such Expressionists as Franz Marc, was attracted to the anti-authoritarian attitude of Dada, and he produced devastatingly satirical observations of Berlin's society. In his *Funeral Procession*, also called the *Dedication to Oskar Panizza*, of 1917–18 [p. 284], Grosz looks down at a riotous funeral, the buildings and streets stained red, with a melee of hideous creatures (the misbegotten fools on a modern-day *Narrenschiff*, or ship of fools) swept up in a triumph of death. Death itself sits astride the coffin, and the priest leading the procession holds his cross up in a gesture of despair and surrender. In the hands of Grosz, who saw humanity awash in the consequences of its own insanity, Dürer's *Apocalypse* was reborn in the twentieth century. Humanity was chronicled by Grosz as mutant, stunted, and deformed by the poisons of society gone wrong. Grosz was one of the many European artists who departed for America in the thirties. There, his aversion to Fascists and Nazis inspired increasingly violent and brutal imagery.

For Kurt Schwitters (1887–1948), Dada represented a kind of cultural rebirth. Discarding the aesthetics and the methods of the past, Schwitters was attracted to the refuse of his culture, which he transformed into art. Born and living in Hannover, Schwitters collected junk (wire, string, rags, newspaper bits, tickets, nails and washers, for example), which he assembled into delicate collages he named *merz* pictures (after *Kommerzbank*, or commerce bank, deliberately fragmenting the word to coincide with his fragmented pictures). His *Picture with Light Center* [p. 285] of 1919 is one of these

KURT SCHWITTERS, PICTURE WITH LIGHT CENTER, 1919.
A poet as well as a painter, Schwitters gave up the traditional materials of oil and canvas in 1918 and took rubbish he found in the streets—old handbills, tramway tickets, string, newspaper scraps, and bits of cardboard—and assembled them into collages. His first exhibition of such work was held in Berlin in 1919, the year in which his poetry was also published.

poetic harmonies created from trash. Battered, rusted, or frayed, the random bits of flotsam shape the vaguely geometrical forms derived from the Cubists. Still hinting at their past, these scraps become art, their delicate colors and textures adding variety to the partly painted surface. With Schwitters, small, inconsequential trifles gained consequence, increasing both in scale and importance within their new context.

Owing much to the Cubists and the Futurists, Schwitters declared his work was not anti-art but a kind of visual poetry. "I am a painter, I nail my pictures together," he once said, underscoring his radically modern working method. Though rejected by some Berlin Dadaists because of his nonpolitical

MARCEL DUCHAMP, FOUNTAIN, 1917. *By endowing a manufactured object with two characteristics of an art work— title and signature—Duchamp transformed this urinal into one of the most celebrated works of Dada.*

sufficiently disturbing to be screened off from the rest of the display. Duchamp's brazen action implied that the artist could be the discoverer, if not necessarily the creator, of art. He predicted correctly that found objects would become a central form for artistic expression in the twentieth century.

While Western European artists struggled to find metaphors for the human condition in the aftermath of World War I, Russian artists, who had formed an avant-garde movement before the Rus-

stance, Schwitters maintained active contact with avant-garde artists in Prague and Holland. He transformed his entire house in Hannover into a massive collage but lost it to Allied bombers in 1943; he himself had fled to Oslo in 1937 and from there to London. Schwitters's ability to elevate the detritus of life to the level of art is a powerful symbol of human creativity, and his *merz* pictures were influential for many later artists.

French-born Marcel Duchamp, who had shocked the art world in 1913 with his *Nude Descending a Staircase,* settled in New York in 1915, where he became the leader of American Dada. Duchamp turned to manufactured objects and declared them "art" in order to provoke the viewer. Expressing contempt for conventional notions of art, Duchamp produced a series of works he called Readymades. His most notorious Readymade was a manufactured urinal that he titled *Fountain* and signed with the whimsical name "R. Mutt" [p. 286]. Sent to an exhibition organized by the New York Society of Independent Artists in 1917, the work was

VLADIMIR TATLIN, MODEL FOR THE MONUMENT TO THE THIRD INTERNATIONAL, 1919–20. *Inspired by Picasso, whom he had visited in Paris, Tatlin created this model for a monument to the Bolshevik victory; its spiraling shape was to suggest continual progress.*

sian Revolution of 1917, witnessed for a few years a reconciliation of their utopian artistic and social ideals with the success of the Revolution. They believed that theirs was a new art for a new state, and they embraced the future with optimism and enthusiasm. Building on Cubism and Futurism, a small group of highly intellectual artists—including Vladimir Tatlin, El Lissitzky, Naum Gabo, and Kasimir Malevich—developed successive interpretations of European modernism, which they called Rayonism, Suprematism, and Constructivism. In each case the new abstraction fulfilled an ideology. Seeing potential for "heroism in modern life," Malevich declared in 1915, "It is absurd to force our age into the old forms of a bygone age. . . . The void of the past cannot contain the gigantic constructions and movement of our life."

Tatlin's *Model for the Monument to the Third International* of 1919–20 [p. 286], created to commemorate the third anniversary of the Revolution, was just such a gigantic construction, devoted to expressing the momentum and potential of contemporary Russian life. An elemental tower form devoid of decoration, it is nevertheless reminiscent of the spiraling triumphal columns erected by the Romans to proclaim their victories as they built their empire. Tatlin's tower is perhaps the most famous monument that never came to be. Russia lacked the steel to build it, or it would have been three hundred feet taller than the Eiffel Tower, and Marxist-Leninists would have had an architectural symbol of their victory. The cubic chamber, intended for debates, the cylindrical chamber for information, and the spherical broadcasting station above were meant to shift positions at regular intervals, and thereby perpetually reflect the new society Communism was expected to create.

In the wake of the Russian Revolution, the state became the patron, and art became a propaganda tool. Following the ideology of socialism, the portrayal of property—of objects—was abandoned in favor of abstraction and universal ideas. Pure geometric shapes and simple colors, suggesting plans for large industrial or urban projects, were adopted. Like the members of the later Bauhaus, artists such as Tatlin fused abstract form and social utility. His contemporary El Lissitzky (1890–1947) created projects, or "prouns," which anticipated futuristic cities and have the feel of space stations or details from

EL LISSITZKY, PROUN COMPOSITION, c. 1922. *As if standing at attention, the aggressively vertical forms of this composition symbolized the progressive and optimistic attitudes of the Russian avant-garde of the time.*

some highly complex industrial design. His *Proun Composition* [p. 287] of c. 1922 is pristine, simple, geometric, and dynamic. There is an affirmative vision, an economy and clarity, that has its roots in the Cubist forms of Picasso. But here they are refined, simplified, and more tectonic.

With the paucity of raw materials, the designs by Lissitzky and his fellow artists were all that emerged; the final projects were rarely executed. Posters, the principal mass communicator, became particularly important for artists, notably Alexander Rodchenko, who designed posters for manifestoes, films, and beer.

But by 1924, Russia's avant-garde artists had fallen out of favor with the conservative tastes of Stalin, who saw in them lingering bourgeois attitudes that might stand in the way of the new state. Overtly or covertly, the Russian avant-garde was

stamped out, deprived of commissions or exterminated in Stalin's purges. Its celebration of the machine and the pristine shapes proclaiming the modern era was short-lived.

In France, infatuation with modernity and with machinery and its powerful potential became the basis for the sophisticated mechanistic images of Fernand Léger (1881–1955), who worked as an architect in Paris before turning to painting. After a brief phase during which he painted impressionistically, Léger experimented with Cubism, which opened a new world of forms and compositions to him. Léger served in World War I and in 1917 was hospitalized after being gassed at Verdun. In contrast to most of his contemporaries, his war experience was not entirely negative. He used cannons, shells, and machinery to build a repertoire of visual forms that encompassed everything from kitchen pots to automobiles. "Beauty," he wrote, "is everywhere. . . . Go see the Automobile Show, the Aviation Show . . . which are all the finest shows in the world." Paintings such as *Mechanical Elements* [p. 288] of 1918–23, with the geometric precision of their shells, gears, cylinders, screws, pistons, and other mechanical parts, were the result of his interests. Léger strove to attain what he called a "state of organized plastic intensity," and he wanted his works to rival industrial products in their robust logic. Transforming the figure into a machine and conflating machines with humanity, Léger developed a striking language of abstraction.

While Léger enthusiastically embraced the machine age, adopting its forms to express a rational and ordered vision, other artists chose the subjective and intuitive realm of the human mind as their theme. Some of the adherents of Dada began to experiment with automatic writing (in which the writer jotted down any thought that came to mind) and also sought other means to penetrate the world of dreams and the unconscious. In 1924 the writer André Breton, a leader of the group, published his *Manifesto of Surrealism*. Particularly important members of the Surrealists, as they came to be known, were Max Ernst, Joan Miró, Giorgio de Chirico, and René Magritte. The Surrealists first exhibited together in 1925 at the Galerie Pierre in Paris. The work they showed presented the subconscious, through portrayal of fantasies, dreams, or nightmares, and through states of mind between

FERNAND LÉGER, MECHANICAL ELEMENTS, 1918–23. *Densely packed and portrayed in shallow relief, the screws, cylinders, and gears of an imaginary mechanical world are contained within the picture by assertive horizontal and vertical elements.*

sleep and wakefulness, dream and reality, insanity and sanity.

Exploration of the subconscious had already taken place much earlier, of course, in the works of such diverse artists as Edvard Munch and Gustav Klimt. However, the pioneer of modern Surrealism was Giorgio de Chirico. Born in Athens of Italian parents, de Chirico (1888–1978) first studied in Greece, and then in Munich, where he was strongly influenced by contemporary German painting. Settling in Paris in 1911, de Chirico turned to such dreamlike subjects as those depicted in *Melancholy and Mystery of a Street* of 1914 [p. 289]. In such

GIORGIO DE CHIRICO, MELANCHOLY AND MYSTERY OF A STREET, 1914. *A shadowy figure, the girl rolling the hoop is surrounded by mundane forms (the typically arcaded Italian buildings, the transport car) that seem dangerous and eerie; it is one of de Chirico's early Surrealist masterpieces.*

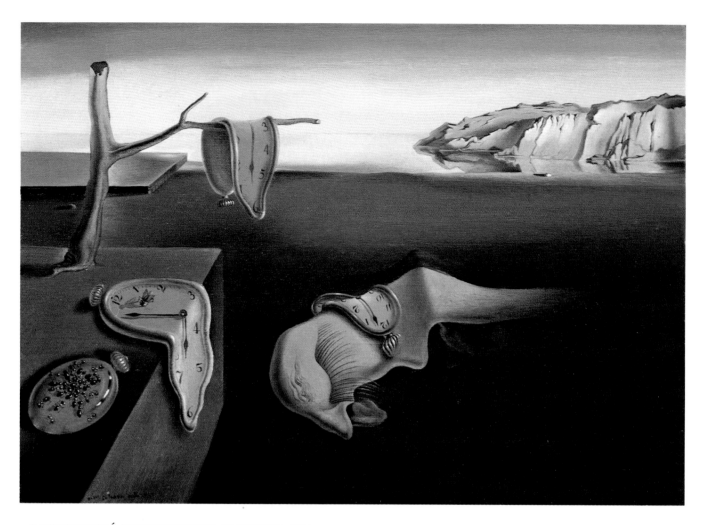

SALVADOR DALÍ, <u>THE PERSISTENCE OF MEMORY, 1931.</u>
Disconnected from any logical space or time, this profusion of recognizable forms has been distorted by fantasy into unreal, disturbing images.

works de Chirico established the haunting juxtapositions that would be used in many forms by other Surrealists. In *Melancholy and Mystery of a Street,* as a girl chases her hoop in a barren piazza, a shadow cast by a form with a spike seems to threaten. The arcade to her right has the dizzying perspective of Munch's *The Cry,* and the commonplace environment in which she pursues her game is just as frightening; indeed, its ordinariness makes the threatening and oppressive mood more palpable. This painting presents the elements of a nightmare: infinite distances, deep voids, uneasily juxtaposed to uncomfortably close forms; glaring lights and menacing shadows; empty and claustro-

phobically filled spaces. These devices became the essential pictorial vocabulary of the Surrealists. Employing logic to portray essentially illogical themes, de Chirico and the Surrealists whom he inspired produced disturbing, evocative images.

Surrealist subject matter attracted artists during the 1920s and 1930s, a period in which many of Surrealism's fundamental images were created. Salvador Dalí (1904–1989), who has become nearly synonymous with Surrealism in the public mind, had explored erotic, irrational, and neurotic themes. As a student in Spain, he was strongly influenced by de Chirico. Dalí had a particular talent for illusionism; his meticulous style of painting and his virtuoso draftsmanship enabled him to make even the most abstruse illusions believable. Narcissistic and paranoid, and always a skilled self-promoter who exploited his own instability, Dalí was championed as a giant and derided as a fraud.

Dalí's *The Persistence of Memory* of 1931 [p. 290] shows his mature phase, when he developed a purely personal vision. Here the infinite and empty space has become a terrain occupied by limp watches, tree stumps, and strange anthropomorphic shapes, including elements of human anatomy (nose, hair, eye, skin) that have been removed from their normal context and placed into unrecognizable but disturbing relationships. Time not only stands still, but the instruments of its measurement are melting, decomposing, and attracting insects. By turns fascinating and terrifying, Dalí's images are disturbing because they make the irrational so tangible. Moreover, deprived of a rational context, the objects permit the viewer to associate freely.

In contrast to Dalí, Joan Miró (1893–1983), a fellow Spaniard, developed a language of visual symbols instead of recognizable objects. Born in Barcelona, Miró's early life was torn between business studies and his love of art. In 1912 he made his decision and enrolled in an art school in Barcelona. By 1914 he was exhibiting works strongly influenced by Fauvism, Cubism, and Post-Impressionism. Winters spent in Paris after 1920 brought Miró into contact with the Surrealists, particularly the poet André Breton. Attracted by the potential of automism and by the imagery afforded through delving into the subconscious, Miró developed his own Surrealist vocabulary. One of his most important works is *The Birth of the World* of 1925 [p. 291]. After staining the canvas to give it the feeling of an ambiguous space, Miró added various precisely drawn signs and symbols that allude to the origins of life implied by the painting's title. Miró's personal pictorial language consists of symbols that are repeated in various configurations which, in their lack of specificity, strive for universal meaning. In works such as these, Miró was looking well beyond the confines of traditional Western art to trace human origins and to forge a new future. His impact, like that of Surrealism itself, was vast.

While the Surrealists were exploring the realms of the psyche, Picasso continued in his own direction, working in a number of interrelated styles, each of which revealed both his artistic independence and his need to find new formal structures to accommodate his continually shifting pictorial and emotional concepts. Indeed, after about 1920, it is impossible to classify Picasso. Though always af-

JOAN MIRÓ, THE BIRTH OF THE WORLD, 1925. *Unlike de Chirico and Dalí, who distorted visible reality for their "surrealism," Miró invented a highly personalized set of abstract symbols which he hoped would have universal significance.*

fected by the latest events in the fast-moving world of twentieth-century art, he stood apart, and his work follows the dictates of his intensely independent and highly creative mind.

Cubism had made it impossible for Picasso and many other artists to return to previous organic conceptions of the figure and of the environment it inhabited, and Picasso sought new solutions, as is evident in the series of colossal figures he painted in the early twenties. Canvases such as *Three Women at the Spring* of 1921 [p. 292] were obviously inspired by the subject matter and some of the forms of Greek and Roman art, which Picasso had seen during a trip to Italy in 1917, but there the resemblance ends. Painted in somber grays, terracottas, and whites, they retain much of the planar construction of Cubism. And, by a simplification and synthesis of form also rooted in Cubism, Picasso has endowed these prodigious figures with

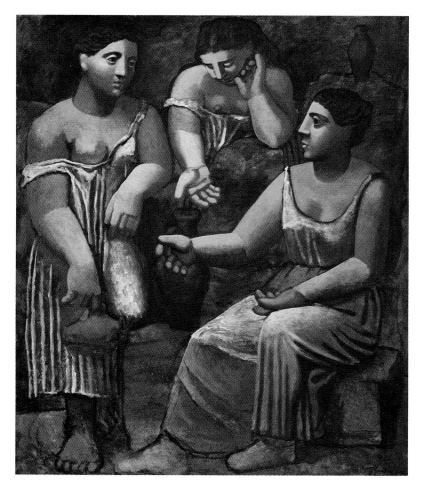

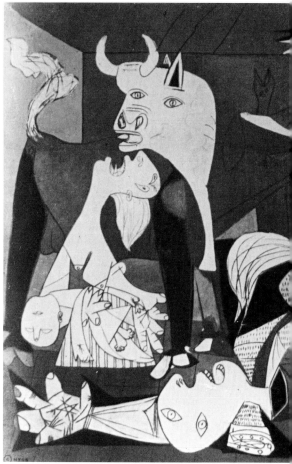

PABLO PICASSO, THREE WOMEN AT THE SPRING, 1921.
In their grandeur, poise, and timelessness, these three massive figures recall the goddesses of the classical past, an era that both haunted and inspired Picasso throughout his life.

uncommon weight and presence. But in *Three Women at the Spring* Picasso returned to the integral human figure, which he could never abandon. The figure was for him the primary communicator of human emotion, the central concern of his art over some seventy years.

Picasso's portrayal of human emotion reached its apex in *Guernica* [p. 293], which commemorates the destruction of a Basque town by German bombers in April 1937 during the Spanish civil war. Like all great art, this painting raises its subject from the particular to the universal; it has, in fact, become one of the most famous anti-war declarations of all time. Picasso has made the fragmented, an-

gular, tortured forms express boundless fear and grief. His belief that "art is a lie that reveals truth" is here confirmed in the unreal forms and somber colors that have been transfigured into the very essence of human suffering and loss. The snorting bull, the wretched mother holding her dead child, and the wounded, writhing horse are images that remain indelibly fixed in memory.

The reductive, abstracting qualities of Picasso's art were echoed in much sculpture produced during the period between the wars. Constantin Brancusi (1876–1957), a Romanian sculptor working in Paris from 1904, was perhaps the most uncompromising abstractor of form of the period. Influenced by Rodin and the revolutionary developments in painting then unfolding in Paris, he created a new sculpture. A mystical personality deeply interested in Eastern thought and religion, Brancusi strove to reduce things to their pure essences, to their fundamental shapes. His *Bird in Space* of c. 1927 [p. 294],

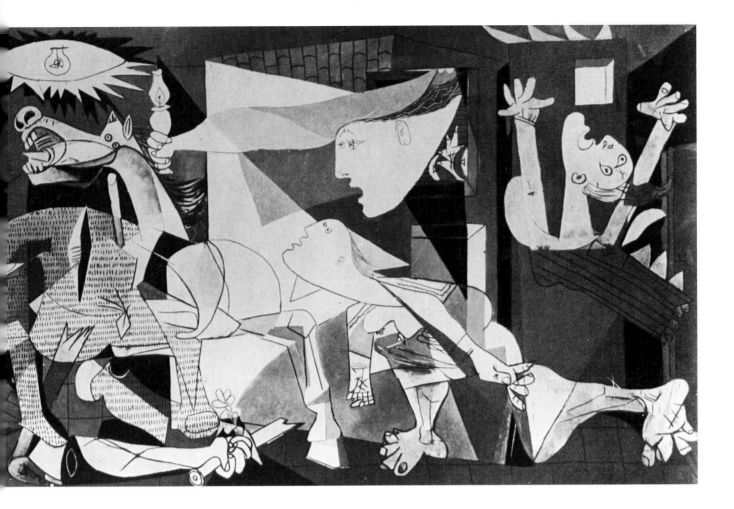

for example, is a simplified polished bronze form that embodies the spirit of soaring flight as it curves effortlessly upward. Elegant and lyrical in its beautiful, expressive shape and subject, it is one of the first purely abstract sculptures of the twentieth century.

Brancusi's influence was strongly felt by Henry Moore (1898–1986), the leading British sculptor of the twentieth century. Moore said Brancusi made him conscious of form, but other art, including pre-Columbian and Renaissance works, also helped the sculptor create a unique style. Always concerned with the human form as a vehicle of expression and meaning, Moore made many single and grouped figures [p. 294] in stone, bronze, and wood, which, like Brancusi's, seem archetypal in their highly formalized conception. Moore's figures appear to have emerged out of the material of which they are made. Often monumental, they seem as natural as boulders or trees and just as suited to their environment.

PABLO PICASSO, GUERNICA, 1937. *Picasso was an ardent supporter of the Spanish Republican cause; he painted* Guernica *for the Spanish government building at the Paris World's Fair of 1937 as a protest against the actions of General Franco and his Fascist allies. The painting has since become a universal symbol of the horror and destruction of all war.*

Moore's large, often open forms expand slowly through space, enclosing large areas of void; simultaneously, the mass of the shaped material is penetrated by space, and air and light flow through the forms.

The period between the two world wars witnessed the rapid evolution and amplification of many of the ideas first developed in the early years of the twentieth century. This was especially true in Germany, where the members of the Bauhaus pursued a quest for a functional, machine-made, and ultimately classless architecture. The paragon for

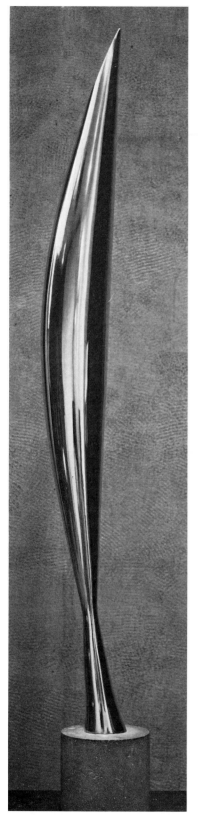

**CONSTANTIN BRANCUSI,
BIRD IN SPACE, c. 1927.**
*Brancusi's statement that
"what is real is not the
external form but the
essence of things" is well
illustrated in* Bird in Space.
*Seldom has the heavy
material of bronze been
refined into such an
elegant and seemingly
weightless form.*

**HENRY MOORE,
RECLINING MOTHER
AND CHILD, 1960–61.**
*Beginning with the late
1920s, Moore emerged as
Britain's most prominent
sculptor. Although much
influenced by contemporary
artists, especially Brancusi,
he never abandoned the
Western sculptor's
traditional concern with the
human figure and the
material from which it is
shaped.*

such architecture was the Bauhaus campus itself [p. 295], in Dessau, designed by Walter Gropius in 1925. The cubic masses of the unadorned, stark classroom and workshop buildings and the connecting bridges create powerful formal relations reminiscent of contemporary painting. In the Bauhaus the arrangement and contrast of steel, glass, and concrete, rather than ornament or hand-carved decoration, give the cubic buildings relief and variety.

Devoid of historical associations, these immaculate buildings and others swayed by Bauhaus principles, both in Europe and in the United States, were to have an enormous though not always salutary influence on future architecture. From Anchorage to Auckland, plain, unadorned, modular buildings became part of the landscape. Supermarkets, shopping strips, department stores, apartments, office buildings, schools, and other structures of every type carried on, although often in much degraded form, the mechanistic, sometimes dehumanizing characteristics inherent in the Bauhaus school of architecture. Lacking any trace of the human hand and completely without character, these later barren and frequently badly constructed buildings are the negative side of the idealism of the Bauhaus purpose to carefully design and build with modern methods and materials. In some ways, the Bauhaus consciously resembled a medieval guild, with masters and apprentices united to design works of the highest quality and utility for the masses. Unfortunately, such a scheme could be successful only on

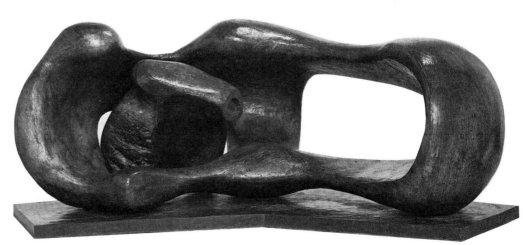

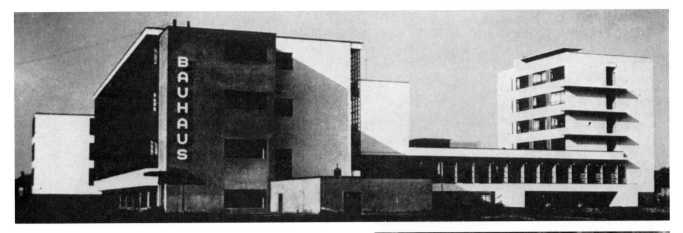

a limited, well-financed, highly controlled scale.

One of the finest and most original architects associated with the Bauhaus was Ludwig Mies van der Rohe (1886–1969), whose designs, while they follow many of the school's principles, have a grace and beauty that often mask their intensely functional plan. Mies's early, unexecuted skyscrapers [p. 295], designed about 1920, were to be buildings of between twenty and thirty stories, very tall for the period. Each was to have hundreds of windows set at slight angles to each other to produce a multitude of reflections, which would have made the shaft of the building glitter and appear to shift in sunlight. Inside the buildings, visible through the sheets of glass, would have been stacks of concrete slabs cantilevered from a central core of columns. The structure and function of these buildings would have been expressed in a simple, elegant fashion, with the very latest building materials and techniques.

Under increasing Nazi pressure, the Bauhaus moved from Dessau to Berlin, where it was dissolved in 1933. Gropius, Mies, and a number of the school's other faculty members made their way to England and America, where their influence was to be widespread. In Germany and Italy, a new architecture of Fascism developed along ideological lines that fostered so-called national characteristics combined with Roman architectural elements, to provide the necessary totalitarian authority needed for the new buildings. There was no room for the modernism of the Bauhaus, even though many of its innovations were utilized in altered form by the Fascists for their vast and intimidating public buildings. (The height of Fascist architectural absurdity was reached perhaps when pitched roofs, con-

WALTER GROPIUS, BAUHAUS, DESSAU, GERMANY, 1925. *(top) These buildings, which consciously break with the past, have been the prototypes for countless industrial and institutional structures throughout the West.*

LUDWIG MIES VAN DER ROHE, GLASS SKYSCRAPER PROJECT, 1920–21. *(bottom) In these sleek glass- and-concrete buildings, Mies pointed the way toward the future of much of twentieth-century architecture.*

GIOVANNI MICHELUCCI AND OTHERS, STAZIONE CENTRALE, SANTA MARIA NOVELLA, FLORENCE, 1934–36. *This sober, spare building located near the center of Florence is both independent in its design and harmonious with the city's older, more traditional buildings. Largely unchanged from its original state, the station still serves the flocks of tourists who arrive by train every day.*

sidered to properly reflect the German tradition in building, were substituted for the flat ones of Mies's forward-looking apartment houses in Stuttgart.)

In Italy, the Fascists were somewhat less hostile to modernist tendencies, and several architects of considerable talent executed important commissions for public buildings. Especially noteworthy is the Florence railway station [p. 296], built in 1934–1936 by an architectural team headed by Giovanni Michelucci.

In France, one of the bastions of traditional architecture, the principles of modernism were advanced by the painter, city planner, and architect Charles Edouard Jeanneret-Gris, called Le Corbusier (1887–1965). Le Corbusier's theories can be traced in many areas of twentieth-century architecture; his schemes for cities, which embodied contemporary and futuristic ideas about building types, population densities, traffic patterns, and public housing, were to have a decisive impact on the modern townscape all over the world. Le Corbusier was well aware of the progress of contemporary German architecture and had worked in Berlin for a short period. Like that of his contemporaries in the Bauhaus, his architecture was revolutionary in its plan and decoration and in its emphasis on the sophisticated use of concrete and glass.

Le Corbusier's Villa Savoye of 1929 [p. 296] is

LE CORBUSIER, VILLA SAVOYE, POISSY, SEINE-ET-OISE, 1929. *Since Roman times, the architecture of the country house or villa has often been calculated to take advantage of the rural setting. Le Corbusier continued this tradition by furnishing the Villa Savoye with roof terraces and large, horizontal windows which allowed uninterrupted views of the surrounding countryside.*

HOOD AND HOWELLS, TRIBUNE TOWER, CHICAGO, 1922. *This design was picked over 258 other entries in the international competition held for the building's design.*

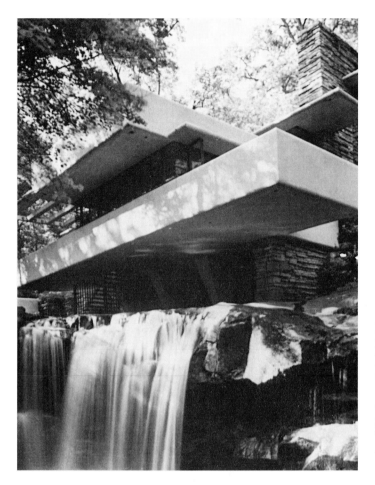

FRANK LLOYD WRIGHT, FALLING WATER, BEAR RUN, PENNSYLVANIA, 1936. *Wright's concept of the hearth as the heart of the home is evident in Falling Water, with the fireplace formed by the rocky ledge.*

a cube of concrete raised on stilts (a characteristic feature of the architect's work), allowing the use, for parking and other needs, of an area normally covered by traditional building foundations. Illuminated by strip windows and topped by a roof garden with rounded concrete walls, the house is as much an unabashed abstract sculpture as it is, in Le Corbusier's own words, "a machine for living." Unlike much previous architecture, most especially Wright's, the Villa Savoye and most of Le Corbusier's other plans show no attempt to provide harmony with the environment. Also, the traditional concepts of coziness and welcome are not part of this austere composition. Rather, like a Cubist painting, the house is a precise, rational, abstract statement about materials and forms and their interrelationships.

Although he may well have been influenced by Le Corbusier, Frank Lloyd Wright (1869–1959) used his own brilliant and highly personal formal ideas for quite a different purpose in what is the masterpiece of his long involvement with domestic architecture, Falling Water [p. 297] of 1936. Wright was aware of the Bauhaus and the International Style of functional architecture, and he openly expressed his dislike of the linked style of Gropius, Mies, and Le Corbusier, and their "cardboard houses," which he considered machine-like and overly standardized—something his free-spirited, romantic, and independent American idealism loathed. Like Le Corbusier, Wright carefully arranged a series of large, horizontal concrete shapes, but here the resemblance ends, for Wright's Falling Water is dramatic and embracing in its openness. The massive platforms soaring over the waterfall, but seemingly pinned to the ground and counterbalanced by stone piers, create a dynamic, exciting relation with the surrounding space. The mass of the house expands into its environment and is, in turn, invaded by light and air. The same organic relationship between man-made object and the landscape is found in Wright's Prairie houses, though in a more dramatic way.

In Chicago, the birthplace of modern American architecture and the site of many of Wright's early triumphs, the skyscraper was still locked in a battle between modernism and traditional architectural forms. A competition for the Chicago Tribune Tower, including entries by Gropius and Mies van der Rohe, resulted in what can be called a Gothic skyscraper [p. 296]. Set on a four-story base elaborately carved with pseudo-Gothic ornament, the shaft of the tall building rises to a tower seemingly supported by huge flying buttresses. But these buttresses have no function; the building, designed by Hood and Howells, is a steel and concrete cage that needs no external masonry support—the Gothic ornaments and buttresses are there as a bow to tradition and, more important, as humanizing elements. In the hands of Gropius or Mies the result would have been something much more severe and uncompromising, as the plans for Mies's glass towers demonstrate. The spirit of fantasy and historicity of the Chicago Tribune Tower was to be a major characteristic of American skyscraper architecture between the world wars; this skyscraper and other

ARTHUR DOVE, THAT RED ONE, 1944. *Dove used abstract symbols to express natural forms: the large black disc stands for the sun; the white areas indicate the power of light; the other forms are metaphors for earth, water, sky, and trees.*

equally quirky contemporary buildings still give the American urban landscape a variety and character absent in many more recent buildings.

Painting in America during this period shows an ideological split between abstraction and figurative art. The Armory Show of 1913 heightened American awareness of modernism. The experiments of Picasso, Braque, and Duchamp helped affirm pioneering abstract efforts among American artists, who regarded the painters of the figure as provincial. Alfred Stieglitz, who maintained a small gallery at 291 Fifth Avenue, New York, and who is considered one of the premier photographers of the twentieth century, exhibited most of the European modernists in his gallery, aided by his friend and fellow photographer Edward Steichen. Matisse, Picasso, Brancusi, Severini, and Picabia were among the Europeans shown. Joining them were such American masters as Georgia O'Keeffe (1887–1986) and Arthur Dove (1880–1946).

For Dove, who had studied in Paris in 1907 and who began exhibiting with Stieglitz in 1910, Wassily Kandinsky was a particularly inspiring artist. Kandinsky's reductive forms, pure areas of color, and suggestive interplay of shapes were derived from nature, as were Dove's. Dove turned to landscape to produce such cosmic visions as *That Red One* of 1944 [p. 298]. Here earth, sun, sky, water, and trees have been transformed into bold, symbolic ele-

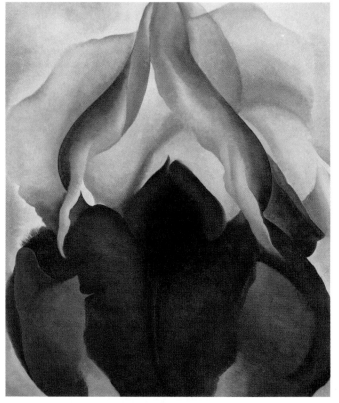

GEORGIA O'KEEFFE, BLACK IRIS, 1926. *O'Keeffe never painted the human figure, concentrating instead on close-up views of flowers for which she is best known. These paintings reveal elemental shapes common to many natural forms which, after 1945, expanded to include bleached bones and the desert.*

ments that conform to the picture plane. The circular, square, rhombic, and rectangular areas defined by the colors echo a natural world where blazing sun, mountains, and trees are seen.

A similar distillation of nature is found in the work of Georgia O'Keeffe. Born in Wisconsin, O'Keeffe studied in Wisconsin, Chicago, and New York before turning to teaching. In 1918 she gave up teaching to join Stieglitz, her future husband, at his 291 Gallery. For O'Keeffe, nature offered forms that could be removed from their original context and made into art. Her favorite forms were flowers and bleached bones, which she translated into large, epic shapes, making them elegant and powerful symbols of regeneration. O'Keeffe's *Black Iris* of 1926 [p. 298] interprets the petals of an iris, magnifying each element and showing in the hidden folds analogues both for female sexuality and the vast expanses of landscape in the American Southwest,

I n 1937, to publicize the plight of the American farmer and his family, the Farm Security Administration began a program of photographic documentation of the devastating effects of the Depression on rural areas. Under the direction of Roy Stryker, a group of talented photographers, including Stryker, Dorothea Lange, Ben Shawn, Gordon Parks, and Arthur Rothstein, provided a

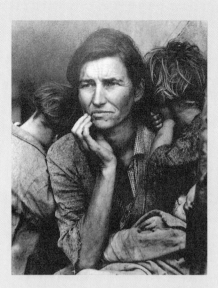

DOROTHEA LANGE. MIGRANT MOTHER, CALIFORNIA, 1936.

sensitive, if harrowing, record of one of the bleakest periods of American rural society.

where O'Keeffe spent much of her life. Like Dove, O'Keeffe put a particularly American stamp on abstraction, maintaining a sense of place. Primal and heroic, American abstractionists such as Dove and O'Keeffe rejected the polish often found in European art.

O'Keeffe, who achieved a visual purity in her work with clean contours, shared an affinity for smooth shapes and simplified forms with a number of other American artists. Charles Sheeler (1883–1965), in particular, produced a clear and seemingly dispassionate interpretation of the visual world. Born in Philadelphia, he studied with the notable American painter William Merritt Chase in New York (as O'Keeffe had done) before going to Europe in 1903. There the work of Matisse, Picasso, Cézanne, and Braque turned Sheeler toward Cubism. Upon his return to America in 1909, he translated the urban architectural environment into cleanly described, nearly abstract arrangements of rectilinear forms. Control of the environment through machinery is a theme that runs throughout Sheeler's work. His *River Rouge Plant* of 1932 [p. 300] celebrates the industrialization of America. Neatly arranged, and viewed with a sensitivity to their compositional potential, the buildings of this industrial plant are idealized, anonymous, silent,

and monumental. Straddling representation and pure abstraction, Sheeler, like O'Keeffe, shifted direction a number of times. Tending toward abstraction in the 1920s, both artists moved toward realism in the 1930s, but returned to abstraction in the 1940s.

Other American painters maintained a loyalty to realism, seeing within representation the potential for expressing important concerns about the human condition. American realism had remained a strong tradition throughout the nineteenth and early twentieth centuries. Inspired by the Impressionists and by Dutch art of the seventeenth century, a particularly vital school of realists, known as The Eight or the Ashcan School for their portrayal of slum life and lower-class urban scenes, was active in the early twentieth century. Led by Robert Henri (1865–1929), these artists supported themselves as newspaper illustrators, and their work has the energy and dash of quick and insightful observation. Henri, born in Cincinnati, was a charismatic teacher who crusaded against academic art, offering an art education based on real-life experience. For him, aesthetic qualities and human feelings were inseparable, and this attitude also shaped the work of two of his most gifted students, George Bellows and Edward Hopper.

CHARLES SHEELER, RIVER ROUGE PLANT, 1932. *Sheeler's clean and precise depiction of this industrial plant is the precursor of later realist painting, particularly the photorealists of the 1960s and '70s.*

George Bellows (1882–1925), who was born in Columbus, Ohio, studied with Henri in New York and quickly established himself as an independent artist. Like Henri, Bellows derived his subjects from the city. Fascinated with New York, he loved the piers, the Battery, the neighborhoods, and the bars. Working quickly and spontaneously, he recorded the pulsating life around him with insight and skill. One of his most famous works is *Stag at Sharkey's* of 1907 [p. 300], which depicts an illegal boxing match. Placing the viewer among the bar's patrons, Bellows portrays the boxers locked in a violent exchange. As the referee attempts to dislodge them, a fighter tries to land a punch with his free arm. The raw physicality and the turbulent yet exuberant existence of city life had a particularly talented chronicler in Bellows; like the German Expressionists, he made the city his subject and responded to its potential for violence. But *Stag at Sharkey's* is not a condemnation of the diminished humanity prevalent in cities, as portrayed by the Expressionists; it

GEORGE BELLOWS, STAG AT SHARKEY'S, 1907. *Sharkey's, a saloon on New York's west side, was near Bellows's studio and he went there often to draw the boxing matches held in the back room. Between 1907 and 1930 Bellows devoted at least six oils to scenes of prize fighters, of which* Stag at Sharkey's *is best known and earned him widespread acclaim.*

EDWARD HOPPER, EARLY SUNDAY MORNING, 1930. *No artist better captured America during the Depression than Hopper, who poignantly underscored the sameness and hopelessness yet endurance that characterized many lives during this bleak time.*

is an objective depiction of the tough and durable temperament of these city dwellers, who seem to be modern descendants of Brueghel's rough men and women.

Another realist artist of the American scene was Edward Hopper (1882–1967), who depicted the loneliness and starkness of America's cities. Hopper exhibited with Henri and his other pupils, but he rejected Henri's optimistic vision and saw the city as a metaphor for human alienation. Born in Nyack, New York, Hopper studied with Henri from 1900 to 1906, and he was in New York in 1913 for the Armory Show. His first one-man show, interestingly, took place in Paris in 1920, but by 1925 Hopper had found his subject—the quiet desperation of life in America's towns and cities. His career spanned the Depression, and Hopper's portrayal of desolate men and women captures the spirit of those hard times.

Hopper's *Early Sunday Morning* of 1930 [p. 301] makes the drab and cheerless existence of a city street its theme. Lit by a sun that imparts no warmth, a row of shops stands deserted on an early Sunday morning. A row of tenement windows, distinguished only by the adjustment of the shades by their invisible inhabitants, exposes the monotonous existence of life in this poor street. Devoid of any variation that could lift the chill of its depersonalized atmosphere, the street is anonymous. Hopper had a genius for finding images that are quintessentially American—*Early Sunday Morning* could be a street of any small American city. Despite the fidelity to external surfaces, this painting, like Hopper's scenes of cold rooms and lonely bars, is intensely emotional, capturing a mood as effectively as any Expressionist painting. Indeed, Hopper ranks as one of the greatest interpreters of American life. His work stands apart and above the many realists and regionalists with whom he is often grouped. In his penetrating psychological analysis of life, Hopper parallels the European artists who made the human psyche and subconscious their subject; his work helped to make American art join and eventually surpass that of Europe in importance.

[16]

THE TRIUMPH OF MODERNISM: 1945–1970

FRANK STELLA, TAHKT-I-SULAYMAN I, 1967. *A mingling of squares and circular forms derived from protractors provided the title* Protractor *series to these systematically superimposed and intersecting arcs. Stella's large scale was inspired by Abstract Expressionism, but his precise forms and unmodulated color exemplify the style of "hard edge," a contrast to the painterly approach of the Abstract Expressionists.*

Victorious over Germany and Japan in World War II, America became the dominant world power politically, economically, and culturally. Between 1945 and 1970 New York was the West's artistic capital, supporting a culture that was avowedly modern. New museums for contemporary art were built there, and the rest of the country followed suit. Frank Lloyd Wright's Solomon R. Guggenheim Museum was completed in 1959; the Museum of Modern Art had opened in 1939 and the Whitney Museum of American Art moved to its present location in 1966. These museums and powerful and taste-setting New York galleries like that of Leo Castelli exhibited a succession of vibrant and energetic artistic experiments that changed modern art. Abstract Expressionism, color-field painting, hard-edge abstraction, Pop Art, and Minimalism followed each other in fairly rapid sequence, establishing abstraction as the artistic and intellectual mainstream in America as well as in Europe. Through these movements, modern artists engaged in the process of redefining art and interpreting the post–World War II culture that had spawned it.

During the economic boom of the postwar era, American culture became bold, aggressive, and unabashedly materialistic and youthful. The children born in the baby boom after the war grew up barraged with the mass media: radio, television, movies, magazines. Their parents bought large cars,

whose styles changed every year, and many lived in sprawling suburban communities with shopping malls and fast-food chains.

In 1949 the Soviet Union detonated its first atomic bomb, and America entered the cold war and the arms race; as fears of Communist infiltration prompted the notorious McCarthy hearings, billions of dollars were spent on armaments, powerful enough to destroy the planet. The years between 1945 and 1970 were punctuated by American military engagements overseas, domestic violence, and youthful activism, as well as by momentous scientific triumphs: the period included the Korean War; the assassinations of John F. Kennedy, Martin Luther King, Jr., and Robert Kennedy; the civil rights movement; the Vietnam War; antiwar protests and campus riots; the Kent State killings of 1970; and the space program that put the first man on the moon.

The arts, much like the rest of America, were bursting with energy—an energy that found its most effective expression through abstraction, which from the 1940s on was absorbed into the American vision. Dedicated to combining abstraction with expression and inspired by Cubism, Dada, Expressionism, and Surrealism, the Abstract Expressionists forged a visual language that transcended these sources to become something new. Paint exploded on the canvas, gestures became not only broad but heroic. Canvases were not merely large but enormous, and the images they contained had little, if any, reference to visual reality. Developed during the late 1940s and early 1950s, Abstract Expressionism dominated American painting for well over a decade, gaining notoriety after a major exhibition at the Museum of Modern Art in 1951. The bold, seemingly arbitrary splashes of paint prompted anger and confusion among audiences and challenged other artists worldwide. For the Abstract Expressionists, the picture surface was all-important; on it, the main purpose was to record the emotions and physical movements of the artist. The final image was not the result of a preconceived idea, but of the process of making the work.

Jackson Pollock (1912–1956) was the hero of the movement toward both abstraction and Expressionism. Born in Wyoming, Pollock grew up in California. In 1929, he moved to New York, where he studied with the influential regionalist painter Thomas Hart Benton, whose interest in covering the entire surface of the canvas with energetically moving forms affected Pollock's work. Equally important to Pollock were his acquaintance in New York with the Russian émigré artist Arshile Gorky; his awareness of the Surrealists, such as Miró; and the abstractions of Kandinsky. From these sources Pollock developed a style that made paint, action, and canvas coalesce in a wholly personal and original way. Laying a large expanse of unprimed canvas on the floor, Pollock moved around its edges, letting dripping swirls of color fall from his brush. A visual paradox, reflecting contrary notions such as control and pure accident, identity and anonymity, drawing and painting, comes together in an image of continual motion contained within a single plane. Between 1948 and 1951 a series of monumental canvases resulted from this process, sometimes called action painting, which have in common large size, numerous threads of color, sweeping overall movement, and complex visual rhythms. One of the finest of the group is *Lavender Mist* of 1950 [p. 305], which, with its elegant and lyrical distribution of colors and textures over the entire canvas, has been compared to Monet's late series of water lilies.

Pollock's huge paintings, which sometimes rival the size of murals and create a visual environment, departed from the tradition of easel painting which had existed since the late Middle Ages; even radical modernists such as Picasso had worked on easels, but Pollock's work was executed on the floor. Pollock also experimented with many kinds of paint, including metallic house paints. After his "drip" paintings, he continued searching in new directions, returning to the brush and on occasion to the figure.

Willem de Kooning, Pollock's slightly older contemporary, was less abstract in his subject matter but equally expressive in the manner in which he handled paint. Born in 1904 in Rotterdam, de Kooning came to the United States in 1926 and soon joined the circle around Gorky in New York. Retaining an interest in the human figure, de Kooning painted a series called *Woman* in the 1940s and 1950s. But he too made paint itself the principal "subject" of his work, using it to describe a figure perpetually in the state of becoming or dissolving into paint. De Kooning fragmented the figure into areas of pigment, applied with such gestural power

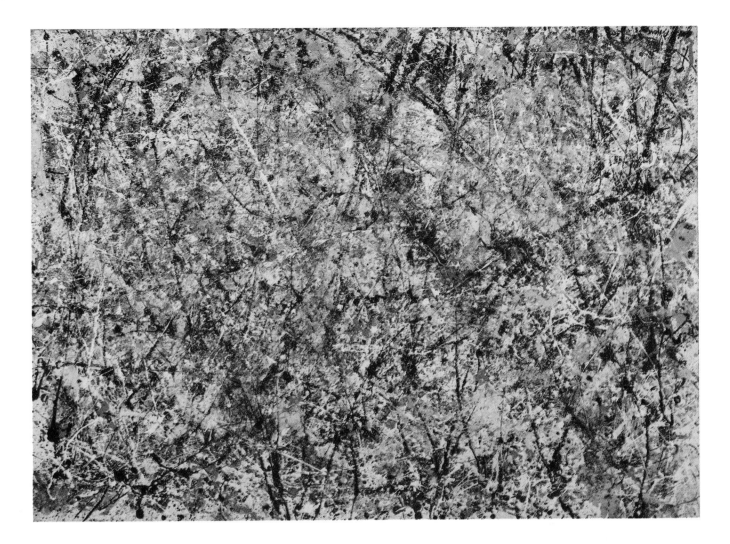

JACKSON POLLOCK, LAVENDER MIST, 1950. *Nearly ten feet long, this painting of swirling forms seems to reflect the artist's giving up control and letting the accidents of paint splashing on canvas yield the image. While Pollock abandoned control in the conventional sense, he did rework his paintings and destroyed many canvases that did not convey the rhythms and arrangements of color he was seeking.*

that he has often been called a gesture painter.

De Kooning's search for an expressive and intense mode of interpreting the figure resulted in portrayals of women that were alternately lyrical and brutal. *Woman I* of 1950–52 [p. 306], is one of the most famous of the series. An archetypal female is portrayed, following an interpretation of women that had emerged with particular power in the late 1890s among artists such as Munch and Klimt. Both a totem for gender and a vessel for raw human emotion, de Kooning's subject has a long tradition, but

his means for painting it was radical. The figure neither emerges out of nor occupies a three-dimensional space; it exists within a spaceless environment of strokes of paint that slash and smear the figure into being and non-being. Thick and sensual, paint is the visual analogue of the subject, and it both dominates and describes her form. By retaining a subject beyond that of his own psychic state while painting, de Kooning was deliberately avoiding the purely "autobiographical" nature of Pollock's work, which seems to record only his emotional state through the medium of paint and lets the subject (albeit highly personalized in its interpretation) remain a screen between artist and viewer.

De Kooning's work has continued to alternate between pure abstraction and rudimentary subject matter. His handling of paint, gesture, and color has

not only enabled generations of younger painters to understand the nature of the material but also reveals, in a new way, the painterly quality of earlier painting.

Abstract Expressionism had an immediate impact worldwide. Picasso, then in his seventies, had already anticipated the potential for pure abstraction with Cubism but still chose to retain the figure, and derided the abstraction of his descendants as antithetical to humanity. The public was generally outraged by Abstract Expressionism, but scores of artists abandoned realism and switched to the bold and vigorous potential it offered. Dominating the artistic scene, Abstract Expressionism rendered most realism obsolete and affirmed the modernity of contemporary art. The properties of color, the impact of scale, and the heroic, expressive, and personal yet strangely anonymous effect of these painted emblems of both the disintegration and the reintegration of form seemed suited to an age that had seen humanity both glorified and diminished by war and technology.

While Pollock and de Kooning were using gesture, other painters emphasized different aspects of Abstract Expressionism. Interested principally in relations between one color and another, Mark Rothko (1903–1970) developed a style that depended much less on distinctive individual paint marks; he concentrated instead on building up large areas of color. Born in Russia, Rothko emigrated to the United States in 1913. After studying briefly at Yale, he moved to New York. Rothko was at first attracted to Surrealism, but in the 1940s he began to experiment with less associative imagery, creating large, floating areas of incandescent color that hovered over other color fields. Eventually these experiments matured into rectangles of colors, dense yet strangely translucent, existing within colored fields. In contrast to the violent emotion of de Kooning's art, Rothko's works are calm and reflective. Instead of idiosyncratic brushstrokes, there is a dense, nearly impenetrable and indecipherable area of color. Known as color-field painting, Rothko's luminous images such as *Orange and Yellow*

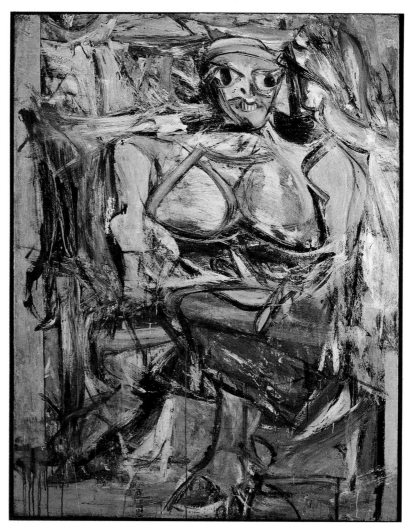

WILLEM DE KOONING, WOMAN I, 1950–52. *Slashes of paint that both build and dissemble the form,* Woman I *is a vivid record of the creative and destructive forces in the process of making art. The sense of violent struggle in his work made de Kooning a hero to the next generation of painters.*

of 1956 [p. 307] have a strongly spiritual quality. With their lack of specific subject, like other abstract works, they attempt to convey universal significance.

Rothko's permutation of Abstract Expressionism was the earliest of the many refinements and reinterpretations of this movement that marked the history of American painting in the fifties, sixties, and seventies. Like the modernist art of the early twentieth century, each required that the philosophical and intellectual basis of its predecessor be

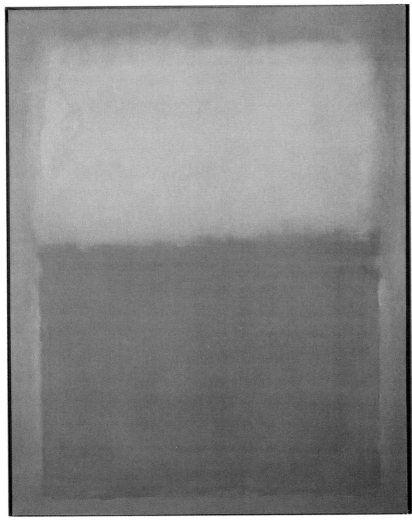

MARK ROTHKO, ORANGE AND YELLOW, 1956. *Rothko's large-scale imagery placed him among the Abstract Expressionists, but his choice of simple geometry links him to the classical abstraction of Mondrian.*

ties in New York after studying at the Maryland Institute of Fine Arts. About 1953, he began to experiment with acrylic paint, which is water soluble and gives a flatter finish than oil paint. Using unprimed canvas, Louis let the paint soak into the cloth, producing veils of colors. A beautiful example of this kind of stain painting is *Beth Aleph* of 1960 [p. 308]. Here luminous streams of color, with the delicacy of watercolor, flow over the canvas in transparent washes. As "automatic" as Pollock's drips, Louis's stain paintings, like Rothko's color-field paintings, are a tribute to color: pure and graceful.

The expressive potential of pure form explored by the Abstract Expressionist painters was inspirational to numerous American sculptors of the period, including David Smith and Alexander Calder. Smith was born in 1906 in Indiana. An early job in an automobile factory gave him not only basic skills in metalworking—he was one of the first American sculptors to weld his pieces—but also an appreciation for the shape, volume, and tactility of manufactured metal objects. Traveling to Europe in the 1930s, Smith encountered Cubism, Surrealism, and Constructivism, as well as some welded metal sculptures by Picasso, all of which had an impact on his art.

Smith experimented with various kinds of metal constructions, including some fascinating painted assemblages in the 1930s and 1940s. Shortly before his death in an automobile accident in 1965, he began his *Cubi* series, which was to be highly influential [p. 309]. For Smith, the essentials of sculpture were solid and void, balance and energy. In constructing cubic forms of various dimensions from stainless steel, burnished and welded, he created abstract assemblages of form, weight, and mass. With heroic proportions not unlike those of Abstract Expressionist paintings, Smith's *Cubi* show the dynamic relationships that could exist between masses and the space they occupy. Intended to be seen outdoors against the landscape, the burnished steel caught the natural light and gave particular vitality to the open spaces between the forms.

Smith's contemporary Alexander Calder (1898–

understood. The visual arts, like contemporary music and poetry, had become a dialogue among artists, and its messages rarely managed to reach beyond the knowledgeable few. Not intended for a general public, contemporary art remained misunderstood and unappreciated by it.

In the aftermath of Abstract Expressionism, artists searched for new ways to interpret the flatness of the canvas and to let color speak. One of the pioneers of that search was Morris Louis (1912–1962). Born in Baltimore, Louis spent the late thir-

MORRIS LOUIS, BETH ALEPH, 1960. *Louis's "stain painting," where the paint soaks directly into the canvas, is the modern-day analogue to medieval and Renaissance frescoes, where paint was bonded with the plaster of the wall. Louis's lyrical veils of color are among the most beautiful of the permutations that developed out of Abstract Expressionism.*

1976) also experimented with relationships between mass and space but took his sculpture one step further—to actual motion. The son and grandson of two well-known Philadelphia sculptors, Calder arrived in Paris in 1926 after taking a degree in mechanical engineering. Strongly influenced by Mondrian, Miró, and the Constructivists, as well as by the Surrealists, Calder quickly developed a sculptural style in metal. For Calder, metal was a modern material because it embodied the "power, structure, movement, progress, suspension, destruction, brutality" of the twentieth century.

Calder's best-known works are his mobiles, moving sculptures of abstract forms connected with rods and wire [p. 310]. Suspended in the air, these assemblages are either machine driven or set in motion by surrounding air currents. Because they are often made of separately joined sections, parts of the sculpture move independently, resulting in a variety of interrelationships of forms. The elegant shapes of Calder's mobiles, with clearly defined edges and often in bright, clear colors, are reminiscent of Matisse and Picasso and of the Abstract Expressionists. Witty and decorative, Calder's sculpture found wide public acceptance.

Calder also created large non-moving sculptures that he called stabiles, which consisted of vigorous planar shapes intersecting and springing up from several points on the ground. His works signaled the acceptance of a new sort of public sculpture, which no longer represented famous or powerful individuals in bronze or stone in the tra-

dition that had prevailed from ancient Greece to the early twentieth century.

The lack of figuration and issues of "representation" confronted all abstract artists in the wake of Abstract Expressionism. One group of artists reacted by emphatically choosing recognizable subject matter instead of dealing with purely painterly issues. To Robert Rauschenberg and Jasper Johns, art was, as it had been for the Dadaists and Surrealists, an intellectual process, where issues of reality versus unreality, meaning versus context, specific versus universal were studied anew.

Rauschenberg (born 1925) was first exposed to Dada ideas by the composer John Cage, whom he met at Black Mountain College in North Carolina in 1952. Cage, who was creating collages of everyday sounds as part of his music, helped inspire Rauschenberg to incorporate common objects into his works. Combining the painterly abstract style of the Abstract Expressionists with the found objects of Dada, Rauschenberg created collages, as well as three-dimensional "combines." A blending of the banal and the sensational, Rauschenberg's collages of images derived from magazines and newspapers were often assembled and distilled through silkscreen, a reproduction process by which multiple prints could be achieved. His ironic multiplication of mass-produced images rendered them anonymous and repetitive, underscoring the mass-media culture to which he was responding.

Rauschenberg's *Retroactive I* of 1964 [p. 311] juxtaposes images (at the lower right) that recall the biblical tale of the expulsion of Adam and Eve with man's space exploration (at the upper left). Like a modern-day Schwitters, Rauschenberg has assembled a flotsam of mass-produced materials; but in contrast to those of his Dada predecessors, his im-

DAVID SMITH, CUBI XVIII, 1964. *Smith's handling of abstract shapes is comparable to the works of Jackson Pollock and a number of other Abstract Expressionists. The Cubis have had a major influence on contemporary sculpture.*

ALEXANDER CALDER, RED PETALS, 1942. *Calder's sculptures often have a whimsical, charming quality, enhanced by their seemingly serendipitous movements.*

ages have obvious meaning. For example, a photograph of John F. Kennedy, perhaps taken at his inauguration, is an ironic reference to the start of a career abruptly ended by assassination in 1963. Surrounded by such common objects as fruits lined up on a grocery shelf, the image of the president is a visual analogue to the mixture of momentous and ordinary events and of images that make up everyday life. Vigorously holding to the picture surface with the aggressive black and white shapes along the top and the shadowy, almost X-ray–like imagery along the bottom, Rauschenberg "painted" both with his subtle distribution of color and shapes and the interjection of painterly gestures. The distant past, the immediate present, the mundane, and the historic are fused in a sophisticated mélange of color fields and superimposed images, collage, and paint. Conjuring up memories, associations, and emotions, this work has the spontaneity of an Abstract Expressionist work and the evocative quality of Surrealism.

Jasper Johns (born 1930) shares with Rauschenberg a rootedness in the paradoxes of reality formulated by Duchamp's experiments with Dada. Born in Augusta, Georgia, Johns moved to New York in 1959, where he worked closely with Rauschenberg. Johns's interest in challenging established notions of reality and illusion made him one of the pioneers of Pop Art, in which images from popular

culture (also part of Rauschenberg's idiom) are transformed into objects of art.

Johns's paintings of flags and targets done between 1954 and 1959 are now considered among the foremost works of American modernism. Shocking when first exhibited in 1958, Johns's *Flag* series [p. 312] demanded that the viewer think about and give new meaning to a well-known image. They posed numerous artistic paradoxes: Is this an object or an image? Does it occupy space? What gives this image its meaning—the way it is painted or the subject? Sophisticated essays on the relationships between art and reality, Johns's early work, like that of the Dadaists, used subjects that were part of common experience. Unlike Rauschenberg, who altered discarded or found objects, Johns "created" his objects—targets, flags, numbers—but both artists utilized images and objects that were commonplace.

The interpretation of reality also inspired the ambivalent and paradoxical figure sculptures of George Segal. Born in 1924, Segal began his career as a painter before turning to sculpture. About 1960, he began making white plaster casts of actual people and placing these reproductions of reality within a real, environmental setting. His *Bus Riders* of 1964 [p. 313], for example, is an eerily lifelike yet unreal portrayal of an ordinary experience. Segal often presents people and events in such a way as to suggest loneliness and alienation. Pale, ghostly, alienated from one another though assembled in a group, Segal's characters participate joylessly in one of the mundane rituals of modern life. Often compared with Hopper's portrayal of the depersonalization of urban existence, Segal's work also has a great deal in common with the art of Rauschenberg and with Rauschenberg's interest in the relationship between art and life. Both Rauschenberg and Segal work with assemblages, but Segal's work is more emphatically figurative, while Rauschenberg, Johns, and the Pop

ROBERT RAUSCHENBERG, RETROACTIVE I, 1964. *By altering illustrations from magazines and newspapers through changes in their color and size, and by juxtaposing images, Rauschenberg not only added the element of artistic control but also strengthened the narrative meaning.*

movement they helped spawn isolated and examined various dimensions of popular culture.

Pop Art gathered momentum in the early sixties, borrowing elements from popular culture and transferring them to the sphere of the fine arts. Andy Warhol (1930?–1987), who began his career as an advertising illustrator, gained notoriety by adopting

JASPER JOHNS, <u>FLAG</u>, 1954. *In choosing images like the American flag, Johns presented the viewer with a symbol whose intrinsic meaning was at once underscored and ironically changed. Such paradoxical reuse of well-known icons in the hands of an artist was a basis for Pop Art.*

the images of commercial art for his work. Warhol created silkscreens of universally recognized images—from Campbell's soup cans to photographs of celebrities—to underscore the anonymous replication of these icons. Perhaps his most famous works are his 1962 silkscreens of Marilyn Monroe [p. 314]. A mass product from a mass culture, endlessly reproducible yet, in the context of the fine arts, increasingly valuable, these images were intentionally of the moment, emphasizing Warhol's notion that everyone could someday be famous for fifteen minutes.

Roy Lichtenstein (born 1923) made a bastion of pop culture—the comic strip—his subject. He turned to comics in the early 1960s after experimenting briefly with Abstract Expressionism. Lichtenstein often "reproduced" one or two frames, as in *Whaam!* of 1963 [p. 315]. Though his works were not replications of actual comics, Lichtenstein went to great pains to make them appear so by enlarging each element of his "source," including the printer's dot. The arrangement of dots and the various other properties of line and color added a formal high-art element to the simplified and trivial violence of the comics. Thus, ironically, a commercial artifact became an object of fine art, hung in art museums.

What Pop painters did with two-dimensional images, Pop sculptors did with objects. Claes Oldenburg (born 1929) developed first as a painter and then turned to sculpture, becoming one of the most famous of the Pop artists. Oldenburg's subjects are

GEORGE SEGAL, BUS RIDERS, 1964. *Segal's compelling fusion of reality and unreality, which gives ordinary experiences a profound impact on the viewer, is well shown in this assembly of bus riders. The portrayal of actual people through the medium of plaster casts increases the effect of isolation and loneliness.*

In an age without heroes, the twentieth century has turned increasingly to ordinary human existence for its inspiration. People living out their lives became a subject for the sixties. After working in fashion photography, Diane Arbus (1923–1971) began to utilize the camera to make candid and sometimes shocking images of those who might be regarded as the real heroes of our time—the retarded, the exceptional, and those for whom the riddle of identity is part of their daily existence. Her portraits, which make those phenomena inescapable to us, are indelible

A JEWISH GIANT AT HOME WITH HIS PARENTS IN THE BRONX, N.Y. 1970

records of the mythic that lies within the ordinary.

ANDY WARHOL, <u>MARILYN MONROE DIPTYCH</u>, 1962.
Warhol's images of Marilyn Monroe helped establish him as a Pop artist. He repeated portraits of Marilyn either as single silkscreened images or as paintings such as this diptych, with the fifty images of Marilyn identical except for alterations of color or shading.

objects so commonplace—the clothespin, the three-way plug, the Swiss army knife, the spoon—that in everyday life no one notices them. But Oldenburg makes the viewer experience and examine them as designed objects on an enlarged scale. Oldenburg's sculptures, like much of Pop Art, are witty and ironic in the isolation and aggrandizement of their subjects. By changing the materials out of which the objects are ordinarily made—by making a clothespin out of steel or a hamburger out of painted cloth or a typewriter out of soft vinyl—Old-

enburg, with whimsy and imagination, transforms the pedestrian and helps viewers to see and experience it in a new way. Oldenburg's development of "soft sculpture"—his *Soft Toilet* of 1966, for example [p. 315]—and his interest in taking common objects out of their normal context is similar to that of Surrealism. As is true with most Pop artists, Oldenburg's principal aim is to amuse and, in a sense, to tease and disorient or disturb. By memorializing and commemorating objects that are in actuality disposable and mundane, Oldenburg has built on the philosophical premises of Dada.

Another descendant of Cubism and Dada was the sculptor Louise Nevelson (1900–1988). Born in Kiev, Nevelson studied in New York and briefly in Munich in 1931; she began exhibiting in New York in 1941. Her mature work consists of sensitively arranged collages of found objects—scraps of wood,

CLAES OLDENBURG, SOFT TOILET, 1966. *Oldenburg's soft toilets are both witty and nightmarish.*

architectural moldings, even buoys. One of her finest works, *Royal Tide IV* of 1959–60 [p. 316], shows her ability to sustain and expand the relationships of disparate forms over vast visual tracts. Her work, with its pacing, syncopation, and rhythm, has affinities to music, just as Kandinsky's and many other abstract artists' have. She creates beauty without irony, much as Schwitters did. Nevelson assumes the traditional responsibility of providing a primarily aesthetic experience, though her subject matter has something in common with pop culture through her adaptation of undistinguished objects.

During the years that Abstract Expressionism gave way to color-field painting and Pop Art, one group of artists developed color-field painting into a refinement known as hard-edge abstraction. Ellsworth Kelly and Frank Stella are the best-known exponents of this style. Kelly (born 1923), who was trained in both the United States and France, contin-

ROY LICHTENSTEIN, WHAAM! 1963. *Thirteen feet long, this gigantic imitation (not reproduction) of a fictive comic strip shows the banal and violent tastes of pop culture.*

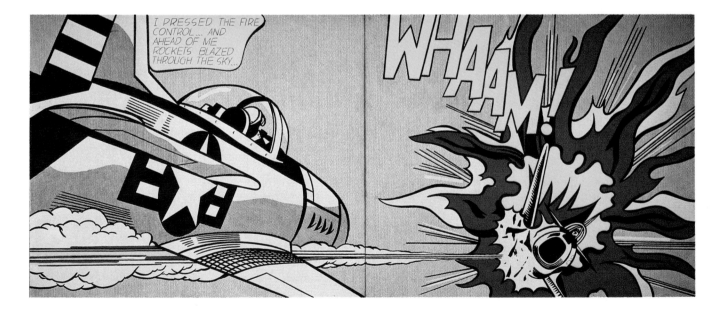

ued to explore the nature of color relationships begun by Matisse, the Bauhaus painter Josef Albers, and color-field painters such as Mark Rothko. In such works as *Yellow-Blue* of 1963 [p. 317], Kelly eliminated the figure-ground relationship still essential to the Abstract Expressionists and such earlier color-field painters as Rothko and Louis. Here pure planes of color have simple shapes defined by clear, crisp edges.

Frank Stella (born 1936), who studied at Princeton, settled in New York in 1958. There he began his experiments with color and shapes that led to his own alternative to the subjective and emotional potential of Abstract Expressionism. Adopting the clear, bold, and emotionally detached language of geometric shapes and brilliant colors, Stella produced a series of variations on a theme. In his *Tahkt-I-Sulayman I* of 1967 [pp. 302–3], for example, he used the circle and developed a sequence of interrelated forms mechanically described and embellished with unmodulated color. Mathematically precise, impersonal in appearance, Stella's immediately successful and decorative images were the perfect artistic analogues to the vast, modern public spaces they so often graced. With its

LOUISE NEVELSON, ROYAL TIDE IV, 1959–60. *One of many contemporary artists to develop collage, Nevelson built assemblages of found objects into "sculptural walls" such as this one.*

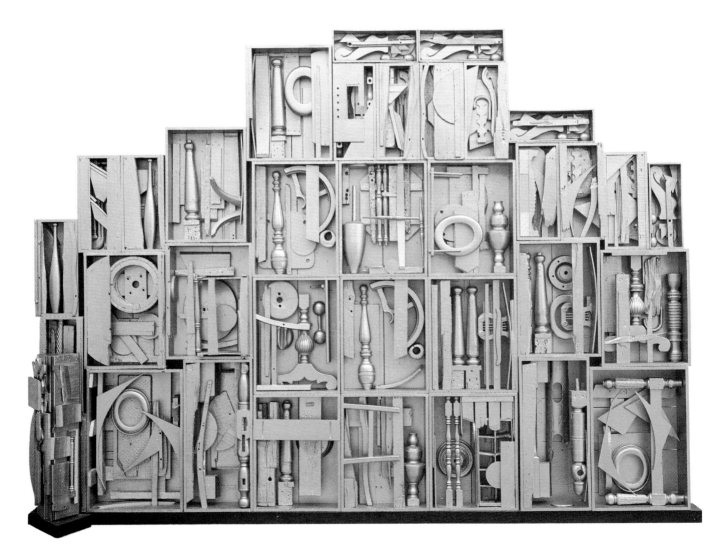

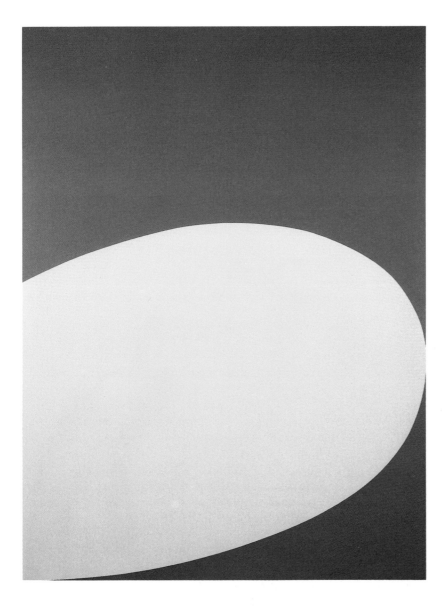

ELLSWORTH KELLY, YELLOW-BLUE, 1963. *In this painting emphasizing the properties of pure color, the rounded yellow shape seems to push and expand within the enveloping blue form.*

of 1969 [p. 318] are characterized by simplicity and restraint. Pure geometry in polished metal, these boxes are, by their repetition and their proportions, an elegant, decorative, and remote expression.

Minimalism in painting and sculpture had a significant antecedent in modern architecture, particularly that built by members of the Bauhaus school who had emigrated to America during World War II. Mies van der Rohe became the dean of architecture in the new Illinois Institute of Technology in Chicago. Mies and Gropius brought with them the Bauhaus ideal of highly functional, severe, and unadorned architecture, something new to the American scene. Almost immediately, this classless, undecorated style began to rival and then replace the indigenous American architecture of Wright and his contemporaries.

The sleek, efficient, and authoritative Bauhaus style was perfect for the corporate image of booming postwar America, and both Gropius and Mies were commissioned to build a number of corporate headquarters in New York. Gropius's Pan American Building of 1958 [p. 319] is one of his least successful structures, looking, with the passage of time, like so many of the other Bauhaus products, dated and unattractive. Lacking both clear articulation and elegance, the building seems a strange and failed transference of the idealistic Bauhaus workshop principles to the streets of corporate America.

A much more notable and influential structure is Mies's Seagram Building built in New York between 1954 and 1958 [p. 319]. The polish and refined detail of Mies's style is here seen in the sleek, soaring box of steel and tinted glass, the direct descendant of Mies's revolutionary glass towers of 1919–21. The building is the image of commercial

pared-down and pristine qualities of color and shape, Stella's work was related to and anticipated Minimal Art.

Minimalism, which ultimately derived from the work of Malevich and the Constructivists, dismissed any reference to the hand, gesture, mood, or idiosyncrasies of the artist. Instead, the anonymous, cold, indifferent, and seemingly mechanical forms that have at their core some mathematical relationship were offered as an alternative to the barrage of imagery in modern life and its primary champion, Pop Art. Minimalism can best be seen in the work of Donald Judd (born 1928), whose untitled boxes

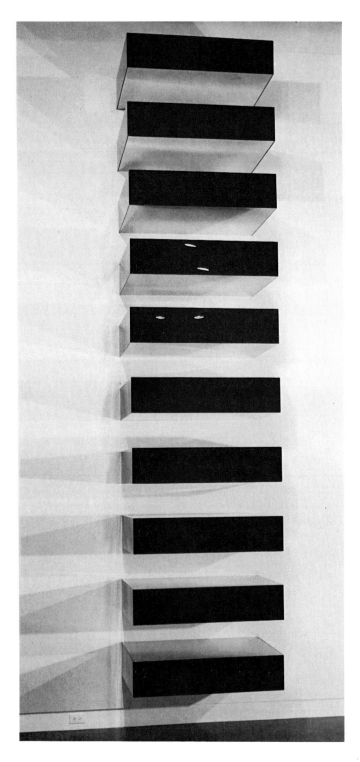

DONALD JUDD, UNTITLED, 1969. *Judd's simplified, purely geometric shapes were inspired by architecture rather than sculpture. The primary shapes, assembled in a regular, mechanical progression, have the monumental feeling of contemporary skyscrapers.*

success—rational, efficient, polished, and pure in its design and execution; but, like most of Mies's structures, it is a building that inspires cold intellectual appreciation rather than fervent enthusiasm.

During the immediate postwar decades, the International Style of Bauhaus-inspired architecture predominated; it was the modern, theoretically acceptable mode of plan and building. Its influence was enormous and was felt in every aspect of architectural design. Yet, a number of important architects refused to be affected by what they considered the impersonal, machinelike face of these buildings, and they offered, instead, a much more personal alternative.

Frank Lloyd Wright continued to be principal among these architects. Wright's genius and fiercely independent architectural thought are evident in the Solomon R. Guggenheim Museum in New York [p. 319], designed in 1943–46 but completed only in 1959, several months after his death. For the Guggenheim, Wright rethought the traditional idea of a museum and substituted a spiraling, central gallery ringed by a viewing ramp. Wright's plan is strikingly original, and the bulging, smooth sculptural shapes are a challenge to the Bauhaus architecture, which Wright loathed. Whereas the Bauhaus was restrained and proper at all times, Wright is bold, expressive, and expansive.

Wright's individualism was paralleled by several other inventive American architects working in the fifties and sixties. Eero Saarinen (1910–1961), the American-educated son of a well-known Finnish architect, rejected the rigid right angles of the International Style in his dramatic terminal for Trans World Airlines of 1956–62 at New York's Kennedy Airport [p. 320]. The huge, weighty concrete structure resembles a pair of wings, and the upward lunge of the roofline gives the entire structure a soaring feeling entirely appropriate for an airline terminal.

Such evocative architecture is a great contrast to the cool and restrained International Style, which used a single idiom for structures with widely varying functions. For instance, in the campus Mies designed between 1943 and 1956 for the Illinois Institute of Technology in Chicago [p. 321], all the structures—classroom buildings, office buildings, and chapel—were undifferentiated in style. For the TWA terminal Saarinen rejected such uniformity and

WALTER GROPIUS, PAN AMERICAN BUILDING, NEW YORK, 1958. *(left) The pile of Gropius's Pan Am Building dwarfs and diminishes Grand Central Terminal, behind which it is placed.*

MIES VAN DER ROHE, SEAGRAM BUILDING, NEW YORK, 1958. *(right) Like Mies's Barcelona Pavilion, the Seagram Building has Mies's great elegance and restraint.*

FRANK LLOYD WRIGHT, SOLOMON R. GUGGENHEIM MUSEUM, NEW YORK, 1959. *(below) The Guggenheim Museum, one of Wright's last buildings, is both brilliant and eccentric.*

EERO SAARINEN, TWA TERMINAL, KENNEDY AIRPORT, NEW YORK, 1962. *The drama and sweep of Saarinen's TWA Terminal remains impressively original.*

made the building's shape indicative of its function. The architecture of the International Style was functional and demonstrative of the aesthetic theory behind it, but it seldom expressed the particular emotional associations evoked by specific building types. Consequently, such architecture is almost always a failure in buildings such as churches, where a particular architectural expression is an essential ingredient.

Further rejection of the planar, boxlike configuration of International Style architecture is evident in the highly influential Art and Architecture Building (1963) at Yale University by Paul Rudolph (born 1918) [p. 321]. Like Wright's Guggenheim Museum and Saarinen's TWA terminal, Rudolph's building is extremely sculptural. It is given volume by a series of towers and projecting facades. The parts of the building move out into the surrounding space in a seemingly irregular manner, and the structure displays a drama and splayed mass that is in some ways reminiscent of Wright's bold Larkin administration building. The Rudolph building is almost brutal with its jagged shapes and stark alternation of mass and void, but the effect is powerful. In the Art and Architecture Building, Rudolph has moved decisively away from the ideals of one of his mentors, Walter Gropius.

The constrictions of the International Style were also abandoned by Le Corbusier, who had been one of the pioneers of austere, hard-edged architecture between the world wars. Le Corbusier's Notre-Dame-du-Haut at Ronchamp of 1954 [p. 321] is a dramatic structure whose overall shape is vastly different from the rectilinear forms of his earlier architecture. As in Saarinen's TWA terminal, the heavy concrete of the structure appears to soar, and the building resembles the prow of a ship cutting through space. An almost medieval feeling is created by the great mass and narrow fenestration. The strip windows of Le Corbusier's earlier buildings have been replaced by a series of slits seemingly placed at random. The whole structure has a new capriciousness and daring.

The decades of the fifties and the sixties thus saw both the hegemony of the International Style in Europe and America and, simultaneously, the first reactions against it. By the 1970s, architecture and the visual arts had been swept up in a reaction against the theories and styles that had evolved around the time of the First World War. The aims of the Bauhaus were beginning to be seen as part of the past. Moreover, these theories were now under attack, as architects and critics began to react against the sterility that unfortunately was a legacy of the International Style.

As artists and architects assimilated, developed, or rejected the approaches of their predecessors, the relationship of their work to the immediate present was increasingly important and their distance from the cultural past ever more evident. Each successive movement seemed to refine and reduce the scope of its ideas and to narrow its dialogue with the past as well as with the present. The shock of newness had been replaced by an expectation of newness. Though artistic progress, change, and modernity were and are inevitable, recently the

ability for art to perpetually change seemed exhausted, and the necessity for art to look only to the present and the future without mining the past was openly doubted. In liberating art from function and in proclaiming art for its own sake, in searching for art that would endlessly shock, challenge, chastise, satirize, revolt, and thereby inspire social change, artists had failed. Their failure was in part the result of their earlier success at separating function from form and function from art. The true message carriers were the advertisements, the billboards, the magazines, television, and films, which, when parodied by artists, very often said much more about art than about society. In dealing with issues that were largely for and about art, artists spoke in terms not accessible to the very society they hoped to change; at the same time, generations of audiences were conditioned to expect newness. The place of the artist as a reinterpreter of the past had been supplanted by the role of the artist as creator of modernity and the future. Many of these artists had pushed issues to the extreme and had ignored or departed from the notion that art could nurture and sustain the viewer, could transcend its time and endure, could build the future out of looking at and mining the past. But in the last decades of the twentieth century, that radicalism seems to have ended; the art world is fragmented, but the potential for expression in the post-modern era is more diverse, allowing tradition back into the fold.

MIES VAN DER ROHE, ILLINOIS INSTITUTE OF TECHNOLOGY CAMPUS, CHICAGO, 1943–56. *(top) Mies's campus was a departure from the traditional American type, which utilized Gothic or Romanesque motifs to establish a link with tradition and the past.*

PAUL RUDOLPH, ART AND ARCHITECTURE BUILDING, YALE UNIVERSITY, NEW HAVEN, CONNECTICUT, 1963. *(above) Rudolph's handling of architectural volume and massing is highly abstract and often startling.*

LE CORBUSIER, NOTRE-DAME-DU-HAUT, RONCHAMP, FRANCE, 1954. *(right) Le Corbusier's severe, planar early architecture gave little hint of the expressive qualities of this highly original church.*

RICHARD ESTES, WOOLWORTH'S, 1974. *Rendered with the nearly obsessive attention to detail and description of reality found in fifteenth-century Northern painting, Estes's Photo-Realist paintings depend as much on what the camera sees as on what the eye sees.*

[17]

ART IN THE POST-MODERN ERA

By the late 1960s and the early 1970s, the prevailing notion of modernity, which had pushed the limits of art beyond previous boundaries, had begun to lose its urgency. Critics called the new pluralistic era which the West was entering Post-Modern. While the terminology of modernity—being on the "cutting edge," "pushing the limits," and "being of the time"—is still current, the shock waves that Cubism created at the century's beginning have been reduced to minor ripples. There are renewed calls for "interpreting the past," for "utilizing tradition," and for art to transcend the moment and to have enduring value. Furthermore, the predominance of America and the New York scene is diminishing, and artistic leadership is now international.

In this era of pluralism and diversity, the sole common thread that runs through contemporary art is its intellectual and theoretical basis, regardless of style. Art may range from the purely conceptual to a ravishing demonstration of technical virtuosity that articulates or visualizes an idea. Moreover, antifunctionalism, an intellectual premise first espoused more than a century ago, has not only affected the fine arts but also has permeated every craft, transforming weavers, potters, glassmakers, metalsmiths, and furniture designers into artists whose main purpose is the creation of art, not functional objects. Having liberated themselves from the

ROBERT SMITHSON, SPIRAL JETTY, GREAT SALT LAKE, UTAH, 1970. *More than six thousand tons of material, moved by heavy modern equipment, were used for the creation of this Earthwork, an artificial spiral on the northern shore of Great Salt Lake.*

past, from function, and from the necessity of manually producing their product, artists have gained enormous freedom, but they have lost much as well. Incessant modernity has generally negated the idea of durability, of an art that transcends the moment; thus "modern" art can rarely escape being dated. Also, for many painters and sculptors, the discipline and primacy of drawing, once an indispensable tool for all artists, has become irrelevant.

The modernist tendency to push the limits of art further has extended it far beyond the bounds of its traditional environments—museums, homes, public buildings and spaces—to include productions that can never be collected, owned, or exhibited in the traditional sense. Often preferring pure concepts over material, artists use materials in the broadest sense, including the natural environment: everything from neon lights, to computers, to the artists' own bodies has been adopted as mediums for modern art. Thus, connections between artist and art work can become so close as to be one and the same, as in the case of Body Art; or so far apart as to be nearly nonexistent, as when an artist telephones his instructions to workers in a museum to create an installation, resulting in a work that the artist himself has not seen or touched.

One of the most interesting developments in Conceptual Art in the 1970s and 1980s has taken place among sculptors of the environment. A pioneer among the creators of Earthworks was Robert Smithson (1928–1973), who died in a plane crash while working on one of his projects. During the late 1960s he became interested in transforming natural environments into works of art. His most famous effort was *Spiral Jetty* [p. 324], a 1,500-foot-long strip of rock and soil extending into Great Salt Lake in Utah. Built with large earth-moving equipment in 1970, *Spiral Jetty* was intended to invoke the universal symbolism of the spiral (whose potential had been adopted by Tatlin for his revolutionary tower in 1918), calling up associations with ancient pictograms, natural growth, and regeneration. *Spi-*

CHRISTO, "SURROUNDED ISLANDS" PINK FABRIC, BISCAYNE BAY, GREATER MIAMI, FLORIDA, 1980–83.
Working on a large scale, like many other modern artists and creating art that is more a brief experience and a memory than an object, Christo has transformed these islands by surrounding them with pink fabric.

task of moving, unfurling, and lacing the floating fabric. Using the traditional method of artistic collaboration, Christo enlarged his "shop" to meet the massive scale of his project. Perhaps more significant than the image itself was the fact that it existed for only two weeks; for the millions of viewers who came out of interest or curiosity, Christo's display helped them see the islands briefly in a new context. His drawings and designs for each project help to fund his subsequent efforts which, to date, have included wrapping various buildings, wrapping Little Bay on the coast of Australia in 1969 with one million square feet of cloth, and drawing a ¼-mile-long orange curtain across a valley in Colorado. Like Smithson and many other conceptually oriented artists, Christo relies on photography to help document his creations; it is through these photographs, one step removed from the work itself, that his art is generally known.

During the 1970s, realist painters who had retained an interest in the figure began to gain recognition, while others, trained in various traditions of abstraction, developed a renewed interest in realism. When the portrayal of the figure reemerged, one of the fundamental issues was how to draw and interpret it.

The realists who first gained recognition presented a psychologically neutral interpretation of the figure in their work, paralleling the cool, inexpressive attitude of most Minimal and Conceptual artists. One of the earliest experimenters with a dispassionate yet suggestive realism was Philip Pearlstein (born 1924). Trained as an Abstract Expressionist, he turned to the figure posed in the studio, which he explored for abstract compositional potential, rather than for emotional content. His work, beginning in the seventies, shows the figure arbitrarily cropped and framed in a way that makes the composition interesting but the body fragmented or oddly truncated. Though primarily a vehicle to describe surface and changes in light and contour, the figure is, because of its complexity and its humanity, more intriguing than purely invented form. However Pearlstein's treatment of the figure as form is deliberately detached. *Two Models in Bamboo Chairs with Mirror* of 1981 [p. 327] is an example of his ability to create intricate, nearly abstract forms out of the vast array of visual information supplied by the simple device of placing

ral Jetty, like many conceptual and environmental works, demanded that the viewer mentally transform the image into art. With Conceptual Art, as with its earlier permutations such as Dada, the viewer's responsibility has grown—his mental efforts have to be greater, and his visual pleasure is often supplanted by intellectual stimulation.

Smithson's completed works were intended to be relatively permanent. By contrast, Christo (born 1935), who emigrated to America from Bulgaria, is famous for his temporary transformations—by wrapping or covering everything from buildings to islands. A recent work was the surrounding of eleven islands in Biscayne Bay, Florida, with skirts of pink polypropylene fabric [p. 325]. Completed in May 1983 after years of planning, the project involved 430 workers, who helped with the enormous

models in the studio. Here, by looking down on his models, having the length of the room bisect the composition, and showing only parts of the bodies, Pearlstein has created powerful rhythms and diverse vantage points; the swirling forms of the chairs are as compelling as the forms of the figures.

Comparisons with Edward Hopper and fragmented antique sculpture, as well as references to a disturbing sexuality, have all been made about Pearlstein's work. But regardless of the interpretations of his paintings, it is their formal power that gives them such interest. The broad gestures that sweep through his images impart an energy that contrasts with the passivity of the subjects; the fluid compositions point to his origins with the Abstract Expressionists. Pearlstein's "abstract" figuration demonstrates that with the advent of abstraction, the figure could no longer be treated as it had been before Cubism and its aftermath.

Pearlstein's use of the model posed in the studio contrasts with another vein of realism that emerged in the 1970s and was based on the photograph. Both approaches have neutrality of subject matter in common, but the Photo-Realists, as they came to be known, portrayed what the camera did, enlarging and exploring the means by which the photographic image conveyed reality. One of the earliest experimenters in Photo-Realism was Richard Estes (born 1936). With cities as his subject, Estes utilizes the diverse information provided by a number of photographs to create such scenes as *Woolworth's* (1974) [pp. 322–23], a work that celebrates formal complexity and layers of illusion. As an unseen side of a street is mirrored in the glass of a Woolworth's store, the viewer is transported to an American street of the seventies, the modern descendant of Hopper's streets of the thirties. Though devoid of pedestrians (except for the viewer, who assumes his or her place wandering down the sidewalk), Estes's image does not suggest the quiet gloom of Hopper's scenes; the eye simply travels through the labyrinthine visual intricacies Estes has created. His paintings retain the clear, mechanical precision of photographic reality, as well as its objectivity, yet their scale, color, and elaborate nature transcend their origins.

Chuck Close (born 1940) also relies on photographs, concentrating on single snapshots of faces. Close transfers the photographic image, detail by

CHUCK CLOSE, FRANK, 1969. *Well over life-size, this enlargement of a photographic image is both disquieting and intriguing.*

detail, onto a large canvas [p. 326]. The great change in scale is often startling and faintly disturbing, for the result is not only a larger than life-size portrayal of a snapshot but a compellingly detailed view into the many distortions produced by the camera in its random transcription of the human face into light and dark registrations. By providing such an intimate glimpse into the microscopic world of photographic pixels, Close offers a new understanding of the limits as well as the potential of photographs as a standard of verisimilitude. Like Estes, Close uses airbrushes and various other mechanical techniques to achieve his dazzling techni-

PHILIP PEARLSTEIN, TWO MODELS IN BAMBOO CHAIRS WITH MIRROR, 1981. *"I've deliberately tried not to be expressive about the models I've been painting for almost twenty years now, not to make any kind of comment but just to work at the formal problems of representational painting in relation to the picture structure."*

cal exposition while maintaining a psychological distance from his subjects.

For Estes, Close, and numerous other Photo-Realists, the simultaneously literal and yet magical re-creation of photographic reality into paint is their primary subject, and meanings contained in the subject, though important, are there largely through

inference. Coolly presented, the image leaves itself open to various interpretations. In contrast, other artists have approached narration as it has been traditionally practiced. A contemporary explorer with figurative narration is Jack Beal (born 1931). In such paintings as *Hope, Faith, Charity* of 1977–78 [p. 329], Beal makes deliberate allusions to the past, not only by portraying a subject that has its roots in medieval allegory but by clearly borrowing lighting and gesture from such masters of narrative as Caravaggio. Studio models play the parts of medieval Virtues—ideals that remain part of our culture but have long since passed out of our pictorial lexicon. Though sometimes close to artifice, these narrative works are courageous attempts to resuscitate the past in a modern vein.

Sculptors have also reinterpreted the figure, creating a greater realism than has been seen for several decades. Duane Hanson (born 1925) is one of the best-known current American figurative sculptors, whose lifelike portrayals of people from Bowery bums to tourists have sometimes disconcerted visitors to his exhibitions—except for their immobility, his figures are nearly indiscernible from living people. His *Janitor* of 1973 [p. 328] convincingly captures the stance, expression, dress, and accouterments of a janitor, who, seemingly tired from his labors, leans against the wall. By so faithfully re-creating ordinary reality out of fiberglass, vinyl, hair, and clothes, Hanson shocks the viewer into seeing what would otherwise be ignored. Despite Hanson's seeming newness, the tradition in which he works is centuries old. Creating life-size figures, modeled on actual persons and dressed in contemporary costume, was one of the sculptural traditions of the West.

While many contemporary realists seek to make their interpretations pessimistic or neutral, a number of artists create more positive and personal imagery. David Hockney (born 1937), who rose to prominence in the 1970s, was trained in England but has become noted for his witty interpretations of American life. His *A Bigger Splash* [p. 331] of 1967 portrays the characteristic elements of California life: palms, a low-slung, modern house, and the ubiquitous swimming pool. Translated into delicate, simplified shapes that retain their meaning but are incorporated into a finely tuned visual statement of form, line, color, and texture, *A Bigger Splash*,

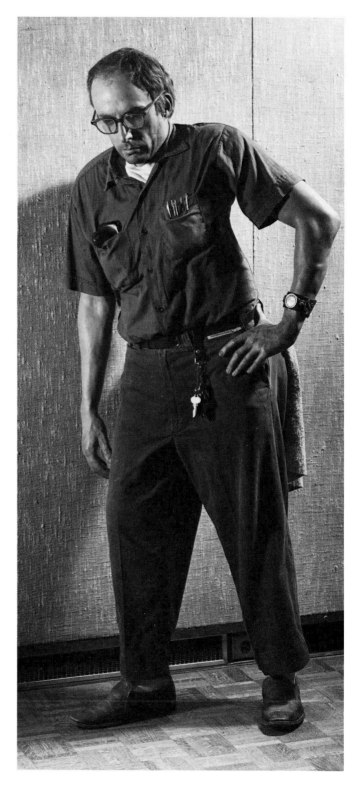

DUANE HANSON, JANITOR, 1973. *Hanson's sculptures portray, among others, janitors, shoppers, tourists, bums. All are highly realistic and are mixtures of both humor and pathos.*

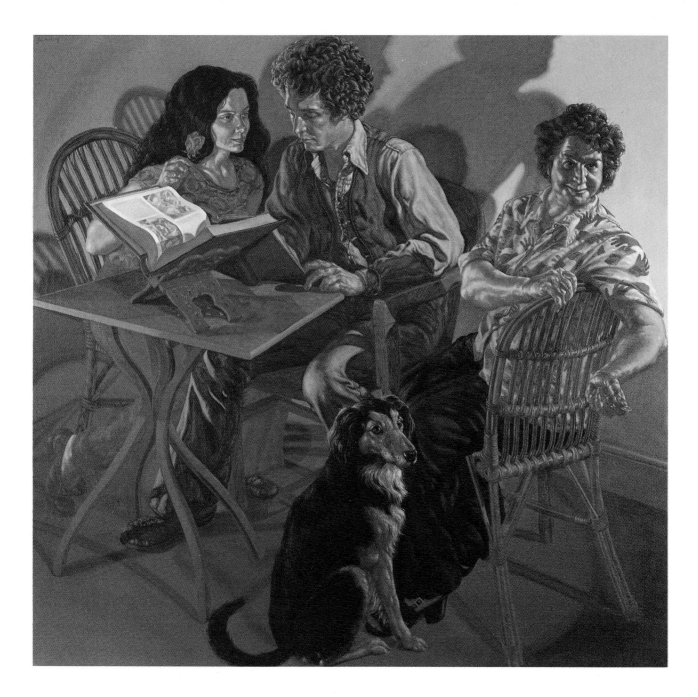

JACK BEAL, HOPE, FAITH, CHARITY, 1977–78. *Beal, like many contemporary artists, is interested in reviving the art of pictorial narration, which has fallen into general neglect in the twentieth century. Using models posed in a room, Beal re-creates a medieval allegory in which each figure means something and tells part of a story.*

with its strange silence, implies both motion and a powerful stillness. Besides using the time-honored convention of flatness, Hockney, like other contemporary artists who use the past, tends to be eclectic in his sources.

A dialogue with the past and its union with the present has also been important to the California painter Wayne Thiebaud (born 1920), whose pursuit of formalism, combined with images of contempo-

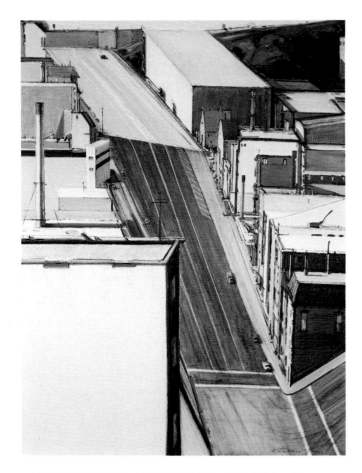

WAYNE THIEBAUD, <u>DOWN 18TH ST.</u>, 1980. *Thiebaud's transformation of a California street and buildings into a pictorial experience demonstrates interest among many realists in the 1980s in a particularly strong compositional formalism.*

rary life, has transcended the Pop era with which he was associated in the sixties. His work has resulted in such extraordinary portrayals of the urban landscape as *Down 18th Street,* of 1980 [p. 330]. Here the complex formal relationships made possible when a street is viewed from an unusual vantage point are depicted. By utilizing a fascinating combination of clarity and confusion, the repetition of patterns and forms, and the interplay of horizontals and verticals, Thiebaud has endowed his subject with a palpable beauty enhanced by the tension between realism and abstraction, which he underscores.

Thiebaud and Hockney are just two of the many older realists whose formal rigor is at the service of visually and emotionally enriching imagery. Increasingly gaining recognition, such painters as Louisa Matthiasdottir, William Bailey, Janet Fish,

Neil Welliver, and many others represent the continuing importance of the artist as the interpreter and transformer of visual experience into something beautiful and life-enhancing. They reaffirm the importance of realism in art, as other artists continue to validate the more recent traditions of abstraction.

Joan Mitchell (born 1926) has shown a sustained interest in the potential of painterly abstraction. Her *The Goodbye Door* of 1980 [p. 332] is a wonderful fusion of calligraphic marks, color, paint, and light, with a lyric quality of landscape and an optimistic vision. Her search for pure beauty in gesture and paint demonstrates that Abstract Expressionism still has a vital impact on contemporary painting.

A contrast to Mitchell's painting is offered by the work of Anselm Kiefer. Born in Germany in 1945, Kiefer developed as an artist during the hegemony of Op, Pop, and Minimalism, but it was Germany's Nazi history that shaped his mature *Departure from Egypt,* 1984 [p. 332]. Its dark coloration, exaggerated perspective, raw surface, and stark horizon, mirrors Jewish history from its origins to the gas chambers of Nazi Germany. Bleak and pessimistic, Kiefer's abstract paintings have gained attention for their powerful message, scale, and impact. Belonging to the long tradition of German art that maintained a censorious view of humanity from the Middle Ages well into the twentieth century, Kiefer's work demonstrates the continued vitality and necessity of this avenue of expression. His international stature also reflects the gradual cessation of American artistic supremacy.

The artistic ferment and relativism seen in the painting and sculpture of the 1970s and the 1980s have also been very much a part of the architecture of the period. By the early 1970s, it had become clear that the ideals and forms of modernism born in the first decades of the twentieth century were of insufficient inspiration for contemporary architects, and that the International Style had failed to fulfill its early utopian promise. Dissatisfaction with the lack of character, the absence of historical association and tradition, and the stultifying sameness in much of the architecture either built or inspired by the pioneers of the modern movements has engendered a reaction in many young architects that is still continuing.

These architects, and a number of contempo-

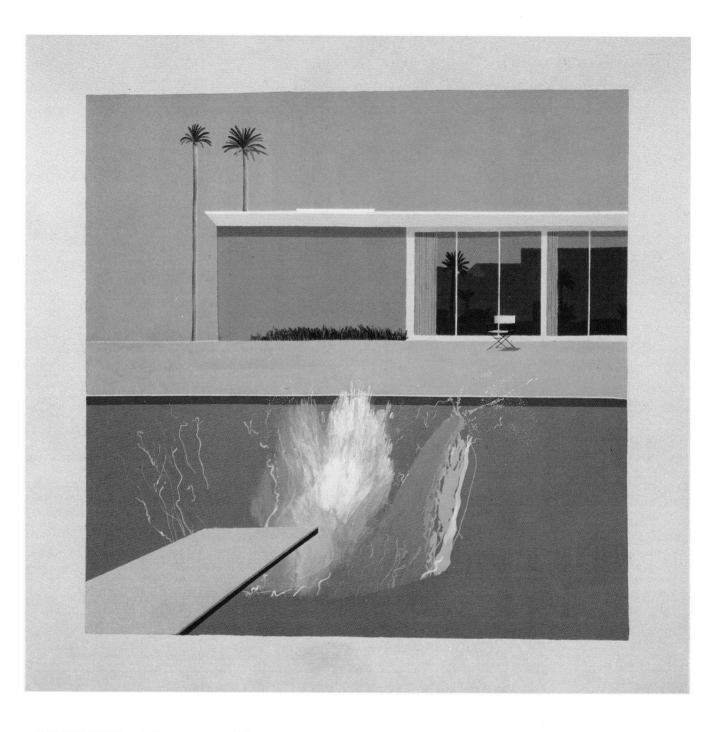

DAVID HOCKNEY, A BIGGER SPLASH, 1967. *In contrast to the heightened realism of American painting in the late 1960s and early 1970s, David Hockney, an English painter, has distilled reality.*

rary theorists, believe that the ideas of modernism begun in painting with the Post-Impressionists and in architecture with Gropius and his contemporaries and, to some extent, with Frank Lloyd Wright, are outmoded. The entire modern movement can now be seen as a closed historical period in the development of Western art, just as the Renaissance and

JOAN MITCHELL, THE GOODBYE DOOR, 1980. *An American living in France, Joan Mitchell is one of the outstanding members of the Abstract Expressionist school who has found the language of color and gestural painting to be a sustaining aesthetic vehicle.*

ANSELM KIEFER, DEPARTURE FROM EGYPT, 1984. *Fusing the traditions of Abstract Expressionism, collage, and German Expressionism, Kiefer has produced hauntingly evocative images that deal with the Holocaust.*

Wu Hall (Butler College, Princeton University, 1983) [p. 333], there is a conscious revival of Roman and Renaissance building forms in the semicircular thermal windows (so called because they were used in the Roman baths). The structure ends in an apse and has a projecting roof over a strip of windows that vaguely resemble a clerestory; the configuration of apse and roof recalls some of the late Roman basilicas. The use of uncovered red brick, a highly traditional building material, and the geometric ornamentation give the structure a decorative quality absent from the much more austere and regular architecture of the International Style.

Color, variety, and capriciousness are also characteristic of Post-Modern architecture, as evident in Michael Graves's (born 1934) Portland Public Services building in Portland, Oregon [p. 335]. Finished in 1983, the structure is notable for its huge abstract forms created by the various changes in fenestration, form, and color. The shape of the building's facade and the several colors are enlivening features that would have been unthinkable in so-called progressive architecture only several decades ago. There is a fantasy about the structure that recalls some of the decoration of the Art Deco

Baroque periods, for example, can be seen as eras clearly separate from modern times. Painters no longer feel Picasso is their artistic mentor; rather, like Gropius and Mies in architecture, he is now viewed as an old master. The continuum with the early years of the twentieth century has been broken, and artists and architects have begun to search for new directions. The term *Post-Modernism* was coined to characterize contemporary art and architecture, and while there is general agreement that Post-Modern is a new period quite distinct in form and intent from the so-called modernists, its exact tenets remain elusive.

In architecture, historical forms and building materials, which were shunned by the Bauhaus and were absent from important architecture before about 1970, are now making a strong comeback. In the work of Venturi, Rauch & Scott Brown—Robert Venturi (born 1925) is one of the most influential architects and theorists of contemporary American architecture—there are many references to traditional forms and shapes. For example, in Gordon

VENTURI, RAUCH & SCOTT BROWN, GORDON WU HALL, BUTLER COLLEGE, PRINCETON UNIVERSITY, PRINCETON, N.J., 1983. *The use of curved walls, historically inspired windows, brick, and color shows a new interest in the traditional vocabulary of Western architecture.*

During the twentieth century, the distinctions between architecture and sculpture have once more become blurred. The Vietnam monument, designed by architectural student Maya Lin and completed in 1983, takes its aesthetics from the sleek, streamlined shapes associated with architecture. Reminiscent of a building wall now embedded in the earth, the monument also has the scale and impact of an ancient ruin. Using the simple device of listing the names of the men and women dead and missing in the war, the memorial is nearly as controversial as the event it commemorates.

style of the thirties, a style much admired by modern architects and designers.

The plurality of modern architectural styles can be observed in the museum, an institution that has become increasingly important as a patron of architecture as well as of art. The lingering influence of the International Style in general and of Le Corbusier in particular is readily apparent in the museum buildings by I. M. Pei (born 1917), one of today's leading institutional architects. In addition to his project for the Louvre in Paris, and the East Building of the National Gallery of Art in Washington, D.C., Pei has built several smaller museums. The Indiana University Art Museum in Bloomington, completed in 1982, has the triangular shapes so favored by Pei [p. 336]. A monolithic structure made of roughly finished concrete, the building displays a severe and powerful mass, characteristic of a number of modern museums. The building's sharp triangular design and its large expanses of coarse, blank walls underscore the role of the museum as the guardian of precious artifacts.

The notion of museum as vault is decidedly absent from Piano and Rogers's Centre Pompidou, Paris, finished in 1977 [p. 337]. Here the building is turned inside out, with a forest of brightly colored beams, heating and cooling pipes, and escalators placed on the outside. The functionalism of the Bauhaus is here taken to an illogical conclusion, in a building that may be said to be devoid of any style in the traditional sense of that word. The huge structure is fascinating in a Disney World sort of way, with its futuristic-looking exposed technology; a similar fascination must have been felt by the nineteenth-century public as it gazed upon such contemporary technological marvels as the great, starkly functional train sheds with their exposed iron beams and arches vaulting vast spaces.

In the last decades of the twentieth century, the human figure has reentered the mainstream of artistic expression. It remains to be seen if the figure will eclipse abstraction or remain one theme in an increasingly diverse artistic landscape. The human figure has, of course, appeared and disappeared from artistic conventions before. With the Greeks the human figure was a symbol, an ideal in which were bound up the most vital concerns of the culture. For the Romans, the figure often represented an individual whose exploits were celebrated in the larger context of the destiny of Rome. With the rise of Christianity, the figure essentially disappeared from art for nearly a thousand years. The Renaissance witnessed its return, and the period's celebration of humanity set artists on the road to interpreting mankind and the human condition, which remained their primary preoccupation until the early twentieth century.

With Cubism, which reduced the figure to a formal artistic problem, artists began to explore and redefine the basic principles of art. Artists questioned the nature of reality, the process of creativity, the choice of materials, and the role and purpose of art itself. In the twentieth century, when knowledge about humanity is fragmented into myriad disciplines, ranging from history to biochemistry, it is not surprising that aspects of the human form and spirit should interest only a fraction of the artistic community.

During the past hundred years, the heroic interpretation of humanity has disappeared. Those artists who have utilized the figure have done so without enhancing its inherent beauty or nobility. They have viewed humanity more pragmatically and unflinchingly, as the Dutch of the seventeenth century did. What is often absent in contemporary views of humanity is a sense of compassion, tolerance, and forgiveness; the role of censor, critic, or neutral formalist has too often supplanted the role of healer and reconciler.

Since the late nineteenth century, many of the traditional functions of art have been lost. Great sculptures no longer adorn important historical sites or commemorate heroes. Art in the West is rarely in the service of religion, royalty, or the state. There is in the twentieth century a great division

MICHAEL GRAVES, PORTLAND PUBLIC SERVICES BUILDING, PORTLAND, OREGON, 1983. *Graves and a number of other so-called Post-Modern architects have reintroduced color as an important element in architecture.*

between commercial and fine art, a radical departure from the past. Great artists, from Praxiteles to Titian to Rembrandt, were "commercial" artists, producing a product to suit a particular patron. While patrons today still commission public sculptures and architecture, most of the work fine artists produce functions primarily as a personal expression of the artist. The twenty-first century may see fine artists reembrace function, or it may see critics and historians more often recognizing the aesthetic properties inherent in much functional and commercial production, including advertising design and highway engineering.

The concept of the artist as the creator of idealized beauty that transcends anything found in nature—which inspired the sculptors of the Riace bronzes or the *Laocoön Group*, the builders of Gothic cathedrals, and painters as diverse as Simone Martini and Ingres—was supplanted in the late nineteenth and early twentieth centuries by an

increasing suspicion of mere beauty and an appreciation for a rougher, often cruder, and often less refined aesthetic. The inherent beauty of material, always important in earlier traditions, gained prominence in the twentieth century, as artists paid homage to the humblest scraps by incorporating them into collages. Nature herself became the material of art, as artists altered the landscape directly with Earthworks. Urging the viewer to become sensitized and mentally involved, the artist has often declined to simply hand the audience a visual feast. Modern artistic appreciation now spans a broader spectrum, incorporating not only exquisite ancient sculpture but also modern assemblages of battered and bespattered objects. Just as the figure is no longer idealized, the concept of beauty has often been stripped of grace, refinement, and delicacy. And yet our thirst for such beauty remains, as the attendance figures in museums demonstrate.

I. M. PEI, INDIANA UNIVERSITY ART MUSEUM, BLOOMINGTON, 1982. *This museum is centered on a large, multistoried atrium covered with a dramatic glass roof.*

It is over a century since a number of nineteenth-century artists gathered to predict who would be considered the most important figures of their time a hundred years hence. Their predictions of Meissonier and Bouguereau were wrong, but it might be worthwhile to attempt a similar clairvoyance today. Doubtless Picasso, Matisse, and Marcel Duchamp would be the names most likely selected, for these artists changed the direction of modern art, and their work is the basis for many subsequent artistic experiments. The departure from representation, the interest in the process of creation, the receptivity to experiment with form, materials, and content all have their origins in the works of these artists, and no subsequent avant-garde art movement, from Surrealism to Minimalism, can be understood without them.

But the open and experimental nature of modern art is now reaching far back into the artistic past and into the visual idioms of non-Western cultures. Often borrowed for purely formal ideas, the art of the past has been stripped of its historical significance. Perhaps the eclectic nature of artistic experimentation will render the ahistorical nature of

PIANO AND ROGERS, CENTRE POMPIDOU, PARIS, 1977.
Like much Post-Modern architecture, this building calls attention to itself by its unique construction and its deliberately unharmonious relationship to the surrounding neighborhood.

contemporary art a complete victory. Certainly the Renaissance, once of central interest to the public and to artists, has declined in importance and has been made irrelevant in much contemporary art, as has the notion of history and the idea of timelessness.

Where is art now and where is it going? Pluralistic, diverse, it displays forms and styles derived from many periods and regions and utilizes both abstraction and the figure; artists have declared themselves masters of nearly every conceivable style, message, and medium. Twentieth-century art, with its affirmation of purely formal principles, has sharpened appreciation for diverse artistic expression, regardless of culture, time, or purpose. The properties of composition, line, color, texture, and form, common to all art, are now more readily recognized and historically valued in every work from Piero della Francesca to an African mask. The pluralism of modern art has grown out of and contributed to the cultural relativism that has become one of the challenging issues of twentieth-century America. In order for humankind to develop, survive, and thrive in an increasingly small and threatened environment, the appreciation of our common bonds is essential. At the same time, the traditional princi-

ples mirrored in much Western art must be upheld, celebrated and advanced.

Individuality, humanity, and the human condition have been at the core of most Western art. Born among the Greeks, the concept of the individual was reinforced by the Romans, and it reemerged as an important ideal in the Renaissance. Since then, Western art has been one of the principal instruments used to examine our nature and to promote the notion of growth, self-understanding, and change. The ability to learn and adapt remains a vital human necessity.

All art, including that of today, has a valuable role to play in humanity's continued quest to understand itself and to reconcile itself to its condition. As modern artists either affirm or diminish the role of humanity in their work, they are helping us to define who we are and where we are going. Were artists to give up that important role, their function as sustainers of civilized life would be lost.

INDEX

Page numbers in *italics* refer to captions.

ILLUSTRATION CREDITS

The authors and Summit Books gratefully acknowledge the following sources for their permission to reproduce the illustrations on the pages listed below. The following abbreviations are used: AR = Art Resource, PC = private collection